DATE DUE			

Female
crime and
Delinquency

Female
crime and
Delinquency

CORAMAE RICHEY MANN

THE UNIVERSITY OF ALABAMA PRESS

Permission to quote copyrighted material is gratefully acknowledged to publishers and authors as follows:

Passages from *Sisters in Crime: The Rise of the New Female Criminal* by Freda Adler. Copyright © 1975 by McGraw-Hill Book Company. Used with the permission of McGraw-Hill Book Company.

Passages from *Women in Prison* by Kathryn Burkhart, copyright © 1973 by Doubleday & Company. Used by permission.

Passages from "Protection of the Rights of Pregnant Women in Prisons and Detention Facilities" by Gerald Austin McHugh, 6 *New England Journal on Prison Law,* copyright © 1980 by New England School of Law.

Passages from *The Criminality of Women* by Otto Pollak, copyright © 1950 by the University of Pennsylvania Press.

Library of Congress Cataloging in Publication Data

Mann, Coramae Richey, 1931–
 Female crime and delinquency.

 Bibliography: p.
 Includes index.
 1. Female offenders. 2. Female offenders—United States. 3. Delinquent girls. 4. Delinquent girls—United States. 5. Sex discrimination against women—United States. I. Title.
HV6046.M36 1983 364.3′74′0973 82-16052
ISBN 0-8173-0144-5

To my parents,
Louise and Edward Richey,
who have always
had consummate faith in me.
I hope this volume justifies
their faith, love, and support.

contents

section five: Females and the correctional system

acknowledgments

I am indebted to many people who contributed their help, faith, and support during the five-plus years that passed in the research and writing of this book. Among this number are those hundreds of undergraduate and graduate students whose interest and curiosity stimulated and helped to crystallize my thinking on the subject of female crime and delinquency. In particular I want to thank two of my graduate assistants—Goliath John Davis III and Allan Barnes—who laboriously tracked down needed references and offered constant moral support.

My grateful appreciation is extended to Professors E. Sokari George, who patiently read and commented on an earlier draft of the manuscript, and James Haskins, who artistically prepared the original graphics for this book.

I also want to acknowledge two very skilled and special ladies, Edwina Ivory, who typed the manuscript from its inception and never wavered from the task despite my near-collapses, and Pat Berry, who also gave typing assistance in the final stages of the manuscript.

To all of these marvelous people, I offer my sincere gratitude.

CORAMAE RICHEY MANN
School of Criminology
The Florida State University

Preface

Most authors who have addressed the problem of crime and delinquency have approached the topic from a male perspective, tending to focus on male offenders while disregarding the female offender. Crime has rather myopically been seen as a "male" problem to the neglect of the female contribution to the phenomenon. The present volume, in contrast, brings to light the other side, the female side of the criminological coin, in an effort to close the informational gap between the deviance of men and the alleged female "differences" extant in the study of female crime and delinquency. Members of both sexes are certainly capable of and involved in criminal behavior. Crime is not the exclusive domain of males any more than certain types of offenses—for example, prostitution—are peculiar to females. This book is written for those specializing in criminology, law, sociology, psychology, and other related disciplines, as well as for the public at large, all of whom increasingly demand more knowledge of female criminality.

Those in the social sciences and law who are interested in deviance, criminological theory, and process, have become painfully aware that there has been a conspicuous lack of social scientific data on the female miscreant. Recent authors have emphasized dramatic increases in the arrests of females, especially among adolescents, and have noted the broadening of the types of offenses committed by females, including a greater degree of violence. In an ongoing attempt to determine the etiology of crime and delinquency, and to generate theory, we can no longer ignore the role of the female in crime. Eventually a unified theory of crime causation must include both sexes if it is to truly be explanatory. *Female Crime and Delinquency* is an effort to generate a unisex theory of crime and delinquency

through a comprehensive description and analysis of the female offender.

In addition to the theoretical and conceptual perspectives of female deviance this volume addresses the subject of the female offender as she is processed in the juvenile and criminal justice systems. Similar to the discrepancies in treatment of women in various occupational capacities in our society, adolescent and adult female offenders have been the recipients of differential treatment. In the areas of law enforcement, the courts, and correctional institutions, we find a double standard of justice and fairness operative where females are concerned. In the courts, for example, the female may be favored (judicial paternalism) or, as is the usual case, discriminated against because of her sex status. Institutionalization generally offers less privileges to females than to males, and little or no preparation for a meaningful vocational career upon release.

Several books of case studies and descriptions of female correctional institutions are in evidence, but unfortunately they deal predominantly with a single aspect of the overall subject and thus contribute to the fragmentation of the study of the female offender. By the same token, recent contributions in the area of courts and law further compartmentalize the subject when they discuss females. The present volume devotes substantial attention to these substantive questions, which co-joined with the extensive theoretical analyses will offer a comprehensive structuring of the topic of female crime and delinquency and thus provide an overview of the female miscreant from a criminological/criminal justice perspective.

The Organization of the Book

The book is divided into five sections. Section One discusses the extent of female criminality and the characterization of female crime. In Chapter 1, the historical overemphasis on prostitution and sexuality as the primary female crime is demonstrated to be inaccurate through the introduction of empirical data, criminal and status offense statistics concerning female arrests. Some authors stress the alarming rate of increase of female misbehavior and arrests, while others see no significant increase; and yet a few writers opine that there is parity in male and female deviance but that women seldom get caught or, if they are apprehended, are seldom processed by the system. This chapter explores these diverse positions and attempts to reconcile the differences between them by providing a clear picture of the extent of the female crime problem.

Chapter 2 focuses on the offenses for which women and girls are more frequently arrested as well as those crimes considered atypical of females. Available studies describing the deviance involved in these offenses are included. A discussion of the ethnicity of female offenders concludes the chapter.

The second section outlines the theoretical and conceptual perspectives of female crime and delinquency. The first chapter in this section, Chapter 3, chronologically follows views of female crime and delinquency causality beginning with the early biological work of Lombroso, who inferred that women were genetically less advanced than men, particularly criminal women, and his subsequent attempts to establish female criminal typologies. Later constitutional theories that led to the current exploration of biological and hormonal factors (menstruation, menopause, pregnancy) and their influence on female criminality are discussed.

The fourth chapter describes the Freudian perspectives of "masculine protest," "penis envy," and weaker superegos that have been seen as psychogenic factors in female crime. How this view has dominated research on female offenders is the focus of concentration that includes the psychological dimensions of the runaway girl, the overemphasis on the sexual offenses of females, and the resultant influence of such a posture on female criminological theory. This chapter also investigates the psychodynamics of the family as an influential factor in female delinquency.

Three major contemporary perspectives on female criminality are examined in Chapter 5: the sociological position which describes the factors that operate differently for male and female offenders; the economic view which explores the social and economic realities of female crime; and the role and opportunity theories which appear to be an effort to collapse the first two conceptual positions. The alleged rise in female crime and its relationship to the women's liberation movement are also included in this chapter.

In Chapter 6, Section Three, attention is devoted to the historical development of the law specifically in terms of the genesis of different laws for females that ultimately led to discrimination on the basis of gender. This chapter also scrutinizes the status offenses of adolescent females and those criminal offenses generally attributed exclusively to female offenders.

Case studies and articles demonstrating the idiosyncratic exertion of the law because of sex status form the substantive content of Chapter 7. One focus is on juvenile cases, particularly those status offenses that presume underlying sexual misconduct and are more stringently punished in the case of the youthful female offender. The application

of the law by police officers toward women offenders is examined both on the basis of the chivalrous dimension and also upon the reported "hardening attitudes" toward females by law enforcement personnel. How both types of belief affect police discretion in their decisions to arrest and their subsequent treatment of female offenders is scrutinized in this chapter. The history of policewomen in America, their roles and functions, and how they adjust to their occupational status are also outlined here.

Section Four examines the courts and judicial treatment of females commencing with the juvenile court, its philosophy, origins, and development. The origin and development of the juvenile court is one of the main thrusts of Chapter 8. Emphasis is on the "child savers"—women who pressed for the establishment of a separate court for children—and the ramifications of their actions for both adolescent females and, later, for adult female miscreants. The impact of the early juvenile court philosophy of rehabilitation and the case-work tradition are treated from the perspective of the female offender. Several recent studies have demonstrated that minor female offenders are held in custody longer than boys who have committed the same offenses, particularly in status offender cases. This chapter outlines the "constitutionalist" approach and explores the due process and other rights of females in the juvenile court as it follows girls through the juvenile justice system.

Two basic patterns of juridical discrimination in criminal cases are examined in Chapter 9: the disadvantaged pattern, which applies to "indigent, black or elementary educated defendants," and the paternalistic pattern, which specifically applies to female juveniles. Legal examples, research, and case studies are utilized to demonstrate how these patterns are imposed upon females. Recent authors have demonstrated that females are sentenced both more severely and also less stringently than males for the same offenses. In the first type of cases many judges adopt the "protective attitude" toward females and hand down indeterminate sentences so that the woman remains "protected" in prison.

The final section considers females and the correctional system and includes information on the availability and types of correctional facilities for juvenile and adult females; the internal programmatic and service structure of correctional institutions for females; the plight of incarcerated mothers and mothers-to-be and the effects of institutionalization on their offspring and families.

Chapters 10 and 11 describe the inadequacies of correctional accommodations for juvenile and adult females, respectively, and the resultant different treatment allocated to them. Material is reported from

the many case studies, governmental reports, articles, and books on other differentiating characteristics of female incarceration—for example, the disparity in rights and privileges, inadequate treatment and rehabilitation efforts, and the limited types of vocational and training programs that leave the female offender ill prepared to enter the employment field with meaningful skills.

Incarcerated women have been referred to as "the forgotten female offender" population. There are some women—those in jails, those on death row, and mothers in prison, some pregnant or with new-born babies—who face additional hardships because of their special circumstances. It is estimated that 50 percent of women in correctional institutions are parents and half of them are the sole source of support of their children, yet there are few provisional resources to strengthen the family. Often these children become the responsibility of other agencies, are "fostered out," or are put up for adoption. The effects of such separations and relocations on both the mother and child are pursued in Chapter 12. Pregnant women and girls in correctional systems encounter their own unique problems, such as the lack of proper health facilities and prenatal care, the denial of abortions, and coercion to give the child up for adoption. The injustice of these practices and suggested alternative solutions for the pregnant offender are discussed in this chapter. Eleven women currently on death row in this country are sketched in an examination of their "living death" situation.

The final chapter of the book summarizes the problems delineated in the earlier chapters and suggests future theoretical directions to explain female deviance and the differential treatment of females in the juvenile and criminal justice systems. Finally, suggestions are offered for needed research and policy changes that are considered requisite to eliminate these disparities in justice.

section one
THE PROBLEM OF FEMALE CRIME

1

THE EXTENT OF FEMALE CRIME AND DELINQUENCY

In this chapter we will examine the extent of female crime and delinquency from available official data of the most recent publications (1978, 1979) of the Federal Bureau of Investigation (FBI). These documents, commonly known as the Uniform Crime Reports (UCRs), will be scrutinized for female arrests, female arrest trends during these years, and for trends over the twenty-year period 1958–1978.

Official data are questionable because of certain inherent limitations listed below. While contemporary attention has been devoted to victim survey data, these are also limited, especially in female crime cases. Hindelang, for instance, studied 1972–1976 victimization survey data and found no appreciable change in the proportion of female involvement in crime over these years.[1] Although Hindelang could not substantiate the "chivalry hypothesis"—that men who are victims of female offenders are reluctant to report these women to the police—generally victims of female offenders were less likely to turn to law enforcement agents than the victims of male offenders.

As seen in Table 1-1, a comparison of selected personal crimes of violence by perceived sex in single-offender victimizations reveals little difference between the official data (UCR) and the victim survey data for the year 1977. Because of this congruity, and since UCR data are more frequently used and thus more readily compared across studies, our discussion is therefore restricted to official sources.

Limitations of Arrest Data

There are numerous problems associated with the various reporting measures utilized to describe arrest data, particularly with the most acceptable source of such statistics in the United States, the Uniform Crime Reports. Although the FBI has been designated by

TABLE 1-1: Comparison of Crimes of Violence, Robbery, and
Aggravated Assault, by Percent Distribution of Female or Perceived
Female Offenders, 1977

Type of Crime	Uniform Crime Report*	Victimization Survey†
	(Female arrests)	(Perceived female offender)
Crimes of violence	10.4	11.1
Robbery	7.4	7.1
Aggravated assault	12.8	11.8

*FBI Uniform Crime Reports, 1978, Table 34, p. 183.
†Criminal Victimization in the United States, 1979, Table 39, p. 41.

Congress as the agency responsible for the national collection of crime
data, there is no mandate issued to the state and local governments to
report such data.[2] As a result, for this and many other reasons crime
statistics submitted to the FBI and reflected in the Uniform Crime
Reports do not include all crimes. Thus, "only a small part of vio-
lational behavior comes to the attention of the law enforcement sys-
tem."[3] Sutherland and Cressey sum up this measurement problem as
follows:

> The statistics about crime and delinquency are probably the most unre-
> liable and most difficult of all statistics. It is impossible to determine
> with accuracy the amount of crime in any given jurisdiction or any
> particular time. Some behavior is labeled "delinquent" or "crime" by one
> observer but not by another. Obviously a large proportion of all law
> violations goes undetected. Other crimes are detected but not reported
> and still others are reported but not officially recorded.[4]

Sutherland and Cressey list six types of evidence that crime known to
the police is not an adequate index of crime:[5] (1) for a variety of
reasons many persons do not report crimes; (2) often, for political
reasons, police may underreport or underarrest criminals, or they
may inflate arrest figures or overarrest; (3) some crimes, such as hom-
icide, receive more attention and are more apt to be discovered than
others; (4) improvement in the law enforcement mechanism—in-
creases in the number of personnel, more efficient training of police
in crime detection and investigation, highly specialized police divi-
sions, and organized drives against specific crimes—tend to increase
the number of potential arrests; (5) the fifty states and the District of
Columbia vary in their classifications of crime, and this affects the

number of crimes known to and reported by the police; and (6) crime and arrest rates are computed on the basis of census-enumerated general population figures that fail to take into account changes in the population except every ten years by a census that consistently under-counts ethnic groups, especially AfroAmericans.[6]

In addition to these limitations in the accuracy of FBI crime report data there are errors in reporting, the tendency for overworked police officers to avoid the onerous paper work necessary to complete reports, and the propensity of some administrators to view such statistical reporting as an additional burden to be avoided.

Problems with the Measurement of Female Crime and Delinquency

A chivalry perspective would hold that male officers are reluctant to arrest females, thus reducing the number of female offenders counted. Also it is suggested that most women offenders are never caught because of the types of crimes they commit.[7] Finally, some observers allege a "paternalism" toward female offenders in the juvenile and criminal justice systems that effectively operates as a filtering-out mechanism—a subject we will address at length in subsequent chapters.

Official accounts, which are largely based upon arrest and court data, are the basis for the compilation of most crime and delinquency statistics. Court data introduce the potential problems of diversion, paternalism, or chivalry which may distort the numbers of female offenders. Female arrest figures present the "danger of using the terms 'arrest' and 'crimes committed' interchangeably," and "arrest statistics may not be the most reliable source of data for determining actual crime rates."[8]

In addressing the purported rise in female criminality Laurel Rans[9] introduces the possibility that women are merely being caught, charged, and convicted more frequently than in the past and lists six contemporary factors that might influence female crime statistics:

1. Comparisons of a specific year's data with previous years or other tables is difficult since the number of law enforcement agencies reporting, as well as the estimated total population used in the FBI samples, varies from year to year.
2. The illusion of increased female arrests might be related to increased reporting of previously unreported crimes, making it appear that crime and arrests have increased.

3. Since 1960 a substantial increase in the number of law enforcement personnel has yielded more officers who can make more arrests.[10]
4. The past decade has witnessed significant increases in the amount of funds allocated for police activities. This has resulted in improved police technology and consequently more accurate detection and eventual apprehension of criminals.
5. Also since 1960 techniques of recording crime and arrest statistics have shown such marked improvement that previously underreported or inaccurate statistics involving female arrests are now diminished. Early crime and arrest statistics, for example, sometimes recorded female arrests under the male category, with a resultant overinflation of men's crimes and an underrecording of women's crimes.
6. Changes in the classification of many property crimes do not reflect inflation or population growth. Furthermore, the "population at risk" (fifteen to thirty years of age) should reflect the growth and aging of the United States population in order to be accurate, but does not.

Since female offenders are a comparatively small proportion of the arrested population (about 15.7 percent), it is important to examine base figures when discussing female crime rates. One researcher, for instance, cites the example of a 450 percent increase in juvenile female arrests for negligent manslaughter between 1960 and 1974; the actual numbers involved indicated only two females arrested for this offense in 1960 and just eleven in 1974.[11]

It is obvious that there are serious difficulties with the best available information we have to depict the crime problem in general, but it is equally clear that unique disadvantages accrue to efforts to examine the extent of women's participation in crime. These drawbacks should be kept in mind as we explore female crime and delinquency in the next section and, subsequently, throughout the book.

The Official Data

The FBI Uniform Crime Reports are dichotomized into Part I and Part II offenses, depending upon the seriousness of the act committed. The Part I offenses are considered the most serious and include the Crime Index offenses, which collectively measure the most common local crime problem. Part II contains nonserious offenses, which are also referred to here as nonindex offenses.

The index crimes in Part I are criminal homicide, which includes murder and nonnegligent manslaughter as well as manslaughter occurring as a result of gross negligence; forcible rape, which excludes statutory rape (that situation where no force is used but the victim is under the age of consent); robbery, which includes strong-arm robbery, stickups, armed robbery, assaults, and attempts to rob; aggravated assault, which implies intent to kill or severely maim or injure but excludes simple assaults; burglary-breaking or entering; larceny-theft, excluding auto theft and stealing not involving force, violence, or fraud; motor vehicle theft, which does not include boats, airplanes, farm or construction equipment; and arson.[12]

For the purposes of the Crime Index totals, these Part I offenses are further subdivided into violent crime (murder, forcible rape, aggravated assault, and robbery) and property crime (burglary, larceny-theft, arson, and motor vehicle theft).

The less serious or nonindex Part II offenses are other (simple) assaults; forgery and counterfeiting; fraud, which includes bad checks except forgeries and counterfeiting; embezzlement; buying, receiving, or possessing stolen property, or attempts to do so; vandalism; carrying, using, possessing, furnishing, and manufacturing deadly weapons or silencers, or attempts to do so; prostitution and commercialized vice; sex offenses, excluding forcible rape, prostitution, and commercialized vice, but including statutory rape and offenses against the common decency and morals of the community; drug abuse violations, such as the sale, use, growing, manufacturing, or possession of unlawful narcotics; gambling; offenses against the family and children, including nonsupport, neglect, desertion, abuse; driving under the influence of liquor or narcotics; state or local liquor law violations; drunkenness or intoxication; disorderly conduct; vagrancy, or vagabondage, begging, loitering, etc.; all other offenses, except traffic; suspicion; curfew and loitering law violations, which apply only to juveniles; and runaway, also limited to juveniles.

In the past twenty years the arrests of females, according to the official data, have not varied by more than five percentage points as a proportion of total arrests. In 1960 females comprised 10.7 percent of the total number of arrested persons; by 1979 they were only 15.7 percent of that total.[13] Nor has the type of offense for which females are arrested fluctuated over this time span. Essentially the female crime of today mirrors the female crime of yesteryear.

An examination of Table 1-2, which relfects female arrests for index, or serious, crimes in 1979, demonstrates that females contributed little to the local "crime problem" in 1979. Violent female offenders comprised only 10.2 percent of the total arrests for that

TABLE 1-2: Female Arrests for Index Crimes, 1979

Offense	All Ages	Under 18	Over 18	
Total Arrests				
Number	408,121	146.896	261,225	
Percent	100	36.0	64.0	
	Number All Ages	Percent Under 18	Percent Over 18	Percent of Total Arrests
Murder and non-negligent manslaughter	2,373	6.9	93.1	13.7
Forcible Rape	210	26.2	73.8	.8
Robbery	9,321	29.3	70.7	7.4
Aggravated assault	30,772	18.3	81.7	12.4
Burglary	28,613	50.2	49.8	6.3
Larceny-theft	322,425	36.0	64.0	30.3
Motor vehicle theft	12,410	56.4	43.6	8.9
Arson	1,997	41.8	58.2	11.3

					Females Only
Violent crime*	42,676	20.1	79.9	10.2	3.0
Property crime†	365,445	37.9	62.1	21.8	25.2
Crime Index total	408,121	36.0	64.0	19.5	28.2

Based on 11,239 agencies; 1979 estimated population 197,679,000.
Source: FBI Uniform Crime Reports, 1980, p. 195.

*Violent crimes are murder, forcible rape, robbery, and aggravated assault.
†Property crimes are burglary, larceny-theft, motor vehicle theft, and arson.

category, with murder and nonnegligent manslaughter the most frequent violent offense; 13.7 percent of the total arrests were for this offense. Within the Crime Index property crime (21.8 percent) is far more frequently committed by females than violent crime, largely due to the elevated incidence of larceny-theft, or shoplifting (30.3 percent of total arrests). The overall Crime Index total for female offenders is therefore 19.5 percent, or not quite one fifth of serious crime commissions.

In her monograph *The Contemporary Woman and Crime,* Rita Simon compared adult male and female arrests between 1953 and 1972 and reports that in 1953 women constituted about one out of 10.6 persons

arrested for serious crimes but by 1972 the ratio was one out of 5.2.[14] This average rate of increase was greater than the average increment of all female arrests for the identified period. Upon closer scrutiny of the figures Simon found that the increase in the proportion of women's arrests for *serious* crimes was "due almost wholly to the fact that women seem to be committing more property offenses than they have in the past."[15] In 1953 women comprised one out of every 12 persons arrested for property crimes, but by 1972 this picture had changed to one in 4.7 persons. Simon emphasizes the fact that the big increases occurred since 1967.[16]

Other researchers concur with these previous analyses of increases in female serious arrest rates as due almost entirely to increased participation in property offenses, particularly larceny-theft.[17] One study of the 1960–1970 Uniform Crime Reports introduces the fact that these crime increments were only characteristic of women offenders.[18] When age was introduced, violent and property crime arrests among females under eighteen increased equally in the period 1960–1970. Adolescent girls (those under eighteen) were found to be more violent than women arrestees with the largest increases in robbery (342 percent) and aggravated assault (200 percent). The girls also demonstrated greater larceny arrest increments (253 percent) than women offenders (90 percent).[19]

More recent data compiled by the author is depicted in Figure 1-1, which compares the arrests of girls and women for index crimes between 1970 and 1979. These data demonstrate that the percentage of arrests of women dramatically exceed those of girls for property crimes (91 percent versus 31 percent). Girls, on the other hand, had a slightly higher percentage increase for violent crime arrests (65 percent) from 1970 to 1979 than did women (56 percent).

In 1979 girls made up 33 percent of arrested females for index crimes, but they differed from women offenders in the types of property crimes committed. They exceeded their adult peers in burglary, comprising 50.2 percent of females arrested for this offense, and in motor vehicle theft (56.4 percent), both of which are considered more serious crimes than larceny-theft, the typical woman's crime.

The arrests of females for nonindex crimes in 1979 (14.6 percent) were less than the arrests for index offenses (19.5 percent). As seen in Table 1-3, more than two thirds (67.5 percent) of the persons arrested for prostitution and commercialized vice were females, the most prevalent offense for females as compared to males. Fraud, at 40.4 percent of total fraud arrests, was the second highest offense of females; and

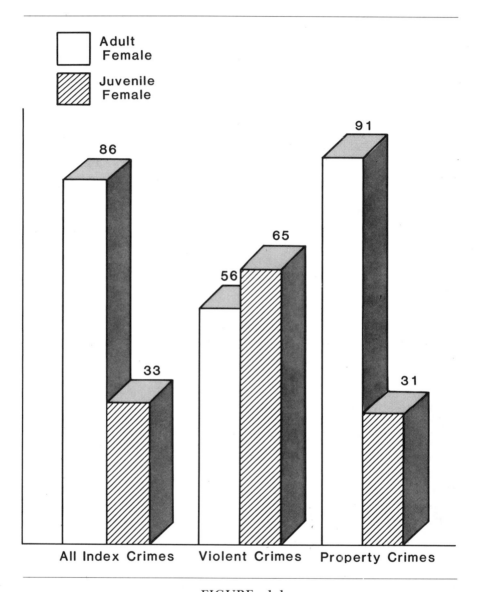

FIGURE 1-1

TABLE 1-3: Female Arrests for Non-index Crimes, 1979

Offense	All Ages	Under 18	Over 18	
Total Arrests				
Number	1,031,760	276,463	755,297	
Percent	100	26.8	73.2	
	Number All Ages	Percent Under 18	Percent Over 18	Percent of Total Arrests
Other assaults	59,302	27.9	72.1	13.6
Forgery and counterfeiting	21,175	13.3	86.7	30.9
Fraud	93,331	2.3	97.7	40.4
Embezzlement	1,950	11.4	88.6	25.3
Stolen property; buying, receiving, possessing	10,996	27.6	72.4	10.7
Vandalism	19,453	50.7	49.3	8.4
Weapons, carrying, possessing, etc.	10,758	13.3	86.7	7.4
Prostitution and commercialized vice	53,919	38.1	61.9	67.5
Sex offenses (except forcible rape and prostitution)	4,779	16.8	83.2	7.8
Drug abuse violations	67,452	26.9	73.1	13.5
Gambling	4,755	1.8	98.2	9.5
Offenses against family and children	5,057	17.9	82.1	9.9
Driving under influence	103,022	2.7	97.3	8.7
Liquor laws	54,743	53.4	46.6	14.7
Drunkenness	77,288	7.8	92.2	7.3
Disorderly conduct	106,433	19.6	80.4	15.4
Vagrancy	7,410	11.0	89.0	22.5
All other offenses (except traffic)	225,201	24.8	75.2	14.8
Suspicion (not included in totals)	2,514	31.1	68.9	14.5
Curfew and loitering law violations	16,596	100.0	—	22.0
Runaway	85,626	100.0	—	58.4

Based on 11,239 agencies; 1979 estimated population 197,679,000.
Source: FBI Uniform Crime Reports, 1980, p. 195.

TABLE 1-4: Ten Most Frequent Female Arrests, 1979

Offense	Rank	Percent of Female Arrests	Percent of Total Arrests
Larceny-theft	1	22.2	30.3
All other offenses (except traffic)	2	15.8	14.8
Disorderly conduct	3	7.3	15.4
Driving under influence	4	7.1	8.7
Fraud	5	6.6	40.4
Runaway	6	6.0	58.4
Drunkenness	7	5.3	7.3
Drug abuse violations	8	4.7	13.5
Other assaults	9	4.1	13.6
Prostitution and commercialized vice	10	3.8	67.5
Liquor laws	10	3.8	14.7
Total		86.7	

Based on 11,758 agencies; 1979 estimated population 204,622,000.
Source: FBI Uniform Crime Reports, 1980, p. 199.

30.9 percent of all persons arrested for forgery and counterfeiting in 1979 were females, the majority of whom were over eighteen.

The categories in which girls are more frequently arrested for non-index crimes are typical teenage offenses: vandalism (50.7 percent), liquor law violations (53.4 percent), curfew and loitering violations (100 percent), and runaways (100 percent). The latter two categories are considered status offenses, or those for which only minors can be arrested.

Continuing an examination of offense classifications *within* the female group, interesting patterns can be distinguished over time periods that suggest further clues to the criminality and delinquency of females. A rank ordering of female arrests in 1979 is displayed in Table 1-4 as proportions of total female arrests for that year. Larceny-theft at 22.2 percent of the total female arrests is clearly the crime for which most females were arrested that year, a situation which has persisted for at least twenty-five years.[20]

The second largest percentage of total arrests within the female group in 1979 is "all other offenses" (15.8 percent), or those crimes that are violations of state and local laws and ordinances. This is a category that appears to be a catch-all even though it varies by juris-

TABLE 1-5: Ten Most Frequent Female Arrests, 1958-1978
at Five-Year Intervals

Offense	Rank Order by Year				
	1958	1963	1968	1973	1978
Drunkenness	1	1	2	4	7
All other offenses (except traffic)	2	2	3	2	2
Disorderly conduct	3	3	4	5	3
Larceny-theft	4	4	1	1	1
Prostitution and commercialized vice	5	5	6	9	9
Suspicion (not included in totals)	6	10	—	—	—
Liquor laws	7	7	8	—	10
Other assaults	8	6	7	8	9
Vagrancy	9	9	—	—	—
Gambling	10	—	—	—	—
Driving under influence	—	8	10	7	4
Runaway	—	—	5	3	5
Drug abuse violations	—	—	9	6	8
Forgery and counterfeiting	—	—	—	10	—

Reconstructed from FBI Uniform Crime Reports for indicated years.

diction. The eleven offenses ranked in Table 1-4 account for 86.7 percent of all female arrests for that year; of that number, 64 percent, or seven of the eleven offenses, are for "victimless" crimes such as disorderly conduct, runaway, driving while under the influence, drunkenness, prostitution, drug abuse, and liquor law violations. Even a superficial glance at these offenses suggests that in 1979 females were mostly arrested for behavior unbecoming a lady.

This pattern of arrests implies that inappropriate actions by females, or those not in keeping with their assigned sex role, can result in a punitive backlash by the justice systems. Furthermore, females have been subjected to arrests for such offenses consistently over a twenty-year period. Table 1-5 displays the rank ordering of female arrests at five-year intervals from 1958 up to 1978 and reveals that drunkenness, prostitution, and disorderly conduct have remained among the top arrest offenses of females over the past two decades.

A previously neglected data source provided in the Uniform Crime Reports is statistical information that permits comparisons between

TABLE 1-6: Five Most Frequent Female Arrests and Crime Indices by Geographic Area, 1979, in Percentages (Excluding Juvenile Status Offenses)

City*		Suburban†		Rural‡	
Offense	Percent of Female Arrests	Offense	Percent of Female Arrests	Offense	Percent of Female Arrests
Larceny-theft	24.4	Larceny-theft	23.4	Fraud	20.2
All other offenses (except traffic)	15.4	All other offenses (except traffic)	15.4	All other offenses (except traffic)	18.5
Disorderly conduct	8.4	Driving under influence	9.0	Driving under influence	11.7
Driving under influence	6.0	Fraud	7.4	Larceny-theft	8.0
Drunkenness	5.6	Disorderly conduct	5.5	Drunkenness	5.5
Violent crime	2.9		2.5		3.0
Property crime	27.7		28.6		11.5
Crime Index total	30.2		29.1		14.5

*Based on 8,555 agencies; 1979 estimated population 143,151,000.
Source: FBI Uniform Crime Reports, 1980, p. 207.
†Based on 5,192 agencies; 1979 estimated population 77,383,000.
Source: FBI Uniform Crime Reports, 1980, p. 216.
‡Based on 2,370 agencies; 1979 estimated population 28,357,000.
Source: FBI Uniform Crime Reports, 1980, p. 225.

female arrests dependent upon the demographic area in which they live. Admittedly it is difficult to make cross-comparisons among these groups because of the varying bases of city, suburban, and rural populations from which the data are derived. Nevertheless, some of the differences between these female groups, seen in Table 1-6, are provocative. Excluding status offenses, the top five, or most frequent, offenses for which females were arrested nationally in 1979 were larceny-theft, all other offenses, disorderly conduct, driving under the influence, and fraud (see Table 1-4). Understandably, these identical offenses should hold for cities, suburbs, and rural areas, since they are incorporated in the total 1979 figure; and this is exactly what was found. However, the rank ordering by frequency of offense reveals some rather interesting, and unexpected, distributional differences.

Whereas fraud was fifth among all female arrests in 1979, it does not appear in the five most frequent arrest categories for cities, as might be expected. Yet fraud was the crime for which most rural females were arrested and ranked fourth among suburban female arrests. It is not likely that the fraud perpetrated by the females in such communities is of the white collar variety, but a speculation that these arrests may be for bad checks—possibly passed in suburban shopping malls—is not beyond the realm of possibility. These new enclosed innovations in shopping facilities may offer too many temptations for the suburban or rural resident. Such a notion might also explain the high incidence of larceny-theft, presumably shoplifting, found to be the number one offense of female suburbanites.

Table 1-6 also indicates the Crime Index totals for city, suburban, and rural female arrests in 1979. Although the highest, 30.2 percent, is not unexpected for city females, suburban females are not far behind at 29.1 percent. Rather surprising is the slightly higher violent Crime Index of the rural group (3.0), which exceeds both city violent offenders (2.9) and suburban females who commit violent crimes (2.5). Clearly, violent crime is not significant within the female offender groups, regardless of demographical area, whereas property crime appears to have more significance.

Whatever analyses can be made of these trends and findings, it does seem evident that women and girls, regardless of locale, are imbibing a lot of liquor, becoming drunk, and driving while in that condition—then getting arrested for such offenses. Also adolescent girls are running away from their homes in legion numbers. Such taboo behavior for the female sex has apparently resulted in disproportionate arrest figures for this group.

The Myth of the New Female Criminal

The evidence cited above indicates that females are far less violent criminals than males. There is a popular belief, at least partly attributed to the media, that women's criminality is becoming similar to the criminality of men, especially where violent and aggressive crimes are concerned. We have found little support for such a myth.

Currently there is some confusion among criminologists and other researchers as to the true extent of female crime and delinquency. Some authors stress an alarming rate of increase in female misbehavior and arrests; others see no significant increases; some writers feel there is parity in male and female deviance, but that women are

seldom apprehended, or if they are caught, they are not processed by the system.

Addressing the changing patterns of female criminality, Freda Adler, in her seminal work on female crime, *Sisters in Crime,* reports:

> By every indicator available, female criminals appear to be surpassing males in the rate of increase for almost every major crime. Although males continue to commit the greater number of offenses, it is the women who are committing those same crimes at yearly rates of increase now running as high as six and seven times faster than males.[21]

The rate of increase seen in crimes of passion—murder and aggravated assault—did not indicate any significant differences according to sex over the 1960–1972 period Adler studied, but she found that the incidence of these violent crimes among females was rising.

Much of the criticism of the myth of a new and violent female offender is directed at the use of Uniform Crime Reports, misinterpretations of such reports, or a combination of both practices. More recent efforts to analyze the extent of female criminality adopt comprehensive approaches to the problem. Steffensmeier, for example, utilized police statistics, court data, the Uniform Crime Reports, and United States Census information in his analysis of women who were arrested between 1965 and 1977 as compared to men.[22] He also added two additional variables previously overlooked by theorists concerned with female crime statistics. First, Steffensmeier used calculated rates on persons from ages eighteen through fifty-nine, or what he defined as the "population at risk," and second, he categorized the crimes into five types which varied in seriousness. These working definitions of *masculine, violent, male-dominated, serious,* and *petty-property* crimes were formulated because of ambiguity previously caused by the use of such terms.[23]

Steffensmeier concludes that no arrest gains were made by women in the male-dominated, violent, and masculine crime categories, but that women's arrests increased more than men's for serious crimes, mainly larceny-theft. Furthermore, "the changes in the category of petty-property crimes are greater than in any of the other categories examined."[24] Women are not catching up with men in crime, according to these findings, but are still being arrested for crimes that have traditionally been considered women's offenses. Figure 1-2 shows the percentage increases of Index Crimes of men and women from 1970 to 1979 and tends to confirm the earlier 1977 study by Steffensmeier and its demonstrated emphasis on increases in women's property crime offenses.

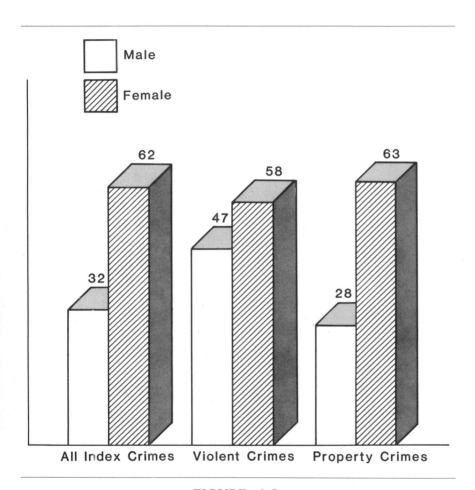

FIGURE 1-2

Earlier in this chapter we mentioned that the increases in violent crime among females appeared to be due to a disproportionate contribution by adolescent female offenders (see Figure 1-1). Another way to examine violent crime among girls is to compare their arrests for such offenses with that of boys. Figure 1-3 shows that from 1970 to 1979 there was a 65 percent increase in girls' arrests for violent crimes compared to only a 39 percent increment for boys. In fact, the increases in girls' arrests for index crimes appear to be appreciably more than boys' arrests, according to Uniform Crime Report data. One might easily leap to the conclusion that girls are becoming more violent than boys and, additionally, that juvenile females are the population reflected in the popular belief of more violent, more aggressive female offenders as portrayed by the media.

Adolescent female delinquency trends were examined by Steffensmeier and Steffensmeier through analyses of national arrest statistics such as the above, national juvenile court statistics, self-report studies, and field studies of female delinquent gangs, from 1965 to 1977.[25] Their data are grouped into "violent, masculine, serious, petty-property, drugs/drinking, status, and sex-related" offenses.[26] The Steffensmeiers conclude that nonofficial trends in female delinquency have not changed significantly in recent years and continue to reflect the traditional sex role model. Although girls' arrests for *masculine* and *violent* crimes revealed small increases from 1965 to 1977, these gains are largely in the "other assaults" category and are of a nonserious nature. The rising levels of female delinquency reflected in the Uniform Crime Reports, according to these authors, are primarily for larceny, liquor violations, and running away from home. Although adolescent female arrests for *serious* crimes increased more than those of their male peers in the time span studied, the Steffensmeiers find that this narrowing of the arrest gap between boys and girls reflects the preponderance of shoplifting arrests of girls.

The Steffensmeiers' examination of male and female juvenile court rates from 1965 to 1977 indicates that gains made by adolescent female offenders were largely due to shoplifting, marijuana and drug use, and status offenses.[27] Marijuana and alcohol use among girls was also a main contributor to the sex differential in self-report studies these researchers explored.

A number of "admitted delinquency" studies have found closer sex ratios than official data would indicate.[28] However, these self-reports do reveal a general tendency for increases in frequency of drinking, marijuana use, and drug use among girls. In fact, one national cross-sectional study of reported behavior of American boys and girls in

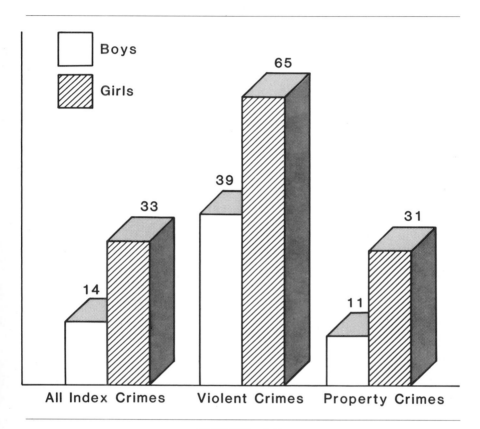

FIGURE 1-3

forty geographical areas throughout the country found that the use of
drugs was the only sharply increased delinquency behavior among
boys and girls over the five-year period studied. This finding was
more pronounced among fifteen- and sixteen-year-old girls.[29] Other
researchers of self-reported delinquent behavior feel that such results
reflect a "teen age culture orientation—drinking, driving without a
license or permit, drug use, and skipping school."[30] In such an adoles-
cent subculture, separate from the larger society, girls apparently
have found a form of equality with their male peers, at least on one
level, delinquency.

2

THE NATURE OF FEMALE CRIME AND DELINQUENCY

There are many ways one can examine the female crime problem. The method selected in this chapter approaches the nature of female offenses from several perspectives. First, those specific offenses historically associated with female offenders will be described with special attention devoted to those offenses designated as sex-specific and sex-related.[1] The second area of focus will include those offenses for which women and girls are more frequently arrested as indicated in the Federal Bureau of Investigation's Uniform Crime Reports (1978). Third, a number of offenses generally considered atypical of females have more recently come to light and will be included. And finally, the chapter will conclude with a discussion of a principal social characteristic of female offenders, race/ethnicity.

Females are arrested for every type of crime listed in the Uniform Crime Reports. However, in this chapter those specific crimes committed by women and girls where there is available literature or research are the primary areas of focus and interest. For convenience these offenses have been categorized as violent, property, and "victimless" crimes, and the status and other offenses of juvenile females.

Violent Crimes

Most crimes of violence by females take place in the family setting where the victims are usually the husband, lover, or child of the woman offender. In one study of female violent crime such victims comprised over half of the homicide cases and over one third of the assault cases examined.[2] For the most part, male and female adult friends or acquaintances were the victims in the homicide cases, whereas more of the assault cases involved strangers.

An Ontario study of violence and dangerous behavior included violent female offenders, one hospitalized group and another group incarcerated in an Ontario penitentiary.[3] These women were found to be slightly older than their male counterparts and were mostly from the lower-middle or working class; their violence occurred within the family milieu. Half of the women who were hospitalized had killed their own children.

Infanticide

Infanticide has historically been considered a sex-specific crime, or one that "actually excludes the members of one sex by legal definition."[4] In her descriptions of the English legal system Carol Smart points out that infanticide is the one exception to equally applicable British law since it is an offense commitable only by women.

Some attribute this offense to the occasion when an unmarried mother must rid herself of a shameful secret through "suffocation, strangulation, and the infliction of wounds or fractures to the skull as the most frequent forms of infanticide."[5] Modern versions of infanticide are not restricted to unwed mothers, and often include married women who use more devious means to get rid of an unwanted burden. No doubt many murders of infants are classified as crib deaths or some form of accidental or natural causes.

In Maria Piers' book *Infanticide,* the following modern horror story is described:

> A doctoral candidate in the social sciences at one of the large midwestern universities, who was teaching courses in the social sciences to employees of a large city sewer system, learned from these employees that during the previous year, four corpses of newborns had been found on the sewer screen. The newborns had been thrown directly after birth into the sewers, a preferred place for children's corpses for millennia. No identification or investigation was attempted in these cases of infant death.[6]

Assault

It is difficult for a woman to use physical strength in an assault, so she is forced to use a knife, some other kitchen item, or a household product. Otto Pollak reports only one method of aggravated assault by women as notable: throwing disfiguring sulfuric acid at the victim,

usually an unfaithful lover.[7] The practice of throwing scarring solutions such as lye, gasoline, acids—and in a recent case involving a well-known rock artist, hot grits—is still a common practice used by women to "equalize" their lack of assaultive strength. Many violent women offenders wait until their male victims are asleep to perpetrate their assaults, which, in some cases, become homicides.

Media attention has recently been devoted to sensational cases of women who killed their husbands in this fashion, allegedly because of previous abuse. One 1977 case that received national attention concerned a woman in Michigan who doused her bedroom and sleeping husband with gasoline and killed him in the fire. Immediately after her acquittal three women in one weekend shot and killed their husbands in the Chicago area. There is also the case in which a New Jersey housewife stabbed her sleeping professional football player husband to avoid any future beatings. Commenting on such cases, one trial spectator said "an open season on men" would be the result of such acquittals. While the validity of this prediction remains to be seen, another recent Florida case is noteworthy, especially because of the brutality involved. A woman and two of her female friends planned and carried out the ghastly murder of her doctor husband by beating him to death with an iron skillet, a bar stool, and other household items. Prior to the murder trial the defendant was also found guilty of conspiracy to murder another woman by means of a "hit" contract in order to prevent her from giving damaging testimony in the murder trial.

Family Violence

Very little is known about family violence, but recent examinations of the problem have revealed some startling cases of women who abuse their children, husband, and parents. The actual extent of family violence is generally unknown. One survey used a household interview technique from which extrapolations were made of the extent of violence directed toward children in the United States.[8] Estimates of the incidence of child abuse in 1975, according to this study, included 1 to 1.9 million children from three to seventeen years of age who were bitten, kicked, or punched by their parents; and between 275,000 and 750,000 who were actually beaten. These were considered low estimates. The younger child is most often the victim, and while mothers are more likely (68 percent) than fathers (58 percent) to commit child abuse, both parents are equally capable of serious violence against their children.

A 1978 report by the American Humane Society on 100,000 cases of child abuse, most of which were reported in lower socioeconomic families, found that 45 percent of the abusers were women. Other authors report no significant sex differences in the patterns of parental abuse of children.[9]

The role that physical punishment plays in child rearing and socialization in our society is felt to lead to the kicking, burning, choking, biting, hitting with the fist, twisting of the arms, and breaking of the bones of children.[10] Additionally, the psychology of the caretakers who abuse or cause the death of an infant or child is noteworthy:

> They are easily thrown into difficulty by marital problems, mild friction in any of their fragile interpersonal relationships, or by increase in long-standing intrapsychic states of depression and anxiety. There may be devastating problems related to poverty, unemployment, alcoholism, poor housing, or the breakdown of appliances and automobiles. Such environmental disasters, while potent exacerbators of trouble, are not essential instigators of abuse; it is well known that abuse and infanticide also occur in significant number in upper socioeconomic levels, despite good housing, education, employment, and lack of alcohol.[11]

The thought of the "little woman" beating up or battering her husband is cause for many deep guffaws, especially from men. Yet this form of spouse abuse is now believed to be more commonplace than previously imagined. Two social scientists, Roger Langley and Suzanne Steinmetz, working independently, report that millions of husbands are battered but do not report such abuse for fear of humiliation. Langley offers the least conservative estimate by contending that 12 million men are physically abused by their spouses at some point in their marriages, and about 1 million of these men are severely beaten.[12] Certain characteristics of a marriage create husband beaters: a big woman and a small man; an older man married to a younger woman who is physically stronger; and a very sick or physically handicapped man who has a healthy wife.[13] Since size and strength seem to be the differentiating variables, these characteristics appear to depict a female bully.

Steinmetz reports about 280,000 men annually are battered husbands who tend not to defend themselves from their wives, either because they fear they could severely damage a woman, or because they feel that a man who hits a woman is thought of as a bully.[14]

A preliminary analysis of findings from 2,143 American families reveals that while 3.8 percent of the wives had experienced at least one of the most severe forms of violence, 4.5 percent of the husbands

had.[15] By projecting these data to the 47 million couples in the United States, it is estimated that 1.8 million wives are battered as compared to 2 million husbands.[16]

A portion of women's abuse of their husbands may be "protective reaction violence" where the wife strikes the first blow to protect herself from her spouse when she believes she is about to be abused. Men and women batter each other in the same way, but obviously "violent men may well cause more damage than violent women," and it may be necessary for the woman to strike first.[17]

While husband beating is called the most "underreported crime," parent abuse has been referred to as "a new plague." This type of abuse involves "elderly people who live with and depend upon their adult children and who are psychologically or physically mistreated by them."[18] This practice, known in England as "granny bashing" and "gramslaming," is rapidly becoming "the hidden crime of the 1980s" in the United States. It is difficult to determine the extent of parent abuse, but a recent study of the phenomenon in Cleveland found that one out of ten elderly parents had been abused by the family member with whom they lived. A year-long investigation by the House Select Committee on Aging views the abuse of the elderly as a widespread national problem almost equal to child abuse with the finding that about 4 percent of our older population, or 1 million senior citizens, experience neglect, beatings, druggings, torture, and rape, mostly at the hands of relatives.[19]

The committee report describes one case of a sixty-eight-year-old mother whose daughter kept her in an unheated portion of the house in "conditions of unspeakable squalor." The area was so cold that when she was discovered by a social worker, the urine from the woman's catheter was frozen. And in another case, when an eighty-five-year-old woman's daughter went to Hawaii, the elderly woman was left to care for herself and lay in her own urine and feces so long that the bedsores she developed became infested with maggots.[20]

It is difficult to judge how many women are the primary abusers of elderly people, but we can presume the number is high because there is a tendency for elderly parents to live with their daughters more often than with their sons and daughters-in-law. In the latter case, if the age-old stories about mothers-in-law have a modicum of truth to them, it is also conceivable that when a daughter-in-law is the primary caretaker of her husband's mother, mistreatment might result.

Recent empirical data reported by Nan Giordano profiled six hundred elderly abused people in six Florida counties as neglected or physically, psychologically, financially, or multiply (more than one type of abuse) abused.[21] The elderly white female tended to be the

average abused individual in each category except the neglected or the financially exploited. The typical perpetrator in physical or psychological abuse cases was a white, married male, usually the spouse; if the victim was not married, the son was the typical abuser. In the neglected cases the victim was either a white male or female, and commonly a white male or female relative was the abuser. Financially exploited elderly individuals tended to be widowed white males and females who were abused by white males or females unrelated to them. The average victim of multiple abuse was a white female who was usually abused by her spouse; if she was unmarried, the abuser, a female, was typically her daughter.

Since ours is a violent society, we suspect that this type of family violence is not only widespread but may also be accelerating. Only one out of six cases of adult abuse are reported, either because the victims are dependent upon the abuser, afraid of being abandoned, fearful of retaliation, ashamed, or confused because of their love for their children.[22]

Robbery

The total arrest trends of the Uniform Crime Reports for the period 1969–1978 show a 62.4 percent increase in female arrests for robbery.[23] Among girls under eighteen years of age the increase was 48.7 percent. Whereas females comprised 4.5 percent of those arrested for this offense in 1958, a slow but steady rise indicates that over 7 percent of today's robbers are females.

The criminal roles of women have been described as:

> . . . the *conspirator,* who instigates or has knowledge of the crime but who does not participate in committing the criminal act itself; the *accessory,* who plays a secondary role in committing the crime—acting as lookout, driving a getaway car, carrying weapons, tools, or the proceeds of robberies and burglaries; *the partner,* who participates equally in all aspects of the crime; and finally, the woman who acts as *sole* perpetrator of crime.[24]

Earlier research found that women involved in robberies were usually accessories, or they accompanied someone else such as a friend or acquaintance, but not those intimate to them. For example, in one study, male thieves revealed they were unwilling to work with women as partners unless necessary; and if they do work with women, they relegate them to secondary roles as accessories.[25] However, there are

recent indications that the characteristics of female robbers are changing to reflect their increasing economic motivation for this type of crime. In one study a stratified random sample of thirty-three incarcerated female robbers in Florida found that in one third of the cases the offense was either committed alone or with other female accomplices.[26] The female robbers studied were engaged in the planning and were active in the commission of the offenses, most of which involved the use of a firearm. Such characteristics were especially true of the female "career robber" who exhibited an internalized, continuing pattern of criminality witnessed in extensive prior juvenile and criminal records, including other robberies. The reasons given for the commission of the offense were: money (40 percent), peer pressure (36 percent), intoxication (18 percent), revenge (3 percent), and pleasure (3 percent). The majority of these women tended to be of higher intelligence than other female felons, and they were single.

Terrorism

One final violent offense that is increasingly becoming associated with women is terrorism. There is some disagreement over the definition of terrorism since this form of violence takes so many forms, in some cases consists of the threat of violence, involves diverse motivations, and deals with a variety of issues. Terrorism can be political or criminal, national, international, or transnational. From the public point of view, however, it is generally agreed that guntoting, bomb-planting, hijacking of airplanes, trains, and other means of public transportation, and other militant, fear-instilling activities are the "garden variety" ingredients of terrorism. The incidents and escapades involving the women in the Baader-Meinhof Gang in West Germany, the Japanese Red Army, the Irish Republican Army (IRA), and our own Symbionese Liberation Army (SLA) are viewed as terrorist activities.

Historically, women associated with terrorist activities have been relegated to subservient roles. They have been part of the support system that includes duties such as "fetcher and carrier, giver of aid and comfort to the masculine mastermind behind the scenes, and stout helpmeet—but nothing more—to the male operative in the field."[27] Some observers view this assignment of terrorist women to support roles as placing them most effectively and not as male chauvinism.

It is possible that women terrorists were neglected by scholars in the past because of their assignment to supportive roles. More recent

TABLE 2-1: Female Arrests Trends for Burglary, 1963–1978,
at Five-Year Intervals

Number		Percent of All Female Arrests	Percent of All Arrests
1963	5,552	1.1	3.0
1968	10,690	1.5	4.2
1973	16,986	1.9	5.4
1978	29,674	2.0	6.3

Source: FBI Uniform Crime Reports: 1963, p. 109; 1968, p. 118; 1973, p. 131; 1978, p. 199.

vicious examples of female terrorist acts are tending to alter the previous sexist attitudes and shatter such role images:

> Although women have functioned in a secondary role within most terrorist groups, they have occupied a very important position within the West German Baader-Meinhof organization as well as the Movement Two June. There, women constitute fully one-third of the operational, as opposed to support, personnel. In addition to the leading roles of Ulrick Meinhof in founding the Baader-Meinhof group, nearly 60 percent of that organization and Movement Two June personnel at large as of August 1976 were women. Four of these women escaped from jail in West Berlin in June 1976.[28]

Recent writers on this subject indicate a dramatic shift in women's terrorist activities from support functions to full-scale terrorist operations.[29] Data on 204 active female terrorists compiled by Risks International show that throughout the world women's participation has increased from 12 percent of the total number of terrorists in 1970 to 21 to 30 percent, dependent upon the area, in 1978. The comparative figures of women's terrorist activities for the 1970–1978 period, according to this source, are assassinations, from no involvement to 22.5 percent, and kidnapping, from 6 percent to over 18 percent. Women were found to account for over 17 percent of those persons involved in facility attacks and 41.6 percent of maimings.[30]

It has often been commented that women terrorists excel their male counterparts in viciousness and cruelty:

> The female terrorist has not been content just to praise the Lord and pass the ammunition; hers has been as often as not, the finger on the trigger of some of the most powerful weaponry in the arsenal of the modern-day terrorist. This new woman revolutionary is no Madame

Defarge patiently, if ghoulishly, knitting besides the guillotine while waiting for heads to roll. The new breed of female terrorist not only must have its hands firmly on the lever but must be instrumental in the capture of the victim and in the process of judgment, as well as in dragging the unfortunate to the death instrument. Women terrorists have consistently proved themselves more ferocious and more intractable in these acts than their male counterparts. There is a cold rage about some of them that even the most alienated of men seem quite incapable of emulating.[31]

Property Crimes

Burglary

Although burglary is not considered a major offense committed by females, interesting changes in the arrest rates of women and girls over the past sixteen years have been recorded for this "unfeminine" type of crime. In 1963 only 5,552 females were arrested for burglary—breaking and entering, a figure that comprised only 1.1 percent of all female arrests and about 3 percent of total arrests for that offense.[32] By 1978 female arrests for burglary totaled 29,674, or 6.3 percent of all such arrests, but still only 2 percent of total female arrests.[33] As seen in Table 2-1, these statistics appear to indicate a pattern of steady increments in the number of females arrested for burglary compared to males. It is interesting that females under eighteen years of age seem to be responsible for the increases. According to the total arrest trends for the 1970–1979 Uniform Crime Reports, the total percent change in burglary arrests for females over that period of time was plus 71.6 percent. For females under eighteen the percent increase was 72.2 percent.[34]

The type of behavior involved in the commission of burglary is what some researchers call "masculine"[35] and others refer to as "sex-related." Sex-related crimes are "those crimes which may be committed by either sex but which in practice appear to be committed more by one sex than the other."[36] In addition to meeting this latter definition, burglary, as a masculine crime, requires typical "male behavior, skills and techniques" and is largely defined as "a crime involving physical strength and daring, elements of coercion and confrontation with the victim, and/or specialized skills."[37] Recent comparisons of male and female crime also include burglary under violent, male-dominated, and serious offenses.

Since close scrutiny has not been applied to female burglars, especially to girls who commit this offense, it is premature to assign the acquisition of masculine criminal talents and techniques to the females who demonstrate this type of criminal behavior. It is also sexist to assume that particular skills and talents belong to a specific gender. In their descriptive accounts of burglaries committed by women, Ward et al. judge female burglaries to be "badly planned," "hastily contrived," and rather sloppily performed, yielding small financial rewards.[38] In the burglaries committed by their study subjects, for example, "the 'take' consisted of $5.00—$6.00 in pennies, 25 packs of cigarettes, sandwiches, cookies, potato chips, four cigarette lighters, and lighter fluid"; in another case a burglarized bakery yielded nine dollars in cash, some cakes, and some rolls.[39] Aside from the suggestion that these female burglars and their companions were hungry smokers, it is erroneous to assume that most female burglars are not really burglars, or that "there is very little evidence that female burglars qualify as 'master criminals.'"[40] The seeming rise in female burglaries could mean that their sophistication may have increased, or, as one researcher commented, "It may well be, of course, that the women who plan the crimes carefully are not caught."[41]

One empirical examination of the characteristics of burglars studied six California police jurisdictions over a one-year period. It revealed that female burglars comprised 9 percent of such offenders, which is well above the 5 to 6 percent national figure.[42] Two intriguing sex differences were noted: females were more likely (81 percent) than males (69 percent) to participate in group burglaries, and they were also more likely to commit burglaries at greater distances from their residences. While the females were less likely than males to have serious criminal histories (63 percent versus 82 percent) and prior burglary arrests (33 percent versus 61 percent), there was a narrowing of the sex difference when drug involvement was examined. Whereas 48 percent of the males had such a history, 33 percent of the females did. The indicated drug preference for the most part showed males with previous arrests for marijuana, while the female drug arrests involved more dangerous drugs.

Interviews with known male thieves who stressed the importance of physical strength, trustworthiness, and emotional stability from a burglary partner also emphasized the fact that women lacked all three characteristics. But one interviewee, who was decidedly in the minority, said of female crime: "They're doing burglaries, house burglaries, almost as much as men are. . . . Used to be the woman would stay at home and let the man do the burglary. Now, the woman is apt to go along."[43]

Larceny-Theft

There is little doubt that the major rises in female criminality are largely reflected in the property crime category, specifically larceny-theft, which for females means shoplifting. Otto Pollak addressed the topic thirty years ago when he described shoplifting as "one of the most specifically female types of crime."[44] Pollak felt that the development of the modern department store and self-service stores contributed to the growth of "the traditional female property offense."[45]

Three types of female shoplifters are generally depicted: the adult occasional shoplifter or pilferer, the amateur shoplifters or "snitches," and the "boosters" or professional shoplifters. The difference between the pilferers and snitches and the professional boosters is that the former steal for their own purposes or to use the merchandise, while the booster obtains cash from the sale of the stolen goods.[46] Whereas professional shoplifters usually work in pairs and steal objects of value that are salable, the nonprofessional shoplifter usually works alone, and her most commonly stolen objects are "dry goods, lingerie, cheap jewelry, or other objects which can be easily hidden and carried away."[47] Both types of shoplifters may use special apparatus or clothing to hide their loot. The professional is more apt to use "booster drawers," special clothing with secret pockets and the like, while the pilferer will usually carry a large shopping bag or handbag to slip the items into.[48]

Cameron reports that about 90 percent of women officially charged with shoplifting had no prior convictions and were largely "respectable" housewives or working women.[49] They did not appear to be neurotic or mentally ill in any way, contrary to the belief that a mental disorder, kleptomania, is indicated in the offense.[50] If shoplifting is a form of kleptomania, Cameron reasoned, there would be a high rate of recidivism among pilferers. On the contrary, there was very little or no recidivism among those who were apprehended but not charged, then freed after interrogation.

The "Victimless" Crimes of Females

The two most common "victimless" crimes perpetrated by women and girls in our society are prostitution and drug abuse violations. There is intense debate as to the extent to which these offenses are "victimless," since the prostitute who "jack rolls" her customer or, with the assistance of her pimp or some other accomplice, mugs her customer has victimized the "trick" or "john." Also, the female drug ad-

dict who steals, robs, or mugs to obtain "buy" money has created victims. Generally, however, the commission of prostitution and drug offenses per se harms no one, except perhaps the female offender herself.

Prostitution

In 1978 the 60,465 females arrested for prostitution and commercialized vice represented 67.7 percent of the persons arrested for that offense.[51] Prostitution ranked ninth in the order of offenses for which females were arrested that year, a decided drop from the sixth position it occupied ten years previously.

Several excellent depictions of prostitutes have been published in the past decade by women authors and researchers. Adler, for example, devotes a lengthy chapter to the topic in her seminal work *Sisters in Crime.* Also, Jennifer James's original research with prostitutes offers an abundance of factual data on this much maligned and controversial subject.[52] These efforts are in contrast to previous treatises on the subject almost exclusively produced by males, who provided most of the earlier research, information, and subsequent definitions of the prostitute and her profession.

The definitions of prostitution tend to vary as widely as the theories of the etiology of this form of "deviance." Some authors look upon prostitution as "at most only a marginal type of vice,"[53] whereas others attach strict social or legal definitions to the offense. And those "in the life" of prostitution and the streets, who are personally familiar with the subject, have their own definition: "A man is a natural pimp and a woman is a natural whore."[54]

The literature reflects two basic definitions of prostitution: social and legal. In the social sense, many see prostitution as "sexual intercourse on a promiscuous and mercenary basis, with emotional indifference."[55] Lemert adds "barter" as a characteristic of the process preceding the sexual intercourse,[56] while Winick and Kinsie view prostitution as "the granting of nonmarital sexual access, established by mutual agreement of the woman, her client, and/or her employer, for remuneration which provides part or all of her livelihood."[57]

It is ironic that under the legal definition "prostitution is really the only crime in the penal law where two people are doing a thing mutually agreed upon and yet only one, the female partner, is subject to arrest."[58] The law recognizes the fact that there are both heterosexual and homosexual male prostitutes, but men are rarely charged with prostitution or solicitation. This condition makes prostitution a sex-

specific offense,[59] since more female prostitutes are arrested for solic-
itation than for the actual act of coitus.[60]

Prostitution is a crime in every jurisdiction except Nevada, where it
is legal in some counties. It is outlawed in thirty-eight states which
prohibit payment for sexual acts; by solicitation laws in forty-four
states and the District of Columbia; and other states utilize vagrancy
and loitering statutes to contain prostitution.

Legally prostitution is considered a misdemeanor, or an offense that
usually involves a fine and/or thirty or more days in jail. As a result, 30
percent of the populations of most women's jails consist of prostitutes,
with even higher percentages in some cities; and 70 percent of all
women in prison for felonies were originally arrested for prostitu-
tion.[61] At this writing the Florida legislature is attempting to pass a
law making a third arrest for prostitution a felony—which indicates
the rather false moral indignation of a primarily male legislative body
in that state.

The method of payment often clouds the true definition of a pros-
titute. If a customer takes a stenographer to dinner and a movie and
they later have sexual relations, such a relationship is mercenary and
probably also reflects emotional indifference, yet the woman is not
considered a prostitute. Women who are promiscuous and have sexual
encounters that involve affection are not considered prostitutes.
Xaviera Hollander, the "happy hooker," describes airline stewardesses
who start out having flings with first-class passengers and later sup-
plement their incomes via part-time prostitution.[62] She also tells of
bored Westchester housewives who were recruited into the trade, and
college undergraduate and graduate coeds who augment their in-
comes through part-time prostitution. Hollander herself was first a
consulate secretary before deciding she could be paid for what she
had been giving away. These women who are employed full time and
receive something of value for sexual favors part time have been re-
ferred to as "white collar prostitutes."[63]

A number of theories that address the etiology of prostitution gen-
erally focus on either economic, sociological, psychological, or social-
psychological causation.[64]

The *economic* factor in prostitution is succinctly depicted in the old
prostitute saying, "All women are sitting on a fortune, if only they
realized it."[65] Winick and Kinsie[66] find that the career sequence in-
volved in the decision to become a prostitute is based upon limited
work opportunities and the recognition of the money to be earned, in
addition to a tendency toward sexual promiscuity. Lemert[67] refers to
the inferior position women hold in relation to power and control over
material rewards as indicative of our culture and prostitution as a

means of equalizing this status differential. However, the most in-depth examination of motivations for entering into prostitution as an occupational choice is found in the research of Jennifer James.

In her 1974–1975 study of over 150 prostitutes James found that prostitution was seen by some of her subjects as the most viable economic and occupational alternative available and that "desire for a higher income and an independent life-style are the major motivating factors for most prostitutes."[68] James lists five motivating factors integral to our economic-social structure that make prostitution appealing to many women:

1. There are virtually no other occupations available to unskilled or low-skilled women with an income (real or potential) comparable to prostitution.
2. There are virtually no other occupations available to unskilled or low-skilled women that provide the adventure or allow the independence of the prostitute life-style.
3. The traditional "woman's role" is almost synonymous with the culturally defined female sex role which emphasizes service, physical appearance, and sexuality.
4. The discrepancy between accepted male and female sex roles creates the "Madonna-whore" syndrome of female sexuality, such that women who are sexually active outside the limits of their "normal" sex-role expectations are labeled "deviant" and lose social status.
5. The cultural importance of wealth and material goods leads some women to desire "advantages to which [they are] not entitled by [their] position" in the socioeconomic stratification.[69]

Winick and Kinsie[70] examine prostitution and the social structure from a *sociological* perspective to establish an explanation for society's hostility toward prostitution. They find the social structure threatened by prostitution because people tend to equate sexual activity with stable relationships, typified by the family.

The protection of the family and the maintenance of the chastity and purity of the "respectable" citizenry is the function served by prostitution, according to Kingsley Davis, who proposes a *functionalist* theory of prostitution.[71] He is interested in why most women do *not* choose prostitution as an occupation. The moral system of a society is more powerful than the economic rewards of prostitution; it *causes* prostitution by defining the sex drive as part of a meaningful social relationship and condemning prostitution as a meaningless sex activity. A man can indulge in such meaningless activities since a function is being performed. For example, if he is on a business trip away from his wife, or if he would like to engage in acts against the moral

order such as fellatio or cunnilingus, he can turn to a prostitute to serve the function of providing him enjoyment of unobtainable or forbidden acts.

Lemert stresses the *social pathology* aspect when he describes prostitution as "a formal extension of more generalized sexual pathology in our culture, of which sexual promiscuity and thinly disguised commercial exploitation of sex in informal contexts plays a large and important part."[72] In this view the context of prostitution is situational, and prostitution is a product of the conflicts and strains of our cultures.

In addition to social structural and social pathological perspectives a *cultural transmission* explanation appears indicated when prostitution is seen as due to a "weakening of family and neighborhood control and the persistence and transmission from person to person, of traditional delinquent activities."[73] While some find evidence that "girl friends, relatives, and the neighborhood were the most important sources of their [prostitutes'] first information about prostitution,"[74] other researchers find that prostitution is not a function of ecological factors and occurs at all occupational and income levels because of "urban anonymity and the weakening of traditional and moral values."[75] In this view the isolated girl in an urban society is alienated from her parents and accepts the behavior patterns condemned by society primarily because of her isolation. The alienation involves "feelings of normlessness, apathy, lack of direction or future goal orientation."[76]

Early theories of prostitution causation centered around the Freudian psychiatric model which suggested some form of inherent pathology. The folk notions adapted from these early beliefs were that prostitutes were either feebleminded, psychopathic, or lacking in morals. No "normal" woman could lead such a life. In fact, earlier psychological interpretations of prostitution are replete with psychoanalytic statements and later refutations of them by other psychoanalytically oriented theorists. Although many theorists of the Freudian persuasion saw prostitutes as frigid with immature psychosexual development and severely deficit object relationships, case studies of sex delinquents and prostitutes failed to indicate any general state of abnormality. Furthermore, James's data revealed a higher rate of orgasm among prostitutes than among the general female population, which refutes the notion that prostitutes are frigid.[77] Class level may be an influence, however:

At the upper level, among the full-time call girls and part-time housewives who appear to lead economically secure, stable, arrest-free lives,

there is no evidence of special pathology. At the lower levels, inhabited
by streetwalkers, drug addicts, juvenile runaways, and deviants of many
different stripes, the population is so prone to psychosocial pathology
that it is difficult to know what part, if any, prostitution contributes to
their many difficulties.[78]

A study of white collar prostitutes found no indications of pathol-
ogy or even hostility toward men. The women interviewed indicated
that money or something else of value (rent, doctor bills, luxury items,
groceries) were the prime factors in their sexual encounters.[79]

Contrary to early applications of psychological premises to the etiol-
ogy of female prostitution, more contemporary research tends to em-
phasize the notion of a poor self-concept as contrasted to indications
of serious pathology. Studies of the relationship between negative ad-
olescent experiences—rape, incest, and other forms of sexual mo-
lestation, age at first sexual intercourse, subsequent relationships with
the first sex partner—and later prostitution suggest that such factors
are potential contributors to a negative self-image which may lead to a
deviant self-image and a life-style of prostitution. Furthermore,
"negative sexual experiences may also undermine the development of
self-respect and enhance the appeal of and identification with alter-
native feminine roles," one of which is prostitution.[80]

Female Drug Abuse

The abuse of narcotics is not a new phenomenon among American
females. Historically, female addicts in the United States outnum-
bered male addicts until the first two decades of the twentieth cen-
tury.[81] There were more addicts during the last half of the nineteenth
century in this country than there are today, with the female-male
ratio at that time at two to one.[82] The earlier female addicts did not
resemble the abusers of today, nor were their reasons for drug abuse
the same. Patent medicines and other "elixirs" were easily come by,
and since opium was legal, opium-tinged home remedies used to
avoid pain were not difficult to obtain. Laudanum, for example, was
opium tinctured with alcohol, and paregoric was a camphorated tinc-
ture of opium. Many old western movies depict the traveling "doctor"
in his colorful wagon, accompanied by his trusted Indian, coming into
the frontier village to tout his "magic cure all," "snake oil," or "elixir."
Women of that era purchased these magic potions for the relief of
physical pain, a case of the "nerves," or because they were experienc-
ing the "vapors."

When the 1914 Harrison Act made opiates illegal, women turned to different drugs—barbiturates, amphetamines, tranquilizers, hallucinogens, and other narcotics—as substitute pain-killers, as a means of escaping psychological pain, or as the route to euphoria.

Today it is believed that female addiction is somehow connected with male addiction, which, at least in the illicit opiate market, is seen as the "greatest predisposing factor." Also, women are presumed to try narcotics out of curiosity and either find themselves liking it, or they get "hooked" (addicted), or both experiences take place.

Despite the fact that men substantially outnumber women in the abuse of illicit drugs, there are indications that the use of marijuana and drugs among teen-agers shows a more significant increase in frequency among girls than boys.[83] Uniform Crime Report arrest trends from 1969 to 1978 reveal a 46.5 percent increase in drug abuse violations for females under eighteen.[84] For all females the 1978 arrests for this offense were 81,710[85] as compared to twenty years previously when only 1,614 females were arrested in 1958 for narcotic drug law violations.[86] These figures represent those who are apprehended, but most women who obtain "legal" drugs—tranquilizers for their "nerves," amphetamines to diet, and barbiturates to be able to sleep at night—rarely come in contact with the criminal justice system.[87] The woman who chronically abuses legal, or prescription, drugs is typically the American middle- or upper-class housewife. Among habitual users of such drugs women, who are only 53 percent of the United States population, are 54 percent of barbiturate users, 60 percent of those taking pep pills, 63 percent of those abusing noncontrolled narcotics, 58 percent of those taking major tranquilizers, 70 percent of those on minor tranquilizers, and 80 percent of those who take some form of diet pill.[88] One result of such hidden or closet legal prescription activity is that no accurate picture of the extent of female drug addiction is emerging.

Surveys of psychotherapeutic drug use—a combination of medical/nonmedical drug use—find substantially higher prevalences among females. Such drugs, also known as "psychotropic" or "prescription" drugs, include tranquilizers, barbiturates and sedatives, as well as stimulants, mostly amphetamines. Females are far more likely to have contacts with hospital emergency rooms for psychotherapeutic drug problems, with twice as many such contacts as males associated with drug overdose problems.[89] Females under the age of eighteen are more likely to experience emergency room drug-related care than males in this age category, whereas males predominate in the twenty-one to thirty age group, and women in the over-thirty age bracket outnumber their male counterparts in such incidents.[90]

In addition to the conspicuous lack of statistical data on female drug addicts, there is also a dearth of information on women in drug studies. National treatment program data indicate that females in such programs are slightly more likely to be younger than males in traditional treatment programs. This pattern is reversed in crisis-oriented facilities and hospital emergency rooms, where women are more likely to be over thirty years of age. Women who die of drug-related causes are twice as likely as men to be over thirty-six, undoubtedly due to their higher use of psychotherapeutic drugs than men in this age category.

Despite estimates that approximately 50 percent of the United States drug-abusing population are women, they are not commonly found in drug treatment programs. Those females entering treatment are more likely to be abusing psychotherapeutic drugs and are not using heroin, methadone, alcohol, or cocaine.[91] According to recent national drug treatment data systems, the percentage of white female clients is greater than the percentage of black female clients, with Puerto Rican and Mexican-American females even less likely to participate in drug treatment programs. The difference between black and white female clients is far greater than the percentage difference between black and white male clients. One set of data, for example, shows 32 percent black female clients and 58 percent white female clients, a 26 percent difference, but only an 11 percent difference between black (37 percent) and white (48 percent) male clients.[92]

The rationale is often given that women are systematically underrepresented in drug studies, and thus not counted among the drug abusing population, because: (1) they represent only a small number of drug cases; (2) women seldom use drug treatment programs where such statistics are kept; (3) they are not as likely as men to attract public attention since their drug-related crimes are less conspicuous or threatening to the social order than men's and consequently result in fewer arrests.[93]

It is commonly believed that most female addicts turn to prostitution in order to supply the hard drugs necessary to their addiction, but the link between drug addiction and prostitution is exaggerated since only 4 percent of prostitutes are drug addicts.[94] A sample of sixty-six female narcotic addicts studied in a women's prison in Great Britain, and again four years later, revealed that during the postinstitutional years there was a significant association between continued deviance and addiction.[95] It was felt that crime and narcotic addiction were not causally related; but the two phenomena share common factors that result in social deviance, since 62 percent of the

study group committed criminal offenses after release and 60 percent had criminal histories prior to their addiction.

In the United States it is generally felt that most addicts are not criminal offenders but get involved in crime to pay for their drugs. One attempt to understand the question of drug-related crime among women is a 1978 Miami study of active female street addicts (79 percent) and females in a drug treatment program (21 percent).[96] Of the 58,708 criminal offenses the 149 female heroin addicts admitted to committing in the two months prior to the interview, there were more instances of property crimes (35 percent), prostitution was second (33 percent), and drug sales third (27 percent). About 21 percent of the sample had participated in "masculine" offenses—robberies, auto theft, and procuring. Twenty percent of the women used handguns during the commission of the robberies and other offenses. In general, these women heroin addicts engaged in an extensive variety of crimes but were rarely arrested, since less than 1 percent of the 58,708 admitted offenses resulted in arrest.

What is known about female drug abusers is scattered and somewhat fragmented. The demographic data available indicate that female addicts appear to be getting younger, with black and other minority females usually younger than white female addicts. Yet female drug abusers tend to be older than male addicts, probably because they begin their drug careers later, in their middle twenties.[97] Also, women addicts, especially heroin abusers, are more likely to be separated, divorced, or widowed (35 percent) than male addicts (15 percent) and are significantly more likely to have children.[98]

Female addicts are thought to have experienced more general disorganization and economic insecurity in their early family life than male addicts. As a part of this deprived family background incestuous assaults by their fathers or other male relatives are quite high, ranging from 20 percent in one study to 44 percent in another. In the latter study, 75 percent of the incestuous assaults took place before the women were twelve.[99] Female drug addicts usually lack a high school education (56 to 70 percent) and have unsuccessful educational and work histories. While men tend to encourage others to use heroin, women rarely proselytize others to drug use.

Finally, while research does not yield any clear clues to the psychological characteristics of female addicts, it is generally believed that their drug use indicates more pathology than that of male addicts since it "represents a greater departure from traditional sex roles." The results of comparisons of male and female addicts with female nonaddicts in Detroit, Los Angeles, and Miami tend to confirm the notion that women addicts have poorer self-images and lower self-

esteem than both male addicts and female nonaddicts.[100] But it was also discovered that the male addicts in the study had lower self-esteem than the comparison group of female nonaddicts. On the basis of these findings the researcher suggests that "addiction itself, and not accompanying behaviors, contributes most heavily to low self-esteem among female addicts."[101] Since the drug culture is male oriented, women addicts are relegated to a secondary status. In the larger society women also occupy a lesser status. These two status conditions suggest, therefore, that "their self-images suffer from this double burden, of the prejudices experienced because they are women *and* because they are addicts,"[102] and not necessarily because they are "sicker."

Status and Other Juvenile Offenses

In 1978, 172,896 boys and girls under the age of eighteen were arrested for running away from home, a figure that comprised 1.8 percent of the total number of arrests that year.[103] While the number of arrests for boys was only 0.9 percent of the total male arrests, girls' arrests for leaving home without permission constituted 6.4 percent and ranked fifth among all female arrests. This type of behavior, by statute, is categorized as a status offense, or an act not considered a crime for adults. Of all minors arrested for the status offense of runaway in 1978, 57.4 percent were females.

Status offenses also include truancy, curfew violations, and other "ungovernable" or "incorrigible" behavior. For the most part these offenses are assumed to involve youthful sexuality by the girl, but not the boy. For instance, if a male teen-ager runs away from home, he is seeking adventure, thrills, or excitement in the tradition of Huckleberry Finn; but an adolescent female runaway is thought to be participating in such sexual misbehavior as promiscuity, cohabiting, or "general sex innuendo."[104]

Runaways

The runaway girl and the delinquent girl have been viewed from a sexually delinquent perspective. Although a girl runs away from home for a variety of reasons, it has usually been assumed that if she did not originally leave for the purpose of indulging in sexual promiscuity, once she was "out in the streets" she would give free expression to her sexual urges. Many runaway girls do end up compromised by

men, some are turned into prostitutes, and others simply elect the life-style of "street girls of the 70s":

> Peggy will not sleep in a doorway tonight. She will stand on the street until some man decides to take her home for dinner and bed in exchange for sex. Peggy is 15 and has been living on the streets of Berkeley for more than a year. Her counterparts haunt certain sections of dozens of American cities. Is she a special problem of the sour 70s? No, she is a variation on a very old one.[105]

While the contemporary media are replete with "shocking" articles on runaway girls, insufficient empirical evidence prohibits denial or confirmation of a link between sexual misbehavior and this status offense. Recent findings suggest alternative explanations for female runaway behavior. A study of forty-two middle-class female runaways and their parents in a treatment-oriented suburban court clinic suggests intolerable home situations as a probable cause.[106] Despite the fact that both parents were in the home, there were disturbed marital relationships that affected the girls. The mothers, who were the dominant forces in these homes, demonstrated long-term dissatisfaction with the sexual relationships with their spouses. The fathers were passive and inadequate, demonstrated violent temper outbursts, and indulged in heavy drinking. As a result of their feelings of maternal inadequacy, because of poor previous relations with their own mothers, these mothers did not provide enough warmth and affection to their daughters. Instead of love the mothers offered material incentives while simultaneously encouraging warm, erotic father-daughter relationships. The dynamics involved in this pattern of family interaction suggest an abrogation of the maternal role and pressure on the daughter to take over this responsibility. Thus the daughter is pushed into premature dating and sexual sophistication. The father, fearing incestuous desire, becomes angry at his daughter's display of dating behavior and imposes severe restrictions on the girl. She, in turn, responds with anger and rebellion and runs away from home.[107]

In their book *The Delinquent Girl,* Vedder and Somerville found that running away is the principal offense leading to girls' commitments to institutions and conclude that "numerous conditions seem to be involved as precipitating factors in these cases: early traumatic experiences, inadequate homes, parental rejection, sibling rivalry, unrealistic parental expectations, unstable marriages and inadequate communication between parents and children."[108]

An innovative study of "self-parental alienation and locus of control in delinquent girls" included a majority of girls in custody for running

away from home.[109] The basic premise was that social maladjustment
is associated with an external locus of control perspective, or a prefer-
ence for distance from others. It was hypothesized that delinquent
females would exhibit alienation more than would a control group.
The external locus of control orientation attributes one's actions to
luck, fate, or the control of powerful others. Since delinquent girls are
presumed to have been raised in an "external-ogenic" atmosphere,
they should have developed an expectancy of external locus of control
reflected in the avoidance of others and a preference for greater
distances between themselves and others, more so than
nondelinquents.

On both testing measures used in the study the delinquent girls
scored significantly different from the nondelinquent controls by ex-
hibiting more external control and by preferring greater distances
from interpersonal stimuli, particularly greater distancing in self-par-
ent alienation. The delinquent girls' specific mean interpersonal dis-
tance scores were, in rank order, higher for the policeman, father,
boyfriend, mother, and girlfriend. The nondelinquents' preferred
distance rankings were policeman, girlfriend, boyfriend, father, and
mother.

Structured interviews with runaway youths in a Nevada youth hos-
tel were undertaken in an attempt to establish a typology of runaway
youth.[110] The results tend to support the notion of multidimensional
causality in runaway behavior. Six profiles of runaway youths were
generated through cluster analysis techniques, with Type I consisting
totally of "self-confident and unrestrained runaway girls." Although
only five of the fifty-three youths in the study were in this cluster, this
category reveals that many of the characteristics of these runaway girls
are similar to previously reported characteristics of delinquent girls:

> They express very low levels of parental nurturance, affective reward
> and affiliative companionship. They feel especially ineffective at influ-
> encing parental decisions affecting their lives (indulgence), and report
> their parents as not being fair in their discipline practices (principled
> discipline). Problems stemming from poor paternal relationships are
> compounded by low levels of parental control (power) and high levels of
> unsupervised freedom (low protectiveness) . . . These girls have, how-
> ever, very high self-esteem levels, they do very well in school (grade
> point average), they report having high access to satisfying educational
> roles, and they have very positive scores on peer and teaching labeling
> measures.[111]

The other major offenses that, along with runaways, are included in
the "big five" that lead to a girl's commitment—incorrigibility, proba-

tion violation, sex delinquency, and truancy—are also commonly assumed to have some connection with sexual misbehavior.

Incorrigibility is a vague statutory term that has become a catch-all for girls who cannot adequately be governed by their parents, especially their mothers. This type of girl is assumed to be as free with her body as she is with her other uncontrollable behaviors. If a girl violates probation, she is also frequently thought to be sexually promiscuous instead of simply rebellious; and it is likely that the reason she was placed on probation in the first place was for one of the sex-linked offenses included in the "big five." Similarly, if a girl is truant from school, she is imagined to be cutting school in order to "lay" or "shack up" with a boy or a man. If a boy is truant, incorrigible, or runs away from home, there is rarely the suggestion that it is to indulge in sex—and if he actually is, what is the fuss? After all, "boys will be boys."

Juvenile Prostitutes

As suggested above, it is generally assumed that teen-age girls who run away from home turn to prostitution in order to survive on the streets. Recent empirical evidence indicates the contrary. An in-depth study of juvenile prostitutes suggests that running away and juvenile prostitution are separate phenomena: "Not only do most runaway girls not become juvenile prostitutes, but not all juvenile prostitutes are runaways."[112] In her book *Baby Pros,* Bracey describes the results of interviews with thirty-two prostitutes under eighteen concentrated in the Times Square area of New York. About one third of the juvenile prostitutes came from homes in which both natural parents were present. Many of the cases included girls who had not run away but their families "had disintegrated around them," making them "throw-away children." Parental abuse and severe neglect were manifested in twenty of the cases, and all revealed indications of friction with adult members in their former homes.

The sexual experiences of the girls in the Bracey study were similar to those described by Jennifer James in her study of women prostitutes. A little less than one third of the study group reported sexual advances by older men, with about half of such incidents involving force. Interestingly, a study of seventeen teen-age prostitutes in Seattle found no indications of incest and few unpleasant early sexual experiences.[113] Whether regional differences would explain the dissimilar experiences of the two groups of girls is unknown, but the two juvenile prostitution studies do share some common findings.

Both studies report that most of the girls are from working and lower-class families. Second, they both offer some empirical substantiation that running away from home and juvenile prostitution are not linked. Third, most of the girls in the New York study (60 percent) were initially influenced by other girls in the decision to "turn out," and all of the girls in the Seattle group intimately knew someone in prostitution before taking up "the life." Fourth, neither study found the pimp to be an essential person in either "turning out" girls or aiding in their training. Bracey suggests that pimps avoid "baby pros" because legally they are minors and also they tend to be "volatile, undependable, and troublesome." Fifth, both researchers found that contrary to popular belief, drugs had little effect on juvenile prostitution and were not a serious problem. Sixth, neither study found a relationship between promiscuity and prostitution. And finally, both researchers view social control theory as the explanatory model for the entry into this form of delinquent behavior. This theoretical perspective asserts that a break or lack of ties with the conventional society and its norms because of assorted problems—deprivations in the family, lack of school success, and other social and emotional factors—facilitates vulnerability to delinquent behavior.[114]

Interesting racial differences among the juvenile prostitutes were noted in the Seattle study. Although the black girls tended to experience first sexual intercourse earlier than white girls, this first coitus was with a boyfriend, whereas white girls' first sexual intercourse experiences were mostly with strangers or casual acquaintances. Second, the black juvenile prostitutes tended to maintain average relationships with their families, while the white girls were more likely to be rejected by their parents. Bracey reports similar findings for the black baby pros in New York:

> Adults also assume that teenagers will be able to take care of themselves; the youngsters are trained early to be independent and self-sufficient. If someone does get into trouble, ghetto families rarely reject that youngster. Our informants indicate that it was an unusual household that would reject a daughter because she had been involved in prostitution. Furthermore, babies brought home would be naturally integrated into already overcrowded households.[115]

Bracey describes girl prostitutes whom she calls "weekend warriors" as "the teenager who lives at home with her family, attends school regularly, and works as a prostitute on selected weekends." From their depiction as "the adolescent version of the middle-class housewife who turns a few tricks in the afternoon to relieve her boredom and make a

little extra money,"[116] these girls appear to be a mini-model of the previously described white collar prostitute.

Girls' Gangs

Ever since Thrasher's seminal work in the study of gangs, first published in 1927,[117] it has been believed that the extent of adolescent females' participation in gangs has been as an auxiliary to a boys' gang or that such groups of girls were not truly delinquent gangs. The role of gang girls has been to conceal and carry weapons for the boys, to provide sexual favors, and sometimes to fight against girls who were connected with enemy boys' gangs. Girls are rarely participants in the planning or carrying out of gang activities in their association with boys' gangs.

Data collected in the mid-1960s on black Los Angeles gangs were recently reanalyzed to demonstrate girls' exclusion from the planning and action components of the gangs' delinquent activities.[118] Not a single incidence was reported where a female had any input in the planning or consummation of a delinquent activity with the male gang members. Girls' primary participatory roles were greatest in minor incidents and violent crimes, and their least participation was in burglaries and property crimes. The violent actions were not planned and usually resulted from incidents that called for self-protection, such as attacks by other gangs. Girls were felt to have a preventive effect on male delinquent behavior, since the boys said they would likely postpone or terminate a planned activity if females were present. One might question the findings of this reevaluation since they are based solely upon the responses of the male members of the eight gangs studied. The girls were not interviewed, and perhaps their version might have differed.

The Molls, an eastern seaport gang of eleven white Catholic girls of Irish ancestry, were found to commit numerous minor crimes such as truancy, theft, drinking, and vandalism, but their primary goal appeared to be that of gaining the male gang members' approval.[119] Thus, the Molls seem to fit the typical stereotype of female gang activities.

More recently, however, Freda Adler discussed young girls' participation in more violent or potentially violent crimes such as muggings, burglaries, and school extortion rings: "Girls can now be found participating in all gang activities with a greater degree of equality. Indeed, in New York City there are currently two all-girl gangs. In London, where British statistics reflect a similar female crime wave,

female adolescents have become a problem of major proportions.[120] While conceding that initially the female gang member's role was peripheral to the male gang, Adler feels that gradually girl gang members have attained more meaningful positions in the gang sub-culture. In the mid-1960s these girls were being arrested as lookouts for the boys' gangs, for carrying the boys' weapons and generally performing the ancillary tasks previously relegated to girls. By the 1970s, "girls had become more highly integrated in male gang activity and were moving closer to parallel but independent, violence-oriented, exclusively female groups."[121]

Peggy Giordano compared 108 female juvenile offenders, the total population of a correctional institution, to 83 predominantly lower-income level girls in an urban high school.[122] Not only did Giordano find significant involvement in serious crimes, she also found that 53.7 percent of the institutionalized girls had been involved in what could be called girls' gangs. The names of these gangs—and 51.9 percent of them had names (for example, the Outlaws, Power, the Cobras, the White Knights)—suggested neither a feminine image nor subordination to a male gang. These girls were found to be no different than boys in designating their sex peer group (other girls) as the most important reference group for status achievement. In fact, a major link existed between these girls' friendship patterns and the extent of their delinquent involvement.

Finally, Walter B. Miller's national study of gang activity in the fifteen largest cities in the United States found that autonomous female gangs were rare, their criminality was substantially less serious than that of male gangs, and there was little support for claims that female gang activity is more violent than in the past.[123]

Therefore, the preponderance of empirical evidence on girl gangs appears to indicate that girls are still maintaining their traditional roles, although in a few isolated examples some girls are breaking the mold of ancillary roles to boys' gangs and achieving delinquency equality.

Race/Ethnicity

Racial differences within the female offender group are difficult to isolate and describe for two primary reasons: the Uniform Crime Reports are not broken down by sex and race; and most studies of female crime and delinquency concentrate on intersex analyses of offender data instead of intrasex comparisons.

About 26 percent of the persons arrested in 1977 were Afro-American (blacks). Since blacks comprise about 13 percent of the United States population, the arrest rate of this group is out of proportion to their numbers in the country. Arrest rates are similarly higher for other minority groups—Puerto Ricans, Mexican-Americans, and Native Americans (Indians)—in comparison to their proportions of the population. It is virtually impossible to determine the contribution to crime of nonwhite females for the reasons indicated above, but a few individual studies lend some support to the notion that black females are at least as criminally involved as their male counterparts. The predominate female offender group among minorities is the black female. There are several indications that Spanish-speaking, Spanish-surname females are rapidly catching up with black females in arrests and incarcerations, particularly in large urban areas, but there are little data available on this subgroup. Our emphasis therefore will focus on the black female offender.

Studies of criminal homicides by race and sex of the offender have demonstrated the following rank ordering in frequency of arrests: black males, black females, white males, white females. One study of arrest and conviction rates in Connecticut found the conviction rate for black males to be about eight times that for white males, but black females exceeded their white cohorts with a rate fourteen times greater.[124] Although arrests and convictions are imperfect methods of determining the criminality of persons, especially nonwhite or poor persons, any other measure is equally lacking when sex and race/ethnicity are the joint variables under scrutiny. An examination of the crimes for which women are imprisoned is another way we can get at race/ethnicity. Chapter 11 offers a more detailed picture of incarcerated women and their offenses, but those sources are also useful here to obtain a picture of the nature of crime among females of different racial/ethnic backgrounds—keeping in mind that these figures represent *incarcerated* women.

A 1977 sample of female prisoners in fourteen states, believed to represent about two thirds of all women in United States jails and prisons, is summarized in Table 2-2, which shows the ranking of women's offenses by race/ethnicity and compares them to the total arrests of females in 1977.[125]

The primary offense leading to the incarceration of white women and Native American women in the sample was forgery/fraud. Hispanic and black women were most frequently imprisoned for drug violations, which were also the second-ranked incarceration offenses for white and Native American women. Nationally, in 1977, drug violation was the third most frequent cause of all women's arrests.

TABLE 2-2: Rank Ordering of Sample of U.S. Incarcerated Women
Compared to 1977 Arrest Data by Race/Ethnicity*

Offense	Total Female Arrests	Race/Ethnic Group in Rank Order			
		White	Black	Hispanic	Native American
Murder	8	4	2	4	3
Other violent	N.A.*	9	10	9	9
Robbery	7	5	4	3	6
Assault	5	8	6	8	8
Burglary	6	7	8	2	7
Forgery/fraud	2†	1	5	5	1
Larceny	1	6	3	4	5
Drugs	3	2	1	1	2
Prostitution	4	10	9	7	10
Other nonviolent	N.A.*	3	7	6	4

Derived from Glick and Neto, *National Study of Women's Correctional Programs,* Tables 4, 10, 14, and FBI Uniform Crime Reports, 1978, Table 34.
*Not available as categorized.
†Forgery and counterfeiting added to fraud.

Murder (homicide) was second in frequency for imprisoned black women, third for Native American women, and fourth for both white and Hispanic women. Two other index offenses were highly ranked among the incarcerated Hispanic subgroup—burglary (second) and robbery (third).

Recent statistics from California, the state that incarcerates the most women offenders, offer a more detailed picture of the arrest offenses of women according to race/ethnicity in that state. As seen in Table 2-3, 60.5 percent of the women arrested in California in 1979 were white, 19 percent were black, 17.3 percent were Mexican-American (Hispanic), and less than 1 percent were Native American. Thus, white women in California are arrested three times more frequently than any other of the identified racial/ethnic female groups.

Table 2-4 ranks California women felons by race/ethnicity according to the seven top offenses for which they were arrested in 1979. As in the national prison study, we again find drugs to be the primary arrest offense of the Hispanic female group (in this case, Mexican-Americans), with burglary second and theft third. White women were most frequently arrested for drugs, theft, and burglary, in that order; while black women's arrests reveal theft to be the most frequent, followed by

TABLE 2-3: Numbers and Proportions of Arrests and Citations of California Women in 1979 by Race/Ethnicity

	Number	Percent	Rank Order
White	135,553	60.5	1
Black	42,631	19.0	2
Hispanic	38,666	17.3	3
Native American	2,171	.96	5
Asian-American	990	.44	6
Other	4,034	1.8	4
Totals	224,045	100.0	

Derived from data received from the California Bureau of Criminal Statistics and Special Services.

assault and drugs. Assault was also the first-ranked offense of Native American women, with drugs second and theft third.

Since the 1977 national sample involved incarcerated women, the top seven offenses for which California women felons were imprisoned in 1979 are compared with the national female prison data in Table 2-5.[126] It is readily seen that few of the offenses for which California women were imprisoned coincide with the national survey rankings. The closest comparisons appear to be for homicide among white, black, and Native American women; among Hispanic women robbery and burglary incarcerations are similar between the two groups.

TABLE 2-4: Rank Ordering of the Top Seven Offenses of California Women Felons by Race/Ethnicity, 1979

Offense	Race/Ethnic Group in Rank Order			
	White	Black	Hispanic	Native American
Homicide	7	7	7	7
Robbery	6	5	6	5
Assault	4	2	4	1
Burglary	3	4	2	3.5
Theft	2	1	3	3.5
Drugs	1	3	1	2
Motor vehicle theft	5	6	5	6

Derived from data received from the California Bureau of Criminal Statistics and Special Services.

TABLE 2-5: Rank Ordering of the Top Seven Offenses of California Incarcerated Women, 1979, Compared to National Study of Incarcerated Women, 1977, by Race/Ethnicity*

Offense	Race/Ethnic Group in Rank Order							
	White		Black		Hispanic		Native American	
	Calif.	Natl.	Calif.	Natl.	Calif.	Natl.	Calif.	Natl.
Homicide (murder)	2	4	1	2	1	4	4	3
Robbery	1	5	3	4	2	3	5	6
Assault	6	8	7	6	7	8	3	8
Burglary	4	7	4	8	3	2	7	7
Theft (larceny)	5	6	6	3	6	4	2	5
Drugs	7	2	5	1	5	1	6	2
Motor vehicle theft	3	—	2	—	4	—	1	—

*Incarceration includes probation with jail and prison sentences.
Derived from data received from the California Bureau of Criminal Statistics and Special Services.

Various explanations have been proffered to account for black-white arrest differences: differential law enforcement practices rooted in the hostile reciprocal relationship between blacks and other minorities and the police; the effects of recent urbanization on minorities; economic and other crime-provoking social discrimination; and the alleged high prevalence and intensity of various criminogenic factors among minority groups. Few explanations have been attempted to account for differences, if any, in the criminality of white female offenders as compared to minority female offenders.

Freda Adler approaches racial differences in female criminality on assumptions about the impact of slavery on the black family. As a result of economic sanctions against the black male after emancipation, there was a sex-role reversal among black women whereby "the mantle of black power—such as it was in a group socially, politically, and financially debilitated—fell on the reluctant but sturdy shoulders of the black female."[127] Since she could work and her man could not, as the titular head of the black household the black woman had to meet her financial obligations in a deviant manner. Thus, according to this perspective, black women have historically exhibited criminal behavior different from white women and more like the deviant patterning of white males. Also, because of her egalitarian social position

vis-à-vis the black man, the black woman is also more equal to her black brother in crime.

Through the use of National Crime Survey personal victimization data—since through face-to-face confrontations the physical charac-teristics of the offender can allegedly be ascertained by the victim—criminologist Vernetta Young concludes that "there is no simplistic answer to the question of whether female offenders differ by race."[128] In her assessment of the empirical validity of Adler's hypotheses on women, race, and crime, Young's data, which are independent of offi-cial statistics, tend to refute some of Adler's basic assumptions. First, Young challenges Adler's statement that "the figures nation-wide il-lustrate unequivocally that the black female's criminality exceeds that of the white female by a much greater margin than black males over white males."[129] Young's victim survey data indicate that for both males and females the ratio of the volume of crime, according to race, was two to one. In other words, the same ratio for black males com-pared to white males held for black females compared to white females.

Whereas lone female offenders within the two racial/ethnic groups committed similar offenses, crime patterns involving multiple female offenders differed by race/ethnicity. White female offender groups were more than two and one-half times as involved in assaultive of-fenses (72 percent) as in theft offenses (28 percent). But black multi-ple female offenders were more equally involved in the two crime categories, demonstrating more of a tendency toward theft (56 per-cent) than toward assault (44 percent).

While Young views her findings as a refutation of Adler's supposi-tion that the patterning of black male and female crime is more simi-lar than the criminal patterns of white male and female offenders, a recent review and statistical analysis of forty-four studies concerned with the relationship between sex and criminality shows "a significant convergence in male and female involvement in deviance/criminality for nonwhites but no discernible pattern for whites."[130] Although there appears to be stability over time in the gap between white males and females in the volume of crime/deviance committed not found among the nonwhite group, the deviant behavior of black females was felt to be becoming more like that of black males. This convergence is attributed to a greater similarity of the economic and social roles of black men and women, and suggests that with greater social equality the deviance of white women will increase and reduce the gap in criminality between themselves and white men.

Partial support for Adler's contention that the black female crime pattern more closely resembles that of the white male than that of the

white female is seen in Young's finding that multiple offender victimizations by black females and by white males exhibited similar patterns, more so than the victimizations of white male and white female multiple offenders. This resemblance did not hold for lone offenders where the three groups were found to demonstrate very little difference in victimization crime patterns.

Obviously, without sufficient statistical data no definitive conclusions may be drawn about the criminality of women based on the social characteristic of race/ethnicity. Much needs to be done, and new empirical doors must be opened before this extremely complex and sensitive question can be addressed.

section two
theoretical and conceptual perspectives of female criminality

3

BIOLOGICAL/CONSTITUTIONAL THEORIES OF FEMALE DEVIANCE

The Early Theorists

Lombroso and Ferrero

Cesare Lombroso, writing at the turn of the nineteenth century, viewed female deviance as rooted in the biological makeup or as an inherent feature of the female species. This "constitutionalist" position ascribed to deviant females the tendency to be cruel, more ferocious, vengeful, and jealous than the male, and generally lacking in intelligence and passion. The criminal female was seen as close to the "normal" female since Lombroso felt that the majority of women were only occasional criminals. The exceptions were prostitutes, who Lombroso felt were born criminals. On the other hand, female delinquents were considered deserted or neglected infants. Aside from this attempt at a causal explanation, Lombroso's position was firmly set in constitutional or biologically based etiology.

Some contemporary thinkers view Lombroso as the "father of the Italian school" of criminology or, more specifically, as the "founding father of the biological-positivistic school" of criminology,[1] a perspective that attempted scientifically to study criminality through an examination of the individual deviant.[2] The evolutionary theories of Darwin, among other influences of that period, strongly impacted upon Lombroso's theoretical ideology. In order to differentiate criminals from noncriminals Lombroso identified certain physical stigmata or anomalies which were alleged to be characteristic of a more primitive or ape-like species of man.[3] Offenders who exhibited four or more such anomalies—for example, a prehensile foot, large jaws, outstanding ears, large cheek bones, long arms, hairyness, and so forth—were considered atavistic, or biological "throwbacks" to a subhuman type designated by Lombroso as born criminals.

In 1893 Lombroso and his son-in-law, W. Ferrero, attempted to apply earlier work on male criminality to the deviant female. They described this effort in *The Female Offender,* a work which they designated as "a study in criminal biology." The skulls and bones of deceased female prisoners were examined, and women in prison were measured and otherwise scrutinized for signs of atavism. These findings were compared with "normal" women who were considered a "control" group, in a decidedly better research design than Lombroso had previously utilized with the men.

Lombroso and Ferrero appeared to devote an extraordinary amount of interest to the skulls and brains of female offenders and noted, for example, that "fallen women have the smallest cranial capacity of all,"[4] that female criminals have skulls more like men than like normal women, and that their brains weighed less than normal women.

In their chapter entitled "Anthropometry of Female Criminals," Lombroso and Ferrero reveal that female criminals are shorter, weigh more, and are precociously gray more frequently than normal women. Such offenders do tend to retain their hair however, gray though it may be, since baldness is less common among female criminals than among normal women. Additional characteristics isolated by these authors were that female offenders have darker hair and eyes; prostitutes have longer hands, bigger calves, and, similar to female thieves, have a larger jaw.[5] In fact, most of the physical anomalies occurred more frequently in prostitutes ("fallen women") than in other types of female offenders, which indicated the degeneration typical of the "born" criminal.

The application of atavism, which Lombroso had previously ascribed to male "born" criminals, or the criteria of four or more indications of degeneration, did not coincide with the physiology of female offenders except in the cases of some of the prostitutes. In order to circumvent this challenge to Lombroso's original theory of atavism, Lombroso and Ferrero concluded that a criminal type of female was rare for a number of reasons: women revealed more conservative tendencies in questions of the social order; they are less exposed to society since, as homemakers and rearers of children, they lead more sedentary lives; they are more primitive than men in that they have less active cerebral cortexes; and they innately have less inclination toward crime. In sum,

> Lombroso and Ferrero argued that women offenders reveal fewer signs of degeneration because they have evolved less than men. Having devel-

oped less far from their origins, they argued that women could also degenerate less far, being as all women are relatively "primitive," the criminals amongst them would not be visible and would be less degenerate than their male counterparts. They accounted for the less evolved nature of women in terms of the lives women *naturally* lead.[6]

W. I. Thomas

Although W. I. Thomas and his wife, Harriet, were staunch supporters of women's rights—a position that might have indirectly led to his dismissal from the University of Chicago faculty,[7]—his earlier work, *Sex and Society* (1907), appears to coincide with certain tenets espoused by the Lombrosian perspective. In this work Thomas is critical of anthropologists for their assumption of the inferiority of women and their subsequent failure to distinguish between congenital and acquired characteristics. Accordingly, he states, "At a certain point in history women became an unfree class, precisely as slaves became an unfree class."[8]

In the chapter "The Adventitious Character of Women," Thomas describes how the initial and dominant life force was female, but that a reversal of this situation takes place through woman's attempts to adjust to man. Such adjustments profoundly modify the mental attitudes of females and their subsequent behavior forms. Thus, male morality was seen as contractual or an adjustment to the regulations of society, while female morality was viewed as more personal and as an adjustment to men.

Similar to Lombroso and Ferrero, Thomas undertakes a discussion of the female brain and its weight, but he felt that the importance of this characteristic as related to intelligence was exaggerated and that brain efficiency was undoubtedly the same in both sexes, contrary to Lombroso's position on the topic. Although a woman's brain is smaller, Thomas points out, so is she. Any differences in intellectual functioning, therefore, are not biologically based but are socially influenced.

Despite Thomas' criticism of his contemporaries' acceptance of the inferiority of women and their lack of differentiation between congenital and acquired characteristics, in *Sex and Society* he proffers several propositions that resemble Lombroso when he dichotomizes the sexes in terms of *katabolic* and *anabolic* dimensions. Thomas related these states to plant and animal life. Men were katabolic, or more rapid consumers (destroyers) of energy, as demonstrated in their feats of strength and bursts of energy. In contrast to plants,

which store energy, animals (human males) eat plants as well as other animals, and in this consumption break down those organisms in the process designated katabolism. Contrarily, women represent the more constructive part of the metabolic process, anabolism, in that they conserve and store energy as the plants store nutrients. Characteristics such as stability, endurance, and passivity are thus associated with the anabolic female in contrast to the destructiveness of the katabolic male. Thus, the similarity to Lombroso's thesis is seen in the earlier work of Thomas, who determined that the physiological differences of katabolism and anabolism are indicative of differences in social behavior between the sexes.

However, Thomas "established his eminence by fusing sociology and social psychology into the analysis of social organization and personality" in the second phase of his "intellectual development" with the publication of *The Unadjusted Girl* in 1923, "a landmark in the emergence of a sociology of deviant behavior."[9] This study of female delinquency demonstrates a definite break with the earlier Lombrosian-influenced, biological emphasis described above, since we now witness Thomas' introduction of the influences of the social environment on deviant behavior, which together with inborn instincts contribute to total behavior.

Thomas' concept of human wishes was influenced by the observations of and experiments on newly born infants in a maternity hospital previously made by the psychologist John B. Watson. Watson had identified three basic instincts that he felt were innate and present in infants at birth: fear, anger (rage), and love (joy). Thomas viewed these fundamental emotional patterns as beneficial in terms of specific life functions. For example, anger was seen as preserving life; fear responses aid in avoiding death; and love contributes to the reproduction of the species. The four human wishes developed by Thomas—the desire for new experience, the desire for security, the desire for response, and the desire for recognition—are the human forces that lead to action.[10]

The desire for new experience, which corresponds to the anger instinct, involves "motion, change, danger, instability, social irresponsibility" and a general "disregard of group standards and interests."[11] Thomas felt that all human organisms crave excitement and stimulation, seeking "expansion and shock even through alcohol and drugs."[12]

The second wish, the desire for security, is antithetical to the desire for new experience in its basis on fear, and characteristically the avoidance of death, "timidity, avoidance and flight" result in a conservative, cautious individual.

Thomas viewed the desire for response as the most social of the four wishes and as the main source of altruism, since it was primarily related to the love instinct and is demonstrated by the "tendency to seek and to give signs of appreciation in connection with other individuals." Examples of this wish are seen in the symbiotic relationship of devotion between mother and child, and the responses between the two sexes in mating, courtship, and marriage. Thomas felt that women were more capable of variable types of love than men since "mother love" is more typical of females. Although such a devotion is present in fathers, it is weaker and less demonstrative.

The final wish, the desire for recognition, is "expressed in the general struggle of men for position in their social group, in devices for securing a recognized, enviable, and advantageous social status." While "the showy motives connected with the appeal for recognition we define as 'vanity'; the creative activities we call 'ambition.'"[13]

Although no society has ever been successful in the regulation of the wishes of its members satisfactorily all of the time, society nonetheless sets up the rules and moral codes to influence the manifestation of the wishes. Whereas the community is a defining agency, the family is the primary defining agent. Thus, since the girl's role is more circumscribed by her family through a "series of aesthetic-moral definitions of the situation," she becomes demoralized, and the beginnings of delinquency in a girl were seen by Thomas as related to an impulsive desire to obtain "amusement, adventure, pretty clothes, favorable notice, distinction and freedom in the larger world."[14] In this process the actual sexual passion, according to Thomas, plays an unimportant role.

Previous psychologists and criminologists viewed the prostitute as a type whose behavior was largely predetermined, forcing her to live no other way. However, Thomas in *The Unadjusted Girl* cites a study of 647 prostitutes that described the low economic status, deplorable home conditions, and lack of education of these girls who, when questioned, gave their reasons for becoming prostitutes in the following rank order: bad family life, bad company, a bad married life, the desire for pleasure (clothes, food, theater), and the desire for money. Clearly these sociological and economically oriented motivations negate any connection with a notion of biologically predetermined prostitution.

Biological Sex Differences

Some researchers on the topic of physical differences between the sexes view biological factors as crucial determinants in the differential etiology of deviance.[15]

A comprehensive review of biological sex differences reported by Frieze et al., who explored infant sex differences in several areas—aggression, nurturance, social orientation, and attachment behaviors—concludes: "While there may be maturational differences in some areas, the evidence to date does not indicate unequivocally that one sex is consistently ahead of the other. Nevertheless, when there are significant sex effects, it is generally the female who is the more mature."[16] They hasten to add, however, that the characteristics of infancy do not necessarily impact upon the sexes in a differentiating fashion, since other steps in the developmental cycle more dramatically reveal biological influence—such as the importance of puberty, when the hormonal system reaches maturity.

There are biological sex differences that increase with maturation. Girls weigh less than boys at birth, and this differential continues to enlarge throughout development until about age twenty, when we see a 20 percent weight difference between the sexes. Secondly, girls have more fat and less muscle than boys. They are shorter throughout childhood and by age twenty are 10 percent shorter than males. With the exception of fine hand movements, girls are not as well coordinated as boys. And finally, girls, as infants, sleep more and are less vigorous than boys.[17]

Some criminology theorists emphasize the importance of size and physical stature in the delinquency of girls. Although Pollak disregards the "frailty" of women as being indicative of their inability to commit particular crimes and rejects such a notion as cultural stereotype, he nonetheless emphasizes American studies of the 1920s which reported higher incidences of female delinquencies, especially sex delinquencies, among "overdeveloped" girls.[18] In all cases the state of overdevelopment was defined as being oversized and overweight.

Cowie, Cowie, and Slater[19] also place emphasis upon similar physiological attributes in their study of 318 girls in a Great Britain approved (training) school in which they sought indications of impaired intelligence and health that they viewed as "constitutional predisposing factors" in the delinquencies. They report that nearly all of the girls, whose offenses for the most part were sexual delinquencies, were educationally retarded, lacked grace or beauty, had tattoos, were oversized, and generally demonstrated other health deficiencies and physical defects as compared to nondelinquent girls.

Despite the stereotype of women as the "weaker sex," an argument that is primarily focused on muscular strength, females are viewed by some contemporary social scientists as having a genetic advantage that is lacking in men. This benefit is seen in the longevity of women,

which is undoubtedly related to their higher resistance to disease and infection. Males, on the other hand, appear to have more genetic flaws and sex-linked physical defects such as hemophilia and color blindness.

The Question of Chromosomes and Hormones in Female Criminality

An examination of chromosomal structure demonstrates the initial biological differences between the sexes. Both males and females have twenty-three pairs of chromosomes, only one of which determines sexual development. The pair of sex-determining female chromosomes, XX, are quite similar, while the equivalent male XY contains approximately 5 percent less genetic material. It is believed that the extra X chromosome in the female provides the female genetic advantage, whereas in the male either a lack of the extra X, or some unknown characteristics of the Y, contributes to the imperfections, to sex-linked defects, and also possibly to their higher mortality rate in every age group, from almost every disease.[20] Nonetheless, it is the Y chromosome that determines maleness, and the lack of Y components leads to the development of females.

Genetic sex (XX or XY chromosomes) is distinguished in the embryo since it is determined at conception.[21] Initially the embryo is female in structure and remains so for about six weeks after fertilization, or until the influence of the androgenic hormones occurs. If the human fetus has an X and a Y chromosome (XY), testes develop which produce "male" hormones—androgens and testosterones. The XX chromosomal composition leads to the development of ovaries about twelve weeks after fertilization, since there is no intervention of the predominantly "male" hormones.[22]

Continuing their espousal of the Lombrosian biological/constitutional position, Cowie, Cowie, and Slater introduce chromosomal differentiation in the etiology of female delinquency by proposing a linkage between criminality and multiple Y chromosomes. They speculate that the Y chromosome represents masculinity and, by inference, suggest that criminality is masculine. Female delinquents, therefore, are masculine and *may* have chromosomal deficiencies or abnormal chromosomal structures.[23]

In sum, there is a paucity of knowledge about the role of chromosomes in sex development, and even less information on chromosomal influences in criminal causality. However, recent work by endocrinolo-

gists on the influence of hormones on behavior has initiated some controversy relative to female deviance.

Males produce twice as much androgen and six times as much testosterone as females, while females are producers of estrogen in excess of males. Since concentrations of hormones have been found in the brain, it suggests the possibility of a "mind-body influence," or a possible hormonal influence upon the brain.[24]

Most research in animal studies reveals consistent results indicating that female sexual behavior and response are concerned with high estrogen and progesterone levels. These are considered "female" hormones, as contrasted with the male sex-linked hormones androgen and testosterone. If, for example, neo-natal female rats receive injections of estrogen, as adults these animals demonstrate increased fighting behavior. The introduction of androgen or testosterone into the newly born female rat results in masculine sexual patterning such as mounting and copulatory attempts. Testosterone appears to have the more significant effects as seen in aggression and male sexual responses in female rats. Several unusual effects are demonstrated by testosterone injections in female rats: "These masculinized females not only lost the usual sexual receptivity, including the normal lordosis response to a male, but also failed to show the normal response even when they were given large replacement injections of estrogen and progesterone. Moreover they showed male behavior that went beyond any previously observed."[25] As adults, these female rats were again given injections of testosterone, and their performance demonstrated the complete male sexual ceremony, including male-type ejaculatory motions. Such changes are felt to clearly indicate that the sex hormones directly affect the brain by making brain tissue overly sensitive to testosterone and less sensitive to estrogen and progesterone.

The evidence of hormonal effects on human subjects is less distinct since other variables, particularly gender identity and gender-role identity, must be considered. In gender identity one is aware of and accepts the fact of one's gender. On the other hand, in gender-role identity one accepts the role and behaviors allocated by society as typical or expected of that sex.

Androgenized genetic females, either because of prenatal exposure to androgenic drugs administered to their mothers or because of an overproduction of androgen caused by malfunctioning of their own adrenal glands, are born with masculine-like external genitalia. Studies of such females find them to exhibit more "masculine" behaviors and attitudes than control groups. Although they displayed more interest in masculine-type toys, clothing, and career choices, "these be-

haviors were still well within the normal range for females in this society," and more importantly, these girls possessed female gender identity.[26] In light of this evidence it does not appear that the presence of prenatal androgens in human female subjects leads to increased aggression or other indications of masculine responses.

Two other types of female hormonal disorders in which the individuals are not genetic females are Turner's Syndrome and Androgen-Insensitive Syndrome. Both groups have external female genitalia, are raised as females, and have experienced no prenatal exposure to the "male" hormone, androgen. The Turner's Syndrome is genetically described as XO, whereas the Androgen-Insensitive Syndrome individual is an XY "female." Since both types lack the normal possession of two X chromosomes, according to the biological perspective one would expect them to be deficient in feminine behavior characteristics. However, one study that compared Turner's females and Androgen-Insensitive females with a matched, normal control group found no differences in femininity between the experimental and control groups, presumably because the syndrome females possessed gender identity and were raised as females; thus the study concludes, "What does seem to be important for the development of gender identity is the assigned sex of rearing (the sex label given by parents and family)."[27]

It is obvious from the available research that anatomy is not necessarily destiny. Whereas experiments with animals demonstrate that behavioral effects such as aggressiveness and sexual response behavior are highly contingent upon hormonal levels, there are no clear analogous findings applicable to human subjects.

The Generative Phases of Women

In the study of the crime and delinquency of female adolescents and women, a substantial amount of attention and research has been devoted to what Otto Pollak refers to as "the generative phases of women": menstruation, pregnancy, and menopause, each of which is dramatically influenced by hormonal changes.[28] Whether such biological changes are coterminous with deviant female behavior is a controversial topic in current criminological research and thought.

Throughout history and cross-culturally menstruation has been associated with taboos, superstitions, fears, and mystery, despite the fact that this biological phenomenon occurs every month in most women between the ages of twelve and forty-eight. In several European countries, for example, the view is held that contact with menstruating

women is capable of withering flowers and fruit trees, turning wine to vinegar, spoiling the production of mayonnaise, and ruining bacon and butter.[29] Contemporary attitudes toward the menses are reflected in the application of negative terms such as "the curse" or "wearing the rag"—denigrations that are usually accompanied by feelings of shame and other negativistic attitudes toward the self. The taboo against sexual intercourse during menstruation is a common avoidance behavior associated with this integral human biological process that spans time and cultures.

The Menstrual Cycle

As seen in Table 3-1, the average menstrual cycle, which lasts for twenty-eight days, is influenced throughout this period by changes in hormone levels in the blood. Estrogen and progesterone levels are quite low during the three to five days of menstrual flow. However, when one of the two female ovaries commences to mature, estrogen production is increased. As the ovum (egg) grows, estrogen levels rise until such time as the ovum is released for possible fertilization (ovulation). Thereafter the estrogen level begins to decrease during the sixteenth to the twenty-fourth days of the menstrual cycle with Day 1 as the first day of the menstrual flow. At the same time progesterone levels begin to rise, peaking on about Day 24. From Days 25 to 28, the time commonly known as the *premenstrual period,* there is a rapid decrement in female hormones.

The incidence of premenstrual symptoms varies from 25 percent to nearly 100 percent depending upon how the syndrome is defined, the questionnaire used, and the subjects chosen,[30] but there does seem to be general agreement that the most common symptoms are a combination of psychological and bodily effects such as irritability, tension, anxiety, depression, nervousness, stomach cramps, water retention, and painful swelling of the breasts.

In addition to the premenstrual syndrome the other commonly assigned set of characteristics associated with the phases of the menstrual cycle is menstrual distress, or that length of time in the cycle from Day 25 to Day 5 (roughly eight or nine days) that includes the premenstrual period and the time of the menstrual flow itself, together known as the paramenstruum.[31] More attention has been devoted to the premenstrual syndrome and the menstrual phase of the cycle in relation to the criminality of women than to the other "generative phases,"—pregnancy and menopause—but:

Table 3-1 The Average Twenty-eight Day Menstrual Cycle and
Concomitant Hormone Levels

Day	Phase	Hormone Level
1 to 4	Menstrual* (Menstruum)	Estrogen and progesterone quite low
2 to 14		Estrogen level rises
15	Ovulation	Estrogen at highest point
16 to 24		Estrogen begins to drop; progesterone rises
25 to 28	Premenstrual*	Estrogen and progesterone low

*These two phases
together comprise
the paramenstruum.

The mere fact that many female offenders commit their crimes in this period is not sufficient to indicate a causative relationship between the procreative phases and female crime. This has to be expected according to the characteristics of the universe from which the offender samples are drawn. Since most women menstruate between certain ages, become pregnant, and experience the climacteric, statistical probability makes it necessary that considerable numbers of female offenders should have committed their crimes while they were in one of these phases.[32]

Research on Menstrual Distress and Female Criminality

A study of premenstrual tension attempted to correlate the phases of female inmates' menstrual cycles with the time of the commission of crimes for which they were incarcerated in Westfield State Farm, a women's prison and reformatory in New York state.[33] All 249 subjects reported symptoms of premenstrual tension. Since no statistical analyses were presented, the significance of this finding is questionable, particularly since it is rare to find 100 percent of any female population experiencing a common syndrome. In a critical analysis of the premenstrual syndrome, for example, one hundred university female students and fifty registered nurses, all of menstrual age, were surveyed; only 39 percent reported premenstrual tension, described as swelling, irritability and depression.[34] This finding suggests that the term "premenstrual syndrome" should not be retained, since the same complex of symptoms also occurs in females who are not menstruat-

ing, are near to the ovulatory phase, are in the premenarche years of puberty, are in the early postmenopausal years, or are experiencing any number of other medical or biological situations.

The Westfield prison study also examined the relationship between crimes of violence and phases of the menstrual cycle. A study of the inmates' records indicates that of the fifty-eight instances of unpremeditated violent crime 62 percent were committed in the premenstrual week and 17 percent during menstruation.[35] No explanation was offered to indicate how a female offender's cycle phase at the time of her offense was determined from the records.

Since Katharina Dalton has been the most frequently cited source on the alleged effects of the premenstrual phase and menstruation on female behavior, her research will be detailed below.[36] In a study of data collected from 217 menstruating girls in an English public boarding school, Dalton attempts to show the effects of menstruation on the schoolwork of the girls who were ages eleven to seventeen. Of the 1,560 weekly marks made on their school subjects, 27 percent of the girls' marks fell during the premenstrual week and 25 percent fell during the menstrual week, but there was a drop of only 10 percent during the postmenstrual week. Despite the fact there were *rises* in 17 percent of the girls' marks during the premenstrual week, in 21 percent during menstruation, and in 30 percent in the postmenstrual week, Dalton considered the 27 percent fall in the premenstruum as a "failure to learn" and the 30 percent rise following menstruation as an "improvement in performance consequent upon the relief of water retention accompanying the full menstrual flow."

Although Dalton prefaced her article by suggesting the possible influences of hormonal variations on the menstrual cycle, and concluded that premenstrual symptoms are increased in times of stress, neither of these possible causes of behavior was developed. In fact, since the first Dalton study was not supported by statistical tests, the reliability of the reported results have been challenged.[37]

In a second study[38] that involved 139 English schoolgirls, Dalton divided the menstrual cycle into seven four-day periods in which Day 1 to Day 4 were the menses and Days 25 to 28 included the premenstrual phase as seen in Table 4-1. These time intervals were examined in relation to the distribution of offenses committed by the girls. As a control for the variable lengths of the girls' cycles, only those offenses committed fourteen days before and fourteen days after the onset of menstruation were evaluated. The offenses were defined as "naughtiness," which included unpunctuality, forgetfulness, avoiding games, talking, eating during lessons, and wearing the wrong clothes. Those girls who committed one or two offenses during menstruation

were designated as "good" girls (26 percent), while the "naughty" girls (36 percent) were those who committed six or more offenses during the time frame.[39]

The schoolgirls, in a random distribution, would be expected to commit 14 percent of the 272 "naughty" offenses, but they were found to commit 29 percent of these offenses during menstruation, or double the expected incidence. Dalton felt she had isolated two types of "naughtiness"—one due to hormonal changes associated with the menstrual cycle and the other related to psychological stress and unrelated to menstruation. Only twenty-seven girls formed the group upon which the latter determination was made. They were selected because each had committed more than four offenses per term; they were also categorized by the head mistress into groups that coincided with categories previously determined by their behavior and menstruation. In the final analysis, only six of the twenty-seven girls were possibly influenced by their menstrual cycles. Furthermore, it was noted that the prefects who administered punishment for misbehavior gave significantly more punishments during their own menses.

It would seem that this study contains serious methodological problems that might have led to erroneous conclusions; for example, the subjectivity of the categorizations; the small numbers used for the final analyses; the intervening variable of the prefects' menstruations; and the omission of the ovulatory phase of the cycle.[40]

Turning to women, Dalton examined the influence of menstruation on the crime commissions of 156 newly admitted adult female prisoners in England and upon their bad behavior reported by prison officials.[41] As in her previous studies the menstrual cycle was divided into seven four-day periods, with Days 1 to 4 and Days 25 to 28 representing the paramenstruum. On the basis of interviews with the women Dalton reports that 49 percent of all their crimes took place either in the premenstruum or during menstruation. Menstruation appeared to be of greater significance in theft (56 percent) and prostitution (44 percent). Assuming a normal distribution, only 29 percent of the crimes would be expected during the paramenstruum, but Dalton reports a chi square significance of less than .001.

Although Dalton finds that seven out of thirteen alcoholic female inmates committed their crimes during premenstruation and menstruation (54 percent), the numbers are too small to determine significance. But a recent article on the effects of drinking on women did report that a woman is more likely to get her maximum reaction from alcohol just before her menstrual period begins. The day the flow starts, the effect of alcohol is lowest, while in "the middle of the men-

strual cycle the blood-alcohol level falls somewhere between the high and low points."[42]

Dalton did not define "bad behavior," but reports that within the ninety-four cases 54 percent were experiencing the premenstrual or menstrual phases of their cycles. Among those reported by the penal authorities only one time, 43 percent were menstruating, whereas the inmates reported more than once revealed a 70 percent incidence of menstruation.

Finally, Dalton's investigation indicates that premenstrual tension— defined as "mood changes, headaches, tiredness, bloatedness or mastitis"—was an important factor, since 63 percent of the women committed their crimes during this phase, and concludes: "The analysis shows that there is a highly significant relationship between menstruation and crime. This could mean that the hormonal changes cause women to commit crime during menstruation and the premenstruum and/or that women are more liable to be detected in their criminal acts during this time."[43]

Similar to her studies of the English schoolgirls, Dalton's adult female offender findings appear to have serious methodological flaws. One obvious problem is the use of self-report data, since it is difficult for most people to recall details of past symptoms. Second, despite attempts to control for cyclical variations in women's cycles, little consideration was given to the regularity of the subjects' menstrual cycles, which appeared to be assumed. A third potential source of error is noted in the possible motives for participation in the study. Why would these subjects give the type of personal information—age, parity, duration of menstruation, length of the cycle, date of last menstruation, and before and after symptoms of menses—to an interviewer? It has been reported that female offenders are "very reticent regarding this fact" (of menstruation), and in criminal trials "women would rather take the responsibility for an imputed offense than to admit that a bloodstain on their clothing or underwear originated from their own menstruation."[44] Fourth, Dalton does not define the "bad behaviors" of the "disorderly" prisoners. And we do not know the menstrual condition of the female guards who reported the women prisoners for their alleged misbehavior. A fifth problem with Dalton's research is seen in the reports of the prostitutes who claimed to have been experiencing their menstrual period or the premenstrual phase in 44 percent of their arrests, since it is difficult "to believe that prostitutes do most of their work during a rather limited period of their menstrual cycle. . . . This runs contrary to the entire literature on prostitution, which emphasizes a heavy and regular work schedule with relatively few days of vacation."[45] Finally, Dalton purports to

demonstrate a statistically significant relationship between menstruation and crime that is some way associated with hormonal changes, yet "the concentration of a hormone in the blood is not necessarily the best indicator of its potency or the best correlate for a given behavior," and "hormones do not operate independently of other physiological activity."[46]

In sum:

> Dalton's samples are quite small, and certainly not representative of any general population of females. For this reason, we cannot consider her results to have any general import. Aside from the limitations of the samples, there is the problem that what Dalton is correlating is reports of menstrual periods with official data on crime, not actual criminal or other antisocial behavior. In other words, the biasing factors that normally affect official criminal statistics are introduced into the equation in the menstruation analysis. In addition to biasing factors in the criminal justice system, it is possible that there are variations in the competence with which some females commit crimes spread over their menstrual cycles. That is to say, the slow reaction time and lethargy that Dalton found to be associated with the premenstrual syndrome may mean that female criminals perform their crimes less efficiently during that time, and so are more likely to be apprehended. If this is true, then what we have is not a relationship between menstruation and crime but rather a relationship between menstruation and the probability of being apprehended for a crime.[47]

Another frequently cited source on the topic of menstruation and female crime is Ribeiro, who reports that nineteen of twenty-two Hindu women committed suicide by immolation while menstruating, and one European as well as three African female suicides were also experiencing menses.[48] An examination of this reference reveals a short letter in response to a 1961 article by Dalton. The suicide incidents were restricted to the years 1958–1960 and were based on Ribeiro's performance of autopsies on the women. No empirical data are reported, and Ribeiro only states he is communicating an "interesting observation."

Ellis and Austin challenge the adequacy of studies such as the above, and find that none have met a necessary set of minimal criteria: (1) a determination of the stability of the menstrual cycle; (2) the use of daily observations of behavior over time instead of reliance on retrospective data; and (3) the use of a "multi-measurement approach" instead of the dependence on self-reports of "critical variables."[49]

In order to avoid such methodological problems Ellis and Austin randomly selected forty-five female felons in the North Carolina Cor-

rectional Center for Women who demonstrated "menstrual cycle stability."[50] These women, who were between the ages of twenty and forty-five, provided data that covered at least three cycles. The dependent variable was "the daily frequency of overt aggressive acts committed during the three-cycle period" as reported by the women, who were paid between five and seven cents for each daily completed form containing the commencement and end of their menstrual flows, other symptoms and emotional states experienced during the three-cycle period, and their overt aggressive acts during the study time frame.

Overt aggressive behavior included both physical and verbal attacks on other inmates. The physical acts, noted as somewhat minor in over 95 percent of the instances, included pushing, pulling, tripping, and pinching. Verbal acts consisted of obscene language, threats, and expressed wishes of harm.

The final analysis did not include the subjects' self-report data, since it was felt the inmates did not trust the researchers enough to admit to actions that might attract severe sanctions, if known. Therefore, only prison officers' observational reports of aggressive acts by the women were utilized.[51] Although no statistical tests of significance were applied, it was concluded that the differences obtained were substantially important, since 41 percent of both kinds of aggressive acts occurred during eight days of the twenty-eight-day menstrual time base, or that period identified as the premenstrual and menstrual phases. The by-chance expected frequency would be 28 percent aggressive acts during this eight-day period, so it was determined that the female inmates "do indeed tend to be nastier toward others during the premenstrual and menstrual phases of the menstrual cycle."[52]

While commenting that a number of studies indicate substantial increases in aggressive behavior during the ovulatory phase of the menstrual cycle, Ellis and Austin state they do not number their study among them; but on Day 12, located in the ovulatory phase, more than the expected number of aggressive acts were observed.[53]

In an attempt to explore the relationship between the triad of "irritability, pain and sex feeling" and aggressive behavior, Ellis and Austin found that the women reported more than normal irritability during the premenstrual and menstrual phases of the cycle, but the women who were most irritable were no more aggressive than the women who denied irritability; nor was there any connection between irritable moods and aggressive acts. They do not overlook the possibility that the women studied might not be more aggressive, but simply more careless and less concerned during these phases of their

menstrual cycles, and thus more easily detected in their aggressive behaviors.

As we have seen, Dalton's study of misbehaving schoolgirls revealed that the prefects evaluating the behavior and administering the punishment were reported to have dealt significantly more punishments during their own premenstrual and menstrual phases. An examination of such a possibility would have offered a refinement to the Ellis and Austin research, especially since it was the reports of the corrections officers that determined the misbehavior of the female inmates.

A Critique of the Influence of Menstrual Distress on Female Crime and Delinquency

It is clear that the extant studies on the alleged effects of menstrual distress on female deviance suffer defects in their research designs and procedures. And surely, "it would seem necessary for contemporary authors to be familiar with the methodological adequacy of the original studies before citing them as factual evidence,"[54] yet the few studies on the subject appear to be frequently cited without verification of the original data.

Since all of the studies reported utilized small numbers of subjects that are generally unrepresentative of female populations, and since they lack control groups of nonmenstruating women, this leads to "the assumption that the menstrual cycle is relevant to the interpretation of a great many cyclic changes in behavior in human females." But:

> Data from particular groups cannot provide a basis for a generalization about all women or about any woman selected at random unless it is assumed that women are equally likely to be or become a member of the groups in which the data were collected. From knowing, for example, that crimes are likely to *have been committed* during certain phases of the cycle, it is not possible to assume the truth of the inverse that women in these phases of the cycle are more likely to commit crimes; this latter is true only for women who will at some time commit crimes.[55]

In addition to sampling deficiencies, the methods of obtaining data are questionable; for example, the use of self-reports, especially the "retrospective calculation" method, introduces potential sources of error by relying on memory concerning the commencement and termination of menstruation. The recollection of such dates is difficult itself, but the women in these studies are also asked to evoke retro-

spectively certain symptoms and frames of mind experienced at the traumatic times of their arrest. A review of the questionnaires used apprises us that these instruments usually contain negative items and lack reliability and external validity, factors which hamper their usefulness as psychometric tools.

Cycle length is commonly designated as twenty-eight days in these studies. But in one sample of three thousand women 80 percent said their menstrual cycles were twenty-eight days long while the remaining 20 percent reported cycles that were multiples of seven.[56] Actually, few women have twenty-eight-day cycles or even cycles with multiples of seven. Evidence of *recorded* cycles of 2,316 women revealed that only 13 percent had cycles twenty-eight days long and 56 percent had cycles longer than twenty-eight days. The problem of menstrual irregularity is another factor generally ignored in these studies.

Researchers on the paramenstruum and female criminality also fail to produce data on the distribution of the antisocial acts allegedly committed by their subjects. Although they report the absolute number of aggressive acts or misbehaviors, there is no indication of how many of the females actually participated in the total number of offenses; therefore it is possible that only a few of the offenders could have been responsible.

Some critics even doubt the existence of a premenstrual syndrome, or an explicit causal relationship between hormones, tension states, and deviance, since "all women have the raging hormones, but not all women have menstrual symptoms, nor do they have the same symptoms for the same reasons."[57] One study of college women found no significant differences on six measures of mood throughout the entire menstrual cycle, and the average ratings of the coeds' moods were found to be similar to the ratings of their male classmates.[58] Furthermore, a survey of 352 single university women who were administered the Menstrual Distress Questionnaire (MDQ) found that the subjects employed menstruation to account for physical malaise and psychological stress related to other causes and that women who report such symptoms during menstruation also experience them in other situations.[59]

Some women may report what they *think* they are supposed to feel. In a study of Princeton coeds, twenty-nine women were led to believe that the onset of their menses could be predicted through new scientific techniques. Fifteen were told they were premenstrual, and fourteen were informed they were intermenstrual or that their periods were not due for a week or ten days. Another fifteen, the control group, were given no information concerning the expected menstrual

date.[60] All three groups were tested on the sixth or seventh day before their *known* period dates. On the Menstrual Distress Questionnaire (MDQ) three of the four predicted symptoms of menstrual distress were significantly higher for the premenstrual women than for the intermenstrual group, while the control group generally fell in between or closer to the premenstrual group. Thus, it seems that *thinking* she is premenstrual leads a woman to reporting herself as having the symptoms associated with the syndrome, a finding that not only questions the accuracy of self-report scales but also tends to "show that psychosocial factors can influence reports of menstrual-related symptoms."[61]

Finally, there is the issue of cyclic variations in behavior, the determination of a "base line" to interpret these rhythmic variations in behavior, and the need for nonmenstruating control groups in studies of the relationship between the paramenstruum and female criminality. Most research assumes that during the premenstrual and/or menstrual phases there is an increase in affect, actions, or other specific identifiable symptomology; but these studies lack a base line of comparison for describing the increases. And, at any rate, some feel that "we cannot make any statements comparing male and female biological cycles unless we are also willing to do studies of possible male biological cycles."[62]

Alternative Possibilities

There are at least three possible alternative explanations that might account for the alleged relationships between menstrual distress and female antisocial or aggressive behavior. First, women's criminal behavior and its subsequent correlates—apprehension, arrest, and incarceration—could *result* in hormonal changes, and not be caused by them. Anxiety or stress may lead to hormone level changes and result in physical symptoms such as early onset of menstruation.

A second possibility concerns the fatigue and lethargy associated with the paramenstruum which might lead to carelessness and/or unconcern in the commission of offenses with a resultant likelihood of detection.

Finally, a social-psychological explanation could be involved in menstrual distress. Women could be psychologically responding to menstruation and its onset as an unwanted event that has little to do with hormone levels. Considering the traditional negative attitude toward menstruation and the taboos, superstitions, and other limitations in behavior during this phase of a woman's monthly existence,

she could be expected to experience anxiety in the premenstrual period. Stress of this type could be related to pregnancy fear, or depression and irritability may be associated with the nuisance of the anticipated menstrual onset with its concomitant personal restrictions. Furthermore, "we must consider the *social* and *cultural* origins of these mood swings as well as the biological ones. The blues may be born of the pervasive cultural attitudes about menstruation generally and menstrual blood specifically."[63]

Pregnancy and Female Criminality

The vast bulk of research on the generative phases of women and their influence on crime causation is concerned with the premenstrual and menstrual aspects of the female life cycle. Little more than speculative observations, with meager empirical support, address the pregnancy and menopausal stages in a woman's life chronology as they relate to female crime and delinquency. No specific offender sample has been statistically identified that focuses on the crimes of abortion and infanticide, offenses germane to pregnancy, yet these crimes have been isolated as specifically associated with this biological condition. Today, of course, abortion is not considered illegal in the United States (despite citizen movements to restore it to that status), but when such acts were criminal, special statutory provisions existed to prosecute women for the offense. In *The Criminality of Women*, Otto Pollak places great emphasis upon the lack of detection of women committing abortions, but he is vague as to how the condition of pregnancy renders a woman criminal: "The psychological characteristics of pregnancy, such as unmotivated changes of moods, abnormal cravings and impulses and temporary impairment of consciousness, point also in the direction of criminal causation."[64] In the inordinate desire for certain foods Pollak sees an association with shoplifting in food markets. However, he makes no connection between these psychological characteristics and the decision to abort or to implement an abortion. If abortions are criminal, females who terminate an unwanted pregnancy are criminals, but women who interrupt their pregnancies for therapeutic reasons are not seen as offenders.

Pollak draws largely upon the social and psychological implications of infanticide. Women who kill their infants are described as predominantly unmarried and thus required to conceal their pregnant state, a strain that consumes most of their energies. Concealment is the primary objective, so the delivery of the child is accomplished in secrecy and unassisted. Because she is physically exhausted after the unaided

delivery, the mother who commits infanticide frequently has as much difficulty hiding the victim as she had concealing her pregnancy. Pollak does not fully develop the psychological causation involved in this form of homicide, but he alludes to it:

> A special crime risk arises at the time when the pregnant person would under normal circumstances have her period of menstruation. The menstrual cycles do not lose their psychological impact immediately at the beginning of pregnancy, but continue to influence the psychological state of women for at least several months afterwards. Women are then under a twofold disturbance of their mental balance, and criminal behavior may result on that basis.[65]

There are diverse opinions as to the extent of mood and behavior changes in the emotional states of pregnant women. Also, disagreement and inconsistency exist regarding the nature of the changes, which range from a "lazy and cowlike" state or "vegetative calm" to a "sense of well-being" or even to a "crisis state." Physical changes are the most negative in the first trimester and may include fatigue, nausea, vomiting, loss of appetite, and depression. The most positive emotional feelings are experienced during the middle period of pregnancy. And it is generally agreed that there is increased tension and anxiety toward the termination of pregnancy:

> So far as emotional state in pregnancy is concerned, the weight of the evidence suggests that it is not generally a period of unusual well being. However, such feelings occur in some women during middle pregnancy and there may be a decrease in psychotic reactions during pregnancy. Milder emotional disturbances, however, apparently increase, especially during the last six weeks.[66]

These emotional disturbances could possibly entail real concerns about the pregnancy, which are greatest near the time of delivery, or they could be related to shifting hormone levels. After the last missed period estrogen levels increase rapidly in the initial stages of pregnancy, with the greatest elevation in the sixth to twentieth weeks. Estrogen levels rise a hundred times at this point, and by the date the woman is experiencing labor this increment could be increased as much as a thousandfold. Progesterone also increases from ten to fifteen times its normal level during pregnancy, and it is known to have a sedative effect. Therefore, "the tremendous hormonal changes could easily underlie emotional lability, but the unusually high hormonal levels, once achieved and steadily maintained, could support a pervading sense of well being."[67]

It would seem that any positive connection between emotional states of pregnant women and crime are rather speculative. In order to make such a linkage, at the very least we would have to know the trimester of the pregnant offender at the time of her offense. Also, if we assume a relationship between hormonal levels and criminality in pregnant women, it would be requisite to explain why they would commit abortion, infanticide, or shoplifting when their female hormone levels are at peaks a hundred to a thousand times their normal levels when other studies have indicated *low* estrogen/progesterone levels influence antisocial behavior.

The Menopausal Syndrome and Female Criminality

As seen above, very little is known about the relationship between pregnancy and the crimes of women. There is far less evidence concerning the incidence of female offenses and the menopausal phase of women. Menopause, or the climacterium, indicates the end of menstruation and the termination of the ovarian function. This event usually occurs in women between the ages of forty and fifty-five years, and includes declining levels of estrogen and progesterone.

Otto Pollak reports a high incidence of women in the climacteric among his criminal statistics on females, but he does not document the fact that these women were experiencing menopause; they simply fell into the age range he assumed would include that syndrome. Pollak reports a higher percentage of women in the age group thirty-five to fifty-four years admitted to two penal institutions compared to all female admissions to those institutions for the period studied. Women in the suspect age group in Michigan, between 1936 and 1938, comprised 29.7 percent of all admissions compared to 25.9 percent of all female admissions. Pollak also compared women in the assumed menopausal age group (35.9 percent) to men in that age range (17.9 percent) on 1940 admissions to Ohio state prisons. Although he did not present offense data on these United States cases, Pollak indicates that a similar study in Germany among women ages forty to fifty found they were incarcerated for insults, breach of the peace, perjury, shoplifting, and receiving stolen goods—offenses Pollak views as characteristic of "emotional disturbance" and "irritability." Pollak adds that whatever "interferes with their roles as wives must be felt by them as a threat to their existence," and refers to "narcissistic suffering," or those thoughts women harbor during menopause associated with their loss of sexual attractiveness. He also states, "The menopausal syndrome includes the psychological characteristics of emo-

tional instability, insomnia, depression of spirit, irritability, and anxiety attacks."[68]

Some women do react to menopause with depression; but even if depression can be traced to estrogen—and therapy that replaces estrogen does tend to be successful in relieving this symptom in menopausal women—not every woman responds to the decrease in estrogen during the climacterium by becoming depressed. In fact, although menopausal women report a fairly high incidence of physical symptoms, they do not reveal the same consistently high number of psychological symptoms indicated in other age groups. Adolescent females, for example, demonstrate the highest incidence of those psychological symptoms commonly associated with women experiencing the climacterium—depression, excitability, and crying spells.[69]

In addition to hormonal changes, middle-aged women encountering menopause are faced with other socialization effects that may be contributing factors to depression. The aging process itself can be traumatic, as can fears of loss of attractiveness, possible marital problems, concern over the deaths of loved ones, especially one's parents, and the "empty nest" syndrome, or the realization that their maternal role is over since their children are now adults with their own lives to lead.

In sum, there appears to be little consistent empirical evidence to support a relationship between psychological or emotional problems and the commission of crimes by women in this age group and biological status. On the contrary, the bulk of medical and psychological data available indicates a wide variety of behavior and reactions of women in the climacterium, none of which can be clearly associated with criminal offenses.

Experimental animal studies demonstrate that behavioral effects such as aggressiveness and sexual response behavior are highly contingent upon hormonal levels, but there is no clear analogous finding in studies of human subjects, especially those related to criminality in women. The view of female crime and delinquency as biologically based behavior centered around the menses, pregnancy, and menopause finds little empirical support. It is doubtful that any single etiological factor can explain deviance in men or women; therefore the emphasis on the generative phases of women as causative factors in their criminality leaves much to be desired. Studies that suggest such a perspective are "indicative of a certain attitude towards women which infers that simple, biologically-based causal factors can explain the motivation and reasoning of complex, culturally located and socially meaningful acts."[70]

4

PSYCHOGENIC APPROACHES TO FEMALE CRIME AND DELINQUENCY

Women have always been seen as psychologically "different" from men. In their classical study of the female offender Lombroso and Ferrero saw the female criminal as enveloping "all the criminal qualities of the male plus all the worst characteristics of women, namely cunning, spite and deceitfulness."[1] These earlier authors felt that women were crueler and tended to be vengeful, ferocious, and cold. Lombroso and Ferrero also viewed female crime as "masculine" since they had determined that the women who engaged in crime were genetically more male than female.[2]

Otto Pollak refers to several possibilities why women are not apprehended for criminal acts with the frequency of men: underdetection, underreporting, and police and court paternalism toward women.[3] But he also suggests that female criminality is largely masked and speaks of the basic deceitfulness of women in general and of criminal women in particular. He describes this lack of veracity in women as "an interplay between physical and cultural factors" that stems from their ability to simulate orgasm in sexual relations.[4] This behavior is in contrast to the physiological fact that a man must have an erection to perform sexual intercourse and therefore cannot hide his failure to consummate the sex act. Women, on the other hand, can participate in sexual intercourse by pretending a desire and its ultimate achievement through the faking of orgasm. Pollak sees further indications of deceit in women's concealment of their monthly menses and the tendency of mothers to be uncommunicative in supplying sex information to their inquisitive children, although he admits that both of these latter types of female furtiveness stem from societal sex mores.[5]

Essentially there are two basic psychogenic interpretations of female crime and delinquency: the traditional, or classical Freudian

view, and the familial perspective. In the latter instance the psycho-
logical and personal interaction within the family, specifically with the
parents, is the causative variable in female deviance. The most exten-
sive body of literature on female crime and delinquency, however,
deals with psychological origins of the Freudian persuasion. Such a
perspective appears to have been considerably influential not only in
a theoretical sense, but also in its adoption by the criminal justice
system as a rationale for determinations in the cases of female delin-
quents, a point we will demonstrate in a later chapter.

Sigmund Freud viewed the female as having a sense of inferiority
largely because of penis envy. Somehow accompanying this purported
inferiority was a lower sense of morality which Freud saw as actually
developing from the original wish to have a penis. Through general-
ization, the resultant inadequate sense of morality became a part of
other areas of the female's life such as the intellectual sphere, result-
ing in a person who had little moral sense, was jealous and emotional,
and suffered from poor judgment.

Freudian Views of Female Deviance

The most pervasive theoretical position regarding female crime
and delinquency causation is rooted in the psychoanalytic writings of
Sigmund Freud. He wrote extensively, and an understanding of some
of Freud's basic hypotheses must be examined in order to provide the
background and rationale for the later expositions embracing his
position. The two major concepts from which most of the theories of
female deviance have evolved are the structure of the personality and
the psychosexual stages of development of the child.

The Structure of the Personality

According to Freud, the structure of the personality contains three
major systems: the id, the ego, and the superego, each of which is
interdependent. The end result of their continual interaction is
human behavior, or personality.[6]

The id is present at birth, includes all of the instincts, and contains
all inherited psychological characteristics. Always seeking pleasure
and avoiding pain, the id demands immediate gratification and the
reduction of any discomfort or tension, which it accomplishes through
the "pleasure principle." The ego, on the other hand, operates within
the confines of the "reality principle," which has the primary objective

"to prevent the discharge of tension until an object which is appropriate for the satisfaction of the need has been discovered."[7] Thus, the ego transacts with the objective world in its principal role as mediator between the instincts and the environment. The superego also attempts to inhibit the impulses of the id, particularly those most censured by society—the aggressive and sexual urges. Through socialization, the interaction between parents and child seen primarily in rewards and punishments, the superego, which develops last, becomes the "moral arm of the personality" and thus seeks perfection, not pleasure.

The Psychosexual Stages of Development

Freud believed that the early years of life are the most crucial determinants of personality formation and that every child passes through defined psychosexual stages of development, each of which is dynamically different.[8] Chronologically these developmental periods are divided into the pregenital stages (oral, anal, and phallic), which are narcissistic oriented, or centrally concerned with the stimulation of one's own body; the latency period, when impulses are contained and there is little dynamic psychological activity; and the genital phase, or the final stage that begins in adolescence and culminates in adult maturity. Freud felt that each of us must successfully negotiate these stages of development. If we fail, personality difficulties of various degrees are likely to appear and seriously affect our later lives.

While all of the pregenital stages are most influential in the ultimate development of our personalities, the phallic stage is the primary focus of psychogenic explanations of female deviance and will be discussed more fully.

At about three or four years of age the sex organs become the central dynamic activity zone as a child enters the phallic stage. Up to this point, the psychosexual development of boys and girls is highly similar, but in the phallic stage we see a divergence in sexual development between the sexes. Masturbation and sexual and aggressive feelings are functions associated with the phallic stage, each of which lays the foundation for the manifestation of the Oedipus complex, which "consists of a sexual cathexis for the parent of the opposite sex and a hostile cathexis for the parent of the same sex."[9] Since Freud believed that everyone is innately bisexual, these sexual feelings for the same parent introduce further complications for the handling of the Oedipus complex, a phenomenon that ultimately conditions attitudes toward the opposite sex and toward people in authority.

The dynamics of the Oedipal situation are more clearly seen in the instance of males. The boy loves and sexually desires his mother; but fearing the jealousy and rivalry from his father and the potential punishment of castration for harboring this incestuous desire, he represses this lust, the castration anxiety he feels, and the hostility he has toward his father. The boy then identifies with his father; through this identification he achieves a normal resolution of the Oedipus complex and attains the final development of the superego. This latter feat is completed because the superego is the final moral inhibitor of sexual (incestual) and aggressive impulses.

The entire process is much more difficult for the girl since she, too, sees her mother as the original love object. Whereas the erogenous focus for the boy is the penis, according to Freud, the clitoris is the center of the girl's sexual fantasies. She soon discovers that she lacks a penis and thus experiences grave disappointment, envy, and trauma—feelings that she blames on her mother. The girl covets a penis, and as a result of this penis envy, she renounces her love for her mother, who is seen as responsible for the girl's lack of a penis; additionally, her mother is considered inadequate since she also lacks a penis. It is at this point that the girl transfers her love to her father:

> Her shift of love to her father derives from her desire to possess his penis. She believes that she can take in the father's penis, thereby unconsciously perceiving her vagina in a new positive light. She also comes to equate penis and child: She takes her father as a love object in order to have a child by him, which symbolically represents attaining a penis. This process places the girl in a position of unconscious competition with her mother. Thus, according to Freudian theory, the girl playing with dolls is really expressing her wish for a penis. The original penis-wish is transformed into a wish for a baby, which leads to love and desire for the man as bearer of the penis and provider of the baby.[10]

After experiencing all of this, the girl is *just entering* her Oedipal phase of development (Electra complex) since the sexual cathexis is now for the opposite sex, her father. The development of the superego is contingent upon the successful accomplishment of this period. Identification with the same-sex parent is also an integral part of superego maturation, therefore the girl must complete yet another psychological hurdle—identification with her mother. Thus, for the girl, the Oedipus complex tends to persist for an indeterminate period of time. Freud felt that girls never really resolve this problem and consequently are unable to develop as strong superegos as men.[11] "Since girls already perceive themselves as castrated, they have less

motive for giving up their possessive love for the father"[12]—although they do eventually achieve identification with the mother and, through absorption of her moral values, a superego.

The Freudian orientation is not limited to penis envy for its explanations of the behavior of females. At any stage of psychosexual development faulty mechanisms, fixations, or other problems may occur. An examination of some of the research and theoretical perspectives on female crime and delinquency derived from the Freudian view will demonstrate the application of his outlook to the psychology of females.

The Freudian Influence on Research in Female Criminality

Most of the early literature assumes that female delinquency is predominantly sexual and therefore tends to focus on that specific aspect of Freudian psychoanalytic theory. Blos, for example, directly states that "in the girl, it seems, delinquency is an overt sexual act, or to be more correct, a sexual acting out."[13] The basis of his theory is that preoedipal factors determine the etiology of female delinquency, and Blos isolates two developmental types of female delinquent: those regressed to the preoedipal mother and those who cling to the Oedipal stage of psychosexual development. His differentiation between the two is unclear, nor does he explain the kind of deviant acts that would be committed by each type of delinquent female.

In a later work Blos refines and expands upon his earlier position by further explaining the earlier types and by adding a third "constellation" of female delinquency.[14] In the first constellation the delinquency is a defense against regression, a denial of the need for a nurturing mother, and also an attempt to avoid homosexual surrender. The delinquent girl's sexual acting out in the second constellation is revenge against the mother because of a real hostility toward her for degrading the girl's Oedipal father. The third constellation of female delinquency, "acting out in the service of the ego," is an attempt, through sexual misbehavior, to restore a sense of reality, since the girl has become emotionally disengaged from her family and such an estrangement has detrimentally affected her ego. Blos concludes that "female delinquency is far more profoundly self-destructive and irreversible in its corrosive consequences than is male delinquency," because it violates the caring and protective maternal role, thus affecting the female and subsequently her offspring.[15] Again, Blos does not indicate any differentiation in type of asocial behavior that will be exhibited by each type of girl in the three constellations, nor does he

compare and contrast the dynamics involved with males. Yet all theoretical roads apparently lead to sexual activity.

Herskovitz flatly states that "the predominant expression of delinquency among girls in our society is promiscuous sexual behavior."[16] He views promiscuity as a symptom of underlying psychological causes. The promiscuous girl is seen as psychologically maladjusted for a variety of Freudian-based reasons: penis envy, an unconscious wish for the father, a basic feminine need to be wanted and loved, and the like. According to Herskovitz, women have an underlying desire to be loved and wanted and concomitant wishes to serve, to mother, and to sacrifice. The need for love and nurturance originates in the early mother-child relationship, and if the girl does not find these needs satisfied, personality traits and symptoms such as sexual promiscuity later appear.

Other possible causes listed by Herskovitz in the etiology of girls' sexual promiscuity are: to prove they are equal to boys (or the manifestation of the Freudian concept of penis envy); a defense against unconscious homosexual impulses; because of a fear of sex, where the acting out behavior attempts to overcome the fear by proving there is really nothing to it in the first place; an unconscious (incestuous) wish for the father whereby sex with another man functions as a substitute for the father; confusion in identity; psychosis; a defense against psychosis; assuaging underlying guilt feelings by committing the sexual act and being punished for it. Despite this variety of possibilities, all rooted in psychoanalytic thought, each is felt to stem from only one type of deviant behavior—sexual acting out.

Other psychogenic approaches to female delinquency also presume some form of emotional disturbance somehow related to sex. In *The Adolescent Girl in Conflict*,[17] Konopka discusses unwed pregnant girls adjudicated as delinquent because of their pregnancy. She feels that the problems of a delinquent girl, despite the type of offense, are "usually accompanied by some disturbance or unfavorable behavior in the sexual area," and that the primary concepts involved in girls' delinquencies are excessive loneliness and a low self-image.[18] A circular paradigm is offered: the girl searches for romance, finds it through sexual experience, is discovered then rejected by society. As a result of the rejection she becomes more self-destructive or delinquent. Konopka sees adolescence as a particularly painful experience for girls, one that results in loneliness and despair. The psychological development of girls, particularly the Oedipus complex, is more difficult for girls to negotiate than boys.

Other familial hazards Konopka describes include a competitive situation with the mother and the dangers of incestuous relationship

with the father. As a result of these fears "the adolescent girl in con-
flict" experiences tremendous guilt as well as strong ambivalence to-
ward her mother. This tends to disturb the identification process and
makes identification with the mother difficult or impossible to accom-
plish. In sum, the final picture of such a delinquent girl includes
excessive loneliness, a low self-image, estrangement from adult soci-
ety, and the incapacity for friendship with contemporaries.[19]

There is differing evidence concerning the notion that deviant
females hold negative self-images. Earnest studied 123 female in-
mates, including a small number of juveniles, in Wisconsin penal in-
stitutions.[20] The data, based upon self-reference group theory,
supported the hypothesis that inmates who viewed themselves as
criminals not only have reference groups which they feel see them as
criminals, but they also had such self-conceptions when they arrived
in the penal community: "an inmate's self-conception was found to be
associated with the interpretation of significant others who had nega-
tive referents for her criminal actions. This differential self-percep-
tion is believed to develop, in part, from interaction and reactions to
significant others."[21]

In another recent study Datesman et al. admit that the items on
their self-concept scale might be sexually biased since the instrument
was generally oriented toward the male role.[22] Nonetheless, they
report interesting sex differences among the delinquents and non-
delinquents they studied. Although the delinquent groups revealed
slightly more negative self-evaluations than the nondelinquents, when
race is controlled, the discrepancies are even more tantalizing. The
white delinquent girls were found to have no better nor worse self-
esteem than nondelinquent white females, whereas the black female
delinquents scored significantly lower than the black nondelinquent
females. Datesman et al. report the differences between the mean
self-concept values for delinquents and nondelinquents in the follow-
ing rank order: black females (2.581), white males (1.284), black males
(.788), and white females (.142). The authors suggest several possible
explanations for these differences: recidivism incidence, female sub-
cultural patterns, and seriousness of the offense.

The Familial Perspective on Female Deviance

In addition to Freudian theory, other major perspectives on psycho-
genic theory pertinent to female delinquency are largely based upon
relationships within the family, particularly with the parents. Despite
the familial emphasis, these theories are also rooted in the Freudian

model, and a common thread of pathology in the girl is seen as the cause of her delinquency.

In his observations of sexual delinquency among middle-class girls, Ackerman finds that the family tends to stimulate and facilitate the acting out of adolescent sexual behavior.[23] A self-fulfilling prophecy is demonstrated by a tendency of middle-class parents to project to the girl that she will be bad, then when she is indeed bad, to punish her for it. This "defensive hypocrisy of parents" forces a girl to discharge her aggression toward her family by revolting through sexual misbehavior, while secretly the girl is frigid and does not really enjoy the sexual experience.

Gertrude Pollak's exploration of premarital sexual conduct among culturally deprived girls reached similar conclusions.[24] The girls in Pollak's study also had poor self-concepts, negative images of family life, and problems with authority, but the social dynamics involved were related to the culture of poverty. It is difficult for the mothers of large, lower-class families to provide a warm and understanding relationship to their children, since the day-to-day struggle to survive takes up most of their energy. These mothers cannot respond to their children's oral dependency needs, which go unsatisfied. The poor self-images of these girls are the result of a lack of positive experiences in the familial relationship, the marital conflict of the parents, and the struggle for physical survival by the family. Pollak finds this especially true since the mother also has a poor self-image. The lack of sustained authority in conjunction with poor experiences in school and with the police further contribute to authority problems in lower-class girls.

Cowie et al. accomplish an exceptionally comprehensive review of earlier studies of delinquent girls, the majority of which stress poverty, broken or otherwise poor home environments, parental disharmony, and other social and family-related problems that impact on the female delinquent.[25] Disturbance of the home life is seen as one of the primary causes of juvenile delinquency, if not the main cause, by those who feel that delinquent girls come from more abnormal families than deviant boys. Such homes typically have poor discipline, lower moral standards, are generally conflicted, and result in more pathological deviations among delinquent girls than among their male counterparts.

Cowie et al.'s own research involved 318 mostly sexually delinquent British girls, fourteen to seventeen, who were found to experience defective relationships with their parents (80 percent of the cases) in a "deprivation syndrome." Although they could not get reliable estimates of incest, Cowie et al. assumed that such incidents are higher

with brothers and, further, that many female runaways leave home because of sexual approaches made by father substitutes. They conclude that girl delinquents, compared to boy delinquents, come from economically poorer homes that contain more mental abnormality; their families have poorer moral standards and discipline; there are more conflicts and disturbed relationships within such homes, most of which are broken; and there is greater mobility or more frequent changes of residences in these families. To explain the anomaly that there was no evidence of important psychiatric abnormality in 48 percent of these delinquent girls, they suggest the idea of a "social" or "subcultural" delinquency that is a normal or natural response to the environment.

Female delinquency is also explained as a failure of the girl to identify with her parents and, concomitantly, the inability of the parents to effectively control their daughter's behavior.[26] One comparative study of delinquent and nondelinquent girls hypothesized that female delinquents fail to identify with their parents because of a lack of stable, consistent social interaction. Socialization was seen as the main dynamic; therefore whatever impedes the effective socialization of a child contributes to the child's delinquent behavior. A checklist measuring the extent of a girl's identification with her parents and her own self-esteem was administered to 119 mostly white, Protestant institutionalized girls. It was assumed that socialization requires stable, consistent, and persistent parent-child interaction, but these conditions were not met in the cases of delinquent girls. Several other factors were identified as peculiar to the delinquent girls: lower family integration, less parental interest, rejected parental roles, frequent school-residential moves, broken homes, and characteristics demonstrating a lack of nurturing, stable, and continuous interrelationships in the family.

One final cross-cultural study of the perceptions of the adequacy of parental roles and the extent of parental affection should be noted in this discussion. Individual personal interviews with twenty-five Anglo and Hispanic-American delinquent girls and an equal number of nondelinquent girls, matched on age, intelligence quotient (IQ), and socioeconomic status (SES), focused on the mother-father-child triad.[27] The delinquent girls felt that neither parent gave them the amount of love they desired, but felt more loved by their mothers than their fathers. Although they did not identify with either parent, they chose their mothers more often than their fathers for identification. When the delinquent girls got into trouble, they had few resources to turn to, since because of the estranged parental relationship they tended not to turn to their parents and they also had fewer extra-

familial social contacts and group memberships than the nondelin-
quents. They would rather turn to their mothers on such occasions
than their fathers, however.

Many of the forces within the family that work against the girl and
result in sexual delinquency are associated with the father.[28] The
family dynamic emphasis on the father figure is seen, for example, in
the flight from an incestuous threat, rejection by the father, the long-
ing for a missing father, excessive paternal strictness, and possible
overstimulation or actual seduction by the father. From this perspec-
tive the father-daughter relationship is far more significant than
other variables present in the home such as inconsistent parental con-
trols and overpermissiveness where sexual delinquency is concerned.

Psychological Typologies of Female Delinquents

Several attempts have been made to establish classifications and
psychological typologies of female delinquents through empirical
studies of their personality patterns. One early effort by Dora Capwell
utilized intelligence tests, personality tests, and academic achievement
inventories in a comparison of 101 institutionalized delinquent girls
and 85 nondelinquent public school girls in Minnesota.[29] The non-
delinquents demonstrated higher intelligence (mean IQ of 101, as
compared to the delinquents' mean IQ of 87), and the delinquents
revealed more pathology on the Minnesota Multiphasic Personality
Inventory (MMPI), particularly on the Psychopathic Deviate (Pd) and
the Paranoia (Pa) scales. On the basis of her analysis of the MMPI and
the Washburn Social Adjustment Inventory results, Capwell con-
cluded that delinquent girls indicated more instability and personality
aberrations than nondelinquent girls.[30]

A systematic classification of 139 delinquent girls in the Las Palmas
training school for girls in Los Angeles, reported in 1965, employed a
Q-factor analysis of a psychological inventory.[31] The resulting types
were found to correspond highly with independent descriptions of
the girls by the institutional staff. The objective system yielded three
primary types of female delinquents, two of which (Types I and II)
were found to be similar to those isolated in prior research concerning
male delinquents. The measurement tool, based upon the Jesness
Psychological Inventory, contained items concerned with attitudes to-
ward the self, family, police, and school.

Type I responses, classified as Disturbed-Neurotic, indicated ex-
treme anxiety, self-blame, psychosomatism, and a preoccupation with
norm conformity. The girls in this category appeared to have overin-

ternalized rules, accepted cultural norms, and were concerned with law and order. These girls, who also exhibited guilt feelings and neurotic reactions, demonstrated recent delinquency which was of short duration.

The Type II girls, who were labeled Immature-Impulsive, seemed to lack personal integration and controls. They preferred immediate gratification and displayed impulsive behavior. These girls rejected external controls, rebelled against authority, were vengeful and distrusting, and saw themselves as lacking opportunities. The staff described Type II girls as aggressive, impulsive, immature, overt manipulators with sociopathic tendencies.

Girls in the third classification, Covert Manipulators, were believed to have falsified the test since they gave expected answers, or those responses that indicated normal, healthy, nondelinquents; yet the staff described them as bright, clever, covert manipulators with aggressive and sociopathic tendencies.

A 1971 article by Felice and Offord entitled "Girl Delinquency . . . A Review," presents an excellent overview of research on the topic of adolescent female deviance classified into testing studies and descriptive studies by the authors.[32] The first category includes three main divisions: (1) IQ studies in which no significant differences were found between delinquents and nondelinquents when socioeconomic status level is controlled; (2) studies primarily concerned with the Wechsler-Bellevue triad in which certain subtests examined for diagnostic cues to adolescent psychopathology are generally upheld, but which seem to be more related to the learning difficulties of the delinquents than to their delinquencies; and (3) personality tests such as the Minnesota Multiphasic Personality Inventory (MMPI), which appear to indicate more evidence of emotional disturbance among delinquents than nondelinquents, but which Felice and Offord feel were not well controlled and generally inconclusive.

Since the 1950s descriptive studies of female deviance have shown a decided shift from the psychoanalytical to the familial-social type and include personal-character studies, some of which have been reviewed above. Felice and Offord were rather dissatisfied with the results of these previous works and in 1972 reported the findings of their own analyses of the case records (family, doctor, school, and social history) and voluntary interviews of eighty seriously delinquent institutionalized girls.[33] Their results indicate three rather divergent pathways leading to female delinquency which they designate as "psychiatric delinquency," "community delinquency," and an unnamed third type.

Group I (psychiatric) was composed of thirty white girls with a mean age of 15.3 years who were located in a private residential treatment center with an open setting. These subjects came from small lower-class families with unstable marriages (30 percent were intact homes) and had the highest "hardship" score among the three groups. This score included guardianship changes, rape, abuse, and so forth. Group I also had the greatest parental pathology—families with alcoholism, mental instability, or trouble with the law. While they were above Groups II and III in highest mean IQ, this group was felt to have the strongest genetic component in their delinquency, hence the name "psychiatric delinquency" group.

Twenty white girls in Group II, or the unnamed delinquent group, had a mean age of 15.6 years and were in a closed-setting state institution. They were below the mean normal IQ (60 percent), were from small towns, came from poor families, and their parents were together (60 percent). The etiology of the delinquency of the Group II girls was not considered genetic by Felice and Offord; however, there was more alcoholism in the parents (45 percent), especially on the part of the father. There were also other disturbed siblings in the family constellation.

The community delinquency group, Group III, consisted of thirty black girls who were also in a closed state institutional setting and had an average age of 15.3 years. This group had the lowest IQs, the highest level of illegitimacy (60 percent), and came from large, very poor families located in a metropolitan area. They had been raised either by the mother alone or by other relatives. These families had the least amount of parental pathology among the three groups. Comparable to the other two groups, Group III also had siblings in difficulties, and in fact had the highest incidence in that category. Felice and Offord defined the community delinquency phenomenon as "peculiar to the ghetto situation where antisocial behavior is more widely accepted."[34]

In analyzing the course of delinquency Felice and Offord found no significant differences between the three groups concerning age of onset of delinquency, first contact with the juvenile system, or first court appearance. Comparisons within groups, however, indicated a significant difference between the girls related to onset of menses and misbehavior. Those girls who experienced an earlier age of menarche also demonstrated an early beginning of delinquency.

Another investigation of the psychological styles of delinquency in girls is reported in a Canadian study that isolated and described three major psychological dimensions of seventy-nine adolescent subjects in

a training school for girls in British Columbia.[35] The data were based on interviews with the school social work personnel and on group tests that included Questionnaire Data (socialization, affect, and hostility scales); Life Data (direct questions concerning the subject's life), and Test Reaction Data (questions concerned with participation in the research effort and reactions to the tests). Standardized individual interviews obtained from the social workers pertained to the girl's case history, the charges against her, and her behavior inside and outside the training school. A control group of thirty-nine nondelinquent girls was matched on age and low socioeconomic status (SES). Factor analyses performed on the scales revealed few differences on the life variables (age, height, number of siblings, and family position) except the delinquent girls were found to weigh more. Several significant differences between the groups were obtained on the psychological indices (socialization, positive affect, negative affect, verbal hostility, risk taking, rating of religion, and degree of risk taking). Rotation of the factors in the socialization scale isolated three factors which were labeled Behavioral Control versus Irresponsible Behavior, Eugenic Family Milieu versus Negative Social Identity, and Optimism versus Self-Defeatism.

Factor I (Behavioral Control versus Irresponsible Behavior) indicates an adoption of irresponsible behaviors and an inability to associate oneself with productive social behavior as a result of inadequate or nonproductive socialization. The second factor, Eugenic Family Milieu versus Negative Social Identity, reveals a negative self-concept as a product of an unpleasant, negative, domineering home that ultimately resulted in rebellion on the part of the girl. This type of girl sees herself as not to blame for her actions, but as molded by her environment. Factor III, Optimism versus Self-Defeatism, related to low ego strength indicated by the girl's expression of feeling miserable, lacking in confidence, and facing a glum future.

Although this psychological approach proved productive in isolating and defining three different styles of female delinquency, the statistical results were unproductive in terms of a typological approach to female delinquency because too many types would be required to describe the subject groups.

A Critique of the Application of the Freudian Psychoanalytic Model to Female Deviance

Although there are several approaches by which one can critically discuss and assess the theoretical perspectives Freud espoused in rela-

tion to the psychology of women, one must keep in mind that Freud's genius and contributions have never been totally disputed; nor has his theory of the psychosexual stages of development actually been refuted.[36] The following critique is limited to the Freudian concepts of penis envy, the female Oedipus complex, the alleged weaker superego of the female, Freud's biases, and his neglect of the social context in his approach to the psychology of women.

One of Freud's pupils, Alfred Adler, challenged Freud's notion of penis envy. In a sense Adler preempted some of the contemporary views championed by modern women when he pointed out that a "sense of inferiority was created in women not because they felt less well endowed physically than men but because an unnatural relationship of male dominance exists between the sexes."[37] Unfortunately, Adler substituted the concept of masculine protest for that of Freudian penis envy. Adler ascribed the term both to males and to females who make an effort to escape from the feminine role. "If it takes an active form in women, they attempt from an early age to usurp the male position. They become aggressive in manner, adopt definitely masculine habits or 'tricks' of behavior and endeavor to domineer everyone about them."[38]

Another of Freud's psychoanalytic disciples, Karen Horney, totally rejected the notion of penis envy and the castration complex in the normal development of women.[39] According to Horney, mutual envy was shared by both sexes, although girls did envy the boys' greater ease in urination and masturbation.[40] Horney further added that there was a male envy of the female, or a femininity complex of men, which was more severe than the masculine complex of women.

In her book *Feminine Psychology* (1967), Horney demonstrates that there is a psychology of women and not just theories of female psychology based on derivatives of a male psychology. In this collection of papers Horney points out that women envy men really for those opportunities men have in a male-oriented society that are denied to women. She also stresses the importance of social and cultural factors that are in interaction with biological ones.

A comprehensive review of studies that attempt to trace evidence of the Oedipus complex in women emphasizes the folly of an endeavor that concentrates on only three persons—mother, father, and daughter—when there is the larger context of the entire family and its potential accompanying influences to be considered.[41] After scrutinizing studies of parental sex preferences of men, women, and children, studies analyzing dreams, and research involving various projective tests, the reviewer concludes that "there is very little evi-

dence of the female Oedipus complex, though the question has not been sufficiently studied."[42]

It is also difficult to support Freud's idea of the weaker superego of women, because if one must generalize on the subject, males appear to have the weaker superego: "Females show more superego in the sense of less lawless behavior, more conformity, stronger moral code, more upset after deviance, and anticipating punishment from an internal rather than an external source. Females also tend to judge social violations more severely."[43]

Several contemporary feminist writers are critical of Freud's theory because they feel that he demonstrated a masculine bias.[44] Their primary objection is that Freud used men as the normative standard by which he assessed women, who are seen as inferior "little men". Because he considered a woman's sex organs as inferior, Freud viewed women as anatomically and emotionally inferior as well. The female offender who is more masculine is thus seen as a sexual misfit, since her rebellion and aggression are indicative of her longing for the envied penis, which one group of writers sardonically points out is never referred to as a "bloated clitoris."[45]

Inasmuch as the total emphasis of Freudian female theory is based upon psychological indices for explanations of female criminal activity, factors such as social, political, and economic realities of female criminality have been ignored. Freud's "anatomy is destiny" position assumes the social reality of people's behavior as given and ignores human needs,[46] when the true reality is that many women commit offenses for economic reasons—they *need* the food or clothing they steal.

In sum, it is unusual that most of the literature and research addressing the etiology of female deviance from a psychogenic orientation is from the Freudian persuasion. There are few indications of a Jungian, an Adlerian, a Sullivanian, or any number of other possible psychogenic theoretical bases that could be employed to approach this phenomenon.

In order to interpret adequately female deviant behavior using the criteria of psychological dynamics, it is apparent that there is quite a limited level of conceptualization in this type of research. Furthermore, there is insufficient evidence to warrant any significant conclusions as to female crime and delinquency causation, since there are so few studies on the subject.

Another striking omission in the psychological perspective is its lack of explanatory data on the etiology of boys' delinquencies. At certain early stages of development, according to Freudian theory, boys and girls have basically similar experimental relationships with the

mother; therefore it is conceivable that there would be a parallel psychosexual development up to a certain point. In fact, the boy's Oedipal conflict might lead to some fairly serious problems in the sexual sphere.

It appears that the literature on psychogenic research and theory leaves serious explanatory gaps in approaching the origins of female crime and delinquency. The Freudian psychoanalytic model is particularly deficient when it presupposes some psychological inadequacy in the female deviant that is presumably not found in the deviant male.

Another issue not dealt with by the Freudian perspective is an explanation of female delinquency that is not sexual. Or, by the same token, how can male sexual delinquency be explained? From the psychoanalytic position, the female delinquent is summarily a sexual delinquent, either because of failures in her psychosexual development, with accompanying fixations at particular stages in that developmental process, or because of some pathological syndrome. The Freudian line of thinking neglects "hidden" or unreported delinquency commonly found in allegedly stable middle- and upper-class families—another explanatory gap that requires closure.

In sum, there is a paucity of research in psychoanalytic theory concerned with female delinquency causation, which leaves several major issues inadequately addressed. The literature that approaches the question from a sociological posture appears to offer more promise and is the subject of the next chapter.

5

contemporary efforts
to explain
female deviance

In a movement away from the biological/constitutional attempts to explain the criminality of women, which view women as "different" from men because of their physiological make-up, and the psychogenic explanations that also see women as "different" but in an emotional sense, several writers in the 1970s and 1980s offer new approaches to the etiology of female deviance.

There are two broad perspectives on the topic, which for the most part are put forward by female theorists. First, there is the economic view, which explores the social and economic realities of female crime. While there is some overlap, the second conceptualization represents a sociological perspective that has two basic components: one which describes the factors that operate differently for male and female offenders in our society, and the other which is concerned with role and opportunity theories. The latter position suggests that new self-concepts, new roles, and concomitant new opportunities available to women contribute to, if not cause, their deviance. As with all theoretical perspectives, there are opposing views, and these will also be discussed in this chapter.

Economic Explanations

Prior to the 1960s and 1970s criminological research focused almost exclusively on the sexual offenses of females and largely ignored other forms of female misconduct. Since the incidence of female deviance is comprising a larger proportion of the total number of arrests, and since females, especially girls, are committing more serious offenses, new attention has been directed toward the female's economic position in the social structure.

The average person on the street thinks of crime as violent acts or some form of personal assault, while the actual "crime problem" generally involves dollars and cents or is predominantly economically based. In 1975, for example, the estimated murder rate was 9.6 per 100,000 inhabitants in the United States; for larceny of $50 and over the rate was 2804.8. That same year the forcible rape rate was 26.3, while the rate for burglary was 1525.9.[1] All this is not intended to deemphasize the seriousness of crimes against the person, particularly in light of the tremendous fear expressed by the citizenry in the face of the threat of such crimes. Our purpose is simply to establish the fact that property offenses are far more pervasive than personal offenses in our society.

Property crimes are committed primarily for one reason: the acquisition of money or of goods exchangeable for money. Obviously men do not have a monopoly on the desire to obtain money or goods by either legal or illegal means; women also have criminal economic motivation. Unfortunately the study of female deviance, with its almost exclusive focus on sexual offenses, has tended to neglect the woman property offender, despite the fact that of all offenses, for decades females have been arrested predominantly for larceny.

In a review of the literature on the etiology of female crime Dorie Klein concludes that all the theories she reviewed ignored the economic and social realities of female crime. She feels that poor and Third World females "negate the notions of sexually motivated crime" and "engage in illegal activities as a viable economic alternative," a point overlooked by other writers on the subject.[2]

Historically, women have been seen as either "good" women or "bad" women, with the latter group categorized as the criminals. This dichotomous perception has been described as the madonna/whore duality, or attitudes that have evolved from "pagan mythology and Judeo-Christian theology" based on the ways men are affected by female sexuality.[3] The madonna aspect refers to women as producers of children who maintain the family line. Woman's powers to excite man's passions and interfere with man's control of himself made her exciting yet dangerous, the *whore* side of the duality. Men protect madonnas but punish whores.

Previous writers on female deviance did not adopt feminist or radical perspectives since their foci were either on individual physiological or psychological traits, to the exclusion of sexism, racism, and class problems. Most female offenders are uneducated, are poor, are mothers, and are members of minority groups; further, demographic findings indicate that these women are self-supporting and frequently have others to support.[4] It is estimated that from 50 to 80 percent of

incarcerated female offenders are mothers. Therefore, the commission of crimes may be necessary to provide for themselves and their families, a factor which makes it conceivable to view their larcenies, burglaries, and robberies in simple economic terms.

For centuries the mythical "world's oldest profession," prostitution, has been considered the primary female offense. In previous chapters we discussed the overemphasis on female sexual misbehavior and promiscuity, and pointed out that prostitution is probably the most misunderstood female offense because it stresses female sexuality to the neglect of economic reality. The prostitute has been viewed by sociologists, criminologists, and other social scientists as the "fallen woman," the "bad woman," certainly as the "whore," or some other value-laden term associated with morality. Current feminist writers reject such notions and offer an economic explanation for the commission of this offense.

Carol Smart, for instance, criticizes Kingsley Davis' hypotheses on prostitution by stating: "He does not consider the situation of women unable or perhaps unwilling to use this one resource in order to find economic security, nor does he attend to the inequalities inherent in the social milieu which leaves women dependent on such a transitory and subjective attribute as attractiveness to men."[5]

In her review of the prostitution literature, Jennifer James notes that the economic motive—the desire for money—is the most pervasive cause for involvement in the profession.[6] She also discards the traditional stereotype of the poor, minority female being forced into prostitution as a desperate economic alternative, since recent studies indicate that as an occupation prostitution provides a very high standard of living. In other words, the selection of this form of income is "institutionalized occupational choice,"[7] and not necessarily a forced way of life. As James puts it, there is good cause for women to move from "a $3,000- to $6,000-a-year income to the gracious living possible with $50,000 a year."[8]

It is clear from contemporary studies based on identified prostitutes that economics is the primary reason that women enter prostitution and remain in the profession. When asked the advantages of being a prostitute, 84.9 percent of James's subjects chose "easy money–material goods" as the first response.[9] When asked why they continued in that line of work, 58.8 percent responded that it was for "money–material goods," and 14.5 percent answered that the reason was "money for drugs for self."[10] Lastly, almost one third of the prostitutes indicated they would give up "the life" if they had "adequate employment."[11]

Even teen-age prostitutes apparently do not want to be left out of the economic mainstream. A recent study of teen-age prostitution found that in about half of the cases studied, the final decision to become a prostitute was economically based and related to financial circumstances and the immediate living situation.[12]

Professional shoplifting (boosting) is another offense where empirical evidence suggests that females engage in the crime purely for profit. Certainly robbery, purse snatching, and burglary can hardly be seen as other than economically motivated, although for the most part studies of female perpetrators of such crimes have yet to be undertaken. The so-called "white collar" crimes of fraud, embezzlement, forgery, and, more recently, computer crimes appear to be on the rise among female as they begin to occupy positions in business and industry that provide a potential environment for the commission of such crimes.[13] We do not know whether women have been successfully committing any or all of these property crimes because few female criminals were considered important enough to study. So perhaps the "gold digger" of yesteryear is the "gold taker" of today who has never been caught, and is laughing all of the way to the bank—if she isn't robbing it.

Economic Pressures on Women and Female Criminality

Some researchers feel that since economic pressures on women have increased, women must turn to crime in order to survive and to support their families. Laurel Rans reports that while the number of women in the labor force almost doubled between 1950 and 1974, the median income of full-time female employees was only 57 percent of their male counterparts.[14] And, as Rita Simon describes the situation, "even though women's overall representation in the labor force from 1945 to 1971 has increased by 40 percent, their participation in positions of authority, prestige, and higher monetary reward has not kept pace with that increase."[15] The result of such economic pressures and inequities, then, is female crime. Furthermore, this approach would account for the preponderance of minority female crime, according to Noblit and Burcart, who state: "Coupling this increasing economic marginality of lower class women with Konopka's argument that the working class woman perceives the lack of equality and privilege in comparison to men and responds to it through individual acts of vengeance, it may be possible to explain increases in female criminality and increases in arrest rates."[16]

As Carol Smart reminds us, we have a dual labor market that is worse for working class and minority women who because of their "sexual, racial and class status, are confined to long spells of unemployment as a reserve army of labour that is superfluous in a declining economy."[17] Perhaps it is more realistic to study the working conditions of the working class woman, she suggests, as these are most liable to arrest and police intervention. Since their economic situation more drastically influences their lives, and the racial situation is decidedly influential in the lives of minority women, these should be the groups of empirical concern when addressing the question of a rise in female criminality.

There are several indications that the economic status of women over the past twenty years has deteriorated in this country, a situation that is more critical for minority women, since 80 percent of women who work are in traditional low-salaried jobs and the gap in earnings between men and women has widened.[18] Increased employment of women, especially since World War II, is believed to have undermined the "traditional sex-linked division of labor":

> Increasingly, women are managers of the pocketbook and are handling a larger proportion of the family's financial and market-place activities. In addition, both rising divorce rates and an increased proportion of families headed by women suggest that the opportunities and temptations for the fraudulent activities of passing bad checks and welfare fraud have greatly expanded. Moreover, these traditional offenses are most apt to be committed by lower-class and minority group women, those least likely to be affected by the women's movement.[19]

Sociological Explanations

Hoffman-Bustamante approaches female criminality from a sociological perspective.[20] Although she restricts her comments and observations to the adult female offender and is limited by the use of arrest rates (an imperfect measure of crime), the factors she describes as operating differently for men and women in crime are equally applicable to adolescent female offenders.

The direction of change in female criminal patterns and actual changes in these patterns are the foci of the Hoffman-Bustamante study, which isolates five factors that operate differently between the sexes in criminal activity: (1) different role expectations and socialization patterns; (2) sex differences in the application of social control; (3) differential opportunities to commit particular offenses; (4) sex

differences in terms of access to criminal subcultures and careers; and (5) the classification of offenses by the legal structure in a manner that relates to sex role differences.[21]

Even though recent efforts by some modern parents emphasize unisex socialization of children, for the most part the traditional separation of the sexes through gender socialization is the American mode. Girls are "sugar and spice, and everything nice," while boys are "snakes and snails, and puppy dog tails." Girls cry; boys dare not cry, it isn't manly. A direct result of socialization into male and female gender roles and expectations is that social control tends to operate differently for the sexes in the average American home. Females, for example, are more closely supervised and disciplined than males and thereby less equal than males, witnessed in the fact that males are permitted to violate certain conventional standards for which females would be censured, such as getting drunk or fighting back if challenged.

Our attention is also directed to the differences in sex roles attached to the necessary skills and economic opportunities in crime when Hoffman-Bustamante points out that women are usually unable to acquire the skills available to men to commit certain crimes. In burglary, for example, forced entry, specialized tools, and the commission of the crime at night are requisite for the successful accomplishment of this crime. Females are denied the "training" of breaking and entering, the access to tools of the trade, which are usually obtained through the criminal subculture, and would immediately be suspect if they were out alone late at night. Also, only 14 percent of females involved in robberies are sole performers, which Hoffman-Bustamante indicates is demonstrative of females' function as partners or accessories to husbands or lovers in the perpetration of crimes.

Another offense area where women are deficit in terms of training and skill acquisition is embezzlement, since women are usually found in low-status occupational positions that rarely afford opportunities to carry out such crimes. Thus, according to Hoffman-Bustamante, "women seem to commit crimes in roles auxiliary to men, in keeping with their sex roles and for lesser returns, often making them more vulnerable to arrest."[22]

Finally, Hoffman-Bustamante emphasizes the tendency of laws to discriminate by sex. Prostitution is sex-linked to female offenders the same as forcible rape is primarily associated with male offenders. Such classifications of offenses by law have tended to correspond to sex role differences much the same as the other factors given above.[23]

Certain elements in the social structure have been identified as contributory to the delinquent behavior of some girls. One early work

examined the social conditions and relationships associated with premature sexual promiscuity among delinquent girls and found that the girls were active in an adolescent subculture in which sexual interaction was viewed as a natural part of the dating pattern.[24] It was concluded that sexual delinquency resulted from conflicts in the dominant value system which produced rebellion, conflict, or alienation.

"Expressive alienation," a concept isolated in Stinchcombe's classic study of alienation in high schools, was defined as rebellion, or the flouting of rules by boys and girls.[25] Stinchcombe objects to the notion that girls are socialized to accept authority more easily than boys, arguing that since college is valued by authorities, if girls responded to authority they would be more likely to go to college. The girls in his study who did not have high scholastic or vocational aspirations substituted housewife-type standards for success goals. They did not elect college as a career goal and tended to have negative feelings and attitudes toward the formal school status system. Stinchcombe identified the causal factors of delinquency as social structural, cultural, and psychological.

The findings of these researchers are significant in female delinquency causation because of attention to factors in the social structure and not to weaknesses within individuals. Contemporary theorists emphasize the influence of sex role position and opportunities available in the social structure in their analyses of female deviance, in contrast to previous assumptions that deviance is somehow innate or indicative of pathology in females.

Role and Opportunity Theories

As early as 1923 W. I. Thomas, in *The Unadjusted Girl*, pointed out that the girl's role is indicated by the family. The young girl is protected, possibly overprotected, and this greater attitude of protectiveness toward females in our society leads to closer supervision.[26] On the other hand, because of their social roles girls are able to take advantage of their gender to commit criminal acts with little fear of detection or prosecution.[27] Whether females have been successful in hiding their crimes and escaping prosecution has not been determined, but the narrowing differentiation between male and female cultural roles is felt by some observers to contribute to increasing arrest rates of females.

According to Cloward and Ohlin, a person is most likely to become delinquent when legitimate means of reaching social goals are closed

but illegitimate means are open. A 1964 study of white nondelinquent and delinquent boys and girls who were matched on social class, intelligence, age, and school grades utilized Cloward and Ohlin's theory of differential opportunity systems to determine if the greater rate of male delinquency was due to differences in sex role objectives.[28] Legitimate means for goal attainment were more accessible to females, but unfortunately these goals were defined differently for the sexes and utilized the traditional model. Girls' goals were seen as "maintaining affective relationships" while boys' goals involved attainment of economic power status. As expected, girls were found to have less accessibility to illegitimate means to culturally defined goals than boys.

Along this same line, there is some empirical support for a perceived lack of opportunities among delinquent girls. It is regrettable that the researchers made the same mistake found in the above study since they also used different perspectives of opportunity based upon gender. [29] The authors do concede the possibility of sex bias in their scale, which measured the male definition of opportunity by such focal concerns as the probability of work success, while the female standard was perceived as chances of accomplishing meaningful interpersonal relationships. This type of differentiation makes the female opportunity structure dependent upon male acceptance, which is a sexual stereotype. Nonetheless, some interesting sex differences in perceived opportunity were reported in this test of the opportunity theory of Cloward and Ohlin. Comparisons of delinquent boys and girls with nondelinquent boys and girls revealed that perceived opportunity was significantly lower for delinquents. More importantly, these differences were stronger for females than for males. In rank order the differences between delinquents and nondelinquents by race and sex are indicated in the following scores: white males (4.033), black males (4.788), white females (5.731), and black females (6.085).[30] This suggests "that girls who engage in delinquent conduct must perceive their opportunities as relatively circumscribed compared to other girls. That is, girls may require a greater push into delinquency than boys."[31] Despite a probable sex bias in the measurement of perceived opportunity, it is most important that the perception of limited opportunity was more strongly related to girls' delinquencies than to that of boys. Nonetheless, there is the lingering question of whether measuring male and female delinquents on different criteria really addresses the problem of blocked opportunity related to sexual status.

Cernkovich and Giordano[32] attempted to overcome this dilemma by comparing males and females on identical blocked opportunity crite-

ria, such as access to educational and occupational avenues to success, and administered self-report questionnaires to 1,355 urban, mid-western high school students in their study. More importantly, they examined the perception of "gender-based blocked opportunity" to determine if the females in the study saw a limitation of access to legitimate opportunities as related to the fact they were females.

Cernkovich and Giordano found that perception of blocked opportunity *was* related to delinquency, but that females' delinquent activities were actually unrelated or negatively related to the perception of legitimate opportunity avenues for the attainment of success goals as blocked because of their sex status or because of sex discrimination. Even more enigmatic was the finding that, regardless of sex, blocked opportunities and delinquency were more strongly associated among whites than among nonwhites. This is a peculiar finding in light of the fact that nonwhites in this country historically have been denied equal opportunities in education and occupations. The authors suggest that nonwhite groups might view such racial discrimination as part of life and become resigned to such a status without "frustration, bitterness or pressures toward deviance."[33]

Most writers on the subject of sex role and crime emphasize the relationship between gender and opportunity by linking the subordinate position of females in the social structure to the denial of both legitimate and illegitimate opportunities. As a result of the socialization process the girl is assigned a social role that stresses the need for overprotection and the maintenance of a passive-dependent role. Society frowns upon the girl who deviates from this proscribed role. But changes in the social structure of our society have resulted in a youth culture that has redefined her behavior as acceptable. Further, in certain communities the economic realities of the female status contribute to the commission of offenses contrary to the imposed role expectations.

Freda Adler expresses the view that crime is decidedly linked to opportunity.[34] She sees girls adopting male roles and committing more male-oriented juvenile crimes such as drinking, fighting, stealing, and participating in gangs. She comments that "the departure from the safety of traditional female roles and the testing of uncertain alternative roles coincide with the turmoil of adolescence creating criminogenic risk factors which are bound to create this increase" in total number of female deviances.[35] The principal factors leading to this "imitative male machismo competitiveness" and the concomitant increase in female crime Adler attributes to significant changes in the social structure of Western society, and states:

As urbanization increases, traditional roles decrease; with increased mobility people lose stable, continuous personal relationships; disintegration of family life grows (the divorce rate has trebled in the last 70 years); the importance of goal attainment is emphasized at the expense of the means to attain the goal; and society is continuously fragmented into depersonalized segments.[36]

Adler is saying that the teen-age girl of today faces a dire plight in terms of role in relation to opportunity. She is instilled with almost boundless ambition, yet the available opportunities for the achievement of desired goals are circumscribed. This Catch 22 situation encourages deviance as a means of reaching the goal and the delinquent girl of today often becomes the adult female offender of tomorrow.

The crux of the Adler position is that females imitate males in both the desire for the same goals and the adoption of male roles to achieve them. Other observers suggest that females are changing their sex role and behavior to a more masculine outlook. We shall now turn to those arguments for an in-depth look at empirical research on the topic of changing female roles, particularly the masculinization of females and their alleged subsequent criminality.

In an application of Hirschi's control theory,[37] Thornton and James challenge Adler's argument that the increase in female criminality is attributed to the incorporation of more masculine gender roles.[38] They view gender roles as "sets of normative expectations held by individuals for their own behaviour as masculine or feminine and held by others for an individual's behaviour as masculine or feminine."[39] Their study of over a thousand eighth to twelfth graders demonstrated that delinquency was not related to masculine identification for either boys or girls. They conclude: "For females, the masculine role, whether in terms of self or others' expectations, does not relate to the frequency of delinquency; this evidence refutes the notion as expressed in Adler (1975) that increasing adoption of masculine roles has resulted in increases in female delinquency."[40]

Another study along this line assumed that if women's attitudes and characteristics have indeed changed in this country, women offenders would tend to be more feminist than noncriminal women.[41] By striving for equality with men and assuming male roles, criminal women, as contrasted with noncriminal women, would be opposed to the traditional female role of dependency and submissiveness historically assigned by our society. Twenty-five incarcerated women who had committed the crimes of theft, assault, murder, shoplifting, breaking and entering, and disorderly conduct were compared with a

noncriminal group of college volunteers. The instruments administered to the two female groups were the Attitude Towards Women Scale (ATWS), which measures how women feel about the rights and roles of women in contemporary society; the Open Subordination to Women Scale (OSWS), which concerns the extent of attitudes toward women's inferiority, narrowness, and offensiveness; and the Minnesota Multiphasic Personality Inventory (MMPI) Mf scale, which measures femininity/masculinity according to the traditional view of a woman's role.

Interestingly, on the ATWS and the OSWS the women offender group adopted the traditional view of women as weak, emotional, less capable than men, and belonging in the home. In contrast, the college group was more feminist and felt that women should be more assertive, assume leadership roles, and maintain equality with men on all levels. Reversed responses were found on the MMPI scale, where the college women demonstrated more traditional values such as dependency, passivity, self-pity, submissiveness, and the like; while the female offenders perceived themselves as less feminine and revealed more masculine scores. The researcher concludes "that the female criminals perceived themselves as being less than feminine in nature in a world where they believe women should follow the traditionally feminine role, a view definitely in opposition to the Women's Liberation Movement."[42]

A final exploration of the extent to which criminal women have assumed a masculine sex role identity, masculine value systems, attitudes, and self-perceptions is seen in the work of Cathy Widom, who also used the ATWS in a comparative study of seventy-three women awaiting trial and a comparison group of women matched for socioeconomic level, race, and education.[43] Widom reports no significant differences between the offender and nonoffender groups on the measures used, which indicates a lack of support for assumptions that female offenders have lower self-esteem and/or masculine self-concepts.

The female offenders, who had previous reported convictions for armed robbery, larceny, burglary, alcohol and narcotics violations, prostitution, and "night walking," did reveal significantly less profeminist attitudes on the ATWS than the comparison group, but when educational level was controlled, the difference disappeared. As it turned out, despite the attempt to match the two groups the nonoffenders were more educated than the offenders.

Clearly there has been substantial evidence that the primary contributors to increases in female arrest rates are adolescent female offenders. Also, previous examinations of female arrests controlled

for age have demonstrated that juvenile females are committing more masculine types of offenses. To test whether there are differences in profeminism according to age, Widom divided her subjects into age groups of under twenty-one, twenty-two to twenty-nine years, and thirty to sixty-five years. Support was found for the hypothesis that younger women (those under thirty) tended to be more profeminist than the older women, but only trends in this direction could be noted since the numbers were too small to offer conclusive evidence.

In sum, Widom's study did not find confirmation for the notion that female offenders are more masculine or profeminist. In fact, similar to earlier findings, the ATWS scores of the women awaiting trial showed them to be more traditional in their attitudes toward women and female roles. Widom admits that the question of whether there is a new breed of younger criminal women is unsettled, but also reports that when she examined violent versus nonviolent offenses, the subjects with previous violent offense convictions and a greater number of previous convictions were significantly younger. Widom suggests that the *kinds* of crime committed may be related to sex-typed self-concepts, since the violent female offenders had lower, although not significantly lower, femininity scores.

What appears to be the common denominator the above researchers and theorists are attempting to uncover is that male status, or perceived male status, confers masculinity which, in turn, leads to criminality in females. The major component upon which this viewpoint hinges is that women are considered passive and men are seen as aggressive. Criminal women, however, adopt male characteristics, primarily aggression, thus subordinating their "natural" female inclinations as well as their societally conferred female roles.

Cullen et al. criticize studies of this type for using group level data and then applying their findings to the individual, which they view as indicative of the ecological fallacy.[44] To circumvent this problem they approached the question from the individual level and used self-reported deviance and the perception of possession of masculine traits in college students. Offenses were divided into violent, property, drug, and status offense categories. The self-perceived male traits consisted of aggression, independence, objectivity, dominance, competitiveness, and self-confidence.

Independent of sex, the Cullen et al. results indicate that "male traits significantly and positively predicted delinquency in all but the drug category,"[45] thus lending some support to the masculinity hypothesis. Furthermore, male traits were found to contribute equally to the extent of involvement in all of the defined offense categories. The authors feel that this finding contradicts the notion that it is

primarily violent crimes that are more commonly associated with aggressiveness and other masculine traits. The effects of male characteristics on delinquency were so persistent for males, however, that this study suggests that other unmeasured factors may be associated with gender as well.

Although Carol Smart rejects the biological and psychological theories of female crime and delinquency, she does not feel that role/opportunity perspectives, specifically the lack of access to illegitimate opportunities, are sufficient to explain sex differences in criminal behavior.[46] She describes two basic limitations to such gender role explanations of female criminality. First, "role theorists do not substantially challenge the prevailing belief that sex roles and gender differences are 'natural,' that is biologically determined,"[47] since they ignore the social genesis of sex roles. Before we can utilize such etiological explanations, Smart feels, we must examine the historical development of the inferior status of women. Second, she is critical of the sex role correspondence to female deviance because it does not explain *why* females would commit crimes after having been socialized to conform.

Smart further disapproves of the "role frustration thesis" which states that some women turn to crime to alleviate the frustration of their circumscribed sex role. She is critical of this thesis because it emphasizes the psychological and emotional components of women.

Partial support for Smart's position is seen in the research of Norland and Shover, who examined three different types of data concerned with the aggressive and serious criminal activities of women: arrest rates, types of offenses, and gender-role changes.[48] They were unable to determine a decided pattern of change over the time period they studied, and conclude that any final determination of the interaction between gender roles and criminality cannot be accomplished until certain problems related to the concept of gender role and the "dimensions" of criminality are clarified. For instance, they challenge the extensive number of definitions of the term "sex role," which range from types of activities to sex-specific personality characteristics. Thornton and James also highlighted this problem by noting that most researchers equate sex and gender and do not bother "to measure masculinity and femininity aside from biological sex classifications."[49] They further point out that "operationalisations of gender most often involve lists of personality traits forming semantic differential scales. These scales of gender traits are based on suppositions that masculinity and femininity are bipolar opposites and that the linkages between the two are unidimensional."[50]

Another set of problems is concerned with crime itself as related to alleged changes in gender roles or our ignorance of (1) the most frequently committed types of crime, (2) the total volume of crime, (3) the most typical victims, (4) the modus operandi and/or type of role adopted in committing offenses, and (5) the motives involved in the crime.[51] In other words, no evidence gathered systematically and independently has been presented to support the claim that women who engage in the so-called aggressive offenses are themselves more aggressive persons than those who do not commit those offenses. Norland and Shover feel that the hypothesis that women's increasing involvement in crime is due to their masculinization is accepted as valid more on the grounds of selective emphasis on certain characteristics of persons or acts than on empirical observation.[52] This impression seems to have been reinforced by such studies as those reported above by Leventhal, Widom, and Thornton and James.

At this juncture it should be clear that none of the theories of female crime and delinquency are comprehensive enough to explain the phenomenon of female deviance. Certainly the theoretical contributions to date leave several salient features of crime unaddressed. If criminologists and other social scientists are sincere in their dedication to uncover the etiology of crime, they must isolate those contributory elements that involve criminal *persons*, regardless of gender role or sex role, after clearly differentiating between the two concepts.

A final theoretical controversy concerns the alleged rise in female criminality. Several contemporary writers have suggested causal explanations to support positions asserting an increase in female deviance. Such efforts can be categorized into those perspectives that assign responsibility to the women's liberation movement; those views that attribute females' increasing crime involvement to the economic pressures on women; and those theorists who insist that changes in the criminal justice system are reflected in the purported increases. There is also an impressive number of writers who refute the role of women's liberation and economic pressures on the alleged rise in female criminality.

The Women's Liberation Movement and Female Crime

Among the various possible influences of the women's movement on female crime elevations, two predominate: the increased opportunties for women to participate in the labor force with concomitant increased opportunities to commit certain kinds of crime; and the changing self-

concept and identity of women and girls as a result of the conscious-
ness-raising of the movement.

Freda Adler, in her pioneer book *Sisters in Crime: The Rise of the
Female Criminal*, was one of the first criminology authors to suggest
that as women become more equal to men, their crime patterns will
more closely resemble those of men. She is careful to point out that
since the majority of incarcerated women are from the lower so-
cioeconomic strata of this country, they are not products of, or influ-
enced by, the women's movement of the 1960s and 1970s; but Adler
does speak of a "new liberation movement" which she calls a "new
feminism." This activity is not an organized social movement, but
reflects a consciousness-raising that affects all levels of women. Thus,
Adler predicts that as the social status of women reaches parity with
men, so will the nature and frequency of their offenses.

An excellent summary of the contemporary women's movement is
detailed in Rita Simon's monograph on women and crime.[53] After
describing the social and political implications of the movement, Si-
mon examines the potential influence of demographic and labor force
variables upon female crime. She hypothesizes that "increased par-
ticipation in the labor force provides women with more opportunities
for committing certain types of crime,"[54] and more specifically, those
women employed in the financial world and in white collar positions
will reveal the greatest increments in crime. Simon's minute examina-
tion of employment figures revealed little change in the occupational
patterns of women in the United States, yet she reports that the great-
est increases in female arrest rates from 1967 to 1972 were for white
collar–type offenses: embezzlement and fraud, forgery and counter-
feiting. Simon thus concludes:

> The more parsimonious explanation is that as women increase their
> participation in the labor force their opportunity to commit certain
> types of crimes also increases. This explanation assumes that women
> have no greater store of morality than do men. Their propensities to
> commit crimes do not differ, but, in the past, their opportunities have
> been much more limited. As women's opportunities to commit crimes
> increase, so will their deviant behavior and the types of crimes they
> commit will much more closely resemble those committed by men.[55]

Noblit and Burcart take Simon to task on her arrest trend analysis
and point out that she neglected to examine the data by age catego-
ries, did not use comparable Uniform Crime Report arrest statistics,
did not control for population changes, and utilized proportions of *all*
arrests as the basis for her analysis.[56] While Noblit and Burcart tend

to agree with Simon that the greatest increases in female *serious* arrest rates are seen in property crimes, especially larceny, they find that this pattern is only indicative of women offenders. But more importantly, Noblit and Burcart see a contradiction in Simon's analysis since women's tendency toward property offenses is related to all property offenses and not just larceny.[57] The larceny increases are more dramatic among adolescent than among adult female offenders. Thus, Noblit and Burcart dismiss the women's movement as a causative factor and suggest that the differential trends in female crime concern lower-income racial minority members, since they are those who are arrested, and do not involve the white middle-class women typically involved in the movement. But in rebuttal to the Noblit and Burcart criticisms, Simon again stresses the white collar, financial crime dimension by demonstrating that the largest increases of female participation in such crimes occurred in the latter part of the 1960s, a time frame that coincides with the movement.[58]

Several other authors have challenged the contribution of the women's movement to female criminality. Laura Crites, for instance, finds little statistical support for a relationship between a rise in female crime and the women's liberation movement.[59] In a position similar to the Noblit and Burcart thesis, she emphasizes the involvement of poor and minority females who make up the major female offender population. This group is passed over by the women's movement and its employment rights and opportunities.

Further damaging evidence refuting women's participation in white collar and occupational crimes is put forward by Steffensmeier, who views Simon's notion of increases in embezzlement/fraud, forgery, and larceny due to increased employment opportunities as faulty.[60] Steffensmeier finds that these offenses largely consist of petty crimes that are not white collar crimes at all but include passing bad checks, credit card and welfare fraud, small con games, and the like. Women's arrests for forgery, he adds, are primarily for forging credit cards, checks, and the false identification necessary to commit such forgeries. Furthermore, he describes the typical female embezzler as a "lower echelon employee in a subordinate position," such as cashier, clerk, or teller. According to Steffensmeier, then, these female offenders are really amateurs who commit petty property crimes and do not meet the definition of the true white collar criminal—one in a position of high socioeconomic status who commits crimes in the course of his or her occupation while in a position of trust. Since there has been very little change in female arrest patterns in the past ten years, Steffensmeier feels that the women's movement could hardly have had an impact on either the type or level of female crime.[61]

Whereas Steffensmeier's earlier research was primarily concerned with women's crime, a later study by Steffensmeier and Steffensmeier addresses adolescent female delinquency and tends to confirm the previous conclusion that female crime patterns have remained stable over the past ten years.[62]

Carol Smart examined official arrest statistics for the United States and England and Wales and observes that dramatic rises in female deviance are not new.[63] She criticizes researchers who fail to examine such rates over all periods of time and instead restrict their analyses to one or two decades. Second, Smart is critical of the tendency to fixate on monocausal explanations of female criminality such as the women's movement, when studies of male deviance indicate several possible etiological perspectives. Third, Smart brings to our attention two fallacies in the women's emancipation argument: (1) that female criminality is changing differently than male criminality; and (2) that an increase in legitimate opportunities necessarily results in increased illegitimate opportunities for women. Therefore, she concludes, we cannot really determine what impact the women's liberation movement may have on female behavior, much less on their delinquent or criminal behavior.

Changing gender roles is another aspect of the movement that is seen as related to rising female criminality. The issue here concerns how new images of themselves contribute to women's involvement in deviant activities. Through ideas espoused by the women's movement, women's consciousness is raised, making them feel capable of carrying out crimes. This alteration of women's attitudes centers on a masculinity-femininity perspective: crime is viewed as masculine, therefore women who are criminal, especially those who commit certain types of crimes exclusive to the male gender, are exhibiting masculine traits. Through the women's liberation movement women will become emancipated and will see their status as equal to men's; therefore they will engage in criminal activities that historically have been a man's domain.

Most of the discussion concerning this possibility is focused upon female violent crime, with the presumption that women are becoming more aggressive in their criminal activities. However, we are again confronted with disparities in the interpretations of official statistics. Laurel Rans, for instance, reports that arrests of women for violent crimes have remained constant since 1960,[64] a position also supported by Simon.[65] In fact, Simon feels that crimes of violence among women should decrease, because the types of emotion that stimulate violence—frustration and powerlessness—would diminish as women are emancipated.[66] Since women, as a result of the movement, will feel

less victimized, dependent, and oppressed, their sense of powerlessness would abate and they would not strike out in violent retaliation.

While Adler states that "we should not assume, however, that women who are committing what used to be 'masculine' crimes are necessarily either members or supporters of the women's movement,"[67] she nonetheless suggests an association between the women's liberation movement and "a wide variety of other aggressive, violence-oriented crimes which previously involved only men."[68]

In contrast to both Simon and Adler, Steffensmeier finds that females have not gained on males in either masculine or violent offenses, or even shifted in such directions.[69] According to Steffensmeier, masculine crimes, which involve masculine techniques and skills, include violent offenses such as homicide, aggravated assault, other assaults, weapons violations, and robbery as well as the masculine crimes of burglary, auto theft, vandalism, and arson. There are no substantial increases among women perpetrators of such crimes, he adds.

The Norland and Shover study of female crime supports this position by finding that "no evidence gathered systematically and independently of criminal behavior has been presented to support the claim that women who engage in the so-called aggressive offenses are themselves more aggressive persons than those who do not commit those offenses."[70] These authors also feel that while the use of the term "gender role" varies, "little theoretical specification of how gender role variation is related to the different parameters of criminality has been attempted."[71]

In sum, it appears that the current literature dealing with the effects of women's liberation on female crime has not empirically established a correlation between the two in terms of a rise in female crime. Much more study, not only of these two phenomena but of gender roles as well, is necessary to document such an association.

The Effects of Changes in Criminal Justice

The final perspective that attempts to explain an apparent increase in female deviance focuses on various changes in the criminal justice system. It suggests that more women are not necessarily being arrested because of a rise in female criminality, but that there is a widening of the law enforcement net since the system itself has improved or expanded. The pertinent question is whether women are actually committing more offenses or whether they are merely being apprehended, charged, and convicted more frequently.

Rita Simon adopts the latter view and suggests that the treatment women offenders receive in the criminal justice system may be a result of the women's liberation movement. The police, prosecutors, and other (presumably male) personnel in the system may be responding to the cry for equality by treating women offenders equal to male miscreants.[72] She is careful to add that even though police may be becoming less chivalrous, this alone cannot explain the large increases in certain female offenses or account for the lack of a rise in female violent crimes.[73]

There is also the possibility that police officers are becoming more diligent in arresting females. In many jurisdictions police are "frisking" women, a practice previously avoided by male officers, and these searches may lead to the discovery of contraband or weapons and consequently to more arrests. Others suggest that recent evidence indicating more women employed in the criminal justice system may underlie the alleged increases in female arrests.[74] It is more difficult for some females to con their way out of an arrest when they are dealing with a peer.

Thus, there may be a number of variables interacting to reflect an apparent increase in female crime. In addition to those previously mentioned, certain types of crime have historically been under-reported, and early arrest statistics did not accurately record female arrests separately from male arrests,[75] therefore, increased reporting may be giving the impression of increased female crime. Furthermore, police technology has improved considerably in the past decade and may contribute much to the detection and apprehension of female offenders.

These multiple possible reasons tend to cast doubt on the reality of a rise in female criminality. On the basis of his research on adult female crime patterns, Steffensmeier accurately sums up the problem by stating:

> It is proposed that the factors shaping sex differences in arrest patterns are changes in reporting procedures and law enforcement practices, economic factors, the maintenance of traditional conceptions of female roles, limited access to illegitimate opportunities due to restricted participation in the legitimate labor market, and the absence of viable female criminal subcultures or of access to male criminal subcultures.[76]

section three
female offenders and the law

6

THE ORIGIN AND DEVELOPMENT OF DIFFERENT LAWS FOR FEMALES

The manner in which the present system of differential sex-based laws developed can be seen in an examination of the emergence of juvenile law over the past several centuries. Although the subordinate position of women in our society has contributed significantly to the legal discrimination against adult female offenders, juvenile sex differentiation throughout the history of law has also impacted on the statutes affecting women.

The Historical Development of Juvenile Law

Under Roman Law minor offenders were given special consideration as to the extent of their legal responsibility. There is little evidence of differential legal treatment of delinquent minors prior to Roman times; the advent of the Roman era is seen as the "greatest influence in shaping Anglo-American rules of minority responsibility."[1]

For many centuries before the Twelve Tables (ca. 488–451 B.C.), which provided specific consideration of youthful offenders, the age of seven was considered the end of infancy; before this age a child, because of lack of understanding, was assumed incapable of committing any crime. This rule later became part of canon law and eventually a part of common law, and today defines the age of immunity in most Anglo-American jurisdictions.

Among early English jurists physical development determined puberty and the fixing of responsibility, which was age fourteen for boys and age twelve for girls. This physical age differentiation, based upon the development of physical characteristics, determined the time at which discretion was presumed to be attained and has persisted to the present day.

Criminal responsibility before puberty depended upon chronological age, the nature of the offense, and the offender's mental capacity, with more responsibility assigned the closer the child was to puberty. Criminal liability beyond infancy still remained, and the early common law judges based discretion upon apparent maturity, the severity of the crime, the ability to understand the difference between right and wrong, and the behavior or demeanor of the offender. There were no birth registrations at that time, so it was difficult to prove age. During adolescence growth spurts in development occur, and since this happens about two years earlier in females than males—with girls reaching their peak rate of growth between ages twelve and thirteen[2]—the potential for differential legal treatment based upon physical appearance is obvious.

The "Statutes of Artificers," passed by Parliament in 1562, authorized the involuntary separation of children from their pauper parents for apprenticeship to others. Similarly, the Poor Law Act of 1601 provided for binding out children of the poor until the age of maturity, a practice later adopted in the Poor Laws of colonial North America. The legal rationale for such action was found in the Latin phrase *parens patriae*.

Originally *parens patriae* was used to maintain feudalism and was related to property and feudal duties. To ensure the performance of these duties from one generation to another became part of the Crown's power. In feudal times the English Chancery Court had protective jurisdiction over all children in the realm, especially those whose property rights were jeopardized. Since many children were orphans, some of whom came from families of material substance, their rights to property were protected on behalf of the king, or *pater patriae*, "father of his country."

The chancellor was the head of the English judicial system, and equity was dispensed by the Council of Chancery. Thus the terms "equity" and "chancery" became interchangeable. Orginally equity was used largely for the protection of dependent or neglected children with property interests, not those accused of criminal violations. In fact, English common law provided that a child could only be punished if he or she violated a statute which specifically included children in its provisions, a procedure some would consider much more sensible than modern-day juvenile statutes.

Generally, common law presumed a child under the age of seven was incapable of criminal intent and therefore could not be held legally responsible for committing a crime. This presumption also prevailed between ages seven and fourteen unless the child understood the consequence of his or her actions. After age fourteen children

were presumed to be responsible for their actions. The possibility of innocence was rejected in cases where children were accused of crimes. They were considered guilty as charged under common law. The jury only had to determine whether a child could understand his or her offense.

English jurisprudence was introduced in America by the early colonists; however, the Latin phrase *in loco parentis* was used to express the state power of control over a child in its custody, rather than the term *parens patriae*, which reflected an interest in the child over and above the interest of a parent.

Ironically, *parens patriae* was first used in the United States by the Pennsylvania Supreme Court in the case of a juvenile female (ex parte Crouse, 1838) to justify statutory commitment to an institution for juveniles. Mary Ann Crouse was committed to a House of Refuge as unmanageable by petition of her mother. Her father tried to get her released with the argument that commitment without trial by jury was unconstitutional. However, the court, in a three-sentence opinion, held that since the purpose of the institution was protection and improvement, no jury trial was necessary. The Crouse case was later used to justify state statutes "to part poor or incompetent parents from their children."[3] Further, the *parens patriae* argument provided a rationale for criminal courts to dispose of dependent and delinquent children through the conferring of parental powers upon institutions, which then apprenticed delinquents throughout their minor years without informing their natural parents.

Today the statutes describing delinquency are generally weak, are based on subjective definitions, lack common meaning from one jurisdiction to another, and are not derived from any fixed criteria.[4] These discrepancies are particularly notable in status offense cases, or those acts not considered a crime for adults—running away from home, "incorrigibility," curfew violation, truancy—yet these are the types of behavior for which most girls are arrested. Furthermore, the constitutionality of such concepts as "incorrigible," "ungovernable," "promiscuous," or "unmanageable" has never been challenged before the U.S. Supreme Court.

In most states the Roman law and the common law of absolute irresponsibility below seven years of age has been adopted by statute or decision, while the upper age limit at which a youth is considered incapable of committing a crime has been fourteen. Recent trends in statutory revision in some states indicate a raising of the age at which a child is considered legally responsible for its actions from seven to ten or twelve, a raising of the age of culpability, and waiving or transferring delinquent youths to adult criminal justice systems for trial. Usu-

ally the seriousness of the crime is the determining factor. While these new punitive measures are believed to indicate a public response to the upsurge in juvenile delinquency, discriminatory legal practices toward females have existed about as long as the common law upon which they are based.

The "Double Standard" of the Law[5]

(Juvenile and criminal justice systems discriminate against adolescent and adult female offenders through vague and broad statutes and a tendency for a predominantly male system to "protect," "treat," or "rehabilitate" females in American society, thus reinforcing a double standard of justice. By far, most legal sex discrimination affects the youthful female offender. Juvenile court laws that differentiate between boys and girls fall into two categories: the statutes themselves that specify what is or is not against the law and those statutes that provide for the special treatment of females.[6]

(Women generally experience prejudicial treatment under the law through sex-specific statutes and their enforcement, such as prostitution and solicitation, but statutes also exist that discriminate in the sentencing of women) particularly indeterminant sentencing. Legal disparities that impact exclusively upon women—voting rights, infringements upon the ability to enter into contracts, marriages, name changes, and other legal inequities based upon gender[7]—are detailed in the excellent work of Karen DeCrow, *Sexist Justice*.[8]

Juvenile Statutes

Until very recently many states had juvenile laws on the books that contained higher age limits for girls, that is, the age of majority, or the age at which a youngster remains under the jurisdiction of the juvenile court. This meant that a girl who was incarcerated for the same offense as a boy would usually have to remain in the penal institution for a longer period of time. It was conceivable that a twelve-year-old female could, in some states, be held in a correctional facility until she was twenty-one, whereas a boy of the same age could be released by age seventeen, eighteen, or even earlier. Ostensibly the rationale of this dual standard was "protection" of the juvenile female, since girls are presumed to be more in need of protection than their male counterparts.[9]

This cultural bias, reflected in the statutes, is indicative of a double standard of morality whereby girls are not permitted the independence and freedom allotted to boys. Although most of these statutes have been revised, a number of states have yet to repeal these discriminatory sex distinctions in their juvenile codes.[10] Since the wheels of progress rotate dilatorily, often a change in the letter of the law does not immediately result in concomitant adjustments in the application of the law, particularly when the philosophy of the court is rooted in concepts of "protection," "rehabilitation," and "treatment." The law in the books is in contrast to the law in action when one examines the current legal treatment of girls.[11] The law in the books is that body of law including the American Constitution, the common law, and the statutes that speak to equal, fair, and just treatment for all, or the ideal. However, the reality of a situation, or the law as it is applied, law in action, can be unfair and unjust. This discrepancy between the ideal and the real is witnessed in differential treatment in female juvenile cases at both the juvenile court and corrections levels.

For the most part the offensive behavior of girls is some type of sex related offense that presumes sexual activity, such as "incorrigibility," "ungovernability," running away from home, curfew violation, truancy, or promiscuity, and calls for "special" treatment of adolescent female offenders for their own protection. None of these status offenses are applicable to adults, and few are applied or stringently enforced when boys are the offenders. The vagueness of these juvenile moral statutes has resulted in the differential treatment of girl offenders. Because of the differentiation of sex roles, girls are punished more than boys for the commission of acts which by statute are vague and broad.[12]

How does one define "lewd," "dissolute," or "incorrigible" behavior—or even "promiscuity"? One contemporary way is to combine many of these status offense categories into the term "beyond control," which describes the juvenile whose behavior is displeasing, baffling, defiant, or threatening but whose conduct is largely seen as synonymous with sexual precocity.[13] The subjectivity involved in juridicial decision-making based on the breadth and vagueness of statutes concerning such offenses clearly contributes to legal discrimination against girls, since approximately 55 to 75 percent of the girls in jails and correctional institutions are held for such offenses.[14]

For Her "Sins" She Shall be Labeled "CINS"

The Uniform Juvenile Court Act, first published in 1925, hoped to provide needed uniformity in the various state juvenile laws and meet

the constitutional requirements guaranteeing a juvenile's legal and constitutional rights. Under this act a "delinquent child" is one who commits a crime under local, state, or federal law; while an "unruly child" is defined as a habitual truant, ungovernable, or one who has committed an offense applicable to a child and is in need of treatment or rehabilitation. In today's parlance the "unruly child" is a status offender.

According to fact sheets compiled by the National Council on Crime and Delinquency, in 1975 thirty-two states and the District of Columbia separated status offenses from nondelinquency categories, several states classified such offenders as delinquents, and a few states labeled status offenders in some cases as delinquents and in other cases separated them into a distinct status offender category.[15] The current nomenclature includes some form of "in need of supervision"; for example, in Illinois it is MINS (minors in need of supervision); in Florida the term is CINS (children in need of supervision); and there are PINS (persons . . .), CHINS (children . . .), YINS (youths . . .), JINS (juveniles . . .)—new labels for the same old offenses. Since California's first effort in 1961 more than forty states have adopted these designations for runaways, truants, and "incorrigibles," and status offender statutes have been written to correspond to such children's misbehavior.

Opponents of status offender statutes argue that such laws are generally vague, are inequitably enforced, and undoubtedly are unconstitutional. Stiller and Elder's exploration of the attorney's role in PINS cases introduces a number of salient points particularly relevant to runaways.[16] First, due process rights are equally applicable in PINS cases, since these children are confronted with sanctions and restrictions by the judicial system. Second, both delinquents and PINS obtain the stigma of delinquency through involvement in the juvenile justice system, and in fact the label PINS carries its own stigma.[17] Third, Stiller and Elder challenge PINS statutes as "void for vagueness," since the behavior is nonspecific and undefined in juvenile codes. Finally, they raise the constitutional question of "overbreadth" on the basis that PINS statutes do not specify the nature of the conduct for which the children are sanctioned—a violation of the First Amendment. In sum, Stiller and Elder find "the fact that PINS proceedings are denominated noncriminal does not weaken the due process claims that can be asserted."[18]

The Juvenile Justice and Delinquency Prevention Act of 1974 (JJDPA) contributed significantly to the acceleration of fairer treatment to status offenders. This law mandated the deinstitutionalization of status offenders by stating that "juveniles who are charged with

or who have committed offenses that would not be criminal if commit-
ted by an adult, shall not be placed in juvenile detention or correc-
tional facilities, but must be placed in shelter facilities."[19] Title II of
the act, entitled the "Runaway Youth Act," decriminalized running
away from home.[20]

To recapitulate, while a few states still classify status offenders un-
der the same statutes as delinquent offenders, the majority of the
states have modified their juvenile codes to separate the two catego-
ries of offenses. For the most part status offenders are identified
either under a form of status offense label (e.g., MINS, CINS) or such
offenders are known as "dependent children" or "neglected chil-
dren." In the first instance, unfortunately, "the creation of a separate
legal classification for juvenile status offenders such as 'children in
need of supervision' (CHINS, CINS), 'persons in need of supervision'
(PINS), etc. has failed to accomplish the major goal of its advocate—to
separate status offenders from juveniles accused of criminal law vio-
lations."[21]

Florida's legislative handling of the status offender definition pro-
vides a unique history of progressive change and demonstrates the
second status offender labeling process. After the U.S. Supreme
Court *Gault* decision in 1967,[22] Florida listed ungovernable children,
truants, and runaways under the caption CINS, a subgroup that ex-
isted until 1975, when legislative action eliminated CINS as a legal
category and redefined truants and runaways as "dependent" chil-
dren. The "ungovernable" child could be treated as either dependent
or delinquent, contingent upon the number of "ungovernable" ad-
judications, until a 1978 revision of the Juvenile Code (F.S. 39) deleted
the delinquency status and included "ungovernables" exclusively un-
der dependency with the runaways and truants. Today all dependent
children are processed by the child welfare system in Florida. Despite
official decriminalization and deinstitutionalization, these youths are
still under the jurisdiction of the Florida juvenile court system, and
upon violation of a court order may be adjudicated as delinquent.[23]

Criminal Statutes Affecting Women Offenders

Whereas "promiscuity" seems to be the catch-all offense for the
adolescent female offender, prostitution is the primary discriminatory
legal offense applied against the adult female. Despite its status as a
"victimless" crime, approximately one third of the women in jails and
prisons are incarcerated for this offense,[24] and in large urban areas

convicted prostitutes in jail comprise in excess of 50 percent of the female inmate population.[25]

Compared to the emphasis on the protection of the juvenile female offender, in the case of prostitution the object of protection in American society appears to be the sanctity of marriage and the family. Thus, expanding attempts at suppression of prostitution are reflected in the vaguely defined and inequitable laws of this country.[26] Ironically, under English common law, upon which our law is based, prostitution was not viewed as a crime. Yet "it is in the Common Law that the caste distinctions between the sexes can most clearly be seen. Their roles are defined as separate and reciprocal."[27]

Two legal practices illustrate how the promiscuity offenses of adolescent females and the prostitution charges against both juvenile and adult females are sex discriminative. First, such sexual misconduct is legally restricted to females, although the incidence of male prostitution is increasing and we are beginning to see statutory revisions to accommodate this developing social problem. And second, the male recipient of the sexual activity, the customer, is rarely sanctioned.[28] A new trend toward neutralizing this inequity is seen in "statutes against solicitation to procure another to commit prostitution," a misdemeanor of the same degree as prostitution, which are currently being utilized in Florida by undercover policewomen in "prostitution decoy" units to make cases against customers, or "johns."[29] Although not common, there are a few statutes that also penalize the male customer; these are infrequently enforced and are used primarily to induce the man to assist in prosecuting the prostitute by his testimony against her.[30]

Additional unequal treatment of women offenders is seen in the judicial sentencing procedures which result in indeterminant sentencing of women because of sex-differentiating statutes. As a result of such practices women end up serving longer periods of incarceration than men. Prior to 1869 women were tried under the same statutes as men, but with the institution of separate prison facilities by sex the use of the indeterminate sentence was initiated for women.[31] Such differential treatment is based upon the erroneous assumption that females can be rehabilitated more readily than males. This philosophy persists despite the fact that female offenders have not been demonstrated to be more model prisoners and thus earn earlier releases than men. In those states utilizing indeterminate sentences for women the women tend to serve longer sentences than the men.[32]

In the past decade three major cases in Connecticut, Pennsylvania, and New Jersey have challenged laws that provide unequal sentences

for women. The argument was that such statutes are in violation of the Fourteenth Amendment guarantee of equal protection.

Carrie Robinson, the defendant in *Robinson* v. *York* (1968),[33] was found guilty of breaching the peace and resisting arrest, and the state of Connecticut argued for longer terms for women who commit misdemeanors in order to provide reformative treatment and rehablitation.[34] The Federal District Court, however, struck down the statute as "violative of the equal protection statute allowing women to be sentenced for longer terms than it or any other statute permits for men found guilty of committing identical offenses."[35]

Jane Daniel robbed a tavern and was tried without a jury for burglary, aggravated robbery, carrying a concealed weapon, and possession of a firearm after conviction of a violent crime. The judge found Daniel guilty and sentenced her to one to four years in prison. However, thirty-one days later the judge vacated this sentence and resentenced her to an indefinite term at the State Industrial Home for Women in Muncy, Pennsylvania. Since no minimum or maximum term of imprisonment was fixed, it was possible that Daniel would serve ten years, or the maximum for robbery. This judicial decision was based on the 1913 Muncy Act of Pennsylvania, which provides for sentencing to the Muncy institution of any female over sixteen years of age found guilty of an offense punishable by more than one year— ostensibly for purposes of rehabilitation.[36] A male offender who committed the identical offense would, according to Pennsylvania statute, receive a set minimum sentence; and depending upon the discretion of the judge, he might receive a shorter maximum sentence than that prescribed by statute.[37]

In *Commonwealth* v. *Daniel* (1968),[38] Daniel appealed by challenging the constitutionality of the Muncy Act, but the Pennsylvania Supreme Court upheld the lower court and thus supported the ideology of effective rehabilitation of women. The Daniel case was then consolidated for appeal with *Commonwealth* v. *Douglas* (1969).[39] Daisy Douglas and Richard Johnson were jointly tried and convicted of an aggravated robbery which they committed together. Johnson received four to ten years, but Douglas was penalized the maximum of twenty years. The sex discrimination in this case was obvious, especially since Johnson had a previous serious record, and the Pennsylvania Supreme Court reversed the lower court decisions in both *Daniel* and *Douglas*.[40]

Shortly after the Pennsylvania Supreme Court struck down the sentencing provisions of the Muncy Act, the Pennsylvania legislature amended the act; the amendment still did not fix minimum sentences for women but did allow for maximum sentences that could not ex-

ceed those for men for the same offense.[41] So women still were not provided equal treatment under this partially indeterminate sentencing statute and subsequent challenges to the amendment have not met with success.[42]

A final illustraton of disparate sentencing of women for the identical offenses committed by men is seen in *State* v. *Chambers* (1973).[43] The New Jersey statute in question provided for the "indeterminate custodial sentencing of females over age thirty to the state correctional institution. Release from custody is predicated upon rehabilitation and is solely at the discretion of the correctional institution's board of managers."[44] Men in New Jersey over age thirty were given minimum-maximum sentences and additionally were able to earn work credits and time off for good behavior—benefits denied to women. Thus, a female offender could be held for as long as five years, while a man convicted of the same offense could be paroled as early as four months and twenty-eight days.[45]

Chambers involved a consolidation of six cases of women found guilty of gambling charges. The state's position was founded in the notion that rehabilitation was more effective for women. However, it could not establish that it took longer to rehabilitate a female offender than a male offender, and thus the New Jersey Supreme Court found the statute unconstitutional.[46]

It must be remembered that these are only three cases involving statutes in only three states in this country. The U.S. Supreme Court has yet to invalidate sex discriminatory statutes in adult female criminal cases, or in female juvenile delinquency or status offense cases. Between 1971 and 1976 the Supreme Court had decided less than a dozen sex discriminating cases, none of which involved a female offender, and even in those cases it seemed clearly indicated that the majority of the court will not apply "strict scrutiny" to sex discrimination cases. When such a test is applied to statutes considered suspect—such as those based upon race or national origin—the law under scrutiny must be demonstrated to serve a "compelling state interest" or one that could not be accomplished by more accurate legislation.[47]

Many contemporary scholars[48] point out that the "suspect classification" standard is applicable to females, since classifications based upon sex are, according to Supreme Court Justices Marshall, Brennan, Douglas, and White, "inherently suspect and must therefore be subjected to strict judicial scrutiny."[49] Unfortunately, the court has refused to stipulate sex as suspect.

There are numerous statutes that discriminate against females and either directly or indirectly affect their judicial fate. For example, a

Maine statute in existence in 1972 permitted indeterminate sentences for both men and women until age twenty-six, but women under the age of forty "are alone subjected to what frequently means a longer actual sentence";[50] some states excuse women for jury service on grounds unavailable to men, thus denying some women offenders the right to be tried by their peers;[51] a Kentucky law permits the husband but not the wife "to engage in an occasional act of adultery";[52] the universal "unwritten law defense" for married men is not applicable to married women who might possibly catch their spouses committing adultery;[53] some states deny women the right to serve on parole boards that decide on women's releases from prisons.[54] This list is far from complete; the many states and jurisdictions have multiple statutes, laws, and codes that undoubtedly are equally sex discriminating but have never been uncovered and reported by researchers.

One wonders why this legal state of affairs so clearly allows females to exist as a discriminated class, particularly in the light of their equal number as members of the population. It is suggested that the answer lies in the fact that the predominantly male Supreme Court reflects the typical "chivalrous" or "paternalistic" attitudes of their judicial peers in the lower courts. Or it may be because "the varying treatment of the sexes by sentencing judges and statutes may be an expression of the American view of the female in society. Generally, legislatures have enacted statutes providing her with 'needed' protection, while sentencing judges have viewed her as having powers of rehabilitation far beyond the average male offender."[55]

We cannot assume that judges are alone in their personal predilections and must therefore conclude that paternalism toward adult and juvenile female offenders is expressed on every level of the system by those American males who feel that females should be "protected" despite the fact that such "protection" is most frequently to their detriment. There are some who feel that the differential treatment of female offenders can be traced to legalized sexism in a judicial and legal system that, for the most part, is influenced and administered by men.[56] The discriminatory process thus commences with male legislators who create the laws, and continues with male law enforcement personnel who promulgate the laws through their extensive discretionary powers; male lawyers who prosecute the female offenders; male attorneys who represent them; male probation officers and other similar court-attached personnel who also have wide discretion and extensively influence judicial decisions; male judges who apply their moral interpretations to the deliberations of female cases; and finally, male corrections officers and parole board members who tend to keep females in cages.

THE DIFFERENTIAL APPLICATION OF THE LAW

Most descriptions of cases demonstrating the idiosyncratic application of the law by law enforcement agents because of one's sex status largely focus on juvenile cases. As indicated earlier, the status offenses of girls are presumed to represent some form of sexual misconduct that contradicts the mores of the community and challenges the moral fiber of our society. The justification for selective application of the law rests in the protective attitude adopted by the police, especially male officers, in what is generally called the "chivalry factor."

There has been a tendency for police to arrest women offenders but to be more lenient toward adolescent female offenders. Some writers believe this chivalrous attitude toward girls is being replaced by a hardening police attitude with an accompanying proclivity to arrest. Both the chivalry factor and the hardening attitudes not only affect police discretion but are also influential in decision-making in other points of the system, where in some instances the treatment is more punitive than that afforded male offenders.

As indicated in Chapter 5, the alleged rise in female criminality may not be due to an increase in female crime, but instead may reflect an increment in female arrests associated with the expansion of female police personnel. The second part of this chapter will explore that possibility by examining the history of the policewoman and her status today.

Police Discretion and the Female Offender

Juveniles

The available, somewhat scanty literature on the application of the law by law enforcement personnel in the treatment and processing of

female offenders is divided. Some authors believe that police officers are more stringent toward females, while others view the police role as lenient. A closer examination of the issue indicates that *age* may be the deciding factor. While women offenders are treated substantially the same as men offenders, differential treatment is afforded girls compared to their male peers when they come in contact with the police. Two major police discretionary decisions are involved: the determination to arrest and the judgment to refer the youth to court.

Screening is the first step in the process that could involve discriminatory sex practices culminating in juvenile court sanctions. The patrol officer's decision to arrest initiates the screening process, which includes several alternatives: warn the youth, notify the child's parents, dismiss the case, refer the juvenile to a diversion program, release the youth but maintain a contact card file in case of future arrests, or file a formal charge, then arrest.[1]

Available studies indicate that officers have tended to release delinquent girls who commit criminal acts and arrest girls suspected of status offenses such as running away from home, being ungovernable, or those accused of sex offenses. In 1952, for example, over four thousand juvenile complaints examined in Detroit police department files found that while boys were largely arrested for burglary, assault, and malicious mischief, the offenses for which girls were more likely to be apprehended were incorrigibility, sexual delinquency, and truancy.[2] A Philadelphia study revealed that police were more apt to arrest a girl who committed a sexual offense than a delinquent one.[3] And research in Honolulu reported: "The overemphasis of girls charged with status offenses has been explained, in part, by the routine police practice of ignoring (or releasing without arrest) girls accused of criminal activity and arresting those suspected of juvenile offenses."[4]

These decisions by police officers and other law enforcement personnel, such as youth officers, are indicative of their extensive personal discretion without any referents to a set of formal standards: "Police judgement of the seriousness of an offense rests on their own and their community's distinctions between adolescent troubles and serious deviation. Since the twenties, police officers appear increasingly tolerant of profanity and smoking among young men and women. However, they remain intolerant of female freedom and flaunting of adult authority."[5] The roots of this narrow-mindedness lie in the belief that once a young woman goes astray—that is, indulges in free, open sex—she is "irrevocably damaged" unless she is redirected to the traditional stereotype of a "passive, polite, attractive, but reasonably chaste object."[6] Furthermore, "oversexuality" is believed to lead invariably to illegitimate children, which is decidedly a

threat to American moral standards and the institution of the family itself.

The other crucial juncture in the decision-making process of police officers concerns the discretion to refer a youth to court after arrest instead of, for example, counseling and release or diversion. Again we find the application of the law more harshly applied to adolescent females. Gibbons and Griswold examined over eighteen thousand serious complaints brought to the attention of police in the state of Washington between 1953 and 1955.[7] Although juvenile court referrals came from other sources, 88.6 percent were from law enforcement officers. Boys were more likely to be referred to court by police officers (91.5 percent) than girls (78.6 percent), but the nature of these "serious" offenses was found to be substantially different between the sexes. While males were court-referred by police mainly for theft and mischief (64.3 percent), females were predominantly sent to court for running away and ungovernability (46.1 percent). Additionally, girls were referred to juvenile court twice as frequently for sex offenses (9.8 percent) as boys (4.7 percent). Of the girls who went to court as a result of police discretion, most came from the nonwhite group, which indicated that not only sex but also race contributed to the biased application of law in these cases.

Two decades after the Gibbons and Griswold findings Meda Chesney-Lind's study of juvenile court referrals in Honolulu revealed substantially the same "harsh police response to the noncriminal activity of young girls."[8] She reports:

> In 1972, girls charged with noncriminal offenses were far more likely than girls charged with crimes to be referred to juvenile court. Only 6.1 percent of the girls arrested for the most serious adult offenses and 12.7 percent of the girls arrested for less serious adult offenses were referred to court, compared with 33.7 percent of those arrested for juvenile offenses. The police were also a good deal more likely to refer a girl than a boy arrested for a juvenile offense to court (33.6 percent and 22.7 percent respectively).[9]

In sum, 70 percent of the girls and 31 percent of the boys were status offenders referred to the juvenile court by the police in Honolulu during the time period studied.[10]

This proclivity for police officers to arrest and refer girls to court disproportionately for minor offenses appears to be asssociated with the paternalistic and chivalrous attitudes of the police, who apparently feel not only that the adolescent female is in need of protection, but that their law enforcement actions are providing such protection.

They are protecting the girl from herself and simultaneously protecting society from the girl. Women, on the other hand, are presumed to know better, and in accordance with this belief are treated similar to men by the police, although there has been a hardening of their approach to women offenders and some police practices are applied only to women.

Women

Policemen have tended to be paternalistic toward adult female offenders because of deeply situated traditional views they hold that women are passive, dependent persons. Thus, policemen tend to be less suspicious, less cautious, and more open with women, which makes it less likely they will arrest women.[11] Many observers feel that the more lenient attitudes of the past are changing; for instance, Rita Simon sums up her many conversations with police on this subject with the paraphrase, "If it's equality these women want, we'll see that they get it"[12]—a direct reference to the women's movement's insistence upon equal status for women.

In Chapter 5, we noted that female offenders processed by the criminal justice system were not likely to be involved in the women's liberation movement and, furthermore, did not embrace its tenets. It is possible, however, that they may be experiencing negative fallout from the movement, seen in police officers' hardening attitudes toward them as offenders, in an increasing tendency to arrest them and then treat them the same as men.[13] Freda Adler, for example, quotes from a discussion with a New York police lieutenant who said, "Like I remember a few years ago, when you would have hesitated to ever put handcuffs on a woman. Not today. . .you *have* to put cuffs on them now. They'll get you just like any man will, if you don't. They've proved that to me."[14] Unfortunately, to date no studies of police attitudes toward female offender arrests have been reported from either the police officer's or the offender's view to document differential treatment toward women offenders, but multiple incidents of specific mistreatment of female offenders have been seen in media reports on harassment arrests and the strip-searching of women.

The harassment arrest is commonly found in the enforcement of prostitution laws. While the methods of harassment may vary by jurisdiction, the pattern of law enforcement is basically the same everywhere.[15] Since the purpose is to deter prostitution, there is no intention to prosecute the offender. No investigation is undertaken to gather evidence, because there is no need to authenticate or justify

the arrest, and the woman is released by the police department after a medical examination. An example of this inequity is seen in a study of harassment arrests made in Detroit, wherein over a six-month period 3,047 arrests were made but only 75 were prosecuted.[16] Also, similar to the more severe discrimination toward nonwhite, adolescent female offenders, police are believed to display biased attitudes toward nonwhite women offenders.[17]

One recent attempt to meet the need for empirical research on the treatment of women by police officers created several hypothetical scenarios to determine law enforcement reactions to women; in addition to sex, they included the independent variables of race, demeanor, and type of offense.[18] The situations involved five types of offenses—traffic, shoplifting, marijuana possession, public drunkenness, and assault. Demeanor was determined in the hypothetical situations as either cooperative or hostile. An example of hostile demeanor of black women is seen in the following episode involving drunkenness:

> During routine patrol duty, an officer observed two black women arguing loudly in the Northern Shopping Center parking lot. As the officer approached, he realized that two women were arguing over a bottle of whiskey. When the officer attempted to question the two women, they became hostile and told the officer to mind his own business. Then the women began to curse the officer for not being out catching the real criminals.[19]

Four hypotheses were explored: (1) "police officers are inclined to react less harshly to women than to men for most offenses"; (2) "the variation in police dispositions across type of offense will be greater for women than for men" (this hypothesis was concerned with chivalrous attitudes toward women and stereotypes of feminine behavior); (3) "women whose demeanor involves traditionally masculine behavior (loud, boisterous, aggressive, vulgar, and disrespectful) are more likely to provoke a severe reaction from police than men with similar demeanor, regardless of the offense"; (4) black women are more likely to receive severe reactions from police than white women."[20]

Although none of the hypotheses were supported, type of crime had the most influence on reactions of the 282 police officers, who were from a large metropolitan area in a southeastern state. The most severe police response was to shoplifting, and in descending order, possession of marijuana, public drunkenness, traffic offense, and assault.[21] Type of crime in association with demeanor had a strong effect on police decisions, seen for example in 40 percent of the variation in

officers' dispositions explained by public drunkenness, as contrasted to only 1 percent for marijuana possession.[22] These two variables, type of crime and offenders' demeanor, appeared to have a much greater direct influence on police officers' decisions concerning women than those about men offenders.[23]

Strip-searching is probably the most degrading, humiliating, and abusive practice perpetrated by police officers upon suspected female offenders. Such an action is even more despicable when imposed upon women accused of minor law violations and traffic offenses. This disgraceful practice is believed to take place throughout the country but was first brought to public light through the Chicago Police Department's misapplication of the law.

In 1978 the American Civil Liberties Union (ACLU) filed a suit against the Chicago Police Department on behalf of a young black woman who had been brutally stripped, then vaginally and rectally searched.[24] Her offense? A minor traffic violation. This case, which was settled for $2,000, was only the tip of the iceberg. Not quite a year later, in December of 1978, the sixty-five-year-old wife of the presiding judge of the Cook County Juvenile Court, who is black, was taken to Chicago Police Headquarters because a cab driver with whom she was having a dispute over the fare told a traffic patrolman that she refused to pay. No police officer would listen to her repeated efforts to tell her story; instead she was subjected to the same dehumanizing strip-search thousands of other women in Chicago police departments and surrounding suburban police departments had experienced. But this time the police abused a "pillar of the community, married to a pillar of the community." The uproar caused by the humiliation of this prominent black woman led to hearings by the Illinois House Judiciary Committee and investigations by the United States attorney and the Federal Bureau of Investigation which, in turn, led to extensive media publicity and public outrage. More than a dozen women traffic violators came forth to describe their strip-searches at one Chicago district station alone, and over 150 women called the U.S. attorney to give statements about identical experiences.

The ACLU estimates that from 1974 to 1979 as many as ten thousand women in the Chicago area were victimized by routinely conducted nude body searches.[25] On March 1, 1979, the ACLU filed a class-action suit in the U.S. District Court to stop strip-searches and to seek damages for the women who had suffered this indignity. Unfortunately, despite overwhelming evidence from dozens of women, the Justice Department decided not to bring civil or criminal actions against the Chicago and suburban police departments, claiming that such an effort would be fruitless and difficult to prove as a "willful

violation of civil rights."[26] Instead they accepted the law enforcement reform promise of new guidelines for strip-searches that would prohibit body-cavity searching and only permit nude searches authorized in writing.[27] The ACLU claims that strip-searching is still going on.[28]

Although most of the thousands of strip-search incidents reported nationally that resulted in suits filed in Chicago, New York City, Houston, Racine, and other cities are the results of minor traffic violations, women and girls have been subjected to such experiences for other minor offenses as well. For example, women have been strip-searched because of domestic quarrel complaints while the men involved were only patted down. One social worker who was aiding some prostitutes was strip-searched along with the prostitutes on a charge of loitering, despite her protests and those of a minister.[29] The following incident further attests to the crudity and brutality of strip-searching: "One of the women represented by the Chicago ACLU alleges that a matron went through her jacket and skirt pockets, riffled through her credit cards and then, without surgical gloves or a quick wash of the hands, manually 'examined' her rectum and then her vagina".[30]

Probably the most baffling and disturbing factor in the strip-search controversy is that the perpetrators are policewomen. These female officers are demanding that other women: "Pull down your pants." "Squat three times. Spread your vagina." "Bend. Hold your cheeks." These degrading directions would cause any evidence or hidden contraband to be dislodged, yet physical probes of women's body cavities are still commonly made by policewomen and not by doctors or other medical personnel.

Policewomen in the United States

Women in this country have played a role in the criminal justice system since 1845, when the first women functioned as matrons who supervised girls and women under some form of custody such as prisons, jails, detention houses, or hospitals for the insane.[31] The first six matrons hired in 1845 by the New York City Police Department to supervise jailed females met with much opposition by police departments and men's reform groups who felt that no "decent, sober, respectable women" would take a job that would put them in contact with "such depraved creatures" who would contaminate and demoralize them upon contact.[32] Women reform groups countered with the argument that "police matrons were necessary to prevent sexual abuse and attacks upon arrested and incarcerated women by police-

men and prisoners, and to protect young girls and first offenders from hardened women criminals."[33]

During the Lewis and Clark Exposition in Portland, Oregon, in 1905 women had police powers conferred in order to care for stranded or molested females and those in other need. The first woman to work on the streets or outside of a police station, Lola Baldwin, was known as a "safety worker," and her duties were to protect girls and women from the rough miners, lumbermen, and laborers at the Exposition, and keep the females from approaching the men as well.[34] But it was five more years before the first woman was appointed to a U.S. police department when Alice Stebbins Wells was given police powers in Los Angeles.[35] Typically, this first policewoman performed the traditional duties assigned to women: working with juveniles and female prisoners, and doing clerical work. Mrs. Wells, who had graduated from a theological seminary and was a social worker, had the primary duties of "supervision and enforcement of laws concerning juveniles and women at dance halls, skating rinks, movie theaters, and other similar places of public recreation."[36] This state of affairs existed for almost sixty years, until 1968, when Indianapolis became the first U.S. city to employ women on patrol by the assignment of two regular, uniformed policewomen to Car 47.[37] Today only 3 percent of the nation's police force are patrolwomen, and for the most part women in policing are still performing the specialized bureau assignments concerned with juveniles, women offenders, and clerical functions.[38]

Policewomen's Work

Women have been hired and assigned to what are considered "safe jobs" in this country's police profession, first of all because of the male belief that women need to be "protected" and secondly because women are seen as inherently unfit for police work—another reflection of male machismo and supremacy. Despite notable exceptions such as the Miami Police Department, which has permitted patrolwomen the same duties and work as male officers, the low acceptance of females in most police functions, especially hazardous ones, is reflected throughout the country.

Women in the United States, in contrast to men, are not required to begin their policing careers on patrol for two reasons: "Law enforcement is a dangerous profession and . . . women, the weaker sex, cannot handle the dangerous situations they might encounter."[39] Such reasoning is faulty in the light of evidence to the contrary that demon-

strates the effectiveness of policewomen. Several studies have found
that not only are women as capable as men in police work, but in some
situations and duties women handle themselves better than men.[40] A
comparative study of St. Louis county policewomen and policemen in
single person patrol cars found, for example, that while the style of
the men and women differed, the policewomen performed as well as
men, despite the political and other prejudicial barriers confronting
women.[41] Other studies of policewomen performance in New York,
Dayton, and San Francisco report that female officers are just as capa-
ble as male officers and function more effectively than their male
counterparts in writing reports and in working with women and chil-
dren; also, they demonstrate less aggressiveness than men.[42] Since
policewomen are less able to rely upon physical strength and prowess
than policemen, they more frequently use tact and ingenuity in con-
frontations and defuse heated situations which male officers often
escalate. Particularly in domestic arguments, female officers are less
aggressive and more communicative with the family than male of-
ficers, and this behavior results in the settling of such arguments.[43]

While the lack of assignment of policewomen to patrol suggests a
pretty bleak picture, when one examines other possible police duties
for women, the picture literally fades into obscurity. Catherine Milton,
in her comprehensive book on the subject, *Women in Policing*, describes
the paucity of other police assignments for women officers. With the
exception of investigative juvenile work, in the United States it is rare
to find policewomen in detective work. Few women work crime scenes,
analyze evidence, are members of crime lab teams, administer poly-
graph tests, or perform other technical services, although many
women are used as radio dispatchers in a number of U.S. cities. Po-
licewomen throughout the country are also scarce in administrative
positions such as personnel work, planning, and research and train-
ing, according to Milton, who raises the question: Why the limited
role of women in policing?

Occupational Limitations of Policewomen

Milton lists several reasons to explain the differential roles of po-
licewomen: quotas in hiring practices, since recruiting is almost
exclusively male oriented; special entrance requirements for women
such as higher education requirements and different entrance exam-
inations that emphasize youth and social work problems; separate
training practices to prepare women for the traditional, specialized
women police roles; different promotional practices and procedures;

segregated bureaus, especially in large cities that assign all or most women to separate divisions; and unequal pay to female officers for performance of equal work as men.[44]

The major reason for limiting policewomen's roles lies in the "preconceptions of most of the men in control of police departments, which, to a degree, reflect general social attitudes of a large part of their communities."[45] Male officers frequently report reluctance to have women on patrol because they view women as not strong enough and thus more vulnerable to being overpowered, injured, or possibly raped.[46] One Florida study found that policemen feared women were ineffective in those patrol situations where there is a high probability of violence, such as in arresting drunks and felons, and in handling domestic conflict situations.[47] A midwestern sample showed that citizens also felt female police officers were less competent in potentially violent police roles like stopping a fist fight; but in contrast to the Florida male officers' views, policewomen were seen as equally competent in settling family disputes (58 percent), especially by the female respondents (67 percent).[48] The discrepancies between these findings may be due to the traditional conservatism of the southern male, seen in the fact that 45.7 percent of the male officers queried felt that a woman's place is in the home and 47.7 percent saw the first goal of women as raising a family.[49]

So we return full circle to the belief that women should be protected and that policing is "man's work." Not only are women thought to be emotionally and physically incapable of effectively handling a policeman's job, but there is also considerable feeling that women actually hinder effective policing since the male officer working as a partner with a woman would not be efficient in the performance of his duties because he feels he would have to protect her. These erroneous beliefs are held despite overwhelming common knowledge and empirical evidence that most of police work is routine and social service in nature, and therefore predominantly nonviolent. Furthermore, evaluations of the effectiveness of policewomen on patrol in five major studies completed in Washington, D.C. (1974), St. Louis (1975), California (1976), Denver (1977), and New York City (1977) indicate that "men are in no more danger with women as partners than they are with men as partners."[50]

Another barrier that circumscribes the role of policewomen is found in the attitudes and fears of the wives of policemen. Although their concerns about marital disruption are largely groundless,[51] many wives voice opposition to the assignment of male and female officers as partners because they fear extramarital affairs between the two. Because of their objections policemen's wives in some depart-

ments "have been an obstacle to the expansion of the role of women in policing."[52]

Benefits of Policewomen

Law enforcement has long been an occupation almost exclusively reserved for men; but with women entering the field of policing increasing evidence indicates that women can perform most police duties as effectively as men, and some functions more effectively. Policewomen not only precipitate less violence between police and citizens, but actually reduce such incidents of violence.[53] An ancillary benefit of the less violent behavior of policewomen is the "spill-over" effect on policemen who learn to control their own physical behavior. The positive influence of female officers on their male peers is described in one study which found that the men tried to "clean up their act" when women were assigned to duty by turning their conversations away from sex, sports, and war stories and toward more positive police work and new tactics. One male officer even managed to lose up to twenty pounds, and communications with their wives improved for some officers.[54]

Second, since policewomen accomplish their jobs with less physical force, such behavior helps to improve the badly tarnished image of police officers who are seen by the public, especially minority groups, as violent and brutal. Policewomen are also more likely to receive cooperation and assistance from citizens when they ask for help in disturbances;[55] the current view of male officers tends to negate such citizen help.

A third benefit that accrues from broadening women's roles in law enforcement is an increase in the crime-fighting capability of a police department. Female officers are more effective in dealing with and searching female suspects at the scene of arrests. In fact, the increase in female offender arrests has been attributed to policewomen.[56] Policewomen also make excellent decoys and plainclothes operatives in special criminal cases warranting undercover operations.

Fourth, policewomen appear to be more responsive to the needs of the community. Most of the population served by the police are women and children, and female officers are more effective than policemen in solving the problems reported by women. They are able to elicit more information from suspects as well as from victims of rape and from juveniles. In similar hazardous jobs women have been found to have a more soothing, sympathetic, and calming approach than men,[57] which in turn elicits a more positive, cooperative response in

the interpersonal interaction with others. Since our society expects women to be significantly less aggressive and physical than men, it seems logical that policewomen would therefore cause less antagonism, fear, and violence from citizens than do policemen.

Role Dilemmas of Policewomen

A female sociologist recently donned a Washington, D.C. police reserve officer uniform and for eight months studied the role of female patrol officers.[58] Through the techniques of participant observation, interviews, and discussions the researcher, Susan Martin, who referred to her female subjects as "token" officers, or simply "tokens," identified two patterns of occupational role behavior adopted by the women officers as a result of the conflict between their sex roles and their occupational roles in the face of constant opposition from male officers adverse to female patrol assignments.

*Police*women respond to their role dilemmas through defeminization in their attempt to win male peer acceptance. As a means of gaining the acceptance of their male peers, they adopt a strong law enforcement orientation that includes not only the male policing view but also male actions, such as maintaining high arrest rates and accepting the need to take physical action while on duty. One *police*woman satisfied with her performance stated: "My partner and I were shot at, and I ran the car through a chain link fence to catch the guy. I jumped on the man and smashed him with my fists. I don't like people shooting at the police."[59]

*Police*women appear to like street patrol and feel comfortable on the street, often refusing opportunities to transfer to station jobs. Several of them have been involved in disciplinary hearings for brutality partially because they used their tools of the trade—guns, nightsticks, and mace. As a part of the police subculture, *police*women are loyal to the police code by "staunchly defending the department and its policies in the face of outsiders' criticisms, including charges of sex discrimination, and concurring in the men's negative evaluations of police*women*."[60]

The other group identified by Martin, police*women*, are deprofessionalized, since they agree to the male terms of subordination and are thus treated as "ladies." These officers are polar opposites to *police*women; they either view police work primarily as a source of income and not an occupation of interest, thus maintaining the traditional feminine outlook, or they become involved in police work but battle with sex discrimination, "their own lack of assertiveness, and

the desire to remain 'ladies on the job as well as off.'"[61] Police*women* take little initiative, have low motivation, make few arrests, and generally are "underachievers" as patrol officers.

In light of these descriptions, it comes as no surprise that there was antagonism between the two groups of female patrol officers in this study. *Police*women tend to view police*women* as being responsible for sex discrimination in the department and for the problems women face there, largely because of their traditional feminine behavior of looking for protection from the male officers and participating in limited police roles. The police*women*, on the other hand, are critical of *police*women because they find their behavior and morals unacceptable. "Some of them try to act like men on the street. They curse and talk and walk mannish. . .The women on the street swear they are superwomen and they aren't. There are things women can't do," one police*woman* commented.[62]

Martin concludes that these contrasting behaviors result in a lack of unity among these women officers that not only limits their political clout but also might contribute to inadequate police performance, since the pressures and problems these "token" officers face must surely intrude upon their job functioning. If Martin's findings are indicative of similar predicaments faced by the small numbers of female police officers nationwide, one can only feel sympathy for these women who must cope with such occupational difficulties in addition to the rigors of police work. Furthermore, Martin's fascinating study may offer the answer to a question raised earlier about the rationale behind female officers' strip-searching of women offenders; perhaps such officers are *police*women who have become role-assimilated and think and act just like police*men*!

section four
females and the courts

8

THE JUVENILE FEMALE
IN THE JUDICIAL PROCESS

History

Before one can explore critically the pathways and outcomes experienced by the juvenile female in the judicial process, it is important to understand the basic philosophy that provided the cornerstone of the juvenile court, inasmuch as it is that earlier ideology which permeates the juvenile court of today and ultimately affects the female offender through the imposition of a double standard of justice.

The founders of the juvenile court system—Tony Platt calls them the "child savers"[1]—viewed themselves as reformers. However, Platt severely criticizes the child-saving movement as not humanitarian but merely a way to expedite traditional policies. He sees the child savers as paternalistic and romantic persons who assumed that adolescents were naturally dependent and in need of a special court. In terms of the prevailing middle-class values of that time, any display of premature independence or unbecoming youthful behavior by the urban poor should precipitate court sanctions. Such children were considered sick or pathological and consequently were imprisoned for their own good. Runaway, abandoned, and orphaned youths had become a serious social problem in eastern urban areas and led to the reform school movement.[2] These correctional systems resulted in longer terms of imprisonment, long hard hours of labor, strict discipline, and the instilling of middle-class values while simultaneously fostering the acquisition of lower-class skills. The reform schools failed in their efforts to treat their wards as dependents, since "the reality of the institutional life—the riots, the exploitation, the cruel punishments—mocked the ideal."[3]

Thus, the juvenile court movement grew out of the failures of the reformatory movement, and the first juvenile court in the world was established in Chicago, Illinois, by a state law entitled "An Act to Regulate the Treatment and Control of Dependent, Neglected and Delinquent Children" (the Illinois Juvenile Court Act, July 1, 1899). The delinquent child was to be treated the same as a neglected or dependent child, and the Juvenile Court of Cook County, which was given jurisdiction over children under the age of sixteen was "to have a special judge, a separate court room and an informal procedure."[4]

New terminologies and practices were introduced in this first juvenile court: petition was substituted for complaint; a summons was issued instead of a warrant; an informal hearing replaced a formal trial; probation officers were provided for investigations; provisions were established for the child to remain in his or her own home, or placements were made in suitable homes; commitments were made to appropriate institutions; and segregation was enforced to separate children from adults in adult institutions.[5]

In Chapter 6 we discussed *parens patriae*, a legal philosophy that elevated state interest in a child over and above parental interest. The concept of *parens patriae* provided the legal basis for the development of the juvenile court; it conferred parental powers upon the court instead of the natural parents of a child. The justification for this assumption of such expansive authority lay in the reasoning that the parents had violated their duty to the child and had no rights to custody. The moral and dominant classes considered paupers as degenerate and immoral. Obviously they had failed as parents, so the court had to be the vehicle to provide specialized treatment and rehabilitation for the juvenile offender.

According to the philosophy of the juvenile court, its aim is not punishment but rehabilitation. This is accomplished through individualized treatment—an ideology that reflects the social work orientation of the original reformers:

> The critical philosophical position of the reform movement was that no formal, legal distinctions should be made between the delinquent and the dependent or neglected. The adolescent who broke the law should not be viewed and treated as an adult offender. He should be viewed and treated in the same manner as a wise and understanding parent would view and treat a wayward child. He should not be considered an enemy of society but society's child who needs understanding, guidance and protection. The goals of the program are rehabilitation and protection from the social conditions that lead to crime.[6]

Tappan studied the judicial, administrative, and social processes of an experimental New York court for adolescent girls and isolated two views on the objectives of the juvenile court: the legalistic perspective, which has a statutory basis outlining specific offenses necessary for the court to have jurisdiction over the youth; and the social work view, which "resists the legal technicalities" and has a goal of prevention.[7] The court he studied developed from a women's court that adopted a moralistic norm in relation to sexual conduct; it also had roots in a children's court with its preventive and rehabilitative emphasis. Tappan finds that such an amalgamation leads to a "conservative, moralistic-retributive striving wedded strangely to a liberal, reformative-preventative drive, this union begetting diverse conflicting aims of punishment, rehabilitation and deterrence."[8] Many observers of juvenile courts would find this description to be universally applicable. At least one judge, Lois Forer, criticizes the juvenile court for relying so heavily on the traditions and values of sociology, psychology, and psychiatry, instead of the law.[9]

The definition of juvenile delinquency broadened as the juvenile court movement spread, and in so doing brought under its jurisdiction a wide variety of previously ignored youthful activities that far exceeded "a humanitarian concern for the special treatment of adolescents."[10] In the first juvenile court act a delinquent was defined as "any child under the age of 16 years who violated any law of this State or any city or village ordinance."[11] By 1967 the President's Commission on Law Enforcement and the Administration of Justice defined delinquency as those offenses which, if committed by an adult, would be a crime. It included violation of specific ordinances or regulatory laws that apply to children, such as curfew and school attendance; restrictions on the use of alcohol and tobacco; and those children designated as "beyond control, ungovernable, incorrigible, runaway or in need of supervision."[12]

One implication of the expansion of the legal description of the children to be "saved" is detected in the composition of the juvenile court case loads. In its first year of existence nine out of ten cases coming before the first juvenile court in Chicago were minor offenders and not delinquents who had committed major offenses.[13] More recently, "most children who are brought before the juvenile courts because of their behavior, are not adjudicated on the basis of criminal acts at all" but are truants, runaways, or have engaged in sexual misbehavior or other immoral acts.[14] Nationally, 40 percent or more of court-referred youth are truants, runaways, curfew violators, and other status offenders; one fourth of all juvenile court adjudications

involve this category of children. Of the youths in custody awaiting dispositional hearings in juvenile court 40 to 50 percent are status offenders, and 50 percent of institutionalized adolescents are so classified.[15] Teen-age girls comprise approximately 70 percent of the minors in need of supervision (MINS) cases heard in juvenile courts across the country that result in commitment to correctional institutions, whereas adolescent boys are only 23 percent of those so incarcerated.[16]

Our society views the behavior of females quite differently than that of males and attempts to socialize boys and girls in accord with these differing role expectations. Girls are presumed by the personnel of the juvenile justice system to have indulged in some form of sexual activity regardless of the offense cited on the petition; therefore, in the case work tradition, in the spirit of rehabilitation, the court assumes the role of protecting the virginal status of the adolescent female:

> The court involves itself in the enforcement of adolescent morality and parental authority through the vehicle of status offenses. The use of these offense categories . . . creates a de facto double standard of juvenile justice in America, one for men and another for women, and results in the preponderance of young women facing such charges before the court.[17]

It is apparent that after eight decades of intervention in children's lives the juvenile justice system has not lived up to its original mandate or even its own ideology. Serious revisions in this process appear to be requisite in order to protect the children under juvenile court jurisdiction. Some would remove children from this jurisdiction; others advocate abolishing the juvenile justice system entirely.

The Abolitionists

On October 22, 1974, the directors of the National Council on Crime and Delinquency (NCCD) adopted a policy that called for the removal of status offenders from the jurisdiction of the juvenile court by challenging the rehabilitative philosophy of a court that imprisons children for noncriminal behavior.[18] In a later article Milton G. Rector, president of NCCD, reinforced this position when he described the treatment of status offenders as a shameful American scandal.[19] This abolitionist approach to the juvenile court is an integral part of the movement to remove runaways and other status offenders from

the purview of the juvenile courts. Juvenile court abolitionists argue that the juvenile court has failed in its original purpose, particularly in regard to the noncriminal behavior of children, and "the result is that thousands of juveniles are taken into custody and processed through the juvenile courts for behavior which would not bring an adult into conflict with the law. Many truants, runaways, and ungovernable children need help, they do not need a record."[20]

The case loads of large, urban juvenile courts reveal disproportionate numbers of poor and minority children, which leads some advocates of the removal of status offenders from juvenile court jurisdiction to cite evidence of class and racial differentiation as sufficient cause for the court's abolition.[21]

There is another, more radical, position that would abolish the juvenile court, a prevalent sentiment evidenced in the opinions of contemporary legal theorists. A recent survey of legislative proposals and activities reflects procedural changes in the judicial handling of juvenile delinquents that are assumed to be related to the American public's concern with increased juvenile crime.[22] The preliminary findings indicate a varied response by legislatures to the alleged problem of youthful deviance and a general reduction in the discretion previously held by the juvenile courts and other youth agencies. While there is confusion as to the outcome of these legislative proposals, it does seem that children who are status offenders are being viewed in a less stringent and punitive manner by legislatures. Indications of this trend are manifested in the enactment of laws prohibiting the detention or incarceration of such offenders with serious delinquents or laws totally forbidding their incarceration.

In a review and analysis of three volumes of the proposed Juvenile Justice Standards recommended by the Institute of Judicial Administration in conjunction with the American Bar Association (IJA-ABA Joint Commission), Wizner and Keller report that the suggested reforms would first abolish jurisdiction over status offenses; this, they predict, will "point the way to more radical change, namely, the abolition of juvenile court delinquency jurisdiction" as well.[23] According to these authors, a "penal model of juvenile justice" introduces procedural safeguards for delinquents, limits jurisdiction and judicial discretion, and precludes the need for a separate court for delinquents since the principles to be applied are practically identical to the adult court model.

The rationale for abolition outlined in separate treatises by law professors Francis McCarthy[24] and Sanford Fox[25] is that delinquent behavior is best served within the already existing adult criminal system. Addressing the similarities between juvenile and criminal pro-

cess, McCarthy points out that the stigma of delinquency is not that different from that of an adult criminal, since both are defined exclusively as violations of criminal law; "guilt" is determined in a court of law similar to the adult system; and the penal character of many delinquent dispositions is not that distinct from the punishments accorded adults in the criminal court. Further similarities between the two courts will be found if the legal reforms recommended by the IJA-ABA Joint Commission are instituted and will result in the juvenile court serving the same function as the criminal court.[26] Presently the juvenile and criminal justice processes differ not only in terminology—since the new language of the "child savers" added a unique judicial vocabulary peculiar to adolescents—but also in the procedural handling of girls and women in their respective judicial settings.

The Juvenile Court Process

In Chapter 7, when we touched on the events concerned with law enforcement and police handling of girls, two significant factors were found to be associated with police discretion: the decision to arrest and the decision to detain or hold in custody until court. Approximately half of all youth taken into police custody are screened out or diverted from the juvenile justice system. It should also be noted that the primary source of referrals to juvenile court is the police. We have seen that police officers tend to refer to court more girls who commit status offenses than girls who are guilty of criminal (delinquent) offenses. Also, more girls accused of status offenses are court-referred than boys so accused. There is additional empirical evidence that the filing of petitions, or those complaint documents that institute formal juvenile court proceedings, are more frequently initiated by parents against their daughters than against their sons.[27] This practice is especially common for ungovernability, incorrigibility, running away from home, sexual misbehavior, and other status offenses.[28] Finally, other sources of juvenile court referrals—schools, social agencies, and relatives—refer a much higher proportion of delinquent girls to court than delinquent boys.[29] As we shall see, this differential treatment of girls persists throughout the juvenile justice process.

Intake

Intake is a screening process in which about one half of all youth cases are "adjusted" and thereby avoid formal proceedings.[30] The

court personnel involved are probation or intake officers, who tradi-
tionally base their decisions upon informal deliberations with the
child and his or her family.[31] This prehearing investigation and
screening of cases draws upon several broad criteria for decision-
making: the seriousness of the offense, chronicity of the prior behav-
ior of the youth, the circumstances concerned with the offense, and
consideration of the needs of the child, its family, and the
community.[32]

In addition to determining alternatives to court processing (diver-
sion), intake fulfills several other purposes: to establish jurisdiction,
or the authority and power of the court to hear a case, dependent
upon age, geographic location, and seriousness of the offense; to
screen out mentally ill children; to determine the legal sufficiency of a
case or that legal issues of fact are involved; and finally, to meet the
bureaucratic objective of limiting the work load of the judge and other
juvenile court personnel.

The extent of the probation officer's discretion is of paramount
important for both boys and girls caught in the system, since:

> Intake is discretionary decision making, most typically performed by
> probation officers, with a primary goal of determining whether a peti-
> tion should be authorized. It is an extension of the historic police prac-
> tice of exercising discretion as to whether a juvenile offender should be
> referred to the court. It is a forerunner to the discretion exercised by a
> judge when, following adjudication of a petition, the judge selectively
> determines a particular disposition to be made in a given case.[33]

The implications for such discretion without reference to formal
guidelines may be more hazardous for girls, however, depending on
the sexual biases of the probation officer, and there is some evidence
that such biases do indeed exist. All too frequently probation officers
take the side of the parent or other complaining adult over the posi-
tion or word of the child. Since a girl is more likely than a boy to enter
the system because of referral by her parents, her chances of being
fairly treated are necessarily diminished. Further, if decision-making
intake officials harbor social biases that view female sexual freedom as
repugnant or female delinquent activities as inappropriate or un-
becoming to young ladies, such prejudgments may affect decision
outcomes.

Detention

Although a juvenile may be detained at any step in the judicial
process, there are two definitions of detention that imply holding a

child in secure custody on an involuntary basis. The term "detention" is generally reserved for the type of restraint taking place prior to a juvenile court hearing. The other form of secure confinement, institutionalization, occurs when a youth is committed to a state facility by a judge.[34]

In most jurisdictions the initial decision to detain a youngster is made by either a police officer or a court probation officer, but at least thirty-five states now require either a detention hearing or a court order within a certain period of time before a child may be held in custody.[35] Despite such judicial review juvenile statutes are vague, ambiguous, or "silent on what factors are to be considered at these detention hearings."[36] Numerous reasons are given for detaining juveniles, but the most frequent rationale for this practice, not found in most state juvenile codes, is that it is in the best interest of the child or for its protection. Other criteria for detention include: (1) "preventive detention," or to avoid any new offenses by the offender; (2) if the release would result in harm or injury to the child; (3) to ensure the court appearance of the youth; (4) to prevent a parent from taking the child out of the state; and (5) when "no responsible adult is able or willing to provide supervision and care for the youth."[37]

A recent study found that almost 60 percent of the thousands of youth detained annually were held solely at the request of parents or school officials.[38] Children are often detained because their parents refuse to take them home, especially in cases where the child exhibits ungovernable or other uncontrollable behavior.[39] Since girls more frequently commit such status offenses, it is readily seen that girls would be disproportionately placed in detention by parents who feel they can no longer control their daughters. Once detained, girls are more frequently held in custody longer than boys because there are few alternative programs or places to send them and they cannot return home.[40] Although the arrest ratio of boys to girls is about four to one, the detention and incarceration ratio is three to one.[41] While awaiting their court hearings, 75 percent of the girls but only 25 percent of the boys are held in detention, and the girls are detained for less serious offenses.[42]

Substantial evidence that girl offenders are discriminated against in detention practices is witnessed in a number of recent studies that indicate girls are more frequently detained than boys for the commission of less serious offenses such as juvenile code violations as well as for criminal offenses.

A study of the Honolulu Juvenile Court found that although girls comprised only 17 to 20 percent of the court's juvenile population between 1954 and 1964, they were 30 percent of the youngsters sent to

pretrial detention.[43] Also, their average stay in custody was three times as long as that of boys. Similar findings are reported in one midwestern state where 31 percent of court-referred girls as compared to 24 percent of the boys were detained, yet the number of boys in that court accused of criminal offenses (69 percent) exceeded the number of girls so charged (44 percent).[44] A recent study by this author also found that of the combined groups for all of the juvenile courts studied in a large midwestern metropolitan area, 47 percent of the girls who came before the bench were in custody, whereas only 26 percent of the boys were being held in detention at the time of their dispositional hearings.[45] The majority of these detained minors were status offenders, and among this specific group of runaways 62.8 percent were females. The delinquent girls were less likely to be placed in detention than their sisters on the MINS calendar (52.4 percent), but they were detained more frequently than the male delinquents.

Even more startling disparities are reported by Wooden, who surveyed detained status offenders in Nebraska and Arkansas in 1974. He found that 53 percent of the girls were in custody for these offenses in Nebraska, as compared to 7 percent of the boys; in Arkansas the figures were 78 percent and 22 percent respectively.[46]

As mentioned earlier, the prehearing detention decision is based upon an analysis of information gleaned from the child, the child's parents, and from anyone knowledgeable of the child or the offense (police, witnesses, complainants, et al.). The intake worker or probation officer seeks extensive legal and social details about the case which are then contained in a report most commonly known as a social investigation.

In order to determine which factors—social or legal—were most influential in detention practices, two very comprehensive analyses of the case characteristics involved in such decisions were reported in 1977. One study in a Michigan county examined 500 juvenile cases in which 205 youths were detained and 295 were not.[47] While 44.9 percent of the children accused of felonies were detained, 47.6 percent of the status offenders were also held in custody. Further, the sex of the offender was found to be associated with the detention decision. Although male delinquent offenders were more likely to be detained (felonies 45.9 percent; misdemeanors 27.8 percent) than females committing these offenses (felonies 38.1 percent; misdemeanors 16.7 percent), the reverse was true for status offenders (males 44 percent; females 52.1 percent).[48] The researcher also reports an association with the likelihood of detention and the extent of home factors such as stability and whether the home was intact or was a broken home and

with school problems such as truancy, absenteeism, and discipline problems. As expected, these case characteristics also influenced the detention decision. Offenders from stable homes and from intact homes were less likely to be detained, especially in the more serious offense cases. For example, the detention rate for youths who committed felonies was 59.1 percent if they had an unstable home, but only 28.1 percent if the home was stable. For status offenses the percentages were 58.8 percent (unstable) and 46.7 percent (stable).[49] In general, the researcher concludes; "The greater detention rate for female status offenders is perhaps consistent with a general cultural notion that boys will be boys while girls must be protected."[50]

The second study examined the detention practices of sixty-six county juvenile courts in one state over a three-year period (1966–1969) and found that the "number of prior court contacts of a juvenile is a significant determinant of detention, regardless of sex, race and offense type,"[51] but girls who committed juvenile code offenses, "regardless of race and of prior court contacts, have a larger percentage of detentions than males who commit such offenses."[52] Surprisingly, white girls were retained more frequently than any other group. This is a curious finding, since most juvenile detention studies report nonwhite children as those most frequently detained. It suggests that these courts "intervene more forcefully in behalf of white parents who refer their troublesome children to the court,"[53] and also render a "disservice to nonwhite juveniles and to nonwhite communities,"[54] if protection of the child and the community are indeed integral to the juvenile court philosophy.

Once held in detention, girls often experience treatment not afforded detained boys. Since adolescent girls are presumed by the juvenile courts to have indulged in sexual activity regardless of the offense on the petition, another sexual discrimination operates in these courts—gender differences in the administration of physical examinations. Chesney-Lind reports that gynecological examinations were ordered for girls even in criminal cases, and where sexual activity was suspected, 70 to 80 percent of the girls in her Honolulu sample received physicals as compared to 12 to 18 percent of the boys.[55] Another female researcher comments on this practice: "The doctor's notations on the forms such as 'hymen intact,' 'hymen ruptured,' or 'hymen torn—admits intercourse' indicates the nature of the court's interest in the physical condition of the girls."[56]

Pelvic examinations are used in detention centers and facilities throughout the country to determine the condition of the hymen (virginity status), pregnancy, and venereal disease whether the female juvenile offender has allegedly committed a criminal offense or a

status offense. One author suggests that some girls may be held in custody primarily to ensure such examinations:

> Staff members of some detention centers, concerned about pregnancy and venereal disease, prefer to retain certain girls over night in order to accomplish a physical examination during daytime hours when a nurse or physician is available. Such practices are not limited to Philadelphia, where "every girl in the Youth Study Center is required to submit to an internal vaginal examination."[57]

The humiliation, degradation, and discomfort of these young girls who are recipients of such a personal invasion of privacy is decidedly traumatic, but more importantly:

> Aside from being a degrading experience for a young girl and probably a violation of her right to privacy, the routine administration of pelvic exams demonstrates the court's assumption that girls who come to the attention of the police and the courts are quite probably engaging in "promiscuous" sexual activity; in short, the court tends to equate female delinquency with sexuality. Like adult women, girls are more likely to be labeled as "carriers" of venereal disease and at fault if they are pregnant and unwed. Such labels as "runaway" and "incorrigible" are buffer charges for suspected sexuality, providing legal categories to cover the court's real interest in the girl's obedience to sexual norms. It is for this reason that girls charged with these offenses are so often incarcerated and subjected to pelvic exams.[58]

A 1974 study of juvenile detention published by the U.S. Department of Justice reported a larger proportion of males detained in all categories except status offenses, with females representing 58 percent of the total number of children in custody in this category.[59] By December 31, 1977, a preliminary report by that department found that approximately one fourth of the 46,000 juveniles in detention were detained pending disposition of their cases, but there had been a dramatic decline in both the number of detained status offenders (one out of ten) and in the number of females held in custody (down 21 percent).[60] Let us hope this downward detention trend continues for all children, but especially for those most discriminated against by the juvenile justice system.

Hearing

Until the 1960s the juvenile court process lacked formal standards and tended to dispense individualized justice, since the original pur-

pose and philosophy of the court was to "save," protect, and rehabilitate the child. Kindness and sympathy, typified in a loving, wise, male parental figure, replaced the legalistic procedures of the adult criminal system. As conceptualized by the early reformers, the grandfatherly judge would conduct small, private, informal, nonadversarial inquiries into a child's problems with the intention of working out a solution for the best of all concerned. This ideal arrangement changed in the wake of recent U.S. Supreme Court decisions that allowed juveniles certain due process rights for their protection. While the bifurcated hearing that developed out of the formalization of the juvenile justice system consists of adjudicatory and dispositional hearings, it is estimated that less than 5 percent of juvenile cases involve adjudicatory hearings.[61]

The *adjudicatory* stage is a fact-finding step in the juvenile justice process in which a determination of guilt or innocence is made, based upon "relevant, material, and competent" evidence.[62] The purpose of the adjudicatory hearing, or trial, is to determine whether the youth meets the statutory definition of the court's jurisdiction: delinquent, neglected, dependent, or status offender. In the cases of juveniles being adjudicated as delinquent, criminal proceedings apply in the standards of proof and rules of evidence. The other types of cases follow proofs and rules of civil proceedings. In the event that the court finds the child to fit one of these statutory definitions, the child is usually declared a ward of the court, and the judge sets a date for a dispositional hearing. In the interim the probation officer is directed to make a social investigation. The judge may also ask for a physical, psychiatric, or psychological evaluation of the child.

In essence, the adjudicatory hearing parallels a trial in the adult criminal system in which guilt or innocence is established. The *dispositional* hearing, on the other hand, is the equivalent of the sentencing phase of the criminal court. The court hears oral and written reports as well as any other social evidence that could help in making the final determination in each case. Since the youth has already been adjudicated as delinquent, dependent, neglected, or a status offender, the rules of evidence are usually not needed in the dispositional hearing. The social investigation report is the primary "evidence" addressed. This document normally contains recommendations for judicial action and often includes a "treatment plan" outlining the goals and approaches to the rehabilitation of the child.[63]

Several disposition alternatives are available to the judge or referee who decides the juvenile case. In the early 1800s dispositional choices were limited to either commitment to a juvenile reformatory or the imposition of an adult penalty that could include commitment to a jail

or some other facility in the adult criminal justice system.[64] Today the dispositional options, which vary according to state juvenile court acts, include: outright dismissal, either because the allegations have been disproven, or they are not sufficiently serious to entail court action; suspended judgment, which is a refusal to enter a finding (however, the child must conform to certain conditions for a fixed period of time); order of protection (care and protection orders), made against any person before the court (for example, the child's parent or guardian) to condition that person's behavior and the home environment in the best interest of the child; fines or restitution to the victim, which may be judicially required with or without a condition of probation; probation; and institutional commitment or placement.[65] Probation, the most frequent juvenile court disposition, is a conditional release of a child under the supervision of a probation officer or some other court or agency official for a specified period of time dependent upon the juvenile statute, and its orders prohibit certain conduct while simultaneously specifying other conditions imposed by the judge. Institutional commitment, the most severe disposition, is the only juvenile court disposition generally feared by juveniles, since it includes the power to commit the child either until the age of majority directly or through successive extensions of the initial court order which could be for as long as fourteen years.

Commitment to an institution is usually limited to those cases that involve a violation of criminal law. Some states have limited by statute the maximum time a child may be held in institutional custody, but renewals of commitments by subsequent court orders in effect circumvent the original attempts to avoid lengthy incarcerations for juveniles. There is also a new legislative trend to create categories of juvenile criminal behavior for the purpose of limiting judicial and agency discretion in the determination of release dates of juveniles committed for serious crimes.[66] Examples of this recent practice are seen in California and Kentucky, which distinguish between misdemeanor and felony delinquency charges; in Colorado, where the legislature created new "violent" and "repeat offenses" categories; and in the state of Washington, which now differentiates between "serious offenders" and other delinquents called simply "juvenile offenders."[67] Whatever the label applied, the purpose for its imposition is clear; the public is demanding that the system get tougher on kids.

Most juvenile court judges do not have all of the dispositional options listed above at their disposal, but are limited to dismissal, probation, or commitment. Nevertheless, they do have wide discretion to select from among the available alternatives. Too often the personal values and philosophy of a judge may strongly influence his deci-

sion,[68] and juvenile court judges "represent an incongruous brew of legal and social considerations, of moralisms and true concern, of individualization and attempted equalization with others who have offended similarly. For some youths, the result is a new beginning. For others, it is the beginning of the end."[69] For adolescent female offenders it can be a nightmare.

Probably the most sexually discriminatory practice associated with the adjudicatory phase of the juvenile court process is the court-referred physical examination, Earlier we noted the inequity of this practice in the detention stage and found it to be an almost routine procedure for girls in some detention centers. If a juvenile female offender has not been subjected to gynecological testing and venereal disease screening at an earlier stage, often the judge in the adjudicatory hearing will ask for such examinations after he has heard the "facts" in the case, especially those which imply sexual activity. Although Chesney-Lind's Honolulu study refers to court-ordered physical exams, she did not specify in which hearing they took place but noted that such referrals were common experiences for girls and not boys.[70]

An observational study of the dispositional hearings of runaways in a midwestern status offender court by this author noted that 6 percent of the girls who came before the judge were placed under court order to obtain physical examinations.[71] No boys were referred for such exams or for VD screening during the time period studied. When queried about these referrals, a probation officer explained that physicals of this type are usually given upon entry into detention unless the girl is only briefly held in custody—that is, no more than one day. In each of the observed cases the runaway girl's history indicated a possibility of sexual contact. One girl who was dismissed and sent home was also revealed to have experienced sexual activity; and in this case the judge informally recommended that her father take her to the Board of Health for examination for venereal disease. Information-seeking about sexual familiarity and possible episodes was standard procedure for the female runaways, but not a single male runaway was questioned about his sexual behavior during his absence from home. In this court delinquent girls accused of crimes were not observed to be interrogated on sexual matters or referred for physical examinations; however, the Honolulu study indicated that girls in those courts were so referred despite the offense committed.

Why is there such excessive court interest in the sexual activity of adolescent girls, whether presumed or real. For an answer we return full circle to two of the cornerstones in the foundation of the juvenile court: the emphasis on "protection" of the child, particularly the

female child, and "paternalism," the "ultimate paternalistic situation, in a society politically and economically dominated by men."[72] Some researchers feel that this is not the case at all—that the juvenile court is really more concerned with the protection of the sexual status quo or the traditional sex role of females as weak, dependent, and law-abiding, and not with the protection of female juvenile offenders.[73]

Over the past two and a half decades several studies of juvenile court dispositions across the country have indicated prejudicial treatment of adolescent female offenders coming before these courts. As in other substantive areas of female crime and delinquency the research is scattered and fragmentary; therefore extrapolations from these studies and their consequences for juvenile females must be undertaken with caution. Nonetheless, these data offer the only empirical evidence currently available on the subject of juridicial treatment of youthful female offenders.

A study in the state of Washington which compared the juvenile court dispositions of boys and girls between 1953 and 1955 found girls were dismissed for serious complaints slightly more frequently (49.9 percent) than boys referred for these offenses (47.7 percent). On the other hand, girls tended to be committed to institutions twice as frequently (25.8 percent) as boys (11.3 percent).[74] The authors noted that the girls were more likely to be nonwhite, from broken homes, and either with school attendance problems or not in school, and their offenses were usually running away from home or ungovernability.

A New York study also found that most of the female juveniles recommended for institutionalization were black girls whose major offenses were behavior contrary to sexual taboos or actions against their parents' wishes.[75] Their "unlawful" conduct primarily involved picking undesirable boyfriends (64 percent of the cases), staying out late, or being promiscuous (80 percent of the cases). These girls were treated more leniently for arson than for verbal abuse! Although a small number of the girls were recommended for discharge or probation (1 out of 11.6) as compared to boys (1 out of 3.5), three times as many girls as boys were recommended for institutionalization. One out of 1.6 girls was recommended for commitment, but only 1 out of 5.6 boys received this recommendation. Put another way, girls comprised only one sixth of the total number of cases but were half of those recommended to an institution.

Many other studies of juvenile court dispositions that examine sex as an independent variable appear to find differential treatment because of gender. But other factors such as type of offense or extent of recidivism might intervene to influence the judge's decision. In order

to overcome this problem a study of 1,103 juvenile offenders in an eastern state controlled for offense and previous record; it found that the family court gave less severe dispositions to female offenders who committed criminal offenses (felonies and misdemeanors) but harsher dispositions than males when the girls were involved in status or noncriminal offenses.[76] While only one fifth of the boys were charged with noncriminal offenses—running away, ungovernability, truancy, and curfew violation—one half of the girls were before the court for these juvenile offenses. The lesser disposition of dismissal or warning was afforded 41 percent of the boys but only 17 percent of the girls. Girls were treated more stringently than boys for their first status offense. With one or more previous offenses they were treated even more harshly. None were dismissed, although 10 percent of boys were; only 7 percent were warned compared to 34 percent of boys; 71 percent were assigned to probation officers compared to 40 percent of the boys; and 21 percent of the girls were institutionalized whereas only 13 percent of the boys were.[77]

Additional research in the South and Midwest provides further support for the body of literature emphasizing more punitive treatment of female status offenders by juvenile courts in areas outside of large, urban, eastern areas where much of the previous data are concentrated. One study in Kentucky, for example, found that between 1970 and 1974 girls were sent to institutions at a greater rate than boys, despite the fact the males were almost five times more likely to have been referred to court for the more serious crimes against persons or property.[78] Research in a midwestern juvenile court by this author that controlled for type of status offense and only examined runaway cases revealed that girls who ran away from home were more often given the most severe court disposition available for minors in need of supervision (MINS), which was removal from the home and commitment to the Department of Children and Family Services for placement.[79] Only 18 percent of the runaway boys were accorded this disposition, but 28 percent of the girls were. Contrarily, the least severe disposition revealed an opposite trend in terms of gender; 64 percent of the boys were significantly assigned the lesser court sanction, as compared to 48 percent of the girls.

Although the above studies took place throughout the country, it is difficult to generalize these findings to the nation as a whole or to demonstrate that differential treatment of adolescent females by juvenile courts is indicated in most U.S. jurisdictions. However, at least one national survey offers empirical support for such an assumption. The National Assessment of Juvenile Corrections Program visited and reviewed placement programs in sixteen randomly selected juvenile cor-

rectional institutions in eleven states. It found the proportion of girls placed in institutions for status offenses was twice as high (39 percent) as the boys' proportion (18 percent), and a disproportionate 57 percent of the female status offenders were incarcerated for running away from home.[80] Similar discrimination was revealed in the placement of girls in institutions for commission of delinquent offenses, although their "serious" offenses most frequently involved alcohol, marijuana, hashish, or other "soft" drug usage, running away from home, and engaging in sexual intercourse. In fact, girls were three times more likely to be committed than boys for drug offenses (21 percent versus 7 percent).

Institutionalization

Nationally 70 to 75 percent of incarcerated girls are in institutions for status offenses compared to 23 percent of boys,[81] and, according to several studies, once they are committed juvenile females are subject to court jurisdiction longer and are held in institutions longer than male juvenile offenders.[82] What happens to them while they are under this court "protection" is often a nightmare for some girls, particularly those who are victims of the process called "dumping":

> After bringing the power of the state against the true parents—either through delinquent petitions theoretically aimed at children for minor delinquent acts but really aimed at bad home conditions, or through neglect petitions—and after social workers paid by the state testify against the parents, and prosecutors paid by the state argue that the child should be taken away from home because it is in his or her "best interest," the state itself, now the Kindly Parent, proceeds to neglect the child in its own parental way through a process we coined "dumping".[83]

As a result of this bureaucratic ineptness a child is shunted from one agency, foster home, or institution to another. Since placements for girls, especially "problem" girls, are generally lacking, far too often girls are "dumped" into detention centers, mental institutions, corrections facilities, or jails because no other place can be found for them. Even more frightening is the placement of girls in institutions away from their home states. In the 1960s and 1970s, for example, the state of Illinois had placed hundreds of children each year in Texas institutions. At least one thirteen-year-old was sterilized there. Officials told the girl and her father that she had received an appendectomy, but

when she had not had a menstrual period for six months, she and her father were finally told of the hysterectomy. Her offense?

> Denise had been in trouble in school and had allegedly run away from home twice. Her father admitted to "neglect" so that his child could receive the care she so desperately needed, according to the Juvenile Court. First, she was placed in several foster homes, and then she was sent to the facility in Texas. One week after the girl's thirteenth birthday, the hysterectomy occurred.[84]

There was no malignancy according to the pathologist's report. This is only one case of abuse that has been brought to light. Of the thousands of girls across the country who are "dumped," we can only wonder how many more have been sterilized.

The double standard of juvenile justice infringes upon the rights of young females through a form of social control under the guise of chivalry. By all indications, this paternalistic approach has been proved to dole out more punishment than protection for misbehaving girls, largely because of the moralistic tenor of the juvenile court and its philosophy.

A paternalistic pattern of sex discrimination in United States courts described as specifically applied to juveniles under age twenty-one assumes that girls are more in need of protection, especially sexual protection.[85] In reality, it seems that society is the object of protection—protection from the sexual freedom of youth in an ever-changing, free society. Mores are being challenged, and the American culture is not prepared to accept the change. If the juvenile court reflects the ethical concerns of the dominant society and a "Victorian fear of extra-marital sexual behavior among young girls,"[86] the threat of sexual promiscuity and unwanted births will continue to lurk suspiciously in the collective social mind of that institution and result in separate and unequal treatment for girls who enter its courts against their wills.

9

Women in the Criminal Justice System

As a result of the historical neglect of the female offender as a meaningful research subject, little empirical data address the processing of women offenders from the initial point of arrest through conviction. The problem of obtaining an accurate picture of the legal outcomes of female offenders in criminal court is further compounded by the lack of national comparative statistics on male and female conviction rates. The few existing studies, which are scattered across the country, are the only sources of available information, and they present differing results as to the treatment of women by the criminal justice system.

In contrast to girls in the juvenile justice system, according to some studies, women appear to be more favorably treated by the courts for the commission of the same offenses as men. However, other researchers report opposite findings in their examinations of judicial discretion and individual state statutes. These mixed findings make the subject of women in the criminal justice system controversial, but it is generally agreed that the legal status of women has always been one of subjugation and inferiority in comparison to men.

Throughout history women were assumed to be "defenseless and in need of support and guidance"[1] and were relegated to a subordinate position as noncitizens, since they could not "vote, own property, make wills, testify in court, serve on juries or obtain divorces."[2] Women have also been treated more cruelly in criminal cases, and while denied identical rights as men, they were nonetheless subject to the same laws as men:

And the law was a great deal more implacable in its demand for punishment of women than of men. We have mentioned the preponderance of legal executions of women over men in medieval Europe, and this preference for punishing women violently and mercilessly did not end with

the Middle Ages. In eighteenth-century England, the Age of Reason, the age of newspapers, coffeehouses, scientific discovery, mechanical invention, street lights, Tom Paine, Ben Franklin, and the *Encyclopaedia Britannica,* women were still being burned alive.[3]

Female criminals in the United States were housed in the same jails and penitentiaries as male convicts until the late nineteenth century, when separate facilities were established for women. While punishment was the primary purpose of penitentiaries, the new institutions for women were called "reformatories" to reflect the intention of reforming or "rehabilitating" females instead of punishing them, no matter how long the process took.[4] It is from this basic premise—the amenable rehabilitative powers of women—that the differential sentencing laws described in Chapter 6 originated. These statutes were discriminatory, and so was the tendency of judges to apply them to females more so than to males. Even where indeterminate sentencing for women only has been struck down, some observers feel that judges are still more punitive toward women for certain offenses, presumably because judges rely so heavily upon their personal morals and convictions in their deliberations and final opinions:

> It is the judge's habits of thought that produce that opinion, nothing less, finally, than "his entire life history." But the bases for his judgment and the law it creates may forever lie concealed—because His Honor is not required to publish the reasons for his ruling. At trial court level he rarely bothers to set forth his thinking. Similarly, the upper courts and even the Supreme Court often rule without any explanation at all.[5]

Unlike adolescent female offenders, women who break the law are in less arrest jeopardy than men, since "police are less likely to detain or arrest women than they are men under identical circumstances."[6] Once they are arrested, however, opinion is divided as to whether they are treated more preferentially than men at other points in the criminal justice system—awarding of bail, pretrial detention, the preliminary hearing, the trial, and sentencing.

Pretrial Outcomes

After arrest, one of the alternatives to detention before trial is temporary release, which can be in the form of either bail or release upon one's own personal recognizance. In the case of bail, which is the most commonly used method, some form of financial security, cash or prop-

erty, is posted to assure the appearance of the accused at the trial. This security is known as a bond or a bail bond, and persons who have been released under such conditions are customarily referred to as "bonded out," "bailed out," "out on bond," and the like.[7] Another way to avoid pretrial confinement is to be released on the basis of a personal assurance that you will return for the trial. Personal recognizance release, as it is called, basically amounts to giving your word that you will be present for the disposition.

Both these methods of temporary release involve decisions rooted in judicial discretion, since what constitutes "reasonable" bail is determined by a judge or magistrate.[8] Bail can present a tremendous hardship for certain members of a community. Whereas wealthy people charged with crimes can easily post bail, poor people often end up deeply in debt if they raise the necessary money, or languish for long periods of time in jail awaiting trial, if they are unsuccessful in making bond.[9] Even if the money is raised for the bond or for a bondsman's fee, a portion is normally kept either by the court or the bail bondsman whether the person is later found innocent or guilty. This practice imposes an extreme handicap on those who are poor; and since most women processed by the criminal justice system are poor and members of racial/ethnic minorities, they are more vulnerable to the vicissitudes involved in the bail procedure.

In Chapter 8, we referred to one of the two patterns of discrimination experienced by females in court, the paternalistic pattern. The second pattern, the disadvantaged or disfavored model, is more applicable to poor, black, or elementary-educated defendants and involves

> unfavorable treatment at virtually all stages of the criminal justice process including (1) receiving a preliminary hearing, (2) being released on bail, (3) having a hired attorney rather than assigned counsel or no attorney, (4) being subjected to relatively long delay while in jail if not released on bail, (5) receiving a jury trial, (6) being dismissed or being acquitted, (7) receiving probation or a suspended sentence if convicted, and (8) receiving a relatively short sentence if jailed.[10]

The two patterns emerged from American Bar Foundation (ABF) data on 11,258 criminal cases in selected samples from all fifty states. Stuart Nagel and Lenore Weitzman separated the ABF data into property (grand larceny) and person (felonious assault) offenses for their examination of criminal court cases by sex—a total of 1,949 cases. They found that while blacks and indigents were discriminated against in bail decisions, an opposite tendency was evident for women.

Compared to 50 percent of the men accused of larceny assigned bail, 76 percent of the female larceny defendants were released on bail.[11] In the felonious assault cases 77 percent of the women so accused were bonded out, but only 58 percent of the men received bail for the identical offense.[12] Nagel and Weitzman viewed these examples as indicative of the paternalistic pattern of favorable treatment to women and a reluctance by the court to impose negative sanctions on women. However, this tendency toward leniency was only beneficial to white women, since black women in the ABF sample were more likely to be incarcerated before or after conviction.

In Chapter 7 we described police harassment of female prostitutes in our discussion of how law enforcement applies the law to women. A frequent corollary of this type of persecution is that judges often insist upon higher bail for prostitutes or deny bail altogether.[13] This practice is one of the exceptions to the prevailing custom of pretrial release of women. There is evidence, however, that those women who do not make bond and are held for trial are detained excessively relative to the types of offenses committed. This is particularly true for black female offenders.[14]

The ABF data reveal that women defendants were not discriminated against in other formal protections for the innocent such as receiving a preliminary hearing and representation by legal counsel. But women were less likely than men to have a jury trial, an important safeguard for innocent defendants. In fact, this difference is even more detrimental to women since both juries and judges tend to be partial to women criminal defendants, and "juries are less likely to convict than judges"; but more importantly, juries may be "especially sympathetic to women relative to men in more serious crimes and also in less manly crimes."[15] Nagel and Weitzman suggest that the women's larcenies and assaults may have been less severe than the men's and thus did not warrant a jury trial; or another possible explanation for the disparity could be that "judges may feel that both juveniles and women should be treated in a more informal, more fatherly, less legalistic way, and that jury trials and defense counsel interfere with such paternalistic informality."[16]

More recent analyses of differences in the treatment of adult criminal defendants utilize multivariate statistical measures to control simultaneously for a number of variables which, in addition to gender, might contribute to alleged differential criminal justice processing. The Nagel and Weitzman study is important as a seminal work because it used national data and contained a large number of cases, but it has several shortcomings pointed out by recent critics.[17] First, the research was based on nationwide data gathered by Lee Silverstein in

1962, and in light of today's events and arrests, findings almost two decades old are questionable, especially for comparisons with more recent, sophisticated studies of the identical problem. Second, only two categories of crime—grand larceny and felonious assault—were examined, to the neglect of nonserious and minor crimes, or those for which most women are arrested. Third, other possible significant variables such as prior record and extent of involvement in the offense were exluded. These research omissions should be kept in mind as we scrutinize more recent studies concerned with sex differences in judicial treatment of offenders, since many of them also fail to consider or control for potentially important variables.

A study of all felony cases disposed of in Alabama in 1974 approached the bail issue in a more detailed fashion by looking at the amount of the bond and whether the male and female defendants were released on their own recognizance.[18] In the latter instance, over twice as many men were released without posting a financial bond. When the amount required to be posted was examined, there were no significant sex differences in the overall sample, but there was divergence when the most frequent bond of $1,000 was set. A larger proportion, or 45 percent of the women defendants in the Alabama sample, were assigned $1,000 bonds compared to only 31 percent of the male defendants so assigned.[19]

Another pretrial discretionary practice examined by both the Alabama and the nationwide studies concerns appointed counsel. It is recalled that Nagel and Weitzman report that the female defendants were not discriminated against in terms of representation by legal counsel, although they did not indicate the proportions of court-appointed and privately retained lawyers. While 28 percent of the male defendants in the Alabama study had attorneys appointed by the court, 36 percent of the female defendants were afforded this right; however, the difference was not statistically significant.[20] A possible racial bias is indicated by the fact that only 26 percent of the black female defendants had court-appointed counsel compared to 42 percent of the white females. The authors find this particularly curious in light of the fact that the median income of black families in Alabama at that time was one half of that of white families in the state.[21]

Trial and Sentencing Outcomes

Critics who view the criminal justice system as discriminatory against women offenders base their arguments primarily on evidence that female criminal defendants are (1) the main victims of indetermi-

nate sentencing with the result that longer sentences are imposed upon them;[22] (2) more likely to be sent to more restrictive institutions such as penitentiaries than men guilty of the same crimes, who are confined in jails;[23] or (3) incarcerated for lesser offenses than those committed by men [24]—for example, prostitution, where "today there are women in jail who are virtually serving life sentences in small 'bits' for prostitution offenses."[25] However, the preponderance of empirical evidence indicates that women are generally afforded preferential treatment by the criminal justice system.

The nationwide American Bar Foundation data reported by Nagel and Weitzman show that in both types of offenses examined, grand larceny and felonious assault, women were more likely to be dismissed or acquitted than men. If convicted, 64 percent of the women who committed grand larceny received suspended sentences or probation, compared to only 43 percent of the men. A lesser tendency toward leniency was seen in the felonious assault cases, where 44 percent of the female defendants and 36 percent of the male defendants were accorded these dispositions. In fact, women were slightly more apt to be jailed than men in assault cases compared to larceny cases, a finding Nagel and Weitzman attribute to the fact that "assault is a more manly crime than larceny, and women are therefore treated more like men when they commit assault than when they commit larceny."[26]

Comparisons between the sexes on length of imprisonment in the ABF study reveal that even though women were more likely to be jailed, they fared better than men who committed felonious assault, since 89 percent of the female defendants received less than one year compared to 57 percent of the men. Oddly, an opposite finding is reported for the grand larceny cases, where women defendants were less likely to be jailed for under a year (33 percent) compared to men (45 percent).[27] This is an unusual finding when one weighs the seriousness of assault offenses against larceny offenses. Nagel and Weitzman do not explain this curious outcome, but it is possible that the judges viewed felonious assault as less premeditated and more of a passionate response by females. Some empirical support for this notion is seen in a New York study of charge reduction in criminal cases, reported by Bernstein et al.[28] These researchers found that defendants prosecuted for assaults were more likely to receive a more favorable reduction in sentence than burglars, robbers, and those prosecuted for larceny. They explain this unexpected result on the spontaneity of the offense as contrasted to premeditation:

> Since premeditation may be indicative of culpability, persons charged with assault and other spontaneous crimes may be more favorably

treated by the courts. Additionally, we observed that the overwhelming majority of assault cases processed were alleged to have occurred between friends and relatives. Since the court under observation serves a lower-class catchment area, the victims of these assaults are lower-class persons themselves. Thus, the leniency accorded to assault cases may additionally reflect the court's adoption of a street-wise definition of assaults as routine for the lower-class culture, thereby reducing the appropriateness of a more harsh societal response.[29]

Also contrary to the arguments of critics of the criminal justice system, the ABF data reported by Nagel and Weitzman reveal that convicted female defendants were less likely to receive indeterminate sentences (27 percent) than men (35 percent). Other contemporary studies of disparities in the criminal justice system further demonstrate that women are handled more gently by the courts, particularly in California.

Rita Simon chose the California court system for a comparison of longitudinal trends (1960–1972) because this system not only offers the most comprehensive statistics on convictions and sentencing compared to the other states, but also the conviction rates in California can be generalized to the rest of the country.[30] Between 1960 and 1972 there was a 31 percent increase in the proportion of women convicted for all crimes in California Superior Courts. Over this time span female drug law violations dramatically increased, and by 1972 such offenses accounted for 43.5 percent of all female convictions. The proportion of females arrested for property offenses also increased during this period, but the conviction rates for these offenses decreased by 13 percent. On the other hand, although violent offenses among female offenders declined, women were more likely to be convicted for such offenses in 1972, seen in an increase of 29 percent, than they were in the early 1960s.[31]

Simon also examined Ohio female convictions, 1969–1971, and reports data comparable to the California statistics. In both states drug violations and forgery were the offenses for which women had the highest conviction rates.

In comparisons of California men and women who pleaded guilty and were convicted, for all offenses between 1969 and 1972, "there is no greater likelihood that men will plead guilty than women; and indeed, the proportion of men convicted is not significantly higher than the proportion of women convicted."[32] Further, more women who pleaded not guilty were acquitted than men with the same plea. And finally, those women convicted of "masculine" type offenses such as robbery, burglary, and auto theft were treated "at least as preferen-

tially as women who are accused of larceny, an offense that is more typically associated with women."[33] Simon considers this finding to be a refutation of the Nagel-Weitzman assumption that women who commit male-type offenses are treated more similarly to men by the courts.

An additional challenge to the Nagel-Weitzman position is reported by Carol Fenster in her recent unique study of district court processing of females in a large western community.[34] Two groups were compared: females who commit crimes with other females (FF) and females who commit crimes with male partners (FM).

The FF group was predominantly nonwhite (44 percent Hispanic; 19 percent black), single, and either on welfare or supported by relatives; more than two thirds had prior juvenile or misdemeanor records, and more than one third had minor children to support. FF females were more likely to commit property crimes, as seen in the following percentages: burglary (25 percent), larceny (19 percent), forgery (10 percent), narcotics violations (25 percent), and robbery, assault, and receiving stolen property (20 percent).

In contrast to the FF group, the FM females tended to be white, either married to or involved romantically with their male criminal partners, supported by their husbands or relatives and not welfare; less than one half had prior criminal records, and more than half had small children. FM females had a propensity toward the commission of victimless crimes—narcotics violations, for example.

One final characteristic of the two groups of female defendants concerns the roles played by the women in the commission of the crimes. Both women in the FF pairs participated equally in the offense, but the FM females were equal in only half of their cases. In those cases where the FM women had unequal roles in the crime, their participation was usually subordinate to the male partner.

Interesting differences were found between the two female groups in the pretrial and sentencing stages. Although little difference is reported on receipt of bail or type of bonding (personal recognizance vs. a monetary bond), the mean amount of the bonds was over $1,000 higher for the FM females than for FF females. Second, the FF females who were incarcerated before trial were held an average of only five days, as contrasted to the fourteen-day mean of pretrial detention for FM females. Third, almost twice as many FM offenders (50 percent) were denied a deferred disposition, in essence a filtering out of the system, than FF females (26 percent), but the FF offenders were more likely to receive the harsher deferred judgments. Fourth, of those women who were fully adjudicated, a slightly higher proportion of FM females (14 percent) received jail sentences than the FF

group (10 percent). And finally, FF females were also slightly more likely to receive probation (90 percent) than FM women (86 percent).

In sum, Fenster reports that compared to FM females, who committed their crimes with male partners, the FF females were generally treated more favorably by the criminal justice system despite their nontraditional life-styles, previous contacts with the system, more serious "masculine" offenses, and the tendency to use weapons in the commission of those crimes.

One reason Fenster suggests to explain harsher treatment of FM women is that judges usually give similar punishment to offenders charged with identical offenses. Her data provide some support for this position, since 44 percent of the FM females received identical final dispositions as their male partners in crime. But, interestingly, only 19 percent of the FF group received the same sentence as their female partners.

These provocative findings certainly offer an exciting challenge for future researchers investigating criminal justice outcomes for female offenders, but bring us no closer to a clarification of the judicial vagaries affecting women defendants in court.

A California study by Carl Pope examined twelve counties for the three-year period 1969–1971 and further refined the analysis of male/female sentencing practices by introducing more controls than previous studies.[35] The total data set included 32,694 male and female felons, and each case was analyzed on the basis of the original charge rather than the conviction offense. This was done in order to obtain a truer picture of the actual crime before, for example, plea bargaining or some other process reduced the charge. Additional controls were the use of other social and legal variables besides sex: race, age, prior record, and criminal status at the time of the arrest. Pope further divided charge at arrest into violent, property, drug, and "other" residual offenses. Another breakdown of the data entailed the division of the sentencing process into type of sentence (probation, incarceration, "other") and length of time sentenced if probation or incarceration were the dispositions.

Pope is critical of prior sentence disparity studies that center on felony defendants coming before either superior or federal district courts to the neglect of municipal court level outcomes, where a "substantial proportion of all felony cases are actually adjudicated."[36] To circumvent this problem another control was added, level of the sentencing court. Finally, Pope introduced a geographical factor, urban versus rural court sentencing. Nagel and Weitzman had separated their cases into property and persons offense categories because differential treatment in rural and urban courts had been noted relative

to these classifications. Rural courts were more sensitive to property crimes, while urban courts tended to be censorious when person crimes were involved.[37] Pope therefore added the urban-rural dimensions (ten rural, two urban counties) to compare possible differences in urban and rural crime patterns and sentencing.[38]

Overall, Pope found that women were more likely to be treated more favorably than men at both the lower (municipal) and superior court levels. In the lower level urban court female defendants were less likely to be sentenced to jail (31 percent) than male defendants (42 percent), and they more frequently received probation (64 percent and 51 percent respectively). The urban superior court data revealed even smaller differences on these sentencing variables, since 20 percent of both males and females went to prison; 47 and 46 percent respectively were sent to jail, and a slightly higher proportion of urban female defendants received probation (32 percent vs. 24 percent).

Rural women defendants did not fare as well in the lower courts as their urban sisters. With the exception of probation, which was granted to 46 percent of the women compared to 35 percent of the men, the overall sentencing differences between rural female felons and their male counterparts were not substantial. The rural superior court sentences were also very similar for men and women coming before these benches, as indicated in the following standardized proportion differentials: only 1 percent more men were sent to prison; 6 percent more male felons went to jail; but 8 percent more rural female defendants received probation. When prior record was controlled, the sentence outcome differentials between the sexes decreased sharply for both urban and rural areas.

Severity of the disposition as measured by sentence length was broken down into 60 days or less, 61 to 180 days, and more than 180 days for each type of geographic area and for both lower and superior courts within these areas. Controlling for previous record, Pope reports that men received the most severe sanction of more than 180 days in urban lower courts (24 vs. 21 percent), urban superior courts (54 vs. 37 percent), and rural superior courts (44 vs. 34 percent); but women fared slightly worse in rural lower courts (9 vs. 8 percent). When prior record was not introduced, women defendants in the rural courts generally received shorter sentences than men. Identical findings for all categories are reported for all cases where probation was the sentence.

Pope's results indicate that women defendants were more likely to receive more lenient sentences than men defendants in both municipal and superior California courts. When prior record was controlled,

these relationships disappeared in superior court dispositions but equalized in the lower courts. Overall, urban women defendants fared better in court than their rural sisters in California.

Another California study reveals a consistent picture of more favorable sentencing patterns for women in California superior courts.[39] In 1974 twice as many female defendants received probation (42.4 percent) compared to men (20.1 percent), and only half the proportion of women were accorded prison sentences (6.6 percent) relative to men (15.9 percent). Men were also the only recipients of death sentences. When race was controlled, women were still found to receive less severe sentences than men despite racial status, but within-sex comparisons reveal that nonwhite females were more harshly treated by the courts than white females.

Proportionately more women were sent to prison for sex law violations in this California study, but it was the only offense that differentiated the sexes. Generally, the more severe the crime, the harsher the sentence imposed, regardless of sex. Controlling for prior record continued to indicate a pattern of more favorable treatment for each of the three categories defining this variable: no record, a prior record with no prison commitment, and a prior record with one or more previous commitments. In sum, "controlling for race, type of crime, and prior record has resulted in the same basic pattern: consistently less harsh treatment for women than for men."[40]

Finally, a study of all 1973 arrests in Washington, D.C., of which 16.4 percent were women, offers additional evidence to contradict the notion that women accused of manly offenses are handled more punitively by the court: "for 'male-type' violent and property crimes, females had their cases dropped more frequently, and males were more often found guilty," whereas "for 'female-type' victimless crimes, the picture was reversed, and males enjoyed more leniency."[41] The researcher, Susan Katzenelson, felt that differential judicial treatment was related to the marginal position of females in a male world. When women commit men's crimes, they are patronized by the courts; but when they are involved in female-type offenses, women are punished more severely for violating society's view of female morality and for threatening the social order through such misbehavior.

Another way to look at the problem that might reconcile the positions of Nagel and Weitzman, Simon, and Katzenelson, is that women who commit "masculine" crimes may also be seen as superseding their assigned sex role. Therefore the predominantly male courts may be punishing them more severely for the role transgression and not for the law violation. Bernstein et al. address such a possibility in their New York charge-reduction study:

In the case of criminal justice processing, females may be less favorably responded to not because of their powerlessness, but rather because expectations for them are higher. That is, unlike their male counterparts, females are presumed to be less likely to engage in law-violating behavior. As such, when they are prosecuted for the kinds of serious non-female-type offenses here examined, they may be more severely responded to because they are violating expectations for appropriate sex-role behavior as well as appropriate law-abiding behavior.[42]

Bernstein et al. found that female defendants in the state of New York were more likely to have their charges reduced than men. If the women pleaded not guilty, only 3 percent were ultimately found guilty compared to 20 percent of the men in this situation. Significantly higher proportions of the female defendants also had their sentences reduced, probably as a result of plea bargaining. Although the proportions of men and women receiving suspended sentences were the same, a higher proportion of men received concurrent sentences, while women were more likely to be afforded consecutive sentences. Whereas this finding suggests more favorable treatment toward the male defendants, Bernstein et al. question such an interpretation because of the small number of women in these categories. Finally, if convicted, females in this study received shorter sentences than the male defendants. These researchers caution us that the shorter sentences of women may be related to either differential treatment or to the nature of the offenses committed, but the small number of women in the total sample again prevents any resolution of this question.

The Elements of Disparate Sex-based Sentencing

The above research efforts indicate little doubt that women defendants are not treated as severely as men who come before U.S. criminal courts. Unfortunately, the reasons why this difference in treatment occurs are not clear, although several writers speculate that antecedents such as "chivalry" or "paternalism" offer the best explanations for the phenomenon. In a recent article Steffensmeier adds "naïveté," "practicality," "perceived permanence of behavior," and "perception of dangerousness" as possible contributory factors to an issue he views as far more complex than the paternalistic conception warrants.[43] The following examination of each of these abstractions offers an indication of the abstruseness of this controversial subject.

The notion of chivalry centers on the premise that women require protection and men are the exclusive providers of that protection.

The genesis of this concept is traced to the Middle Ages in Europe when knights were sworn to protect "ladies" from "dragons and devils."[44] Thereafter a code of proper behavior toward women developed and became a part of social convention. Today some writers believe these social amenities are reflected in judicial leniency by predominantly male judges who view women as weak, dependent, and passive. For instance, Pollak, in *The Criminality of Women,* draws heavily upon this premise in his thesis of female criminals, when he observes:

> One of the outstanding concomitants of the existing inequality between the sexes is chivalry and the general protective attitude of man toward woman. This attitude exists on the part of the male victim of crime as well as on the part of the officers of the law, who are still largely male in our society. Men hate to accuse women and thus indirectly send them to their punishment, police officers dislike to arrest them, district attorneys to prosecute them, judges and juries to find them guilty, and so on.[45]

There is a paucity of empirical evidence to support allegations of the chivalry of judges, and what literature is available on the subject is for the most part descriptive and anecdotal,[46] which leads one criminologist to conclude that the idea of a "chivalrous" justice system is a myth since "among women offenders themselves, for instance, it is a well-documented fact that Blacks fare worse in the justice system than Whites."[47]

Paternalism is a more insidious concept than chivalry because it stems from a "power relationship of male domination" that connotes the superiority of men and the inferiority of women, according to one writer, who warns:

> It is important to be wary of a society which permits paternalism to color the perceptions of those who make and enforce the law. Those perceptions profoundly affect behavior of those in power and the behavior of those paternalized in a manner that is inconsistent with the operation of a democratic state. A basic denial of self-determination is what is taking place.[48]

Another sex-role stereotype that allegedly impacts on judicial verdicts favoring women defendants is the concept of naïveté. Women are seen as "less capable than men of committing criminal acts."[49] One researcher cites the following example as illustrative of the naïveté attributed to female defendants: "Judges often say that they cannot help but compare women defendants with other women they know well—namely, their mothers and wives, whom they cannot imagine

behaving in the manner attributed to the defendant."[50] It is difficult
to determine from this example which of the involved parties are
naïve, the judges or the defendants.

Preferential treatment of female offenders based on practicality
tends to focus on those women who are mothers. As we will see in
Chapter 12, the psychological effects associated with the incarceration
of a parent are detrimental to the emotional well-being of both the
mother and the child. Moreover, if the female offender is the primary
caretaker of her children, this financial responsibility will have to be
borne by relatives with possible help from the community, or by the
social welfare system itself.[51] It has been suggested that the influence
of parental status on more lenient judicial decisions may be another
myth, since at least one experimental test of this notion revealed that
being a parent did not favorably affect sentencing.[52]

Fundamental to the view of perceived permanence of behavior is
the previously noted idea of rehabilitation of women offenders. Many
judges feel that women are more capable of reform than men since
females rarely exhibit the criminal tendencies of men.[53] Not only are
women offenders perceived as being more receptive to change, a few
studies have shown that "female offenders are, in fact, more amenable
to treatment and less likely to recidivate than male offenders."[54]

Finally, perception of dangerousness as a rationale for disparate
sentencing based on sex concerns the potential threat to society pre-
sented by the offender. Men are seen as more dangerous criminals
than women offenders because of such male characteristics as ag-
gressiveness, greater physical strength, and superior physical prow-
ess.[55] People fear male criminals but tend to be less frightened by
female offenders—a fact that causes one writer to comment, "There is
good reason to believe that the danger and fear factor is the major
variable accounting for sex differences in criminal justice out-
comes."[56]

Clearly, there is no single determinant of sex-based differential
sentencing, assuming such a phenomenon exists. Since extensive sys-
tematic research is needed to resolve the question, an obvious first
step in this direction would be a comprehensive assessment of a sam-
pling of judges to ascertain their rationales for sentencing and "which
women inspire the most chivalry."[57] Previous studies of sentencing
judges suggest that in addition to legal factors such as seriousness of
the offense and prior record, the personal history of the judge, his
personality, the social traits and personal characteristics of the defen-
dant, are influential in the decision-making process.[58] Many of these
studies were done in the 1930s, but even more recent efforts lack the

methodological rigor necessary to prise out the basic motives of judges.[59] Until the shortcomings of past research efforts have been circumvented by more directed and intensive measurements of judicial attitudes toward the offenders whom they sentence, we will undoubtedly remain locked into myths and mystified by innuendo on the subject of differential sentencing based on sex status.

section five
females and the correctional system

10

correctional institutions for girls

The voluminous literature on incarcerated females, especially imprisoned women, is in distinct contrast to the lack of systematic information about females' progression through other points in the criminal justice system. Despite the fact that corrections is written about more than any other topic concerning female offenders, the content of the literature is overwhelmingly concerned with dramatic case studies or "war stories" of female inmates told to a third party, autobiographies of prisoners either before or after release, histories of the development of female prisons, and the like.[1] Extraordinary interest has also been devoted to the social networks or "family" groups established by females in institutions, the homosexual patterns of these and other inmate groups, and extensive descriptions of female inmate argot.[2] Therefore, with the exception of a few empirical studies and government reports, for the most part the problems and programs of incarcerated females have not received much attention. Furthermore, proportionately more literature has been devoted to the adult female prisoner than to the incarcerated girl, an omission that may have contributed to the lack of public awareness of the serious plight of such children.

One specialized institution established for the confinement of adolescents is the closed institution, usually called a state training school, or long-term facility.[3] Training schools are found in every state but Massachusetts, which closed its seven training schools between 1971 and 1973 except for the Lancaster Training School for Girls, which did not close until July of 1975.[4]

Until the first House of Refuge for children was established in 1825 in New York City, neglected and delinquent children were placed in the same facilities as adults—prisons, jails, and almshouses.[5] These places not only held dangerous criminals but also contained drunks and insane adults to whom children were exposed under unbelievable

and inhumane conditions. Although children are still held in jails throughout the country, federal guidelines in the Juvenile Justice and Delinquency Prevention Act of 1974 prevent such placements if the state desires to maintain eligibility for federal funding of its juvenile programs. This measure has helped to reduce the practice of housing minors with hardened criminals, but has not eliminated the problem.[6]

Kenneth Wooden, whose comprehensive study of juvenile institutions, *Weeping in the Playtime of Others*, exposes the horrific experiences of incarcerated children as a national disgrace, describes two types of training schools: "one, a miniature penitentiary with high walls, locked individual cell doors, solitary confinement and bloodhounds; the other, the most common type of training school, the cottage system introduced in 1856 to give children a semblance of home life, with 'house parents' in dormlike structures set in quiet, pleasant areas."[7]

As of 1977 there were 7,175 juvenile female residents in public institutional facilities in the United States,[8] a decrease from the 12,948 held in 1971. Of this number 4,767 were in long-term facilities. Together, the short-term facility, which has an average stay of fourteen days per resident, and the long-term facility which has an average custodial period of 184 days, cost $708 million per year. The per capita cost of $14,123 for each child held in 1977 is double the 1971 figure of $7,002. Juvenile incarceration is a costly business not only in terms of public expense but, more importantly, in human costs. The situation is particularly staggering when one examines the reasons why girls are in these institutions.

The Offenses of Girls in Training Schools

We earlier found that more than twice as many girls as boys are charged with status offenses. While there is a strong movement to remove status offenders from penal institutions, large numbers of girls are incarcerated for such offenses as well as for other minor offenses. In a one-year study of incarcerated male and female youthful offenders in Connecticut, 18 percent of the boys were originally committed for status offenses as compared to 80 percent of the girls.[9] A national study by the National Assessment of Juvenile Corrections (the NAJC Study), undertaken between 1972 and 1974 in sixteen randomly selected institutions in eleven states, found that the proportion of girls committed for status offenses was twice as high as the proportion of boys.[10] Only 32 percent of the girls in the NAJC Study were institutionalized for criminal acts, while 74 percent of the boys were. The major status offense for which the girls were incarcerated

was running away from home (57 percent). Wooden's national study reveals that many of the incarcerated girls were confined only because they had participated in sexual intercourse, thus supporting the contention that "female care and supervision within the penal system are steeped in sexuality."[11] Wooden also cites a 1971 Law Enforcement and Administration of Justice Study that found two thirds of the girls held in institutions around the country to be status offenders compared to one third of the boys so classified.[12]

The American Bar Association Survey of State Training Schools (ABA Survey) in 1974 found that "many girls are sent to institutions not because they are dangerous but simply because there is no other place for them."[13] This is especially true of females in need of supervision (status offenders), who constitute one out of every five females confined, compared to one out of every twelve males confined, the ABA report concluded. Community-based alternative programs such as halfway houses and group homes are comparatively rare sources of referral for girls, who usually end up "dumped" in state training schools.

At least in one state, Minnesota, the situation appears to be improving for some girls. A recent study in that state found that female status offenders were only slightly more likely to be institutionalized (69.7 percent) than male status offenders (61.6 percent); girls who committed criminal offenses were more apt to receive probation (40 percent) than boys (15.2 percent) and were not as frequently sent to institutions (60 percent) as boy delinquents (84.4 percent).[14] In Minnesota the final decision to keep a child incarcerated is the result of a diagnostic evaluation or "staffing." This process takes place at the institution and in a sense is the final disposition of the case. Either the youth is admitted to the treatment program of the institution or released back into the community. On the basis of this 1977 study, these decisions did not support the idea of "a sexual bias in the processing of delinquents at the institutional level," but did indicate "a possible double standard in the processing of status offenders." According to the researcher, it is possible that the lack of available community placements for girls might have been an influential factor.

Location and Size of Juvenile Female Institutions

Typically, most inmates of penal institutions are from large, metropolitan areas of a state. For instance, Giallombardo's comprehensive survey of girls' correctional institutions revealed that 86.8 percent of the female inmates in the Eastern facility, 79.5 percent of the girls in

the Central, and 73 percent in the Western institution were from cities and metropolises over thirty thousand in population.[15] With the exception of Western, the majority of the girls were from areas of over a hundred thousand population (Eastern 81 percent; Central 62.8 percent; Western 43.4 percent). Also typically, the institutions are geographically located in rural areas far from the girls' home communities. In the ABA Survey, for example, 11 percent of the male institutions were located in urban areas, but not one of the female institutions was.[16]

Many serious consequences are associated with the locating of these training schools so far from a girl's home. Judge Norma Johnson finds the situation particularly difficult for teen-age mothers, and also points out that the denial of opportunities to associate with nondelinquent male peers "prevents the young woman from developing, during those crucial adolescent years, the ability to deal with males she will encounter once released to the outside world."[17] The little heterosexual interaction permitted institutionalized girls is generally limited to social events with boys from a training school, although some facilities permit rare socializing with local boys or those from nearby military bases.[18]

In addition to the deprivation of social exchange with "normal" boys, Giallombardo describes other problems attributed to the location of training schools far from urban centers: barriers to communication with the outside world; difficulty in recruiting staff, particularly persons who have rapport with city-bred girls; lack of treatment resources; and limited transportation and access to the institutions, which hinders visits by parents, relatives, and friends.[19] Under such circumstances it does not take very long before a girl's ties with the external world are seriously weakened.

The NAJC study found the isolation to be even more pronounced for female status offenders because they were not allowed to leave the institutions as frequently as other inmates. The outings allowed actually contributed more to their isolation, since their shopping and field trips were limited to groups and they were not allowed to have contact with outsiders. The stigma of traveling in buses and vans labeled with the training school name added to feelings of isolation and of being different.

Rigid visitation guidelines for family and friends were another source of isolation reported by the NAJC study. The situation was exacerbated by restrictions on phone calls and correspondence with parents and friends. Such contact was difficult enough because over half of the children were more than seventy miles away from their homes.

A recent trend to house both sexes in juvenile institutions is seen in a 22 percent increase in all facilities admitting both boys and girls between 1971 and 1974.[20] In long-term correctional institutions the increase for this time span was 107 percent, and reflects a 66 percent increase in sex integration among training schools. While these facilities have their own types of problems, one-sex only institutions have been found to be more psychologically abusive to girls than to boys. One of the factors responsible for this discrepancy is the size of the institution.

In contrast to the extensive overcrowding in adult prisons, juvenile correctional facilities are not operating to full capacity, even though staff size and expenditures continue to rise.[21] Whereas one in ten of these public institutions was occupied in excess of capacity in 1977, one in three was used at less than a 70 percent of capacity rate.[22] Female institutions are less likely to be filled to capacity (76.6 percent) than male institutions (97.2 percent), and also tend to be smaller.[23] Several negative outcomes result from the smaller size of female juvenile facilities—scarcity of recreational, educational, and vocational programs, more stringent rules and security regulations, reduced medical care, and inadequate psychological treatment programs.

Visits to adolescent female correctional institutions reveal that security in girls' facilities is more stringent than in boys' facilities of the same kind. Wooden, for example, found that "rules were more rigid, fences were higher, confinement cells smaller" in girls' institutions throughout the country.[24]

The smaller size of girls' training schools is, of course, due to the smaller number of incarcerated girls. The ABA Survey found that 81 percent of the male institutions had a capacity of at least 150, but only 16 percent of the female institutions were that large.[25] Girls' facilities are often described as resembling college campuses. Although most juvenile institutions are not totally enclosed with walls and high fences, and thus may be considered physically attractive, the main purpose of these training schools is punitive and custodial.[26] The preoccupation with detention and discipline in girls' correctional institutions is most vividly seen in the overemphasis on enforcing rules and regulations.

Social Control in Girls' Institutions

The Connecticut study of incarcerated youths mentioned above showed clear sex differences in methods of social control. Girls had fewer rights than boys in the institution: an earlier curfew, an isolation

room, no home newspapers, guarded mail, and no cigarettes. Boys, on the other hand, did not have these restrictions and deprivations in the training schools of Connecticut. The ABA national survey also found that female correctional facilities had the most restrictive policies for visiting privileges compared to male and coeducational institutions, both of which allowed more frequent home visits and more frequent visiting hours.[27] Giallombardo describes practices in girls' training schools that resemble those of adult prisons, such as mail censorship and extremely limited visiting privileges, which further isolated the girls from contact with the outside world.[28] She cites long lists of written rules given to the inmates which contribute to the picture of these institutions as "miniprisons."[29]

Females have little privacy in juvenile institutions and are kept to a rigid time schedule not experienced by their male counterparts. Every facet of life is stringently controlled—a time to get up, to eat meals, to attend activities, to go to bed—and always repeated head counts are made during the day and the night. Whereas boys ordinarily have dormitory facilities, the usual arrangement for girls is private rooms. They are locked in these rooms at night, and as a result even going to the bathroom becomes a serious problem. If a staff person can be summoned, the girl may be successful in getting her door unlocked to use toilet facilities; if not, she is forced to use a trash receptacle, coffee cans, or whatever is available, much to her humiliation. As one girl describes the experience:

> It's kind of an indignity having to go in the trash can. But it's been going on for a long time. When I was here before (1966), you peed in the trash can. At night you bang on your door and the staff says: "I've got to see if I can get Security." That sometimes takes a while, so you end up using the trash can. Then Security comes up, and if you don't go, you get fined or get written up for defiance. So you go into the fuckin' bathroom and you pretend you're going, and you fiddle around washing your hands, and you go back to your room. It's weird.[30]

If a girl violates one of the numerous rules and regulations, the punishment can be quite out of proportion to the infraction, and usually involves isolation in stripped security rooms. Although it is probably the extreme, one psychologist described an isolation cell in one institution chillingly: "The room was large with a high ceiling. In the middle stood a cage, a gigantic bird cage, human-sized. The wrought-iron bars were worn chest high to a pewter polish from the hands that had clung there. The cupola was circuslike."[31] During his

tenure in this girls' institution one girl placed in this cage hanged herself.

Tranquilizers are frequently used as a social control measure in female institutions, and handcuffs and straitjackets are additional means of restraint and control. In many states girls of all ages are handcuffed together when they are transported to and from the training school. This preventive measure is allegedly practiced to keep the girls from running away.

Running away from the institution is a very serious offense because "it represents, in the last analysis, the ultimate negation of authority."[32] Inmate escapes are also frequently considered a source of embarrassment to the institution. Thus, every attempt is made not only to contain the girls through harsh rules and regulations but also to capture them if they run away and punish them severely when they are caught. In his revealing *The Wire Womb* psychologist Henry Lampman describes life in a girls' penal institution and gives this account of the desperation of both the girl and the staff in an attempted escape:

> As I approached the administration building, women began to stream out. Some leaped into parked cars, started the engines, and streaked off to the gates. Others ran headlong across the field to the south, where a young, dumpy-looking girl was scaling the fence.
> The ten-foot high, chain-link fence was easy to climb, except for the top, across which was strung three strands of barbed wire. The girl was unable to climb over the wires but was squeezing herself through them. As the women approached her, she panicked, lost her grip, and fell through the barbs, tearing her clothing and skin. She picked herself up, and, clutching her torn clothing, scrambled into a nearby irrigation ditch. By that time, one of the cars drove up. Several women hurried out; they surrounded and seized the frantic girl.[33]

When a girl who runs away from a correctional facility is returned to the institution, the usual type of punishment for this infraction is "punitive segregation,"[34] a form of isolation that includes the revocation of privileges such as mail, visiting, smoking, school attendance, and participation in school activities. While in seclusion the girl is not permitted to wear clothes other than night apparel. All meals are eaten with a spoon (usually plastic) in the seclusion room, where the child remains until she learns to conform and is aware of the errors of her ways. Since her "ways" are quite often diametrically opposed to staff notions of how young ladies should comport themselves, extended stays in punitive confinement are frequently the norm.

The staffing of girls' correctional facilities offers a tragic, paradoxical situation. While most of the girls in such institutions are from

urban areas, the majority of the institutional staff has lived and been raised in rural communities or small towns. They are not familiar with, nor equipped to understand, the background and needs of urban youth. Also, most of the staff members are white, whereas the racial composition of the inmates is often predominantly nonwhite.[35] Thus, not only are geographical dissimilarities a potential problem, but also racial and ethnic differences contribute to the schism between inmates and staff.

An additional staff characteristic that separates the girls from their keepers is noted in one male psychologist's impression of the female staff in his institution: "I sensed something was curiously missing, and reflecting upon it, became aware that I had not met one married woman graced with the bloom of mature love. They were spinsters, widows, or very young women. Chastity—that was the criterion for employment here".[36] Chastity as a norm for institutional staff members, most of whom are female, is antithetical to the experiential background of the girls, many of whom are institutionalized for youthful sexuality and have had totally different sex experiences than the female staff who monitor and control them. The attitudes of incarcerated girls toward the staff were noted as "antagonistic" in the NAJC national study, with female status offenders significantly less likely to trust staff or feel that the staff cared about them.[37]

In a 1962 study of delinquent boys in residential treatment the "cottage parents" reported that the youngsters could not be controlled without their cooperation, which was secured with friendliness.[38] Of course if the cottage parent was too friendly, his or her authority was endangered. An examination of this question was undertaken by the present author through a survey of nineteen "family instructors" who were surrogate parents directly responsible for the care and social development of girls in an urban institution for delinquent girls.[39] In all cases, and as a total group, the respondents disagreed with the statements that most delinquents cannot be trusted and may attack you unless you are careful. On the contrary, they felt that most youngsters will respond to friendship (89 percent) and sympathetic understanding (79 percent), which entailed being close to the girls but not so close as to jeopardize staff position and authority.

The excessive emphasis on sexuality that is decidedly peculiar to female institutions is further seen in the exorbitant interest in the physical condition of the girls, particularly concerning virginity, pregnancy, and venereal disease. In one institution, for example, "physical examinations of girls being admitted to the Sheldon Farm for girls in Pennsylvania determine whether they are virgins or not. Virgins are assigned one color dress; all others wear a different color."[40]

Other indications of overreaction to youthful sexuality are reflected in the ABA finding that girls in coeducational institutions were more frequently given vaginal examinations upon returning to the institution from home visits than girls in all-female institutions.[41] The NAJC study found that one set of procedures included the compulsory gynecological examination of girls who were truant, nine days after their return.[42] In this same institution, nurses were required to keep a record of the girls' monthly menses in order to detect possible pregnancies. Another study describes the "Monthly Menstruation Report" in a Texas facility posted "on the door of all female cottages which lists every inmate (regardless of whether she menstruates or not) and records the onset and finish of each menses."[43] The purpose of this practice is obscure.

All of the female and coeducational institutions in the ABA Survey gave tests and treatment for venereal disease. In a previous chapter we noted the humiliating practice of exposing young girls to traumatic physical examinations as a part of their juvenile court experience. It is highly probable that the same girls, if incarcerated, must again experience such examinations, although in most cases, they have never been out of custody! As one researcher discovered;

> Examinations for venereal disease are carried out with outrageous frequency. Young ladies in custody have been known to undergo as many as three or four pelvic exams for the disease. At some facilities, ten-and-eleven-year-olds are forced to submit to "vaginals" each time they are transferred to a new facility, even though they have not been released between placement [sic]. In one town in Louisiana two detectives complained to me about the county coroner, who forcefully examined all runaways: "You know when he is working because you can hear the young girls screaming at the other end of the hall."[44]

Despite testing for pregnancy many juvenile institutions housing females demonstrate little interest or concern for sex education or contraception for their wards. In at least two of the girls' programs in the NAJC study no contraceptive devices were provided, and those girls already on birth control pills were prevented from continuing to take them after entry into the institution.[45] The ABA survey also found that girls in coeducational institutions were less likely to be provided contraceptives than girls in the all-female institutions. Yet girls who were pregnant were more likely to be permitted abortions in the coed institutions (55 percent) than in the all-female institutions (47 percent).[46] Some institutions force girls to agree to abortions or suffer the consequences of solitary confinement. In fact, this form of

isolation is often used as a punishment for having gotten pregnant in the first place.[47] If a girl succeeds in having her baby, she is frequently pressured to put the child up for adoption, often to her later regret.

Such inconsistencies in the handling of the sexuality of institutionalized girls clearly highlight the extent to which staff are out of contact with the contemporary youth culture. This is especially puzzling considering the information frequently given in the media that more than 50 percent of adolescent females are sexually active, regardless of race and social class.

Institutional Programs for Girls

Not surprisingly, academic and vocational programs, and the few job opportunities available in juvenile female institutions, emphasize the traditional female roles of wife, mother, and homemaker.[48] The disparity between the educational opportunities afforded male inmates and female inmates is generally seen in the lack of accreditation of girls' academic programs, and the fact that girls are often denied the higher level of educational attainment boys receive.[49] The ABA survey found substantial differences in educational programs between the boys' and girls' institutions studied. For example, male facilities were the most likely to be accredited and offer GED courses, while coed institutions were most likely to offer remedial reading and other special programs. Certified teachers were rare in all-female institutions; 21 percent of such facilities had uncertified teachers, compared to only 3.8 percent of the all-male institutions and none of the coeducational institutions.[50] Also, in female training schools academic curriculum may be commingled with vocational education to the neglect of basic school preparation; for instance, "home care, home nursing, cooking, problems of family living, and sewing," were included as an important part of the academic curriculum in one of the three institutions Giallombardo studied.[51]

Vocational training in institutions for girls, if available at all, is limited because of dated, outmoded notions of the vocational opportunities open to females and in the emphasis on sewing, cooking, and beauty culture that fail to yield any viable means of future support for young women.[52] In one coed facility, for example, boys were offered a choice of training in "printing, gardening, auto mechanics, furniture repair, upholstery, shoe repair, building trade skills, and electronics," but the only trade available to girls was data processing.[53] The ABA Survey also found differences in vocational opportunities based on sex. The most frequent programs offered in female institutions were

cosmetology (56.2 percent), business education (56.2 percent), nurses' aide instruction (50 percent), and food services (37.5 percent). Boys' programs, on the other hand, included auto shop (69.3 percent), welding (50 percent), and small engine repair (38.4 percent).[54] More variety was seen in the vocational programs in male institutions, where a total of thirty-six different programs were offered, or an average of 5.5 programs per institution, compared to only seventeen different vocational programs in the female institutions, or an average of 3.3 per institution. Over three times as many female institutions (15.8 percent) as male institutions (4.7 percent) had no vocational training. Even when a potential for meaningful employment such as key punching is offered, the equipment is frequently so obsolete as to render any acquired skills virtually useless on the job market.

The emphasis on women's work is also stressed in the work assignments at female institutions. Girls are often the custodians in their places of incarceration, since they are required to do the cleaning, cooking, serving of food, laundry, and keeping of the grounds. All too often structured work experiences, or "busy work," is substituted for recreation in girls' institutions; such inmate labor is frequently called vocational training, or therapy.[55] These "prison industries" are more prevalent in female institutions than in male institutions, and girls, if paid at all, are paid less than boys for their work. The average wage for girls in the ABA Survey was twenty-five cents per hour, or one fourth of the dollar per hour minimum wage given in boys' institutions. Furthermore, female institutions were the least likely to compensate the children for maintenance jobs compared to male or coeducational facilities. Almost one half of the female institutions had no money or credit compensation (47 percent), compared to 38.4 percent of the coed institutions and 28 percent of the male facilities.[56]

The Social Organization of Girls' Institutions

The subculture of incarcerated girls has been variously called a "social world," "networks," or "survival systems" by those describing the development of "families" as a "response to the deprivations of prison life."[57] Since several researchers have depicted this informal social system in detail,[58] we will only briefly summarize the phenomena here.

All penal institutions have been known to contain some form of inmate culture that develops out of a necessity to survive the harshness and isolation of incarceration. The difference between male and

female adaptations to such deprivation is distinct, and is also related to male and female roles in our society.[59] In female penal institutions the structure that is established parallel to the outside world is consistent with the traditional female role as the bulwark of the family. Thus, the courtship, marriage, and kinship networks which incarcerated females create are duplications of the world they left behind. Both juvenile and adult females establish these social worlds in their respective institutions. Although the argot may vary from institution to institution, the adopted roles and family relationships are basically the same in every girls' institution studied.

The key element in the informal social organization of girls' facilities is the family group. Kinship relationships vary in size dependent upon the family network and the number of "relatives" in the family. The basic dyad, of course, consists of the parents. Then there are children, aunts, uncles, grandparents, cousins, in-laws, and the like. The second major variable requisite in the understanding of this social system is the male role played by the female inmate—for example, husband, brother, uncle, or grandfather. And finally, it is important to view objectively the female roles associated with the adopted male roles, such as wife, aunt, or grandmother.

Homosexuality is not a constant variable in this artificial family structure, although it is commonly presumed that homosexuality "touches almost every incarcerated juvenile at one time or another in varying degrees."[60] While lesbianism does exist in female training schools, this social system of "family" is not based in lesbianism. Most of the family members are "straight" girls who will return to the "normal" world of heterosexuality upon their release. Some who were lesbians in the external society may return to their former "gay" lives, while others who made the temporary adjustment to penal life by assuming masculine roles may find themselves retaining a homosexual life-style upon their return to society.

Several functions are provided by the kinship networks of girls' penal institutions. The primary value of this system of "courtships," "marriages," "in-laws," and "divorces," is to provide a measure of affection and belonging to girls who are lonely, isolated from their natural families, and deprived of their freedom. Further, these social systems offer a substitute for the girl's former world. Other functions are seen in the form of protection for a family's members from verbal and physical attacks by other inmates or, when necessary, providing "verbal persuasion" with the staff. Extra food, rare goods and services, and other similar benefits accrue to girls who are members of families.

Even the institution is aided by this social structure since, through the process of socialization, the family members are taught to conform to the rules and regulations of the institution. This socialization function of the inmate subculture contributes to the social control of the facility while it simultaneously helps to keep the family members out of trouble. They conform to the institutional rules because they do not want to be expelled from the family group.

The informal social system within girls' institutions provides alternate relationships and life-styles for those which were severed by the incarceration. Although these networks of families involve homosexuality as a temporary adjustment to confinement for some girls, the extent of possible psychological harm to future heterosexual relationships has yet to be assessed. Earlier we indicated that sexually segregated correctional facilities may prevent a girl from developing certain skills in dealing with males at a later time in her life. This potential problem may be compounded by the informal social structure just described. There is little doubt that such an artificially created environment in conjunction with the incarceration itself must impose psychological hardships on female inmates. Giallombardo finds at least three types of situational experiences faced by incarcerated girls that may negatively impact on meaningful heterosexual relationships later in life:

> (1) The adolescent female offenders have not yet established adult heterosexual relationships in the external world, and they have little or no basis for comparison; (2) the confirmed lesbians among them have considerable prestige and power, and they are important socializing agents; and (3) the ambivalence of many staff members concerning the courtship, marriage, and kinship ties leads many of the adolescent offenders to believe that these relationships are acceptable to the staff.[61]

The adversities imposed upon incarcerated girls through stringent surveillance and other forms of institutional social control are exacerbated by the paucity of recreational activities available to them. Severe restrictions placed upon movement on the campuses and the limited number of excursions permitted to the outside community result in sheer boredom that generates pressure toward participation in an alternate social world. Girls are usually institutionalized longer than boys; and after months of confinement with little exposure to academic, vocational, and recreational outlets and overexposure to menial work with little, if any, pay, it is little wonder that imprisoned girls are compelled to develop a "social world" of their own.

11

Prisons For women

Observers concerned with the limited number of programs for the incarcerated adult female offender and the specialized problems she faces while imprisoned illustrate their frustrations with the corrections system by dramatizing the appalling lack of interest in women prisoners. Such inattention to the plight of the female offender in jails and prisons results in a shortage, or a total lack, of funds designated for her care and growth. Several reasons are often cited for the neglect of the woman inmate, who is considered by many as "the forgotten offender." Most frequently mentioned is the fact that women form only a small percentage of the total number of arrests and an even smaller number of those incarcerated.[1] Although the number of women prisoners under the control of federal and state correctional authorities has been annually increasing in excess of their male counterparts, women still only comprise 4 percent of the prison populations[2] and 6 percent of those inmates in our nation's jails.[3]

A second reason frequently given for the apparent invisibility of women criminals refers to the types of crimes women commit that lead to their incarceration. Many female offenders are incarcerated for drug use, "moral" and sex offenses, or minor property crimes—offenses that do not present the threat of inconvenience to society that men's crimes do. Women simply are not dangerous.

Finally, women prisoners are ignored because "once they are incarcerated, women's docility brought little attention or concern to themselves."[4] Policy makers and the public become aware of problems in institutions when protests and riots forcefully bring them to awareness. Out of such disruptions prison reforms are generated. Women inmates rarely riot, destroy property, or make reform demands; but, as we will later see, they are beginning to do so.

The Developmental History of Women's Prisons

The history of penology in this country presents a dismal picture of the treatment of all criminal offenders. Until penal reforms were instituted in the middle of the nineteenth century, men, women, children, mentally ill persons, and every form of degenerate were frequently locked up together. No consideration was given to age, type of offense, or circumstance. Since women's crimes were predominantly restricted to sex offenses and drunkenness, a criminal woman was considered disgraced, dishonored, and pathetic.[5] Those women who were involved in criminal offenses were not considered dangerous, and often their male partners took the total blame, thus precluding their imprisonment.[6] Prisons were seen as places to exact retribution or restitution for misdeeds. The concept of rehabilitation—making positive changes in the offender in order to restore him or her to society as a useful member—was late in coming.

As we shall see, this notion of rehabilitation has undoubtedly been the single most damaging influence on female corrections, largely because the idea of "treatment" for women entailed the fostering of sexual morality, the imposition of sobriety, the instilling of obedience, and the prescribing of the sex-role stereotype of mother and homemaker.[7]

With the separation of the sexes as well as the rehabilitative goal in mind, the first separate female prison evolved in Indiana as a response to prison reform movements affirmed at the 1870 National Congress on Penitentiary and Reformatory Discipline. Three years after the Congress the Indiana Women's Prison opened as a model prison for young girls sixteen and over and for older women. By 1913 four more institutions for women opened: in Massachusetts (1877), New York (1901), the District of Columbia (1910), and New Jersey (1913). In 1917 there were fourteen states with women's "reformatories" or "industrial homes."[8] The first federal correctional institution for women opened in the rural area of Alderson, West Virginia in 1927 and thereby removed female federal offenders from the local jails, state prisons, and the District of Columbia Women's Reformatory where they had been housed previously.[9]

However well intended, the reform movements opened up a Pandora's box of new problems for female inmates:

> Because of their smaller numbers and the requirement of separate facilities, the per capita allotment of funds could not be utilized as efficiently as it was for males. In consequence, their quarters were more cramped,

women of all ages and crime types were thrown together, there was little provision for work or exercise, understaffing was thought to necessitate more rigid rules, visiting privileges were restricted, and job training was inadequate. There was little they could do besides sleep, talk, play table games, or sew.[10]

The reformists further demonstrated their philosophy in the architecture of prisons for women. Instead of the massive fortress-like penitentiary housing used for men which had high concrete walls, armed personnel, and gun towers, the "domestic model" for women provided each woman her own room in "the home":

> "The home" planned for women was a cottage that was built to house twenty to thirty women, who would cook their own food in a "cottage kitchen." Several similar cottages would be arranged in quadrangles on green, tree-filled lawns. The cottages in most states were built to contain a living room, dining room and one or two small reading rooms. The idea was that a domestic atmosphere would help the women learn the essential skills of running a home and family.[11]

This was the first "cottage" penal facility for women. Since that time three additional types of women's prisons have developed. The "campus" plan is designed to resemble a college campus. Grass and trees surround numerous buildings, each with separate functions and separated by grassy court areas. In the "complex" model several buildings which may contain one or more functions such as living areas, dining halls, vocational training facilities, or classrooms, cluster around the central administration building. The "single-building" style consists of one major facility that houses all of the prison functions.[12]

Despite the lack of double barbed wire fences, gun towers, armed guards, and concrete walls, most women's institutions retain the traditional categories of minimum, medium, and maximum security differentiated by the degree of surveillance, the number of security-check body counts, the frequency of room searches or "shake downs," freedom of movement, and architectural design. The most desirable type of incarceration, minimum security, allows freedom for a number of activities within the prison schedule and rules. However, most women's prisons are medium security, which are more restrictive than minimum security institutions but permit more freedom than close custody or maximum security facilities. Close custody means that the inmate must be escorted at all times by a custody officer for daytime activities such as meals, group sessions, and counseling, and she is barred from participation in night activities. The small proportion of dangerous women, estimated at 5 to 8 percent, is found in strict cus-

tody under the highly controlled environment known as maximum
security. In addition to the more dangerous inmates, women under
death sentence are also confined to maximum security. Temporary
maximum security may be imposed on women who are dangerous to
themselves or others because of emotional disturbance. This status is
also used to punish rule-breaking.

A recent innovation in contemporary prison reform is the coed
prison, defined as "an adult institution, the major purpose of which is
the custody of sentenced felons, under a single institutional admin-
istration, having one or more programs or areas in which *male and
female inmates are present and in interaction.*"[13] The first coed prison,
created by the Federal Bureau of Prisons in 1971 at Fort Worth, Texas
as an alternative to women's correctional institutions, had certain ex-
pectations: creating a more normal atmosphere through the reduc-
tion of homosexual systems and activity, permitting of heterosexual
relationships, protection of inmates who would have problems in pre-
dominantly same-sex institutions, and aiding in the reduction of ad-
justments to be made at release time.

Of the 3,074 federal prisoners in coed institutions in 1977, the 997
women represented 58.1 percent of all federal female inmates as com-
pared to the 7.5 percent male representation in such institutions. On
the state level that year 1,232 women comprised 9.7 percent of the
state coed prison population, while the 2,377 men in coed facilities
were only .53 percent of their group.[14]

The ramifications of co-corrections are varied. When the women's
prison at Framington, Massachusetts converted to a coed prison,

> . . . the inmates were somewhat uncomfortable around those of the op-
> posite sex. After the initial timidity was overcome, some noticeable
> changes emerged. Women inmates began wearing make-up. Courtesy is
> common. Derogatory and vulgar comments are rarely heard. The at-
> mosphere is one of relaxation and cameraderie, not hostility and para-
> noia, as in most prisons.[15]

Certain basic premises of co-corrections are presumed, including
"increased diversification and flexibility of program offerings, and
equal program access for males and females."[16] It was also believed
that women would have "access to programs, special projects, experts
and visitors commonly unavailable; that participation in programs
with men would offer women realistic training opportunities; that
women would have a calming effect on the more-violence-prone men;
and that co-corrections would be more like the real world to which the
inmates return, thus facilitating the often difficult re-entry."[17] Unfor-

tunately, the state coed correctional systems have fallen short of these expectations established by the federal model. Whereas the two federal correctional institutions using the coed format at Forth Worth and Lexington, Kentucky, have a larger variety of activities and a more permissive environment than most prisons, the state coed systems are more limited in scope and tend to consist of institutions "under a single administration in which male and female inmates are present and interacting in at least one program area." This situation is partly due to the fewer number of inmates and facilities, but nonetheless the women prisoners are the ones most adversely affected.

Claudine SchWeber describes two basic disadvantages of women in coed institutions: the social/sexual environment and the availability of programs compared to their use.[18] In the first instance, since there are so few women in any prison system, their population is more heterogeneous than male prison populations. As a result, female inmates range from minimum to maximum security status, while the greater number of male inmates warrants limitation in coed programs to minimum security prisoners. Because of the security status distribution, women's lengths of stay vary, and some women experience longer incarcerations than others. This is not the usual case with men since they are mainly minimum security inmates. There are only four federal prisons that house women—Alderson, West Virginia in the East, Pleasanton, California in the West, and the two co-correctional institutions at Fort Worth and Lexington. It is therefore virtually impossible to obtain a homogeneous group of women for coed facilities.

In addition to the fact that men dominate the higher status positions in coed prisons, SchWeber found that the women in them "had to overcome institutional messages about the appropriate work for women, as well as their own conditioning, in order to displace men in occupational courses."[19] Furthermore, although more educational and vocational opportunities are available to women in sexually integrated institutions, many women do not take advantage of the programs offered to them.

The factors affecting women's participation appear to be related to the administration's stress on education as compared to other possible activities, institutional concern about the women inmates, and the proportion of women in the coed prison setting. In other words, if there is a positive emphasis on education and recognition of women as unique clients, and additionally if there are sufficient numbers of women in the prison population, there is more participation of women in the programs. SchWeber suggests that the optimum male/female ratio of 40:60 might be the "tipping point" at which women will demonstrate meaningful program participation. However, she also suggests an-

other possible means to maximize women's options—the co-ordinate prison, in which the women's institution is separate but the female inmates share programs and services with a nearby male facility.

Women Inmates

In addition to the four federal prisons that house women felons, as of March, 1979 there were forty-six state prisons for women.[20] Thirty-four states, Puerto Rico, and the District of Columbia have separate institutions for women, and sixteen other states house women separately in male prison facilities.[21] Those states with only a few convicted female offenders place them in city or county jails; eight states contract with other states for their incarceration. Idaho, for example, sends its women felons to Oregon; New Hampshire, Rhode Island, and Vermont incarcerate theirs in Massachusetts; and Montana, North Dakota, and Wyoming house theirs in Nebraska. Hawaii is unique in its transportation of convicted women sentenced to over two years to mainland federal prisons.

While earlier studies revealed that few inmate populations in women's prisons exceeded their institutional capacity, more recent surveys report that "existing facilities have been jammed to the rafters, or women have been forced to serve all or part of their terms in county jails" due to the increase in the numbers of sentenced women prisoners.[22]

Women make up only one out of thirty persons sentenced to prison, and their share of the U.S. inmate population has remained at approximately 4 percent for many years. As of December 31, 1978, there were 12,720 female felons housed in federal (1,828) or state (10,892) prisons. Although in 1978 California had more women in penal institutions than any other state (1,147), the largest numbers of incarcerated women were in the South (5,213), with Texas next to California as second in the country (1,005) and Florida third (837). Regionally the North Central area was the second most prison populated (2,374), followed by the West (2,067) and the Northeast (1,238).[23]

In 1978, 4 percent of imprisoned women were being held for sentencing compared to only 1 percent of men so held. Most of the nation's unsentenced women were held in California (62 percent) under civil commitment, mainly for narcotics addiction.[24] The women who were sentenced fared better in federal courts than in state courts, since from 1977 to 1978 there was a 6.4 percent drop in sentence lengths of more than one year to federal prisons, while states increased 4.7 percent during this period.[25] An examination of the top

three states—California, Texas, and Florida—reveals an increase in female institutionalization of almost 10 percent in both California and Texas, but a 5 percent decrease in Florida from 1977 to 1978. In 1978 California and Texas were more likely to give women sentences of one year or more than in 1977 (+26.2 percent), whereas Texas (−9.4 percent) and Florida (−4.7 percent) showed decreases for this time span.[26]

The Offenses of Incarcerated Women

Ruth Glick and Virginia Neto produced, under a Law Enforcement Assistance Administration (LEAA) grant, the most comprehensive study of women's correctional programs accomplished in many decades. Their national sampling included states that contain approximately 52 percent of the female population eighteen years and over in the United States, and accounts for about 66 percent of all women in U.S. jails and prisons.[27] The fourteen sample states[28] in the Glick and Neto study are felt to be representative of the total incarcerated female population in the nation. Much of what follows relies heavily upon their outstanding research.

Glick and Neto broke down the types of offenses for which women were imprisoned into unsentenced, misdemeanants, and felons. Almost 30 percent of the unsentenced women were charged with crimes against the person, 30.6 percent were imprisoned for property crimes, 22 percent for drugs, 3 percent for prostitution, and 14.3 percent were in the "other" or "unknown" categories. Misdemeanants, who were heavily concentrated in property (41.1 percent) and drug offenses (20.2 percent), had a low violent crime offense proportion (11.4 percent), also low prostitution (7.2 percent) and almost 20 percent were in the "other" and "unknown" offense statuses. Women felons, on the other hand, were primarily committed for crimes against the person (43.3 percent), with property crimes (29.3 percent) at less than the other two classifications and drugs about the same (22 percent). "Other" and "unknown" offenses comprised only 5.4 percent of female felons offenses.

Offense categories of the imprisoned women in the Glick and Neto study were found to vary by ethnic group. Hispanic-American women were incarcerated mostly for drug offenses, seen in the fact that 40.3 percent of Hispanic women were in correctional facilities for this offense. Only 22.1 percent of the total incarcerated female population were in prison for drug offenses, and nationally only 4.7 percent of all women arrested in 1979 were charged with drug offense violations.[29]

The second most frequent offense of incarcerated Hispanic women was burglary (12.7 percent), an offense for which only 5.7 percent of the total sample went to prison and only 2 percent of all women were arrested in 1979. Robbery, the third most frequent sentencing offense of Hispanic women (8.7 percent) in the Glick and Neto study, was committed by 0.6 percent of women arrested nationally in 1979 and by 11.3 percent of the sample female prison population.

Recent data from California and New York, states that have large populations of Hispanic women, offer a more detailed picture of the offenses of incarcerated Mexican-American women in California and Puerto Rican women imprisoned in New York State. In 1979 Mexican-American female offenders were predominantly sentenced to prison for drug offenses (25 percent), burglary (19.3 percent), and robbery (18.2 percent).[30] Not surprisingly, these figures coincide exactly with the Glick and Neto rank orders for this group. However, these more recent statistics indicate substantial rises in percentages for robbery and burglary and a large decrease in drug offense prison sentences for California Mexican-American women since the Glick and Neto data were collected in 1975.

New commitments to the facilities of the New York State Department of Correctional Services in 1976 reveal incarceration offenses for Puerto Rican women offenders similar to those seen in California. The most frequent offense was dangerous drugs (53.8 percent), with robbery second that year (17.9 percent), and homicide third (10.3 percent).[31] Puerto Rican female commitments comprised 22.1 percent of all New York State female commitments for drugs (51.5 percent were black; 25.3 percent white), 14 percent of women imprisoned for robbery (black 60 percent; white 26 percent), and 8 percent of the females incarcerated for homicide in 1976 (black 80 percent; white 12 percent).

The commission of drug violations (20.2 percent) was also the primary reason black women were in correctional facilities, according to Glick and Neto, but this was almost half of the Hispanic rate (40.3 percent) and less than the total proportion for the institutional population (22.1 percent). Black women were slightly more likely to be imprisoned for murder (18.6 percent), an offense comprising only 0.2 percent of all female arrests nationally. The third most frequent incarceration offense of black women was larceny at 14.1 percent, which was higher than the 11.2 percent of the Glick and Neto sample but much lower than the national arrest rate for women for this offense (22.2 percent) in 1979.

Native American women closely resembled white female offenders in the two most frequent offenses that led to their incarceration. Forg-

ery/fraud was found to be the number one offense for both groups, but Native American women were slightly more apt to be in prison (23.8 percent) than white women (22.3 percent). Their proportions also exceeded that for the total female inmate population (15.6 percent) for this offense. Both white and Native American women were found to have drug offenses as their second most frequent cause of incarceration (20.4 percent and 21 percent respectively) in the Glick and Neto study. Murder was the third-ranked offense of incarcerated Native American women (13.4 percent); and while second to black women for this offense, they were still less than the overall proportion of 15.3 percent for the total female inmate population.

Finally, white women in the Glick and Neto study tended to be imprisoned for forgery/fraud (22.3 percent), drugs (20.4 percent), and other nonviolent offenses (14.1 percent). Interestingly, as seen in Table 11.1, the top four incarceration offenses of white and Native American women are identical.

A look at the state picture shows that female felons were more likely to be incarcerated for drugs in California (28.7 percent), New York (37.4 percent), Texas (24.4 percent), and Indiana (20.2 percent). Women murderers were more frequently found in Florida (36.7 percent), Massachusetts (23.5 percent), North Carolina (22.8 percent), and Georgia (35.7 percent). Forgery/fraud was the primary imprisonable offense for women in Minnesota (41.4 percent), Colorado (52.8 percent), and Nebraska (36.2 percent). And Illinois incarcerated most of their female felons for robbery (29.6 percent).[32]

Length of sentence was directly related to the severity of offense with, not surprisingly, the longest terms given to women for murder and the shortest for prostitution. As to the latter offense, other reports indicate that almost one out of every five women is arrested for minor sex offenses; for example, in California it was found that 68 percent of the women in the state prison had at some time been officially charged with prostitution or promiscuity.[33]

Whereas male prisons classify their offenders by the seriousness of their crimes and then assign men to different correctional institutions based on these categories, only the federal system makes any attempt to classify female offenders among different facilities.[34] Thus, the inmate populations of female correctional institutions are more heterogeneous and contain a more diverse collection of women in terms of offense, length of sentence, and age than male prisons. Misdemeanants, mentally ill and retarded women, girls, and women in custody classifications ranging from minimum to maximum security status are all housed in the same facilities throughout the country, a practice that

TABLE 11-1: Partial Offense Data on U.S. Incarcerated Women Compared to 1979 Arrest Data by Ethnic Group

Offense	Ethnic Group in Rank Order (Including Percentages)				Total Percent in Prison	Total Percent 1979 Arrests
	White	Black	Hispanic	Native American		
Murder	4 (12.9%)	2 (18.6%)	4 (8.6%)	3 (13.4%)	3 (15.3%)	8 (0.2%)
Other violent	9 (2.2%)	10 (2.3%)	9 (0.9%)	9 (3.0%)	10 (2.1%)	N.A.*
Robbery	5 (3.2%)	4 (13.8%)	3 (8.7%)	6 (6.6%)	4 (11.3%)	7 (0.6%)
Assault	8 (3.2%)	6 (7.5%)	8 (1.6%)	8 (5.8%)	8 (5.5%)	5 (2.1%)
Burglary	7 (6.2%)	8 (4.2%)	2 (12.7%)	7 (6.0%)	7 (5.7%)	6 (2.0%)
Forgery/fraud	1 (22.3%)	5 (11.3%)	5 (8.2%)	1 (23.8%)	2 (15.6%)	2 (8.1%)†
Larceny	6 (8.1%)	3 (14.1%)	4 (8.6%)	5 (7.2%)	5 (11.2%)	1 (22.2%)
Drugs	2 (20.4%)	1 (20.2%)	1 (40.3%)	2 (21.0%)	1 (22.1%)	3 (4.7%)
Prostitution	10 (1.3%)	9 (3.1%)	7 (2.4%)	10 (0.7%)	9 (2.4%)	4 (3.8%)
Other nonviolent	3 (14.1%)	7 (5.0%)	6 (8.0%)	4 (12.5%)	6 (8.7%)	N.A.*

Derived from Glick and Neto, *National Study of Women's Correctional Programs*, Tables 4, 10, 14, and FBI Uniform Crime Reports 1979, Table 34.

*Not available as categorized.

†Forgery and counterfeiting added to fraud.

fosters special problems for women on every level of the prison system.

Age and Racial Characteristics of Incarcerated Women

Numerous studies of women in prison describe personal and social characteristics of female offenders such as education, occupation, religion, age, race, marital status, number of dependents, psychiatric history, status of parental home, intelligence level, and drug/alcohol use and abuse of both the female offender and her parents. It has consistently been found that female felons tend to be single yet are mothers; have lower IQs and less education than the average woman; have little work skills and previous work histories in lower echelon, usually service-related occupations; are from relatively unstable, often broken homes that show alcohol and drug experiences and abuses or mental illness; are predominantly nonwhite; under thirty years of age; and generally are losers. This section will focus on two of these characteristics, age and ethnicity; the next chapter will discuss in depth the incarcerated mother and her children.

The age distribution of incarcerated women indicates that almost 65 percent are under thirty years of age, compared to 40 percent in this category within the total female population in the country. The median age is twenty-seven years for felons and twenty-four years for unsentenced women and misdemeanants. Glick and Neto report that Nebraska had the youngest inmate population with 65 percent of their female inmates between eighteen and twenty-five years of age, while Minnesota had a much older incarcerated group with 29 percent of their imprisoned women at thirty-five and older.[35] Recent data from research on the entire women prison population in Michigan reveal a modal age of twenty-five to twenty-nine years among the women sentenced to prison in 1978, an increase from the modal age of twenty-one to twenty-four years which had persisted over the 1968–1978 period studied.[36] Also, 1977 statistics on New York State female commitments show that the highest proportion of women imprisoned in that year were in the twenty-five to twenty-nine years age group (27.6 percent.)[37] Nationally, however, the number of incarcerated women has been increasing in the younger age brackets, and certain offenses appear to be age-related. Women under age twenty-five, for instance, were more likely to commit larceny; women under thirty-five were sentenced more frequently for robbery, burglary, and prostitution; while women over thirty-five were commonly imprisoned for murder. Drug users were distributed rather evenly across the age

groups, but regional differences indicate that the Southeast has fewer such offenders over thirty-five than the other regions.[38] For many years the average age of female inmates in prison was thirty to thirty-five, and although there are still large numbers of imprisoned women in this age group, there has been a steady rise in prison incarcerations of women in younger age categories.[39]

However, more than age minority status appears to be the characteristic that most differentiates incarcerated women. There is a much higher proportion of female minority group members among women inmate populations than nonwhite men among incarcerated males. Native American and black women especially seem to be overrepresented proportionate to their numbers in the population at large.[40] Glick and Neto, for example, report that while blacks comprise only 10 percent of the adult female population in the states they studied, 50.2 percent of the incarcerated women in those states were black. Even in states where the numbers of black women are small, the incarcerated black population is disproportionately large. In Minnesota, for instance, less than 1 percent of the population is black, yet 17.7 percent of the female inmates were black. Native Americans were only 0.4 percent of the sample state populations in the Glick and Neto study but were 3.2 percent of the prison inmates. Hispanic groups were difficult to distinguish, since in Florida, Cubans are considered as a language group and not an ethnic group; the Hispanics in the Glick and Neto findings consist mostly of New York Puerto Ricans and Mexican women in Texas and California. Yet they too appear to be disproportionately represented at 9.1 percent of incarcerated female populations. White women, on the other hand, were 89 percent of the adult female population in the fourteen states Glick and Neto studied, but were only 35.7 percent of the incarcerated women.[41]

A study recently reported by the U.S. General Accounting Office (GAO) that looked at female offenders in the criminal justice system found the following distribution of incarcerated women by race as compared to the racial distribution of women in our society; whites are 82 percent of the general population, but only 36 percent of the inmate population; blacks, who were 11 percent nationally, are 50 percent of those incarcerated; Hispanics, who comprise 5 percent of the general population, are 9 percent of those women in institutions; and Native Americans, who are only 0.4 percent of this country's members, are 3 percent of the imprisoned women.[42]

The U.S. Department of Justice (USDJ) national prisoner statistics provide an even more detailed picture of incarcerated women according to racial status. As of December 31, 1978, there was a total of 12,720 women in penal facilities in the United States. As seen in Table

TABLE 11-2: Numbers and Proportions of Incarcerated Women in Federal and State Prisons by Racial Status, as of December 31, 1978

	Number and Percent	White	Hispanic	Black	Native American or Alaskan Native	Asian or Pacific Islands	Unknown
United States	12,720	5,041	633	6,483	161	32	370
Percent	100.0	39.6	4.9	50.9	1.3	.002	2.9
Federal	1,828	509	218	974	22	2	103
Percent	100.0	27.8	11.9	53.3	1.2	.001	5.6
State	10,892	4,532	415	5,509	139	30	267
Percent	100.0	41.6	3.8	50.6	1.3	.002	2.5

Derived from U.S. Department of Justice, Prisoners, Table 8, p. 19, and Table 9, p. 21.

11-2 black women comprise over 50 percent of that number and are slightly more likely to be housed in federal institutions than in state facilities.[43]

Although Hispanics are included among whites in the USDJ compilations, thus inflating those figures, partial data on women of Hispanic origin reported for the first time by the USDJ enable extrapolations that provide a more accurate picture of the ethnic/racial composition of women's prisons in the United States. Thus, we see in Table 11-2 that Hispanic women, similar to black women, are more likely to be institutionalized in federal institutions, while white female offenders predominate in state facilities. Furthermore, according to separate data, women of Hispanic origin are more frequently incarcerated in the Northeast (9.5 percent) and are predominantly Puerto Rican, while in the West they are most likely of Mexican descent (4.5 percent).[44] The numbers for Native American and Asian women are too small to be analyzed in any meaningful fashion, but we have noted that Native Americans are disproportionately represented in prison populations.

Table 11-3 compares black women with white women by region and reveals that black inmates are far more likely to be incarcerated in the South, while white women are disproportionately incarcerated in the West.

The Physical Setting of Women's Prisons

Upon first viewing a women's prison, visitors are usually impressed with its campus-like atmosphere. Geographically, most penal institu-

TABLE 11-3: Numbers and Proportions of Black and White Women
Inmates in State Prisons as of December 31, 1978 by Region

Region	Regional Total	White	White Percent	Black	Black Percent	Percent Black in General Population
Northeast	1,238	551	44.5	680	54.9	13.0
North Central	2,374	935	39.4	1,182	49.8	16.0
South	5,213	2,137	40.9	3,041	58.3	13.0
West	2,067	1,324	64.0	606	29.3	6.0
Total	10,892	4,947		5,509		

Derived from U.S. Department of Justice, Prisoners, Table 8, p. 19, and Glick and Neto, *National Study of Women's Correctional Programs,* Table 6, p. 217.

tions for women are located in rural areas with pastoral vistas considered more pleasant and attractive than the highly secure institutions for men. There are rarely concrete walls, gun turrets, and the other security measures typical of men's prisons.

The remoteness of female penal institutions is generally considered a serious disadvantage for women in spite of the superficial attractiveness of the surroundings. To be physically distant from one's children, family, friends, and legal counsel results in a communication deprivation and an atmosphere that is considered extremely tense and oppressive, as well as one that reinforces inmates' feelings of isolation and powerlessness. The original rationale for the establishment of women's prisons, that women needed more privacy and a quiet setting in which to reflect and thereby become rehabilitated, has instead tended to add to women's feelings of helplessness and dependency in such institutions. Communication with the outside is severely limited for a number of reasons: rigid and sharply limited visiting hours, restrictions on the numbers and types of visitors, and, most importantly, the long distances from home. Most incarcerated women are from urban areas quite remote from the institutions in which they are housed. Also, since most of their families are poor, family members cannot afford the trips to visit them. In one institution, for example, "prisoners can have 'visits' twice a week for 20 minutes each time. Even these visits—through glass—are isolating experiences. Women can't touch their men, mothers don't hold their babies. Children under 18 are not allowed to visit at all."[45] In state prisons, if a mother has

been sentenced for two or more years, her children may visit; but most of these institutions will not allow a mother to hold her child.

Distances are so great and transportation is either nonexistent or so expensive as to prevent many women from seeing their loved ones except rarely. In one prison studied 41 percent of the female felons had not had a single visitor in a six-month period.[46]

Typical visiting regulations at women's prisons are seen in the following:

> Any person on a woman's approved visiting list may visit her twice a month. Visiting on weekdays will not be limited to a specific length of time. On weekends, visiting will be limited to one hour for local visitors. For those visitors traveling over 100 miles, visiting will be unlimited *according to available space.*[47]

Such restrictive visiting regulations are especially punitive for women in federal prisons because there are only two institutions exclusively for women in the federal system. While visitations are more lenient in the federal scheme, the sheer isolation of a woman in either the far western or the far eastern part of the country usually places her hundreds of miles from her family and friends. Many women in federal institutions, therefore, serve their entire sentences without a single visitor.

The unnatural environment produced by the isolation of women's prisons has increasingly become recognized by the correctional system, and new efforts to provide a more normal family environment are being planned and implemented at some state prisons in the form of conjugal visits and family visitation plans. The California Institution for Women has a private three-room apartment for forty-eight-hour conjugal visits and family visits, if the female inmate meets certain requirements. She must have a clean prison record or no write-ups for six months, be in minimum security, be within six months of consideration for parole, or be an eligible long-termer. Currently facilities for conjugal and family visits are available at the women's prisons in the states of Washington, New York, California, and Mississippi.

Although most women's prisons are located in rural or other areas with small populations, urbanization has tended to reduce their inaccessibility. Glick and Neto make this comment on the subject: "Many of these prisons in our sample were virtually isolated when they were built, but urban growth, suburban development and the concomitant improvements in highways have brought residential communities and their resources and services closer to some of these formerly remote areas."[48]

The isolation of women's prisons not only prohibits visiting by family and friends; it also severely limits communication and contact with the female inmate's attorney. Greater difficulty in obtaining legal counsel or conferring with an attorney already engaged may hamper any possible postconviction legal action. Distance also denies access to a woman's parole board. And those women who are mothers have special problems related to custody, support, and other legal matters pertaining to their children.

There are more severe restrictions on mail privileges for women inmates than there are for their male counterparts. This additional communication problem adds to a sense of isolation and deprivation. Typical mail practices in women's prisons include: heavy censoring, severe limitations of usually two times per week, and the prohibition of correspondence with men other than members of the family. All correspondents must have their names placed on an approved list which is checked to determine the backgrounds of the designated individuals.[49] Many women have few acquaintances who can pass the background check, since sometimes the only people the women know or are related to are other incarcerated persons or ex-offenders and these are ineligible for the approved list. Thus, these women become more isolated from the outside world.

Staff

The remoteness of women's prisons affects staff-inmate relations in two significant ways: first, most of the staff are recruited from the rural area surrounding the prison while the majority of the inmates are from urban areas; secondly, it is difficult to attract competent, well-qualified staff to such isolated institutions. These problems can be particularly detrimental since the correctional officer is the most crucial prison staff member or the person who has the most continuous contact with the inmates.[50]

The backgrounds of the custody officers reflect the nonurban, farm, or rural milieu from which they come, usually within a close radius of the institution. In addition, a noticeable weakness in the correctional system is the lack of training requirements for correctional officers. It is obvious how both of these shortcomings result in vastly different orientations toward the inmates, who are predominantly from urban areas. Also, since the staff members are mostly white and most of the inmate population are members of ethnic minority groups, the problem of interrelations between inmate and staff are compounded. Often racial hostilities between inmates are felt to

be directly instigated by the white staff in order to "divide and rule."
Also racial favoritism is felt to be exhibited by white correctional of-
ficers toward white inmates because they are their own kind and/or
because of racial prejudice they harbor against minorities. The ten-
sion created by these alleged practices is vividly described by one
inmate:

> "We don't get shit around here," a black woman said. "Don't tell me no
> white girl has to do time like I have to do time. They get the best and
> they still be carrying that white thing around on their shoulders, signify-
> ing and strutting—like ain't I somethin. . . . You'll see it, they get away
> with all kinds of shit we get locked for."[51]

In many institutions for women Hispanic women are not permitted
to speak Spanish, to read or write letters in Spanish, to subscribe to
Spanish language magazines or newspapers, or to converse with their
visitors or friends in Spanish. This practice is mainly because the staff
cannot understand the language. Since many Hispanic inmates do
not speak English, these customary procedures tend to isolate these
women even more.

Staff attitudes and opinions of their female charges seriously affect
the climate of the institution. In her intensive study of the women's
federal penitentiary at Alderson, West Virginia, Rose Giallombardo
found that the staff viewed inmates as "lacking in moral fibre,"
"weak," "like children," and "selfish."[52] As a result of their mental
attitudes and judgments, staff treat female inmates like children,
thereby reinforcing dependency. This practice is most vividly seen in
two major ways: the "mother-daughter" relationship and "naming."

Studies of women's prisons have shown that administrators describe
the staff-inmate relationship as a mother-daughter connection. This
built-in affiliation is described by one female inmate at a state
institution:

> Out of the 450 women here, 300 act like kids. . . . A lot of women in here
> want to be babies, and they foster that kind of dependency in here. I
> have seen an officer tell a woman to clean her room. And the woman will
> say, "Oh, Ma, bring me a soda and I'll do it." I'm sure in the men's
> prisons those men don't go around calling the officers Daddy.[53]

Naming has several dimensions. After the initial "degradation cere-
mony" of receiving a number in place of one's name and the loss of
status associated with this labeling process, inmates in women's cor-
rectional institutions find themselves informally addressed by staff

members by their first names; simultaneously it is insisted that the inmates refer to staff with proper titles of address.[54] Even more disparaging is the practice by staff of referring to women inmates as "gals" or "girls," which further relegates them to the status of children.[55]

Many female inmates view correctional officers as women who are there primarily for the income and not to help them. In her examination of the complex staff subsystem Esther Heffernan found some justification for such a belief at the District of Columbia Women's Reformatory in Occoquan, Virginia. Heffernan identified different subgroups within the staff and found that at least one group of correctional officers and personnel looked at their work mainly as only a job. According to Heffernan:

> Their major supportive relationships and status sources are outside the prison. They tend in some ways to be "ideal" employees, since they are impartial, generally obey the rules and regulations, and frequently are kind and considerate to the women. They "keep their mouths shut," have relatively little contact with the staff "I say, you say," and do their job well. Like the square, they are in the prison, but not of it. Consequently, they usually remain in the positions for which they were hired.[56]

Heffernan also found that staff structures tended to parallel inmate structures in that their backgrounds were reflected in their orientation to the prison and prison work in much the same manner that the inmates' orientation to prison was influenced by their differing backgrounds. One of the results of differences in staff backgrounds was evidenced in conflicts between personnel, particularly between custodial and treatment staff, professional and nonprofessional staff, and those schisms involving race, class, and urban versus rural differences. Common complaints made by custodial and treatment staffs demonstrate the cleavage between them: whereas the custodial staff complained about laxity in security and prison routine, the treatment staff objected to the "punitive" approach taken by the correctional staff. Class distinctions seemed to be at the root of this conflict, since the professionals tended to be middle-class and highly educated, while the corrections officers were usually lower-class with little education. The fact that these two groups are often in direct competition for top administrative positions in the institution further contributes to class conflicts in correctional work.

Conflicts such as these undoubtedly have a bearing on the frequent administrative turnovers in female prisons. Glick and Neto found that

in a one-year period the superintendent was replaced in eight of the fourteen major female state prisons, and in several of these institutions three or four persons occupied the warden's office during a one-year period.[57] Changeovers like these affect staff morale, create uncertainty in the inmates, and adversely affect program operations.

Administrative changes can be for the better, of course, Giallombardo reported that the 1961 change of wardens at the Federal Reformatory for Women at Alderson brought about new policies that changed a suppressive emphasis to a treatment-oriented milieu. The new, more permissive attitudes by the administration included the extension of new privileges such as relaxing movement restrictions, the elimination of custodial escorts, more smoking privileges, the adoption of a new name—"residents"—for the inmates, and other changes that created a more positive and responsible atmosphere.[58] Today the administrations of some women's prisons seem to reflect the attitudes and practices generally found in men's prisons, unfortunately, with more punitive, hardening attitudes toward women inmates.

The Prison Experience for Women

A new woman prisoner arrives at the correctional facility by prison bus or official car. She may be handcuffed or not, but at the least is flanked by strong custody officers. In a sense she has now lost her identity and has become a number and not a name. At the institution she may even be fingerprinted and photographed again for the institutional records. This "fish," as she is called, soon loses her dignity when she is stripped and body searched for forbidden articles called contraband. A shower, shampoo, and "delousing" usually follow, and the neophyte female inmate is then issued prison clothes and bedding.

"Reception and orientation" is the name of this processing, and it also includes a medical examination where the woman is checked for tuberculosis, diabetes, venereal disease, and other chronic illnesses. Psychiatric exams are an aid to determining her treatment needs, and educational tests ascertain her aptitude and potential for school. During the two- to six-week period in which this all takes place the woman inmate is confined to a segregated area away from the other inmates. When the doors clang shut and the key is turned forcefully in the massive lock, independence is barred out and the new status of institutional dependency commences.

As a part of the prison orientation women prisoners are made aware of the extensive rules and regulations of the institution. Although women's prisons are usually not maximum security, the rules regulating their conduct seem stricter than those at men's prisons.[59] Administrators explain that the small size of female inmate populations as well as the minimum security physical structures of women's facilities necessitate the more stringent rules and regulations. Since all women are housed in one institution, regardless of convicted offense, the rules made to control the few are extended to the total inmate population. Rules and regulations become means of social control in lieu of guards, guns, walls, and towers. It follows that sufficient staff is necessary to ensure the enforcement of the rules and regulations, therefore we find there are more staff members per inmate in female institutions than in male ones. In Wisconsin, for example, a medium security institution for men had an inmate/staff ratio of six to one; a men's maximum security prison revealed a four to one ratio; but at the medium security Wisconsin Home for Women there was one correctional officer for every two inmates.[60] Nationally, the average inmate/staff ratio is 2.4 inmates per full-time staff member in women's penal institutions.[61]

There is usually a formal explanation of the routines, rules, and general procedures of the institution within the first twenty-four hours of the woman inmate's reception. Sometimes rule lists are given to each individual, or they are posted in places where inmates gather such as dining halls, cottages, and dormitories. Rules are oppressive measures of social control; further, rules and regulations cannot be challenged by the female inmate. Not only does she lack the power to change the prison rules, but she is also unable to question their legitimacy, which further contributes to her dependency and frustration.

There is little agreement as to what constitutes a major or a minor infraction of the rules and regulations within the various disciplinary systems of women's institutions. Generally, major infractions include fighting, possession of contraband, property damage, escapes, arson, violence, and the use of weapons. Glick and Neto reported that in eight out of ten institutions homosexual acts are considered major infractions. Minor infractions may consist of use of foul language, walking on the grass, yelling, or having torn sheets.[62]

The disciplinary actions for violations of the rules and regulations also vary considerably from institution to institution. Glick and Neto found that punishments for minor rule infractions ranged from a reprimand to the loss of up to sixty days "gain time," or that period subtracted from the women's sentence for good behavior and/or special work duties. The range of penalties for major infractions typically

include loss of privileges and isolation in a cell for sometimes up to ninety days, or, for certain infractions, court prosecution.

Various names are used for solitary confinement, or the place where the rule-violating woman prisoner is locked up. The "hole," the "control room," the "bing," the "rack," or the "strip cell" are probably more descriptive terms than the euphemisms frequently employed by staff such as "administrative segregation," "reflection," or "loss of privilege module." Whatever it is called, this form of negative sanction for women is clearly inhumane, as one can see from the following observations by investigative reporter Kathryn Burkhart:

> These cells are drearily the same in every jail I've visited—windowless and bare. Some have one thin, dirty and bloodstained mattress on the floor. Some have no mattress. Some jails provide blankets for the women confined, some do not. In some quarters, women locked in solitary are allowed to wear prison shifts—in others they are allowed to wear only their underwear or are stripped naked. Toilets are most often flushed from the outside, and women complain that on occasion sadistic matrons play games with flushing the toilets—either flushing them repeatedly until they overflow or not flushing them at all for a day or more at a time. ("If the toilet backs up, there's nothing you can do about it but live with the stench.") Food is passed into the room two or three times a day between the bottom of the dusty door and the unwashed floor, as are sanitary napkins if the woman is menstruating.[63]

These custodial practices are often viewed by women inmates as deliberate efforts to "diminish their maturity" by treating them like children and fostering dependency. A recent study of a southeastern correctional facility for women found that women were locked in their rooms each night and most of the weekend. Prayer periods were required, and severe Sunday restrictions were imposed against playing cards, watching television, or washing personal clothing. Automatic "lockups" were the fate of women who elected not to attend religious services in this institution.[64]

Women in prisons have been slow to respond to what they feel is unjust treatment. As a result, riots and demonstrations have been rare in women's institutions. But as female inmates are becoming more aware of their rights, they are becoming more militant. In recent years women prisoners have made demands, rioted, set fires, attacked correctional officers, gone on hunger strikes, and destroyed buildings, just like their male counterparts at Attica in 1971, Pontiac, Illinois in 1978, and more recently the New Mexico State Prison in 1980.

In 1971 the women at Alderson prison had a sympathy riot for their brothers in Attica which raged four days and required extreme force

to contain. The women at the Philadelphia House of Corrections rioted in 1973 and attacked and injured male guards and one female matron. Women inmates have also rebelled at the California Institute for Women and other penal institutions throughout the country. Not only have women in prisons become politicized; their uprisings indicate that they are no longer going to be oppressed by a correctional system consisting of stringent rules, ever-present vigilance, enforced dependency, and few attempts at the so frequently touted goal of women's corrections—rehabilitation. Demands made by protesting incarcerated women are directly related to the prison, its programs or lack of same, and institutional life in general. Female penal institutions have consistently been found to be deficient in programs and services in comparison to men's prisons. More importantly, in addition to being denied those opportunities, women in prisons in this nation have been denied the right to be women.

Problems and Programs

More than any other single factor institutional size negatively influences the extent and quality of services and programs for incarcerated women. The small scale of women's prisons is seen as the cause of low financial support. And concomitantly, because of the smaller population custodial costs per inmate are higher, forcing the sacrifice of a variety of services and care for her well-being.

Health and Medical Care

Glick and Neto differentiate between health care and medical care. Health care is "defined primarily as health maintenance, including educational programs designed to provide knowledge of how the body functions and how to recognize early signs or symptoms of disease."[65] In an institutional setting health care also includes those aspects of the program contributing to a healthful environment—for example, food services and exercise. Medical care is the delivery of medical services in response to illness or injury. Women's prisons suffer from the inadequate provision of both health and medical care, since "few institutions provide total *health* care, though all have some type of *medical* care."[66]

The size and the remoteness of prisons directly influence the provision of medical care. If an institution is of a small scale, as most women's facilities are, budgetary considerations hamper the supply-

ing of complete medical services, since it is difficult to pay the salaries needed to attract and keep qualified medical staff. Secondly, the isolated location of women's prisons makes it hard to recruit and retain good medical personnel. Not surprisingly, then, the usual range of medical services in women's institutions includes "intake examinations; sporadic 'routine' examinations, primarily in response to a problem or a specific request; emergency care available with evening coverage by paramedical personnel; and limited dental care."[67]

The most frequent medical problems of incarcerated women reported by medical staffs are gynecological, nervousness/anxiety, headaches, and pain. The most frequent chronic illnesses noted are diabetes, hypertension, epilepsy, drug addiction, and alcoholism.

Too often "Band-Aid" type solutions are offered to solve the medical problems of imprisoned women. One of these commonly used methods is the extensive dispensing of medication. In the Glick and Neto sample, forty-two of the fifty-three institutions reported frequent dispensing of pain medications to inmates, and thirty-one facilities reported frequent dispensing of tranquilizers and psychotropic drugs (mood elevaters). The following description of "pill lines" graphically illustrates this assembly-line, Band-Aid method of medical treatment in women's institutions:

> The women were lined up behind the table with their hands behind their backs. Mrs. Brown (not her real name) stood behind the table and a matron sat on a stool next to her. As the inmate stepped to the front of the line with her hands still behind her back, Mrs. Brown would find that particular woman's medication and pour the pills onto the back of her tongue, then pour a small cup of water into the woman's mouth, too. The guard would watch the inmate's mouth—to make sure she swallowed the pills and didn't keep them "under her tongue" to give to someone else or get high on later. The inmate would then step away and the next inmate would step up, mouth open, for her medication.[68]

Tranquilizers and mood elevaters, which are commonly used as a means of social control in some institutions, are sometimes forced on rebellious or upset women. Kathryn Burkhart describes this practice and its victims:

> More often, it seems, at Riker's and at other prisons, women inmates walk the halls in what seems to be a dazed, zombie-like state. Their words are slurred, their eyes are glazed, their clothes disheveled. Some women I have seen on one day having to be supported by other inmates even to walk look like totally different people a day or two later, when they said they "got off the medication." Some women complain that they

are given Thorazine and Millaril against their will when they are upset
about something; others complain they are unable to get tranquilizing
medication when they want it.[69]

Correctional authorities' belief that pills are panaceas for the ails of
women prisoners too often provides a poor substitute for proper med-
ical care. Closely associated with this pill-pushing is the almost para-
noid belief that a woman might be faking an illness or is a malingerer,
practices which often result in a lack of attention to the complaints of
women who are indeed seriously ill. Medication may be withheld from
epileptics who enter an institution until they demonstrate their physi-
cal condition by a "couple of seizures." Also, imprisoned female drug
addicts are often forced to kick the habit "cold turkey" when heroin
substitutes such as methadone are unavailable or denied. Sometimes
the medical care comes too late, and the inmate dies.

It is reported that in some women's institutions pregnant prisoners
who desire an abortion are denied this right. And, if a woman con-
tinues her pregnancy to term, she is faced with special and unique
medical problems in the correctional setting. The needs of pregnant
inmates frequently go unmet. Most institutions lack medical facilities
for either the mother or her baby.[70] Some inmates complain that a
pregnant woman is unable to get milk, vitamins, or other special foods
necessary to the maintenance of optimal health for herself and her
unborn infant.

Another frequent complaint of women prisoners concerns the qual-
ity and quantity of the food. Aside from complaints of too little, too
monotonous, or too poorly prepared food, a serious dietary concern is
the recurrent objection to so much starch in the diet, and the concomi-
tant weight gain. Weight problems can be a particular hazard to a
woman's health and well-being when exercise is minimal or nonexis-
tent—which is frequently the case in women's correctional facilities.

Finally, women in prison complain about the vaginal searches for
contraband they must suffer when they return to the institution after
court appearances or other permitted leaves. These examinations are
not only degrading but painful, and the women complain that some-
times infections and later bleeding occur as a result. What is ironic
about this procedure is that these vaginal examinations are frequent,
yet the preventive pap test for cervical cancer is not often given.

In sum, health and medical care for incarcerated women is rather
poor, but the picture is not all bad. Many progressive prisons offer
cosmetic surgery and other medical and dental repairs to correct
physical defects and improve women's health and appearance. These
cosmetic efforts do much toward improving the mental health of the

few inmates who obtain such specialized care. For the bulk of women inmates, however, mental health care and services are not only limited but also of questionable effectiveness.

Treatment Programs

In an earlier section we described the conflicts between professional or treatment staff and the custodial, nonprofessional personnel in women's prisons. In addition to this problem, the question of treatment extends beyond the personnel level to the organizational level of an institution. Historically, the goals of women's correctional facilities have been primarily custodial, despite rhetoric devoted to the rehabilitation model. Fortunately, progressive innovations in some women's prisons have attempted to deemphasize the punitive, custodial function and stress treatment goals. Often this approach is not accepted, and the resulting conflict, described as a "clash of interests," impedes the successful functioning of the treatment modalities. As Giallombardo analyzes the situation: "The basic conflict between the competing goals of self-maintenance and custody on the one hand, and treatment on the other, is a structural weakness of prisons: Any disturbance in the equilibrium of the system results in reconciliation of competing purposes at the treatment level."[71]

These conflicts, the scarcity of funding, and the remoteness of women's prisons all contribute to a dearth of treatment programming with competent personnel for female inmates. In addition, the complexities of a heterogeneous prison population containing inhabitants who vary in educational level, age, and lengths of sentences, and who must work to maintain the institution and its products, further endanger treatment efforts. Thus, the most frequent treatment modalities in women's prisons are Transactional Analysis (TA) and Behavior Modification, both considered superficial treatment modes. Individual psychotherapy is available in a few institutions for women, but the paucity or lack of professional staff casts doubt upon the meaningfulness of counseling and psychotherapeutic efforts.

Recreation

Earlier in this chapter mention was made of the need for recreational opportunities to maintain the physical well-being of female inmates with a typical institutional diet of starchy foods. Sports and leisure activities such as music, painting, and drama serve another

important function as an aid to the release of tensions and frustrations and a relief from the monotony of confinement. In women's prisons the primary recreational facilities consist of television and board games. Space, equipment, and special facilities are necessary components for successful recreational programs. Women's institutions generally lack all three. Men's prisons usually have large outdoor areas suitable to meet recreational needs, but women's institutions seldom have playing fields. Where such areas are available, there is usually insufficient staff to supervise the activities. Because women are not seen as dangerous and as less likely to escape, in some states they have certain recreational advantages over institutionalized men—outings to movies, athletic events, swimming, and the like.

Education and Vocational Training

Academic education is offered in most women's prisons. Remedial education is prevalent, and basic courses leading to an elementary education or a high school diploma are commonly provided. Some prisons offer college curricula leading to the Associate of Arts degree or, more rarely, to the Bachelor of Arts. Eleven states offer college courses to women inmates either through correspondence courses or in conjunction with nearby colleges.[72]

Female inmates at the upper and lower ends of the academic scales do not usually benefit from prison educational programs. The small number of women at the upper end of the continuum who already have college degrees have no educational channels and are rarely permitted to tutor, teach, or employ their academic knowledge in the prison. At the lower end of the academic ladder are the mentally retarded and the educationally handicapped. There are no special programs for these women even if they are identified, and they rarely are.

Adult education courses which are offered include subjects such as consumer education, family life education, child development, and personal grooming. While such courses are undoubtedly useful, they also indicate sexual stereotyping. Evidence that such courses are associated with the traditional roles of housewife and mother is seen when these educational courses for women are compared to the social education programs common to men's educational curriculum. These recent trends in correctional education for men are "specifically geared to reorienting the incarcerated or community treated offender with the normative and socially acceptable attitudes and values of free society," and include major areas such as "improving communication

skills, personal management, personality development, social and family relationships, laws, and economic issues."[73] Social values are instilled with a goal of restructuring an inmate's attitudes, values, and orientations to societal institutions and undoing years of "negative acculturation." However, no mention is made of efforts toward these ends in the studies of women's prisons. Instead, the roles of mother, homemaker, and successful shopper are perpetuated in the few adult education courses available in women's institutions.

Vocational education and skills training for women inmates also follow the sex stereotype of the traditional female role. The most frequently offered training is in the areas of clerical skills, cosmetology, and food services. A recent federal report by the General Accounting Office found that vocational programs in female prisons are fewer than at male institutions.[74] The average number of programs for men is ten; for women it is three. Even the larger female prisons do not offer more than two or three programs, and these are almost always limited to preparing women to be domestics or occupy other "women's" vocations.

In general, vocational education programs in women's prison are as dead-ended as the types of jobs they prepare women for. The scarcity of vocational training programs is especially difficult for women serving longer sentences, since there are few opportunities for them to learn new skills or to earn sufficient money to help their families on the outside.

Several reasons are offered to explain the dearth of vocational programs for women prisoners: (1) the usual argument that women in prisons comprise such small numbers as to make programming cost prohibitive; (2) the high cost of training per female prisoner, since there are so few; (3) the notion that women criminals present less of a threat to society than male criminals and therefore do not require the same financial expenditures; (4) low participation of women in such programs; (5) the inaccessibility of female institutions; and (6) the fact that society still views a woman's status as wage earner as secondary to her traditional role of housewife and mother. As a result, legislators and corrections officials continue to provide men's institutions with the best vocational facilities they can, "while teaching women merely to cook, sew, and clean" in keeping with their assigned role.[75]

Just as women in prisons are beginning to rebel and riot in response to discriminatory institutional standards, they have also discovered the law and the courts as vehicles to achieve equality in the prison setting. Although handicapped by the lack of law libraries and other legal resources, a few challenges to differential treatment have been made under the Equal Protection clause of the Fourteenth Amend-

ment to the U.S. Constitution. One of the first known cases where female prisoners successfully challenged their exclusion from a correctional program under the Fourteenth Amendment was *Dawson* v. *Carberry* (1971) against the San Francisco women's jail.[76] Another landmark case decided in 1979 in the U.S. District Court involved a class-action suit against the state of Michigan, in which the judge ruled that "denying women in prison vocational and educational opportunities equal to men's was a violation of their 14th Amendment rights to due process and equal protection of the law."[77] A dozen or more similar suits are questioning such discriminatory practices across the country, and the courts have established that the higher costs necessary to provide women prisoners equal treatment are invalid when weighed against the violation of their equal protection rights.

Institutional Maintenance and Job Programs

In most women's prisons the inmates are required to spend at least a part of their day performing institutional maintenance. Such "busy work" is often administratively disguised as vocational training, despite the fact that these unskilled work assignments provide few job skills to assist in the later procurement of gainful employment. Even more appalling is the common practice of using housework as punishment. However, the usual custom is the exploitation of women through their use as personal servants to prison administrators and other state officials. Glick and Neto found that some women in the prisons in North Carolina and Georgia worked as maids in the governor's mansion.[78] In North Carolina, for example, eight female inmates were assigned to the home of the governor where they cleaned, cooked, washed, ironed, and served parties.[79] Personal service assignments are standard in the homes of prison superintendents; in fact, such household servants come with the administrative position as a fringe benefit. As one writer comments, "It's usually humiliating enough to be a house servant when you're being paid meager wages [and] see no alternatives—but to have it be involuntary servitude gives me the plantation shudders."[80]

Prison industries differ from vocational training and institutional maintenance labor in men's correctional facilities, but in women's prisons it is often difficult to differentiate between them. Free or low-paying prison labor of women inmates is frequently called "vocational training," although most of these jobs leave women ill prepared to compete in the job market upon release.

Various reasons have been suggested to rationalize the use of women as laborers in prisons: (1) as a deterrent to crime; (2) as relief from the monotony of prison confinement; (3) to help time pass more swiftly; (4) to reduce the operating costs of the institution; (5) to teach skills and develop good work habits; and (6) as treatment, in the sense that work is therapeutic.[81] Several counterarguments to these reasons have been put forward: "that participation in industrial programs is inconsistent with the rehabilitative function of women's prisons; that women should not be used as part of a state-created work force; and that women should not be subject to the form of punishment embodied in certain prison industries."[82]

A stronger objection is that women in prison are denied work in prison industries which can ultimately result in a meaningful source of livelihood. Industries in women's prisons resemble the paucity of their vocational programs by averaging 1.2 industries per prison as compared to 3.2 for men. Furthermore, there is little overlap in the types of industries in which both male and female inmates may work. For example, of the six types of industries established in women's prisons, most prisons for men (twenty-three out of forty-seven) provide employment in from one to three of these types, but no women's prison offers employment in any of the twenty-five industries available to men.[83]

Giallombardo's study of the women's federal prison at Alderson revealed that almost half of the inmate population were concentrated in cooking, cottage maintenance, sewing, weaving, farm and dairy work, landscaping, baking, and painting. Glick and Neto found the sewing industry to employ the largest number of female inmates in their national study. This industry produced uniforms for inmates and staff as well as clothing and other items for state institutions such as hospitals and for highway crews. Not too surprisingly, the largest prison sewing industries are usually located in states such as New York, California, and North Carolina, which have sizable garment industries. Unfortunately, it has been found that women who work in prison garment industries seldom secure jobs after their release because the training is "technologically useless" due to the antiquated equipment used in the prisons.

The making of American flags, once a thriving female prison industry, has become a dying enterprise, which provides a clear indication that the sewing of American flags is not relevant to future employment. In fact, there are very few prison industry programs that provide training for women beyond that leading to employment as a hotel maid, cook, waitress, or laundry or garment factory worker. Currently the trend is toward making more opportunities available either

through co-correctional systems, where women and men can benefit from the vocational training, and industries in each other's institutions. But it must be kept in mind that prisons are in business, and its industries are big business. The garment factory at Alderson, for example, is its biggest industry and grosses more than $3 million annually, yet it pays the 155 female inmates from 34 to 84 cents per hour.[84] State and federal prisons are sustained by cheap inmate labor. Most women's prisons pay nothing for industrial maintenance work, and inmates who are paid for prison industry work generally receive less than men in such industries. Pay ranges from zero to a maximum of $1.00 per hour for a forty-hour work week.

Work conditions in some of the prison industries would cause the factory to be closed down if it were in the free society:

> In summertime, women in these shops often pass out from heat asphyxiation and lack of air ventilation. More than one woman has told me of the tremendous production pressure put on them—broken only by two ten- or fifteen-minute cigarette breaks in the morning and afternoon. Silence rules are still rigidly enforced in some of the factories.[85]

As a result of such conditions, work stoppages do occur in prisons, but the harsh sanctions for such behavior usually act as deterrents to work strikes or protests.

One of the main gripes of incarcerated women concerns the remuneration for their efforts. But there are no protective unions; no collective bargaining units exist for women prisoners. Refusal to work usually results in confinement to maximum security because "people refusing to work are potentially disruptive to the institution; plus prisons cannot function without inmate labor."[86]

Work furloughs or work release programs are available in at least twenty-five prisons for women, and work release women represent 2 percent of the prison population. In order to qualify, a woman must usually be nearing her release date and also be in a minimum custody status. She is responsible for getting to her employment and back on time, must avoid drugs, alcohol, and her former associates as well. She eats and sleeps at the prison, usually separate from the other inmates in order to avoid the temptations of returning with contraband or messages from outside for the other women. She must still live within the prison rules, of course, despite the taste of freedom associated with work release status. The average pay is from $2.00 to $3.00 per hour, but she is obligated to pay room and board at the institution out of this. The North Carolina Correctional Center for Women in Raleigh, for example, requires its work release women to pay $3.45 a

day, five days a week, to the system and additionally pay another percentage to the Department of Welfare if their families are on public assistance. According to the program director at this prison, "If they are employed someplace where they only make a minimum wage, by the time they pay out all this money they have little left." And an inmate commented, "The more you make, the more they take."[87]

The Informal Social System

In recent years several in-depth studies of women's prisons have been reported, among them Rose Giallombardo's excellent pioneer work on the federal prison for women at Alderson, West Virginia; Esther Heffernan's fascinating study of the female prisoners in the District of Columbia Women's Reformatory at Occoquan, Virginia; and Kathryn Burkhart's probing interviews with female inmates in correctional institutions from coast to coast. Each of these seminal research efforts describes the informal social system and structures that have evolved in institutions for female offenders which differentiate them from the argot roles and functional systems established in men's prisons. The following discussion blends the major findings of these researchers and highlights the major characteristics identified as indicative of the social system in women's prisons.

Each of the researchers found a system of "kinship" ties established within the prison in the form of "play families," which are highly similar to the groupings described in the previous chapter on female juvenile institutions. At the root of the family is a dyad configuration in the form of a "marriage" or some type of marital relationship from which the broader kinship structure radiates. Female inmate communities are thus believed to be large networks of these loosely structured families which vary in size. Sex and age differentiate the roles played by family members. The broader experience and knowledge of the older inmate, for example, call for roles such as grandmother, mother, and father; and the adoption of a particular sex role, male or female, necessarily eliminates some potential family roles while opening up others. The husband-wife dyad may or may not involve sexual intercourse, although some women playing the parts of men—fathers, husbands, grandfathers, sons—model themselves after men by walking, dressing, talking, and acting in a masculine fashion. Play families are largely attempts to reproduce the nonconjugal relationships of the family in the outside world. In fact, there are some indications that the true homosexual does not participate in playing such roles and that they are usually held by women who temporarily assume such roles

while in prison only to return to their proper female roles when their families visit and later when they are released. There are homosexual alliances that result in "marriage" units, but it is believed that these "legitimate" marriages preclude family systems.[88]

Women's informal prison family systems differ from the subsystems found in men's penal institutions and clearly serve several important functions for the women prisoners. They are a response to the loneliness and deprivations of prison life, and they fulfill economic, socialization, and protective purposes.

In the first instance, the family permits a sense of belonging and relieves the loneliness and tensions brought about by the isolation and trauma of incarceration. Members of the family provide a sense of security and emotional support demonstrated in their personal concern for each other. Involvement in the family directs a woman's thoughts and energies to events within the prison and reduces preoccupations and concerns with outside events, or what is commonly known as doing "hard time."

The economic role of the family is a major aspect of such relationships, and the family is frequently considered the basic economic unit in the inmate exchange system in women's institutions. "Bartering," "hustling," and "making out" are all means of surviving in the prison system by obtaining those goods, services, and contraband through the "underworld" of the institution. Families are the distribution centers for most of these goodies, and each member is obligated to provide these items as well as legal commodities such as commissary goods for the benefit of the family members.

In the "real" or "outside" world the most important agents of socialization of children are the parents, who by example and instruction orient their children to the acceptable behaviors necessary for optimal functioning in society. The institutional "parents" perform the same function by socializing their "children" to act the roles of inmates. This conditioning to prison life includes how to interact respectfully with the institutional personnel as well as with inmates, and includes a familiarization with those inmates to be avoided. Attention is particularly devoted to the prison rules and regulations to assist the family member in avoiding trouble with its consequent loss of earned "good time" days.

Although violence is not nearly as prevalent in women's prisons as in male institutions, the family offers an important protective function. The larger the family size, the more protection its members have against other inmates. If an inmate not in a family threatens one of its members, for instance, she has to face that entire family. Thus, the

final purpose of the family system, protection, provides a deterrent to violence and harm in women's prisons.

In addition to the family memberships adopted by women in prisons, "argot" roles comparable to the classifications in men's prisons emerge based upon inmate behaviors. *Snitchers* who give information to the staff are generally despised by the other inmates because such a woman "denies the cohesion of the inmate community and jeopardizes the successful execution of the many illegal activities that take place in the prison to mitigate the pains of imprisonment."[89] Those female prisoners who, because of their institutional work assignments, have an authority position over the other inmates and use this position to issue orders or report other inmates are contemptuously called *inmate cops* or *lieutenants.* The accidental noncriminals who are alien to the prison community because their orientation is to the prison administration and societal values are somewhat derisively called *squares,* since they are viewed as "suckers" and "fools." *Jive bitches* are troublemakers. They distort facts and generally cause conflict and unrest between inmates. Such women especially cannot be trusted in a system where few inmates trust each other completely. Yet, despite the universal lack of trust, some inmates manage to build up relationships that are friendly. Two of these social roles are seen in *rap buddies,* who are compatible in conversation, and *homeys,* who are from the same hometown or community.

The illegal economy provides a special system of argot roles to depict those inmates engaged in the prison economic system. The *connect* has a work assignment that permits the procurement of scarce goods, services, and/or information; while the *booster,* on the other hand, steals such items from the institution and "merchants" them, usually in large quantities. *Pinners* are lookouts who act as sentries when illegal activities are taking place, and thus are highly valued because they can be trusted.

Labels applied to homosexual behavior in women's prisons depend upon the "specific role assumed, the adeptness with which the role is played, or the motivation for the behavior."[90] Two broad categories are differentiated: *penitentiary turnouts,* who are involved in prison homosexuality because of the unavailability of heterosexual relationships, and *lesbians,* who prefer homosexual relationships since this was their preferred sexual life-style outside the prison. Although only about 5 to 6 percent of women are thought to have prior histories of homosexuality before incarceration, estimates of from 50 to 80 percent of female inmate populations have been suggested to depict the extent of homosexual alliances within women's prisons.[91] While there are numerous homosexual dyads, *femme* or *mommy* constitutes the

female role and the *stud broad* or *daddy* involves the assumption of the
male role.

At Alderson, Giallombardo felt that power and authority resided in
those women who occupied stud roles in the informal family kinship
system. But Heffernan's prison research delineates argot roles of
women centered on status and power. The *gorilla* or *bully* displays
active aggression against other female inmates and sometimes against
prison staff as well. These women violate the property rights of oth-
ers, use physical coercion, or employ verbal threats to assert their
positions as "enforcers." In contrast to the power of violence seen in
gorillas and bullies, *big shots, king pins,* and *big spenders* have economic
power. These women have money and all of the benefits of the eco-
nomic exchange system that accrue to money. Thus, they claim the
best seats to watch TV, personal maid service, and unlimited personal
attention.

Giallombardo does not identify power roles at Alderson such as
these described by Heffernan as typical of Occoquan; however, the
differences might be accounted for by nonuniformity between federal
and state prison systems. Or it is possible that the Giallombardo study
of the 1960s found a different type of inmate than those later studies
of incarcerated women. Today it is difficult to accept the notion that
incarcerated women who assume or are ascribed power positions in
the prison are "stud broads." Undoubtedly as the heads of the "fami-
lies" a great deal of power is assumed by the male role occupiers, and
there is no doubt that the informal social systems such as Giallom-
bardo described exist throughout both the adult and juvenile female
institutions; but to view today's women, especially today's female crim-
inals, as locked into such sexual stereotypes and traditional systems
for their prison power base seems naïve. Recent empirical evidence
suggests that power and authority in women's prisons are not limited
to a social structure primarily centered on homosexual behavior.

Imogene Moyer utilized field observations, interviews with inmates,
and case records in a southeastern correctional institution for women
to study the process of social interaction, how leaders emerged, and
what their characteristics were. She reports that the leaders were
"women who were not only able to utilize institutionally approved
programs for their own personal advantage, but were defined by
other inmates as women with forceful characters and personalities
who were able and willing to speak out for themselves and other
women and were interested in bringing about change at the institu-
tion."[92] The identified top leaders in this women's prison had estab-
lished reputations for being able to fight and otherwise physically
defend themselves. Additionally, the leaders had been convicted of

traditionally masculine offenses such as burglary and robbery, instead of shoplifting, insufficient-funds checks, or other traditionally feminine offenses.

Five of the seven top leaders were playing the stud role in homosexual relationships, a finding that tends to support Giallombardo's notion of the power of the stud role, but the values and behaviors demonstrated by these female prison leaders do not suggest a true family orientation as described by Giallombardo. Instead, by playing the male role these women, similar to men in conventional society, were able to "establish themselves in positions of dominance and power and to emerge as the leaders of the institution."[93]

Release from Prison

Parole is viewed as a privilege. It is a status to be earned by demonstrating that one can function in society in an acceptable way. Most states do not have separate boards to hear women's cases, and often the members of parole boards are not directly connected with the prison and thus use noninstitutional criteria in their decision-making. In fact, it is not always clear just what criteria parole boards use for granting parole. Since women receive indeterminate sentences in so many states, parole boards may heavily weigh a female inmate's institutional record in deciding parole. Or the female offender may have to convince the parole board in a brief interview that she is "rehabilitated," whatever that may mean.

In addition to institutional behavior, other factors weighed by parole boards include industrial time and meritorious good time earned. Simultaneously parole boards are too often prone to base their decision on the original or prior offense records, a practice that tends to cancel out the careful conduct a woman might have maintained in prison. Women appear to be convicted for those offenses—property crimes, drugs, or alcohol—that have less successful parole outcomes anyway, which compounds the problem. Rita Simon's examination of the parole performances of men and women by offense in 1968–1970 reveals that women did not appear to receive preferential treatment in paroles compared to men. She found that women convicted of forgery and fraud were most likely to be paroled. This is a curious finding since, with the exception of drug offenses, this category is one with the least parole success. It is the largest offense type among women offenders, and Simon felt the explanation might be related to the number of female offenders or the size of the pool of female inmates in a specific offense category.[94]

Women with histories of prior commitments, as well as those with drug use histories, had less successful paroles than men, which Simon

felt might be related to parole officers' high expectations and standards for women's behavior while on parole. Haft follows this same line of reasoning in her discussion of discriminatory parole standards whereby women may be required by parole boards to meet higher standards of proper conduct, such as not living "in sin" upon release. In this instance a double sex standard may be operating based on "society's view that extra-marital sex is normal for men but depraved for women," a belief that is likely to cause the refusal or revocation of parole more readily for women than for men.[95]

Most men have home and families to return to upon release from prison, but when a woman is released she usually has to reestablish her home and family. For reasons yet unknown, the family ties of imprisoned women break up more easily than those of men. As a result, a woman is often faced with many serious problems upon release: regaining custody of her children; finding suitable housing for herself and her children; finding a job that provides sufficient income when she has few marketable skills; reestablishing severely damaged mother-child relationships; beginning a new life-style rather than returning to the criminogenic environment she left behind—all these in addition to the usual problems facing parolees.[96]

Prerelease programs are designed to assist with these kinds of problems. The purpose of such efforts is to make the transition from prison to society easier for the inmate, but many women's institutions do not offer prerelease programs or staff correctional counselors to work with women nearing release.

In 1864 a privately owned halfway house for women discharged from prisons and jails was opened in Boston called the Temporary Asylum for Discharged Female Prisoners.[97] Since that time halfway houses have grown in popularity as a residential means to assist the female inmate in reentering the community. Halfway houses, however, have their own peculiar sets of problems where women offenders are concerned. The Glick and Neto national survey, for instance, found that client body searches, room searches, and surveillance were practiced in seven out of the ten halfway houses they examined. Also, the lack of public acceptance in the community often prevents the establishment of such facilities or results in harassment when they are instituted. In many major cities community residents refuse to allow halfway houses in any but the least desirable communities; and some homes are even met with violence from the neighborhood residents, along with strong political resistance,[98] in efforts to deny even this opportunity to female offenders. Obviously, orientation and preparation of the community for halfway houses and other community transitional programs for women offenders is requisite for successful programming of this type. Unfortunately, this is not being done.

12

THE MOST FORGOTTEN
FEMALE OFFENDERS

The "forgotten female offender" is an appellation many social scientists feel is appropriately applied to the entire population of incarcerated female offenders. It has been seen that the 4 percent of prisoners who are women receive rather poor treatment in the hands of the criminal justice system. Unfair and discriminatory as their status is, there are subgroups within the imprisoned female population who suffer special kinds of problems and hardships over and above the rigors of prison life faced by other female offenders. These are the women referred to here as the *most* forgotten female offenders: the prison mothers, especially those who become mothers while behind bars; women in jails throughout the United States; and the handful of women on death rows.

Incarcerated Mothers

One way to approach the problem of parenting and prison is to examine the experiences of the female inmate in terms of her status as a mother or a mother-to-be. The situation of the pregnant female offender focuses on her physical and psychological care during pregnancy and the medical care involved in the delivery and aftercare of herself and her child. A second type of mother-child incarceration situation centers on the circumstances surrounding the mother in the jail or prison setting and her newborn infant. Finally, there are the numerous women who were mothers at the time of their incarceration who face special problems at that point when the criminal justice system first intervenes in their lives, at arrest and throughout their trial, sentencing, and the duration of their terms of confinement. Some female offenders—those who were pregnant upon entry into

the system—experience a total gamut of hardships; those few women who become pregnant while imprisoned enter later on a similar problem continuum; and most incarcerated mothers clearly suffer a double punishment: confinement because they committed a crime and various agonies that accrue to being an imprisoned mother.

The Pregnant Inmate

Some countries do not imprison pregnant women; others assign pregnant prisoners to special mothers' prisons; but in the United States differential treatment of this kind is rare. On the contrary, it has been observed that an incarcerated pregnant woman may indeed be treated worse than other inmates *because* of her condition. Substantial evidence exists that prison staffs single out pregnant women for harassment because of hostility, disapproval, or dislike of women whom they view as not "worthy enough to have children."[1] Often to prevent a pregnant inmate from becoming an "unworthy" mother, she is either coerced into having an abortion or forced, through brutal and uncaring treatment, to abort. The pressure to have an abortion has been identified by the American Civil Liberties Union as one of the basic problems of incarcerated women. Official prison coercion to abort resulted in a significant prisoners' rights suit, *Morales* v. *Turman* (1974), in which

> an inmate testified that when she arrived at Texas' Gainesville School for delinquent girls, she was three months pregnant. On January 24, 1973, she was given ten pills that she was told would start her menstrual cycle. She was warned against taking the pills by other inmates, because the other women had lost babies after taking them. Faced with the threat of solitary confinement if she refused, she took the pills and exercised as directed. On February 1, she began bleeding, but was refused medical attention. On February 15, she aborted a three month old fetus.[2]

The previous chapter revealed that female inmates often complain of the starchy diets and inadequate health and medical care received in women's jails and prisons and, further, that national surveys of female penal institutions verified these complaints. The pregnant prisoner is more affected by improper diet and the lack of prenatal gynecological care because of her condition, especially those pregnant women in jails:[3]

Prison diets are typically high in starches and low in protein and vitamins. A pregnant woman, however, requires a diet high in protein, vitamins, and other nutrients. Links have been established between nutritional deficiencies during childbearing and a high prenatal mortality rate due to fetal growth retardation, hypertensive disorder, and premature delivery. Nutritional deprivation has been shown to result in cellular damage in the brain of the fetus. Although a child born to a malnourished mother may physically recover, damage to the nervous system may be irreversible, permanently impairing the individual's intellectual functioning.[4]

Prenatal care in women's prisons and jails seems to be a luxury and not a right. The lack of medical personnel, particularly gynecologists and obstetricians, constitutes maltreatment of pregnant inmates and has been found by the courts to be cruel and unusual punishment in a number of cases.

We have seen that women drug addicts are frequently forced to withdraw "cold turkey" in the jails and prisons in this country and are often denied methadone, if they are using that heroin substitute. Also, we are aware that substantial numbers of women are imprisoned for drug violations and are addicted when they are incarcerated. What is little known, and far too often ignored, are the problems of the addicted pregnant woman inmate. In *Garnes* v. *Taylor* (1973) expert witnesses established that the routine institutional practice of withdrawing pregnant women from methadone typically results in the aborting of their fetuses or, if a spontaneous abortion does not occur, the withdrawal process may be harmful to the fetus.[5] Furthermore, "cold turkey" withdrawal from heroin involves such physical trauma that this method may injure the fetus. Despite these hazards to the mother and child many female correctional institutions not only carry out such practices, but also seem unaware of the special problems of an addicted mother and do not provide individualized medical care in such cases.

If they make it in time, after all the regulations and red tape, pregnant inmates usually have babies in local hospitals. Since these facilities have not provided prenatal care for the prospective mother and she has probably had little, if any, prenatal care in the jail or prison, the dangers of a complicated delivery are compounded. This medical situation is particularly hazardous since many institutions wait until labor has begun before transporting the mother to the hospital. The new mother is usually transferred back to the prison four days after delivery while her child is either sent to relatives or placed in a foster home.[6] Additional medical problems are faced by the prisoner mother in the transfer back to prison:

Normal prison policy of subjecting incoming women to vaginal searches is sometimes not suspended with respect to postparturient women. This results in subjecting them to painful, degrading, and dangerous searches shortly after giving birth. Such searches create a risk of dislodging stitches when an episiotomy has been performed or a risk of severe infection.[7]

Standards addressing the treatment of pregnant prisoners have existed for over fifty years. In fact, the most detailed standards were those proposed by a national commission on prisons in 1931 which recommended nonincarceration, if possible; the provision for prenatal, obstetrical, postnatal, and infant care; safeguards for the health of the mother; and other standards to protect the mother, her child, and the placement of her child. Current standards, especially those set by the American Correctional Association, which are the most frequently followed, are not as detailed; in fact, they are more cursory than the standards of the United Nations or the American Public Health Association for the treatment of prisoners.[8]

Current legal opinion suggests that ignoring these standards and mistreating pregnant women in prisons either deliberately or through indifference to their special medical needs have constitutional implications. As a result of "deliberate indifference to serious medical needs," such as improper or inadequate diet and nutrition, and lack of prenatal, emergency, or postnatal care, a pregnant inmate's constitutional rights are violated according to the doctrine of cruel and unusual punishment. Closely associated with this legal standard is the "unnecessary and wanton infliction of pain" clearly seen in the physical abuse of pregnant prisoners by means of solitary confinement, assignment to strenuous jobs, and dangerous vaginal searches upon return to incarceration. Furthermore, a woman's right to control her own body is threatened when the fundamental right of procreation is denied by prison officials.

Unfortunately, pregnant inmates, particularly those in jails, have little legal recourse to assert their constitutional rights when confronted with inhumane treatment at the hands of corrections authorities. Even if litigation were possible, the odds are that the woman would already have aborted or have her baby before her case could get to court. And if she did get to court, the abused pregnant prisoner would face two additional problems: the fact that "a certain amount of judicial hostility toward damage actions by prisoners" exists and also it is difficult, if possible at all, to place "a dollar value on the loss of a constitutional right."[9]

Mothers and Babies in Prison

Only three states in the country have statutory provisions that allow mothers to keep their newborn babies with them in prison—California, New York, and Florida. In California the child does not necessarily have to be born while the mother is incarcerated. Any woman committed to a penal institution who has a child under the age of two, as well as a woman who gives birth while an inmate, may have her baby admitted to and kept in the institution until the child reaches the age of two, or for a longer period at the discretion of the welfare board.[10] In Santa Clara County, California, an experimental program houses women and their children in an apartment complex with no guards, locks, or other security measures. No one has ever tried to escape from this facility.[11] New York's Bedford Correctional Institution for Women has had a prison nursery for the past fifty years where babies of inmates, by statute, are normally kept for up to eighteen months. Florida, as in many other instances involving the rights of prisoners in that state, presents a peculiar case on this issue and will be examined in some depth.

Unlike California and New York, the Florida statute applies only to children born in prison. Originally enacted in 1957, Florida law provided that if an inmate gave birth to a child while in a Florida institution, such a child could be retained by that institution until the age of eighteen months or, in exceptional cases, longer, dependent upon the discretion of the Department of Offender Rehabilitation.[12] In 1977 this statute remained substantially the same:

> If any woman received by or committed to said institution shall give birth to a child while an inmate of said institution, such child may be retained in the said institution until it reaches the age of 18 months, at which time the Department of Offender Rehabilitation may arrange for its care elsewhere; and provided further, that at its discretion, in exceptional cases, the department may retain such child for a longer period of time.[13]

Up to 1975 women who wished kept their children with them in prison, and a nursery was provided. But in 1975 the male superintendent eliminated the prison nursery. Time passed, mothers were without their babies, and few if any of the female inmates knew about the Florida statute; keeping the babies had simply been the practice. In 1979 a young woman inmate, Terry Jean Moore, rediscovered the Florida statute, and went to court to try to keep her baby daughter, Precious.

Florida has two prisons for women—Florida Correctional Institution for Women at Lowell (FCI), a minimum/medium security prison, and Broward Correctional Institution for Women (BCI), a maximum security prison. Terry Jean Moore, a young woman who "faced a harsh, vindictive judge who sentenced her to 12½ years in prison for a $5 robbery and a jailhouse mattress 'frustration fire,'"[14] a woman who never should have been imprisoned in the first place, became pregnant by a BCI guard. Baby Precious, as she was called by the Florida press, was the result of this union behind prison bars. She was born March 25, 1979, and due to a restraining order transferred with her mother to FCI on April 5, 1979. Undoubtedly in reaction to a nationwide *60 Minutes* television focus on sentencing disparity in Florida that used her case as an example, Ms. Moore and Baby Precious went free on parole in August, 1979, after both had served five months together in the FCI prison clinic. In October, 1979, after easy passage by both the Florida House and Senate, a new F.S.944.24(2) went into effect, which read:

> If any woman received by or committed to said institution shall give birth to a child while an inmate of said institution, such child and its welfare shall be within the jurisdiction of the appropriate circuit court if the mother chooses to keep the infant. Upon petition by the Department of Corrections, the mother, or another interested party, a temporary custody hearing before the circuit court without a jury shall be held as soon as possible to determine the best interests of the child. The department shall provide and maintain facilities or parts of facilities, within existing facilities, suitable to ensure the safety and welfare of such mothers and children, to be used at the discretion of the court.[15]

Since that time, dependent upon the judge hearing the case and his predilections, eight women have been permitted to keep their babies in Florida prisons while four others have been denied that privilege, and three cases were on appeal as of April, 1981.[16]

A heated battle ensued in the Florida House in 1981 over a bill to repeal the 1979 statute allowing a woman inmate the right to petition the court to keep her baby born while she was imprisoned. The male legislators won, and the eleven babies and their mothers in the baby cottage at FCI lost when the governor allowed the bill to become law. The battle may not be over yet. A prisoner rights group plans to challenge the repeal when the next pregnant woman asks the judge to permit her to keep her child, by asserting that "a woman does not lose her right to be a parent when she is sent to prison."[17]

Several arguments have been raised in opposition to the placement of babies with their mothers in prisons; for example, during legislative hearings on the issue one female Florida legislator said with apparent horror, "I can't even believe my ears. . . . There's no child that can be brought up properly inside a prison."[18] This is a common belief of opponents to the practice of allowing inmate mothers to keep their babies. But physical surroundings are of little consequence to an infant as long as he or she receives love, attention, adequate food, and the other basic necessities for comfort.[19] What is most significant at this early point in a child's life is the bond formed between the mother as the primary care-giver and her infant. Almost fifty years ago Sigmund Freud, in his psychoanalytic approach to the human dynamic, emphasized the uniqueness of the mother-child relationship, especially in the child's formative years (from birth to about age six). Developmental psychologists have found that the critical age in which attachment bonds between mother and child are formed is between six and eighteen months to two years of age.

Although the phenomenon of bonding certainly takes place between father and baby:

> For most babies, the primary caregiver, or "need satisfier," is the mother—the source of food, protection, warmth, stimulation, and affection. The bond, or attachment, that she forms with her baby begins during pregnancy, possibly when she first feels the fetus within her body. It is a gradually unfolding relationship that blossoms with the baby's birth as the mother and baby exchange messages and feelings with all of their senses—with the meeting of their eyes, through skin-to-skin contact, with body warmth and movements, by smell, and by sound. In fact, the first minutes and hours of life may be especially, perhaps critically, influential for the initiation of the maternal bond, triggering a sequence of nurturing responses that may have long-lasting effects on the mother-child relationship.[20]

Breaking the bond through separation of the mother and child can have serious consequences not only in the immediate expression of distress and anxiety the child experiences; there may also be long-term deleterious effects on the child. One potential syndrome, affectionless psychopathy, has particular implications for the criminal justice system. The symptoms of this syndrome indicate an anti-social personality, an inability to relate to people, a lack of guilt, an inability to follow rules or form long-lasting relationships with others, and a potential for future law-breaking behavior.[21] Research has demonstrated that this form of psychopathy is the outcome when an attachment bond is not formed between a child and its care-giver.

A second argument against permitting mothers to keep their babies in prison with them focuses on the effects on other inmates. According to this position incarcerated fathers cannot have their children with them; also, the question is raised about the many other mothers in prison who would like to have their children with them. Very few men are the primary care-givers for the children, since this is the traditional role of mothers. As indicated above, bonding does take place between father and child, but the mother-infant interaction is more crucial, especially in the first minutes and hours after birth. *All* women should be with their infant children during these critical formative months, but in the face of resistance to *any* child's placement in an institution with its mother, because of the bonding process priority should be given to those babies born in prison.

It is also argued that a baby in prison might be harmed by another prisoner or held hostage. Such a scenario might take place in a men's prison where violence, riots, and hostage-taking are more commonplace; but, as indicated in the previous chapter, women's prisons are entirely different and tend to be more passive, psychologically controlled institutions. As a result of the more low-keyed environment women rarely riot, take hostages, or exhibit violence except against each other. The New York Bedford Hills prison for women has never had a hostage-taking or any violence against a child in its fifty-year prison nursery history. At any rate, such an argument is moot, since the babies are not kept in cells but in special cottages or nurseries set aside specifically for them and their mothers, away from the other inmates.

Probably the most inane argument challenging the idea of babies in prison is that women would either get pregnant to keep from going to prison or get pregnant while in prison in order to get preferential treatment and early parole. Being pregnant does not prevent judges from sentencing women to prison. Most pregnant inmates were in that condition before incarceration. In Florida, for example, from 1979 to 1981 only two of the twenty-five women who gave birth in prison were impregnated while in prison. As to the argument that women would have babies to get special treatment while incarcerated, one female representative challenged her peers in the Florida legislative battle on this issue by stating, "If any of you would like to go through the rigors of childbirth in order to get preferential treatment, I'd like you to stand."[22] No one did.

It has been suggested that women in prison are "different" and are not sincerely interested in properly caring for their children or have less regard for them. The counterargument is that mothers are often in prison because the offenses for which they were imprisoned, usu-

ally economic crimes, were committed for the sake of their children whom they did not want to see hungry, inadequately clothed, or poorly housed. More than half of Florida's female inmates, for example, are incarcerated for economic-related crimes such as worthless checks, shoplifting, larceny, and drug offenses; and it is commonplace for a woman in Florida to receive four years for writing bad checks, an offense for which 14 percent of the women are there in the first place.[23] It must be remembered that the majority of women in prisons in this country are mothers, and additionally they are poor. It is precisely their caring for their children that brings them into contact with the criminal justice system.

Finally, prison administrators and state legislators, mostly men, argue that keeping babies in prison introduces administrative problems and additional expense. In the Florida case when the Department of Corrections reported that the cost of keeping the babies from March, 1979 to January, 1981 was $16,970,[24] the prisoners' advocate, the Florida Clearing House on Criminal Justice, countered:

> The *real* expense to Florida's taxpayers is in sending women who write bad checks to prison for four years, rather than having them make restitution and putting them in a job skills program so they can get good jobs—job [*sic*] that will enable them to support themselves and their children. The *real* expense is in sending women to prison for shoplifting three dresses from Sears. The *real* expense is in sending women to prison for 25 years for killing their husbands or lovers after years and years of documented, physical abuse.[25]

The cost to the state of keeping a baby in prison with its mother is no more than the cost of keeping the baby in a foster care placement until the mother's release from prison.

The Children of Women in Prison

The Glick and Neto survey of women in jails and prisons found that 56.3 percent of incarcerated women had one or more children living at home at the time of their arrests, for whom the mothers were the sole source of support.[26] This appears to be a conservative figure, since other studies of the problem have reported 67.1 percent,[27] 70.4 percent,[28] and 80 percent,[29] respectively, in the populations they examined. Recent data from Florida, for example, indicate that in 1980, 70 percent of the women in Florida prisons had one or more children under the age of three, were single, and were the sole source of sup-

port for their children.[30] Nationally, incarcerated mothers had on the average 2.48 children, a number higher than the 1973 national average for the general population of 2.18 children.[31]

Family size appears to vary by ethnic group, since whites (38.7 percent) and blacks (31.4 percent) tend to have one minor child at home, Hispanics are more likely to have two children (26.5 percent), and Native Americans have the largest number of dependents—three or four children (26.7 percent). In fact, Native American women inmates were more likely than any other ethnic group in the national prison study to have five or more children. Almost one third of imprisoned women (32.1 percent) in the study had at least one minor child at home, 19.9 percent had two children, and 22.4 percent had three or more minor dependents. Women in jail who had not been sentenced were found to have almost identical numbers of children living at home as sentenced women, a finding the researchers felt dispelled the myth that women with children are treated more leniently by the court in not being detained while awaiting trial.[32]

Until very recently attention devoted to incarcerated parents and their families tended to center on the male offender, because of the proportionately small number of incarcerated women, or possibly because the majority of imprisoned women are poor and/or members of minority ethnic groups. At any rate, the estimated tens of thousands of children of incarcerated women have been overlooked by legal and mental health professionals, and "because of the lack of a national family policy, no effort is made to evaluate policies and practices in the criminal justice system in terms of their impact on family life."[33]

We have already traced the progress of a female offender from arrest through sentencing and incarceration, but until quite recently her children have remained shadowy figures in the background of the typical criminal justice experiences of their mother. Many children have a great deal of exposure to the system. Often they witness their mother's arrest; some children have been in court when their mother's case was tried; other children have visited their mother in jail or in prison. At each of these points in the criminal justice system little concern is exhibited toward the children of female offenders. At the first contact, "police officers generally display an appalling lack of sensitivity to the needs and fears of children when they arrest a woman."[34] In their zeal to make the arrest, they focus attention on the mother as an alleged offender; the children affected are generally not seen as a police priority. The following example is believed to be typical of law enforcement personnel behavior in such cases:

A woman with two young children (ages two and four) was arrested on a drug possession charge. The police burst into the house and cut open

the heads of her four-year-old daughter's dolls to search for drugs as the child looked on in tears. They then handcuffed the woman and led her away without giving her any opportunity to comfort her children.[35]

If the woman's children are at school or otherwise not in the home, the police are unlikely to think of their welfare at the time of the arrest, since their primary concern is the "apprehension of the alleged offender and/or community safety."[36]

The pretrial, detention, and trial stages of the criminal justice process also show inattention to and a lack of responsibility for the needs of a female offender's children. If the woman has a lawyer, sometimes the attorney can be persuaded to intervene in the family crisis presented by the arrest. The system itself, however, has few resources directed toward the responsibility and care of these dependent children. The situation is particularly grave when women offenders are detained or sentenced to jails, since the physical arrangements, lack of adequate personnel, and stringent rules often introduce barriers to contact between the mother and her children. Many facilities prohibit younger children from visiting; even those who are older—for example, ages fourteen to eighteen—if allowed to visit are denied physical contact with their mothers and must see them through a heavy mesh screen or thick glass. Because of rigid policies such visits are usually brief and are limited to strict visiting hours that may be difficult, if not impossible, for the children to adhere to, especially when transportation may be a serious problem.

In itself the trial is a traumatizing experience for a mother and her children, but it is more shattering when a female offender, possibly in front of her offspring, is sentenced to prison and taken directly there from the courtroom. Frequently such a decision is unexpected, and the mother has been unable to make arrangements for her children, or even talk to them and explain what is happening, before being led away in handcuffs, to the horror of her witnessing children.

The mother who is sent to prison faces the same problems concerning her children as women in jails, except these problems are intensified because of the great distances from home, the lack of transportation, or the money to pay for transporting the children to the facility—that is, assuming the prison allows children to visit in the first place. It is frequently the case that either state laws or a shortage of personnel to properly supervise visits from family members prohibits family visits. This type of inattention to the needs of the family is particularly ironic in light of studies which indicate that permitting a woman to perform her mothering function actually contributes to her rehabilitation and helps to keep her family united.[37] Even more

inconsistent is the emphasis the correctional system places on keeping the woman inmate in the traditional female role through work assignments, vocational training, and prison industries, while simultaneously denying her a woman's most traditional role, mothering. The psychological effects of this maternal deprivation have serious implications for the mother, the development of the child, the mother-child relationship, and the family.

Effects of the Separation on Inmate Mothers

Studies have repeatedly demonstrated that concern about their children is the most consistent problem of incarcerated mothers. Prison mothers tend to be dissatisified with the care provided to their children by caretakers, particularly those in foster homes. In part these negative feelings are related to quality of care and the possibility that their children may be becoming attached to the caretaker; but also the mothers are experiencing guilt and conflict because they are not providing the care required for their children.[38] In one study, for instance, guilt feelings, which were the most frequent expressions of the mothers, centered around their offender-mother status.[39] These mothers were very concerned about the influence of their prison status upon the child's development and the mother-child relationship. They feared the child would lose respect for them and become difficult to control, or become belligerent when reprimanded and remind the mother of her status, or perhaps that the child would not love her because of her offense and her resultant absence. There was also the constant worry of how the child would cope with the separation itself. A range of studies indicate that many mothers anticipate difficulties: "rejection, loss of respect, lack of intimacy, excessive dependency by children due to fear of other separations, problems in control and discipline, inability or lack of knowledge in relating to children, and regaining custody of children."[40]

In addition to the guilt there is evidence suggesting that the separation of an incarcerated mother from her child psychologically resembles other forms of loss seen in divorce, death, and other separations from children characterized by such symptoms as "remoteness, emptiness, helplessness, anger, guilt, fears of loss of attachment, and rejection."[41] Carrying the weight of these intense feelings undoubtedly contributes heavily to a need to become a part of the social system or family network typically found in women's prisons. The uncertainty and anguish suffered are unrelenting parts of the imprisonment, as are the agonizing thoughts a mother has when the time for release

approaches, for now she must face new problems—those of readjusting to her children and relating to them, especially where discipline is concerned, and insecurities about her parenting abilities.[42]

Effects of the Separation on the Children

Children experience emotional and psychological trauma at every stage of their mother's progression through the criminal justice system. Some children are witnesses to the criminal offense that resulted in their mother's arrest. Many children are on the scene of their mother's apprehension and arrest, experiencing confusion and terror at seeing her handcuffed, placed into a police vehicle, and taken away. As mentioned above, children have seen their mothers sentenced in court and, prior to that experience, visited their mothers in detention facilities where they could not touch each other. As a result, these children often exhibit physical, emotional, or psychological problems and difficulties in school. Such children may develop a psychopathic personality over the long term as a result of being exposed to the callousness of the criminal justice system. Apparently the largest proportion of children's problems reported by incarcerated mothers are psychological or emotional. For example, in one study 69.9 percent of the mothers felt their children's problems were mainly restlessness, aggressive behavior, or withdrawal.[43]

Age is an important factor in the emotional response to separation from the mother because of incarceration. We have already seen that the infant shows anxiety and distress at such a separation. A child between the age of two and five years suffers breakdowns in acquired skills such as toilet training and verbal skills.[44] In older children there is a possibility of delinquent behavior and academic problems.

One psychiatric study of the reactions of children ages five to fifteen to the incarceration of a parent examined the acute reactions of such children and some of their coping mechanisms.[45] The most frequent acute reaction was a temporary drop in school grades and an increase in aggression. Boys were more likely to handle the situation with aggression than girls. Many of the children in this study were humiliated by the parental arrest and felt a great deal of shame. Guilt was also felt, because the child felt that his or her behavior possibly contributed to the incarceration. Another acute reaction is seen in the antisocial behavior of children of incarcerated parents, especially among boys in the twelve-fourteen age bracket. Girls also exhibit antisocial behavior, usually in the form of promiscuity, running away, and

drug taking. Often the antisocial behavior of the child resembles the offense for which the parent was incarcerated.

In addition to these emotional problems children of imprisoned mothers report they are teased by peers and young relatives about their mother's status, which makes them feel ashamed and angry.[46] Probably no one can be more cruel than a child, especially in a situation of peer harassment and more particularly when a mother is involved as the object of derision. Although some children are able to ignore the teasing, others strike out physically or verbally. It is obvious that another side effect of the mother's prison status on the child is poor peer relationships. These children have become stigmatized, and the stigma is even more painful when it is applied by other children.

In addition to the social stigma that imprisonment carries, the family structure itself has been threatened through the loss of a significant member. In those cases where the mother is the primary care-giver and source of support, her removal creates severe financial strain on the relatives left to take care of her children. The few studies on families of imprisoned persons have focused on the enforced separation of the husband or male member of the family, but when a mother is the sole source of financial support, clearly these findings would also apply to her. The monetary hardships occur when the principal wage earner is removed, despite the sex of that person.

Once the primary care-giver is removed, the family often begins to disintegrate. Children are separated from their siblings, a process which removes even that possible source of comfort and familiarity. One study of the effects of incarceration on the children of imprisoned women found that over 50 percent of the children in the study had been parted from one or more of their siblings.[47] The retention of the mother-child relationship during her incarceration becomes paramount not only for the emotional health of the children and the mother, but also as a cornerstone to the maintenance of the family structure. This relationship can also be a powerful motivator for the rehabilitation of the mother.[48] By maintaining the mother-child relationship during the period of confinement, the impact of the separation is minimized. Unfortunately, the way the corrections system operates, the family is punished along with the offender mother. Instead of fostering the strengthening of the mother-child relationship, institutional practices make it difficult for women to maintain contact with their children. Furthermore, as seen in the previous chapter, the institution's efforts to force dependency upon its female inmates negatively impact on the mother-child relationship.

Programs for Inmate Mothers

Fortunately there are a few programs across the country that function to help maintain contact between inmate mothers and their children, thus contributing to the preservation of the mother-child bond and the family structure. As previously indicated, women's prisons in New York State, Florida, and California have nurseries within their facilities. In California the Kinderheim Program allows prisoner mothers to "vacation" at home with their children every six months.[49] Also, the State Correctional Institution for Women in Muncy, Pennsylvania, allows infants to stay in the prison hospital, where their mothers are able to spend half of each day with them, until placements are arranged.[50]

Other programs designed to maintain ties between incarcerated mothers and their children include the Daniel Boone Career Development Center, a minimum security institution founded in 1976 in Belleview, Kentucky; the Purdy Treatment Center for Women established in 1971 in Tacoma, Washington; Project MOLD (Mother Offspring Life Development Program) opened in Nebraska in 1977; and the camp retreat program at Clinton Correctional Facility in New Jersey, which permits incarcerated mothers to spend a few weekends with their children in a camping experience.[51]

One federal program at the California Federal Correctional Institution for Women at Pleasanton has a nearby women's shelter where mothers and their babies may live together.[52] Another similar program is the Cluster II program in Norristown, Pennsylvania, a residential facility where female offenders and their children live in semi-detached houses in a Philadelphia suburb. This program is an alternative to prison and also a facility where women serving the last three to six months of their sentences can reside with their children as they make the adjustment back into the mainstream of society.[53]

The few innovative programs that serve inmate mothers and their children have "varying philosophies, operate under different auspices, and serve different size populations,"[54] but they are a small step in the right direction even though they are unable to address the multiple needs of the total number of children of women inmates.

Legal Problems of Incarcerated Mothers

In addition to whatever legal problems an imprisoned mother might have with appeals and other elements of her case, parole hearings, and other legal matters, there are numerous problems associ-

ated with her status as a mother—for instance, the determination of her child's placement, parental rights issues, custody and possible adoption battles, foster care concerns, paternity actions, divorce, and visitation rights. These and other child-related legal problems face an incarcerated mother who has little, if any, access to legal counsel.

The courts, guided by standards established by state legislatures, determine the placement of an unattended child. These decisions range from a temporary denial of custody of the child to permanent termination of parental rights.[55] The court action includes placement of the child either in a foster home, with close relatives of the mother, or in an institution. If, at the time of her arrest or incarceration, a female offender's child is left with a third party who gives the child up to a social service or welfare agency, the agency normally petitions the court for legal custody of the child. If there is no third party to assume responsibility for the child at this crucial time in the mother's and child's lives, the appropriate state agency arranges for foster care placement either by a court commitment of the child to the agency or by the mother's voluntary agreement to place the child with the agency, if she has the time to make such arrangements prior to her incarceration. This type of voluntary placement does not give the agency legal custody of the child at this time, but usually the agency petitions the court for custody later. Thus, whether a child is placed in foster care voluntarily or involuntarily, placement proceedings are often the initial step in the permanent severance of contact between an imprisoned mother and her children.

Parental rights, while not explicitly defined, generally include "the right of custody, nurture, companionship, service, earnings, and decision-making with regard to the child's religion, medical care, discipline, and education. The parent has the corresponding legal responsibility to support the child."[56] If the court terminates these rights, the court order severs all legal bonds between the biological parent and her child, which specifically means that the mother has no right to custody, visitation, or communication with her child.[57]

Some states have statutes that permanently terminate the parental rights of a parent in prison. This can be brought about in at least four ways. (1) A few legislatures specify that a mother's incarceration is sufficient cause for the termination of her rights as a parent.[58] (2) In certain cases the nature of the crime itself is used as the basis for determination; for example, in California parental rights may be terminated when the crime is such as to "prove the unfitness of such parent or parents to have the future custody and control of the child." (3) Vague standards may be used to determine parental unfitness, as in Arkansas, where a "dependent-neglected" child who is under such

improper guardianship as to "endanger the morals, health, or welfare of himself or others" may be removed from parental custody since the parent's conviction is seen as evidence of unfitness. (4) In some states felons lose their civil rights and thereby are unable to legally challenge attempts to adopt their children since their consent as a nonperson is not required for adoption proceedings.[59] In some cases, of course, it may be best to terminate the mother's parental rights—for example, if she has received an extremely long term in prison, particularly in a maximum security situation where visitation is precluded, or if the parent is a threat to the child and has caused serious harm to it.[60]

Every state has procedures established to terminate parental rights. Depending upon the jurisdiction, the court usually employs one of the following three methods: finding that the child is neglected; initiating a special hearing to determine the mother's fitness; or instituting an adoption proceeding.

An "unfit" mother is incapable of performing her parental duties or has abandoned her responsibilities as a parent. Since incarceration alone is not abandonment, the notion that the prisoner-mother has abandoned her child and is thus unfit, and must relinquish her rights to prevent the adoption of her child, is clearly invalid; yet it is common legal practice.[61]

Many prisoner-mothers are forced to give up custody either at the time of arrest or before their incarceration. One recent study found that mothers were forced to give up their children either by the state (10.6 percent), by their own mothers (3.1 percent), or by an ex-husband (2.5 percent).[62] An additional 26.5 percent of these mothers reported that they were not forced, but voluntarily gave up custody temporarily while they were incarcerated, for the benefit of the children who would receive better medical or other services as a result. In these cases the mothers plan to regain custody when they are released from prison. Whether they do is doubtful.

Since women inmates are more likely to be the primary care-givers and custodial parents of their children prior to incarceration, they are more likely than imprisoned fathers to face legal problems related to the custody of their children. However, available legal service programs are largely directed toward male prisoners. When a mother is advised that a petition concerning her child is pending in court, efforts to secure legal representation are extremely difficult due to the rural location and relative isolation of most women's prisons, which also lack legal services programs.

Probably the most serious problem faced by an incarcerated mother is a petition for the adoption of her child. It is relatively commonplace

for a child's caretaker or the social service agency involved to file an adoption suit against the incarcerated mother, especially if she is serving a long prison term. If the adoption petition is granted, the outcome is permanent severance of the mother's parental rights to her child. Many states require the consent of the natural mother if her parental rights have not been forfeited, but in the best interests of the child some states permit an adoption over the objection of the mother, primarily because of her conviction and incarceration. As in cases of determination of parental unfitness, abandonment seems to be the determinant in adoption cases. Incarceration or failure to support a child because of incarceration does not support a finding that the child has been abandoned, but some statutes specify the length of time that constitutes abandonment. Therefore, if the mother's term of confinement is longer than the time spelled out in the statute, abandonment is determined to have taken place.

The rationale most frequently given for granting adoption without the consent of the natural mother and without demonstrating that her conduct is such that her parental rights are forfeited is that the prospective adoptive parents have become the "psychological parents" of the child.[63] But other rationales are found in many statutes to accomplish the same goal—permanent removal of the child from its mother. Such statutes may be grouped in the following categories: "failure to support, extreme and repeated cruelty to the child, foresaking parental obligations, neglect, desertion, habitual drunkenness or drug addiction, open and notorious adultery or fornication, mental illness, and imprisonment with or without a loss of civil rights."[64] Clearly the offenses for which many women are incarcerated fall into many of these categories, since the majority of incarcerated women have been imprisoned for victimless crimes such as drug or alcohol violations and prostitution. Thus the system has a built-in provision that works against a mother's retention of her children.

Women in Jails

A sympathetic male warden offers the following view of the women in jail:

> Being in jail is harder on a woman than a man. Men are always together. They grow up taking showers together, sleeping together. . . . They've been in the Army with other men and are used to being around each other naked or dressed. Women are taught to undress in private and be modest. They don't like to undress in front of other people. Women

have stall showers, men have one big shower room, . . . so think how much harder that would be on a woman. She comes in here and we undress her and tell her to "bend over, lady," to look for contraband. We make her bathe in front of everyone. Right off that gives them mental problems that are hard to handle. The initial shock is the toughest thing. That sort of thing can break your spirit.[65]

Then there is this inside view of jail by a female inmate at the Riker's Island Correctional Institution for Women in New York City:

We sit in the bull pen. We are all black. All restless. And we are all freezing. When we ask, the matron tells us that the heating system cannot be adjusted. All of us, with the exception of a woman, tall and gaunt, who looks naked and ravished, have refused the bologna sandwiches. The rest of us sit drinking bitter, syrupy tea. The tall, fortyish woman, with sloping shoulders, moves her head back and forth to the beat of a private tune while she takes small, tentative bites out a bologna sandwich. Someone asks her what she's in for. Matter of factly, she says, "They say I killed some nigga. But how could I have when I'm buried down in South Carolina?" Everybody's face gets busy exchanging looks. A short, stout young woman wearing men's pants and men's shoes says, "Buried in South Carolina?" "Yeah," says the tall woman. "South Carolina, that's where I'm buried. You don't know that? You don't know shit, do you? This ain't me. This ain't me." She kept repeating, "This ain't me" until she had eaten all the bologna sandwiches. Then she brushed off the crumbs and withdrew, head moving again, back into that world where only she could hear her private tune.[66]

Both of these views describe the horror and desolation of local jails in this country which were never planned to hold female offenders in the first place. Yet as of February, 1978, women comprised 6 percent of the total number of adult inmates in our nation's jails. Regionally, the South led in the number of jailed female offenders (3,355), followed by the West (3,096), North Central (1,681), and Northeast (1,145). Jails in California contained substantially more women than any other state (2,166), followed by Florida (687) and Texas (619).[67] Five out of every ten female inmates were black, and Hispanic females accounted for about one out of fourteen females confined in jail. In 1979, whites formed about nine tenths of the general population, but their proportions of jailed inmates were far lower, seen in the fact that only 48.8 percent of females in jail were white.[68]

Jails, especially southern rural jails, make women's prisons resemble the college campuses for which they are often mistaken. The experience of Joan Little in a small county jail in North Carolina is typical of

the sexual abuse of female prisoners in many small jails. Investigative journalist Patsy Sims drove throughout the South visiting more than twenty jails where she interviewed over fifty women in an attempt to determine how representative the Little case was, and if there had been any resultant reforms. Joan Little, who is black, had killed the white Beaufort County jailer who attempted to sexually abuse her. Her case was considered atypical, but Sims found that sexual molestation and harassment by male guards and trustees continues in southern jails:

> In my interviews with more than 50 women serving time in southern jails or work-release programs, inmate after inmate repeated virtually the same stories of what happened to them, or to the woman in the next cell: the oral sex through bars; the constant intrusion of male trustees who slither in and out of the women's cells as unrestricted as the rats and roaches; the threats of "you do, or else"; the promises of "Girl, you got thirty days, we'll knock off ten if you take care of my friend here."[69]

Sims thinks much of the abuse is due to the commonly held attitude that women offenders, especially black prisoners, are the same as animals. Since they are seen as "fallen women," women are subjected to sexual and other abuse as well as humiliation.

Separation of the sexes usually does not occur in rural jails. When women are separated from the men, the resultant condition is virtually solitary confinement. Often the lack of housing for female offenders throws them all together. In these instances females of all ages who are there for various offenses, those who are unsentenced as well as sentenced, are all confined together. Potentially dangerous women who are psychotic are sometimes held in the same cell or "bull pen" as other female inmates while awaiting commitment to the state mental hospital.[70] In metropolitan areas ten or fifteen women are often jammed into non-air-conditioned cells designed for eight, sleeping two to a bunk or on the floor, sometimes with no mattresses.[71]

Many jails are dirty and unsanitary. Women inmates told Sims about the filth and about having to go for weeks without towels or sheets, baths or showers, or even hot water. She also learned of a Texas jail where "a two-story stairwell, windowless and unairconditioned, had been converted into cells for women" and of "a jail where the women's section had no lighting at all, except for one hour a day when the sun shown through a window seven feet away."[72]

The initial orientation or reception of women prisoners in county jails is a brutal experience that begins when a woman is brought into the jail in handcuffs or waist chains. After the paper work of booking

and a "pat search," the following process takes place in most urban jails:

> Everybody that is arrested is given a bath. They are instructed to remove all of their clothing, including their underwear. Then we give a narco search. Do you know what that is? Well, I'll explain. I would have a flashlight—and I would feel through her hair, and use the flashlight to look inside her ears, behind her ears, in her nose, in her nostrils and her mouth. I would look between her fingers, both sides of her hands, under her arms, and around her breast area. If her breasts are so heavy, I would have her lift them up—sometimes they tape things under them. I'd have her spread her toes apart. Then I'd have her turn around and do the same thing down her back—hair, arms and all. Then I would have her spread her legs and bend over and I would look up into her vagina area to search for weapons, contraband or narcotics. The only area I touch is her hair. I can see into her vagina because her legs and buttocks are spread and I use the flashlight. I don't touch her. I couldn't say I look into her rectum—I look into her buttocks area. I have her lift her feet and check the bottom of her feet. That's a complete narcotics search.[73]

After a bath or shower and stinging spray for body lice, fingerprints and photographs are taken and the inmate is then sent to the nurse for questioning. Any prescribed medication the inmate might have on her is confiscated to be replaced later by jail-issued medication.

Adequate health care is a rarity in jails, especially for the gynecological and obstetrical needs of women. Matrons often determine who will see the doctor on his or her infrequent and brief visits to the jail. Medical emergencies, particularly in small and moderate-sized jails, present very serious problems since a female staff person must accompany the woman inmate. Many county jails have no doctor available at all; therefore, if a woman is severely hurt or dying, she is transported to the hospital. Health maintenance in jails is virtually nonexistent. Many jails offer no medical or psychological assistance for drug abusers. Some jails permit inmates who are already in methadone treatment programs to continue participation. Some jails, on the other hand, do not permit it; therefore, many women addicts must go "cold turkey" when confined in jails. The enormity of this problem is more disturbing when one considers the fact that in 1978, one fourth of the women confined in local jails were once heroin addicts, a rate that notably exceeded the male proportion of daily heroin addiction (14 percent). For black women the rate was higher (29 percent) than for white women (22 percent). These female drug abusers were more likely to have been under the influence of heroin

when they committed their offense (one in every eight) than jailed male offenders (one in seventeen).[74]

Because space is more limited, television is the primary form of free-time activity for women in jails. Recreational programs require either volunteers or staff, and both are scarce in female jail units. Again because of their small numbers women are excluded from necessary activities while incarcerated; if funds are available, any recreational programs are mostly directed toward the male population of the jail.

Exercise and sports activities are notable for their absence in women's jails. A few facilities have separate outdoor exercise areas, but the shortage of staff to supervise inmates precludes participation by female prisoners in exercise activities. In some jails women share the exercise area used by men, but because men are felt to need more exercise than women and there are considerably more men than women, the schedule for women is often severely limited.

According to a recent study by the U.S. Government Accounting Office,

> In many jails women are idle 75 to 100 percent of the time. They pass their days in front of a television (if available), playing cards, or staring through barred windows. Those few jails that do offer vocational, educational or work release programs frequently deny female offenders access to them, even when Federal funds support these programs. Various reasons are given for restricting access:
>
> —Coed training and education programs are security risks. No separate programs are provided the women because of their small numbers.
>
> —Women must be sentenced in order to participate. This precludes participation by the larger number of pretrial and presentence detainees.
>
> —There is no way to house separately those women who would participate in work release programs. (Such segregation from other inmates is believed necessary to control contraband).[75]

Most of the jails in the Glick and Neto national survey of women's correctional facilities had some type of educational program for women—basic literacy and/or high school equivalency preparation,[76]—but the value of these programs in preparing the female inmate for employment is dubious for a number of reasons. First, these programs are generally of poor quality because of lack of staff, space and facilities, security, and all of the other reasons that prohibit recreation and other types of programs for women in jail. Second, the educational task is undoubtedly greater since the educational attainment of jail inmates is substantially lower than that of the general

population within the same age level (eighteen–fifty-four years). Third, the majority of women in jail have little work experience to build upon. About two out of every three women in jail in 1978 were without a job prior to being jailed, whereas less than half of the women in the general population were unemployed that year.[77] This economic problem is more evident for black women in jail since 71 percent of this group was unemployed before incarceration.

In addition to the lack of educational and employment skills women in jail face grave responsibilities in terms of dependents. Many of these inmates were responsible for the support of dependents prior to their confinement. The 1978 survey of jails revealed that black females made up the largest inmate group with dependents (58 percent) with a median of 2.3 dependents, while white female inmates had the smallest number (37 percent) and 2.0 dependents. A little less than half (46 percent) of these women had never married. This was especially true for black female inmates. Whereas 34 percent of black women in the general population age eighteen–fifty-four have never married, 57 percent of the black females in jail were single. On the other hand, white women in the general population in this age group who were never married were only 19 percent, as compared to 36 percent of the jailed white females. Although white female inmates had a lower proportion of never marrieds, their separation or divorced rate (34 percent) was higher than that of black women (26 percent).[78]

The above findings clearly indicate that women in jails in this country are largely members of racial/ethnic minorities, are mostly poor, have few employable skills and little education, but simultaneously have serious economic responsibilities since they are faced with the need to support themselves and a number of dependents. It is no wonder that these twists and turns in their lives lead to crime. Yet, what are their crimes? Glick and Neto found that 43.5 percent of the women in jail were misdemeanants and the majority (66 percent) of their offenses were "victimless" crimes such as drug abuse and prostitution.[79] Other reports show that over 30 percent of the inmates in most women's jails were convicted for prostitution; once in jail, they serve longer sentences than other misdemeanants.[80] What is tragic about this group of forgotten female offenders is that they probably should never have been in jail in the first place.

The Women on Death Row

In contrast to women in jails, who have generally been incarcerated for minor offenses, the women on the death rows of this country are

isolated from society and other female inmates for the most serious crime possible, the taking of another human life. As of May 8, 1982, there were eleven women sentenced to death in the United States, all were in southern states—America's most concentrated region for "warehousing in death." Almost three of every five persons who received the death penalty in 1979, a total of ninety-three persons, were sentenced in southern states, including three women (one each in Georgia, Oklahoma, and Texas). Also in that year there were forty-four death sentences in the West, eighteen in the north central states, and four in Pennsylvania, the latter state representing the total number for the Northeast.[81] By December 31, 1979, the South held the largest proportion of death row inmates in the nation (81 percent). Florida (138), Texas (117), and Georgia (71) accounted for 62 percent of the United States total of 567 persons sentenced to death.[82] Less than two years later, on July 21, 1981, a total of 827 persons, including nine women, were on the death rows of this country[83] experiencing what has been described as a "living death."[84]

For a number of years there was a national moratorium on executions. From 1967 until 1977, when Gary Gilmore was executed by a firing squad in Utah, legal challenges to the death penalty were fought in numerous court battles. On June 29, 1972, in *Furman* v. *Georgia*[85] the U.S. Supreme Court found that capital punishment, as it had been imposed, constituted "cruel and unusual punishment" in violation of the Eighth Amendment to the Constitution; further, the states were "arbitrary and capricious" in applying the death penalty. The court rendered capital punishment unconstitutional. States revised their statutes, and in 1979 John Spenkelink in Florida and Jesse Bishop in Nevada were executed.

No women have been executed in this country since 1962, when Elizabeth Ann Duncan was put to death in California for murdering her pregnant daughter-in-law. National reporting of executions began in 1930, and since that time thirty-two women have been put to death under civil authority—twelve in the South, nine in the Northeast, five in the West, four in the Midwest—and two by federal authority. With the exceptions of the two federal executions for kidnapping and espionage, the remaining thirty women depicted in Table 12-1 were executed by the states for murder. Twelve of these women (37.5 percent) were black; the rest were white.[86]

The most commonly prescribed method of execution in the thirty-seven states with capital punishment laws in operation on December 31, 1979, is electrocution, which is used in eighteen states. Ten states use lethal gas, four stipulate lethal drugs by injection, three choose hanging, one state has asphyxiation, and Utah allows the condemned

TABLE 12-1: Women Executed in the U.S. 1930–1979,
by Region, Year, and State

Region and State	Total	Year(s)
United States	30	
Northeast		
New York	4	1934, 1936, 1944, 1951
Pennsylvania	2	1931, 1948
North Central		
Ohio	3	1938, 1954
Illinois	1	1938
South		
Delaware	3	1935
North Carolina	2	1943, 1944
South Carolina	2	1943, 1947
Georgia	1	1945
Alabama	3	1930, 1953, 1957
Mississippi	3	1937, 1943, 1944
Louisiana	1	1943, 1947
West		
Arizona	1	1930
California	4	1942, 1947, 1962

Derived from U.S. Department of Justice, *Capital Punishment 1979*, Table 4, p. 19.

a choice of death by hanging or firing squad. The six southern states which house the eleven women on death rows—Texas, Maryland, Georgia, Oklahoma, Kentucky, and North Carolina—elect various methods of providing death. Texas and Oklahoma employ lethal injection, Georgia and Kentucky stipulate electrocution, while Maryland and North Carolina use lethal gas.

Profiles of the Women

The woman who has been on death row the longest, Rebecca Machetti, also known as Rebecca Akins Smith, was thirty-five at the time of her offense. She has been in isolation at the Women's Correctional Institution at Hardwick, Georgia, since April 27, 1977, for the 1974 shotgun murders of her former husband, Joseph Ronald Akins, and his wife of only twenty days, Juanita.[87] Prior to her transfer to a death row cell, Machetti was held in the Bibb County Jail in Macon, Georgia, for two years.

Rebecca Machetti's superior intellect is seen in the fact that she is a member of MENSA. She is also a trained nurse, and, in fact, her nursing background was alleged to be related to the killing of her ex-husband. Her current husband, John Eldon Smith, also known as Anthony Machetti, actually committed the homicides with a mutual friend, John Maree Jr. Rebecca Machetti allegedly had prepared a poison drug in a syringe to effect the murder, but her husband was unable to administer the drug and shot the Akins couple instead. While Mrs. Machetti claimed it was a revenge killing—retribution for the way Akins had treated her in their seventeen years of marriage—the state felt that the motive was to obtain life insurance proceeds and other monies due herself and her three daughters as Akins' beneficiaries. There was also the suggestion that the murder would aid in Tony Machetti's attempt to establish Mafia ties. Mrs. Akins was killed because she had the misfortune of being with her husband. At this writing, Mrs. Machetti has lost her third attempt to have the U.S. Supreme Court overturn her 1975 conviction and sentence for conspiracy in the murders.

Velma Margie Bullard Barfield also claimed she wanted to "get back at them" for being "mean" to her after she was accused of poisoning her mother, her fiancé, and three other elderly people for whom she worked as nursemaid and housekeeper.[88] When Mrs. Barfield, at age forty-four, was convicted in 1978 of poisoning her fiancé, Stewart Taylor, by putting arsenic in his beer, under questioning she confessed to three other murders, those of Mr. and Mrs. Record Lee and Dolly Edwards. When arsenic was found in Taylor's body, autopsies were performed on the other exhumed bodies, including Barfield's mother, and it was discovered they had been poisoned over a long period of time. There was some suspicion that Barfield might have killed her husband, who died in 1969 in a fire while smoking in bed, but she denies any involvement.

The state successfully demonstrated that Velma Barfield committed the murders for money. She had forged a $1,000 check on her mother, the Lees had discovered forgeries on their accounts, and in an argument with her fiancé over her forgeries and out of fear that he would turn her in, Mrs. Barfield gave arsenic to Taylor. The reason she forged checks was to obtain drugs. Barfield had been hospitalized for drug overdoses three times and had a long history of pill-taking for depression, which at one time had led to a nervous breakdown. She claimed she only wanted to make Taylor sick, and had nursed him for three days before taking him to the hospital where he died. Barfield attended all of the funerals and cried for each of her victims.

Velma Barfield claims she has "found Jesus," apparently in the Women's Prison at Raleigh, North Carolina. A born-again Christian, she has stated she does not want appeals on her behalf since Jesus will care for her, but appeals have nonetheless been instituted on her behalf by advocacy groups.

A go-go dancer when she met her husband, Steve, in 1978, Michelle Binsz at thirty-two found herself on death row at Lexington, Oklahoma, a little more than a year after her marriage.[89] Binsz is believed to have been the brains behind the contract killing of Robert Busch, a private investigator. Michelle, her husband, and a friend, Carla Rapp, went to the victim's house to "hit" him under a contract with Robert Keller, an executive of Kellco Oil Company. Using wigs for disguises, they entered the Busch home, where Steve Binsz shot and killed Busch. The license plate of Rapp's car had been noted; when she was found, she turned state's evidence on the Binsz couple. Glasses left at the scene were tied to a prescription for Michelle Binsz. Carla Rapp's case was dismissed, Keller received life, and the Binszes were given the death penalty. Mrs. Binsz insists someone else committed the murder.

Emma Ruth Cunningham is one of the two black women on death rows in the United States and the first black woman on Georgia's death row since 1973. She is at the Women's Correctional Institute in Hardwick, Georgia, with Rebecca Machetti, with whom she sometimes has rare talks. Although Cunningham, then age twenty-seven, did not actually participate in the beating death of a sixty-three-year-old white man in Lincolnton, Georgia, she received a "double" death sentence for armed robbery and murder since she was considered just as guilty and was convicted on the basis of "vicarious liability."[90]

As a teen-ager Cunningham wanted to be a rhythm and blues singer, but despite her tries she did not achieve any fame. She then married at age eighteen to escape her overprotective parents, dropping out of high school in the process. In the 1979 murder of William Beall Crawford, Emma Cunningham waited across the street while her husband, James, told her he had to see Crawford on business. When an anonymous tip led to her husband's arrest as they were on their way to New York to start a new life, Emma was not arrested. Her husband confessed that he committed the murder in a panic when he was caught burglarizing the Crawford home. Emma was later pressured into signing a statement that she had peeked into Crawford's window before her husband entered and had later received some of the money taken from the burglary. Mrs. Cunningham states that she was coerced by a deputy sheriff who suggested she make such a statement or her children would be taken away and she would never see

them again. Later, in her trial, her husband refused to testify for her and implicated Emma in the murder by saying she had planned the burglary. Ironically, the way Emma Cunningham became involved was that she returned to Georgia to check on her husband and as a consequence was also arrested for the murder.

On February 13, 1981, the Georgia Supreme Court affirmed the death sentence given to Shirley Tyler, for the 1979 murder of her husband, James Wilson Tyler. The 6-0 decision found that the aggravated circumstance necessary to support a death sentence in Georgia was indicated in the Tyler case because of "inhuman torture." She had put rat poison, parathion, in her husband's chili and also "had made two earlier attempts to poison her husband before succeeding."[91]

The second of two black women recently given a death sentence, Shirley Tyler was not housed with Machetti and Cunningham at the Women's Correctional Institute but was held in the Pike County Jail.[92] While the state claimed she committed the murder to collect insurance money, Tyler, the mother of three children, insists she is innocent and that her husband was suicidal. In their twelve-year tumultuous marriage Tyler had to have her husband locked up several times because he drank and beat her and the children. He had threatened to commit suicide, and because of the beatings, her depression, and these threats, Tyler's attorney tried to introduce "mitigating circumstances." The court refused to allow it, and the all-white jury found her guilty of first degree murder. Again, as in other of the death row female cases, luck seemed to run out on Shirley Tyler. Two weeks after her husband died, on her own volition Tyler, who was thirty-four at the time, went to see the sheriff for a "friendly chat" that somehow ended with a signed confession and a murder charge. There was no attorney present, and in fact Mrs. Tyler did not see her court-appointed lawyer until two weeks before her trial. The contention that this confession was not freely made to a Georgia Bureau of Investigation agent was ignored in her appeal to the Georgia Supreme Court, which ruled that "for an officer to advise the accused that it is always best to tell the truth will not . . . render a subsequent confession inadmissible."[93]

The husband of Linda May Burnett, twenty years her senior, stood by his thirty-one-year-old wife in her murder trial in spite of the fact that her co-defendant in the murder of five people was her lover. Mrs. Burnett, the mother of three children, claims she is innocent and that her only mistake was agreeing to serve as an alibi for her boyfriend, Ovide Joseph Dugas, Jr.[94] The 1978 kidnap-murders of five of Dugas' former in-laws, including a two-year-old child, were described as "execution-style" murders, since each victim was shot once in the head

with a 22-caliber rifle. The alleged motive was revenge. Dugas blamed his former in-laws for breaking up his marriage with their daughter, Mary.

Linda Burnett denies being present at the killings, but tape recordings of her versions of the murders while under hypnosis proved to be a "major breakthrough" for the prosecution.[95] In the tapes Mrs. Burnett admits to killing all four of the adults in one version; in a second version she claims she only killed Dugas' ex-parents-in-law. The prosecution argued that the second version revealed in the tape recordings was a result of hypnosis, but that Mrs. Burnett was not under hypnosis when she described her role in the murders in the first version; thus those tapes were admissible in court. Both Burnett and Dugas were convicted and sentenced to die for the killing of the child, but they were also charged with the other four deaths, which led to Burnett's current segregation in a basement cell of the Texas Department of Correction's Goree Unit in Huntsville.

As in Texas, there is no death row for women in Kentucky, where LaVerne O'Bryan is held in maximum secure segregation in the Kentucky Correctional Institution for Women in Pee Wee Valley. Mrs. O'Bryan at the age of forty-three was sentenced on September 12, 1980, for the arsenic poisoning of her ex-husband, John O'Bryan, who died in July, 1979. She is the first woman sentenced to death in Kentucky.[96] She is also charged with the 1967 murder of Harold Sadler, with whom she lived for several years and from whom she inherited an automobile yard. After John O'Bryan's death, Sadler's body was exhumed and the autopsy revealed the presence of arsenic poisoning.[97] In addition, Mrs. O'Bryan was sentenced to twenty years for the attempted arsenic murder of her former sister-in-law, Lee Anna O'Bryan, who suspected Mrs. O'Bryan had poisoned her ex-husband. For nearly one hundred years no one had been charged with murder by poisoning in Kentucky.

LaVerne O'Bryan does not think she has committed a crime and believes that both men died of "a rare form of cancer."[98] The motive in both cases appeared to be money. Sadler left her the business that she and O'Bryan operated even after they were divorced in 1972. In fact, for the seven years since their divorce and until his death, the O'Bryans lived together. It was brought out in the trial that Mrs. O'Bryan had agreed to sell the home and business to her ex-husband for $52,000; but as the time neared to close the deal, the prosecution argued, Mrs. O'Bryan was afraid of being left penniless. Psychologists found her to suffer from an extreme form of neurosis, hysterical amnesia, that may take as long as four or five years to treat. When she

was in the Jefferson County Jail during her trial, for example, Mrs. O'Bryan complained of symptoms that resembled arsenic poisoning.

The second woman on death row in Texas is Pamela Lynn Perillo, who joined convicted murderess Linda Burnett at the Huntsville correctional facility in August of 1980 for the strangulation murder of Bob Skeens in Houston. Although no woman has ever died in the electric chair in Texas, the capital punishment method used before the adoption of the more humane form of death by lethal injection, Chipita Roderiguez was hanged from a mesquite tree in 1863 for murdering a horse trader for his gold.[99] In today's parlance, Perillo, at twenty-four years of age, also murdered for "gold."

Pamela Perillo and James and Linda Briddle were hitchhiking when Bob Banks gave them a lift near the Houston Astrodome. Banks took the trio to his home, introduced them to his friend Bob Skeens, took them to the rodeo, and let them spend the night in his home. The next morning Banks and Skeens went out for coffee and doughnuts; upon returning they found that Perillo and James Briddle had decided to rob and kill them. Briddle forced the two men to the floor at gunpoint, and he and Perillo tied their hands and feet. A rope was placed around Banks's neck, and with Briddle on one end and Perillo on the other, they pulled for ten minutes as Banks writhed on the floor until he died, while his friend Skeens watched.[100] It is unclear whether the trio ate the doughnuts at this point or after killing Bob Skeens, who died in the same fashion an hour after witnessing the strangulation of Banks. Crime scene photos revealed a nearby empty doughnut box.

Leaving the bodies in the house, the trio took Skeens's car, $800, a tape player, three guns, and a camera, and drove to Dallas. From there they took a bus to Denver. Once in Denver, Perillo called the police and confessed, an act which, according to her attorney, demonstrated "a first step toward rehabilitating herself" and resulted in the arrests of the other two defendants.[101]

The ninth woman on death row and one of the youngest at age twenty, Annette Stebbing, was sentenced to the gas chamber in Maryland for a murder that also involved strangulation. In separate trials Stebbing and her husband, Bernard Lee, were found guilty of the murder-rape of their step-niece, nineteen-year-old Dena Marie Polis in April, 1980. Stebbing's husband received a life sentence in a bench trial, while Mrs. Stebbing, then nineteen, elected a jury trial and was sentenced to death in April, 1981.[102]

The Stebbings were to drive Ms. Polis to Baltimore to visit her boyfriend; en route, with her permission, they stopped in Hartford

County, Maryland, In her trial Mrs. Stebbing testified that after returning from the woods where she had gone to relieve herself, she found her husband having sex with Ms. Polis in the back of their van and strangled her. Earlier, however, Mrs. Stebbing had confessed to the Baltimore police that she "held Ms. Polis down in the back of the van and strangled her while her husband raped her." The latter version is the one the jury believed. Before announcing the death sentence, the judge described the crimes as "the most heinous and despicable activities ever to come before this court," adding, "your crime involved rape and murder, the act of sodomy when the victim was dead and the theft of the victim's finger ring."[103]

Both of the remaining female death row occupants are white, nineteen, and sentenced to die in the Georgia electric chair. Janice Buttram was only eighteen when she joined her husband, Danny, in the murder of nineteen-year-old Tennessean Demetra Parker, who was stabbed ninety-seven times, raped, and sodomized in a motel room in Georgia. Buttram's admitted motive was jealousy and a fear of losing her husband to Ms. Parker because "she was prettier than I was."[104]

A love triangle was also indicated in the 1982 Georgia case of Teresa Faye Whittington, who at age nineteen shot her lover's wife, Cheryl Marie Soto, who was three months pregnant. When the first shot turned out to be only a flesh wound and Whittington saw the victim moving around in the house after having been left for dead, she returned to the house and shot her again despite Mrs. Soto's plea for her life. The previous year the husband, Richard Soto, also charged with the murder, had taken out a $50,000 life insurance policy on his wife.[105]

An examination of the circumstances involved in each of these eleven cases of death row women reveals several common characteristics, even though the information is sparse and is predominantly limited to newspaper accounts which clearly have certain flaws and biases.

First, in each murder a man is involved either as the victim or in complicity with the woman. In three of the cases—those of O'Bryan, Barfield, and Tyler—the victims were ex-husband, fiancé, and husband, respectively. O'Bryan was convicted of poisoning her ex-husband because she felt he would render her "penniless." Velma Barfield feared her fiancé, who tended to drink, would expose her forgeries. And Shirley Tyler ended years of abuse at the hands of a drunken spouse. One writer commenting on the Barfield case noted, "It is not uncommon in our society for women to be dominated and abused by fathers or husbands who have deep problems of their own,"[106] which suggests that women who kill may either be respond-

ing directly to male abuse or have in some way been personally scarred because of a man, and subsequently committed murder. There is the possibility that the eight other women on death row, if not dominated by their men, exhibited a certain dominance over the men involved. Instances of female dominance are suggested in the Binsz Oklahoma "hit" murder, the Maryland Stebbing rape-murder case, Perillo's strangulation of two strangers in Texas, and the Machetti case, in which she remained in Florida while her husband and his accomplice traveled to Georgia to effect the murders. The Linda Burnett murder case in Texas clearly indicates some form of influence or dominance by her boyfriend since Mrs. Burnett—a married mother of three children—had only had sex relations with her lover for a month before he involved her in the slayings of his five former in-laws, for *his* revenge. Ms. Whittington killed her lover's pregnant wife, according to her attorney, because "he controlled her being." Janice Buttram's brutal act was a result of jealousy and love. Also, Cunningham appears to have been implicated by her husband and was not even on the actual scene of the murder. Further, her husband's later accusations hint at his willingness to take her to death with him rather than let her be free while he dies in the electric chair in Georgia.

A second common characteristic in these murders involves motive. With the exception of Burnett's lover's revenge against his former in-laws, Buttram's jealous fear of losing her husband to a prettier woman and, at least as Annette Stebbing claims, her jealousy of her husband, money was somehow involved in the remaining eight capital cases. Machetti, for example, wanted insurance money; the Whittington motive was said to be $50,000 worth of insurance; Tyler also was accused by the state of killing for her husband's insurance, although she claimed spouse abuse; Barfield feared exposure of her forgeries and murdered her fiancé; the Cunningham and Perillo cases involved robbery in addition to murder; O'Bryan was afraid of being left penniless and also apparently killed her former common-law husband in order to inherit his business; and the Binsz murder involved a hired "hit" contract.

A third curious factor in the cases of the death row women relates to the method of killing and the age of the murderess. It appears that the younger the woman, the more brutal the murder committed. Throughout history poisoning, a more passive crime, has been the typical female method of killing. Although the victim's death is often agonizing, this form of murder is considered more feminine or ladylike since no weapon or physical contact with the victim is involved. Only three of the women used poison—Tyler who was thirty-

four, O'Bryan, then forty-three, and Barfield, who was forty-four at the time. Rebecca Machetti, thirty-five at the time of the murders, was sentenced because of a murder conspiracy and was hundreds of miles away at the time of the killings of her ex-husband and his wife; thus, in a sense, her participation could be considered passive. At age twenty-seven, Cunningham was outside across the street when her husband beat the victim to death in his home. In contrast, the murders by twenty-year-old Stebbing and twenty-four-year-old Perillo were both the result of strangulations. In the cases of Binsz, then thirty-two, Burnett, thirty-one, and Whittington, nineteen, guns were used. Although Binsz did not actually pull the trigger, Burnett did, possibly four times out of the five murders. Whittington shot and wounded, then shot to ensure the kill. Stabbing was the method used by Buttram, who was only nineteen at the time. Whether this portends a trend away from the more "traditional" methods of female murder cannot be determined, considering the few cases involved, but future studies of the means used by women to kill their victims could contribute to our knowledge of this phenomenon. Although meager at best, these speculations suggest support for the notion that it is the younger woman who is becoming more violent. In fact, recent analyses of violent crime by females, especially crimes of assault, aggravated assault, and weapons violations, show more pronounced increases for young girls than for women, although both groups clearly reveal rises in violent crime rates.[107]

Death Row as a Living Death

Newspaper accounts, movies, and television portrayals have given the public some idea of the isolation and pain experienced by men on death row. Male inmates under a death sentence have been interviewed, tested, researched, and written about; but there has yet to be a study of women on death row or what they feel, experience, and suffer. Research involving in-depth, tape-recorded interviews of thirty-five men confined on Alabama's death row in 1978 discussed the psychology of death row confinement and found that

> death row is barren and uninviting. The death row inmate must contend with a segregated environment marked by immobility, reduced stimulation, and the prospect of noxious impingements from staff. There is also the risk that visits from loved ones will become increasingly rare, for the man "civilly dead" is often abandoned by the living.[108]

The men related their death row experiences as "living death," or "the zombie-like, mechanical existence of an isolated organism—a fragile twilight creature that emerges when men are systematically denied their humanity."[109]

Sonia Lee Jacobs, also known as Sonia Linder, was originally sentenced to die but was resentenced to life on March 26, 1981, by the Florida Supreme Court.[110] In May of 1977, when she was confined on death row, she filed a civil rights suit in the U.S. District Court charging discrimination. Unlike men on death row, Jacobs was kept in solitary confinement, and the court ruled "such confinement afforded plaintiff solely because she is a female sentenced to death, constitutes cruel and unusual punishment."[111] Jacobs won, but the women remaining on death row are still experiencing a "living death."

After confinement in the Bibb County Jail for two years Rebecca Machetti, upon losing appeal, was transferred to death row at the Women's Correctional Institution in Hardwick, Georgia, where she has been since April 27, 1977. Since her imprisonment Machetti has suffered migrane headaches, depression, skin rashes, and a stroke that left her with impaired vision.[112] In 1978 Mrs. Machetti insisted she was sexually assaulted by a black chaplain employed at the prison and has feared revenge from some of the black inmates for telling the officials about the rape.[113] She is completely segregated from all prisoners except for Emma Cunningham and Shirley Tyler, both black women on Georgia's death row for women.

Mrs. Cunningham talks infrequently with Rebecca Machetti and lives mostly in quiet isolation. The women have small air-conditioned rooms with television sets at the end of the infirmary. They are kept locked in their rooms but are released for meals, exercise, and occasional visits from family members. Cunningham has refused to allow her children to visit her, preferring that they not know what is happening to her.

Shirley Tyler was originally confined in the Pike County Jail, and was usually the only female prisoner there. Unlike Cunningham, she had twice-a-month visits from her son and daughter, which were her mainstays. Still, the years in jail have affected her physically; she has lost weight and suffers from periodic ear infections. Tyler no longer cares about her personal appearance, which is believed to be a result of her deep despair. In February, 1981, she lost an appeal to the Georgia Supreme Court to overturn her death sentence and joined the other two women in the women's death row at the Hardwick infirmary. At this writing, Mrs. Tyler has been avoiding the electric chair through a stay of execution issued by a federal court judge.

Janice Buttram, the fourth Georgia woman sentenced to death, is being held in the Whitfield County Jail awaiting transfer to Hardwick; the fifth, Teresa Faye Whittington, who received her death sentence on May 8, 1982, is in the jail in Madison County, Georgia, while her murder case is appealed.

Velma Barfield's cell at the Women's Prison in Raleigh, North Carolina, is the size of a small bathroom. She is able to leave it for only one hour a day for a recreation period, always accompanied by a male guard and a female guard. Unlike most women under the death sentence, Barfield is able to talk through the bars of her cell to other women prisoners. She is seen as difficult and withdrawn, which is not too surprising considering her miserable childhood and adult life. Velma Barfield, who was the second of nine children and the oldest girl, was raised very strictly on a small, poor, tobacco and vegetable farm. She and her siblings feared her father; this was particularly true of Velma, who had the major responsibility for the younger children. Her fear and anger against men undoubtedly returned with her first marriage when her husband drank and hit or verbally abused her. How much this life-style contributed to her ultimate nervous breakdown, hospitalizations, drug use, and depression can only be imagined. Her fiancé also turned out to be a drinker who was easily angered. So the three significant men in Barfield's life—father, husband, fiancé—apparently aroused the same anger and frustration in her one after another.

Three empty cells separate Linda May Burnett from other inmates housed in the basement of the Goree Unit at Huntsville, Texas, so she is segregated but not really isolated. She would no doubt prefer to be isolated from the other women because they are cruel to her, call her "baby killer" and "snitch," one of the worse prison labels. Once a cup of urine was thrown on her. This experience and the constant name-calling have made Burnett see her place of confinement as a "zoo." She describes her cell as no larger than the bed she had at home, but she is allowed to shower daily, to walk occasionally in the courtyard, and her three daughters visit her frequently. Linda Burnett cries a lot, but tries to keep busy watching television, crocheting, writing letters, and reading her Bible. While she apparently cannot relate to the other inmates, Burnett has high praise for the warden, matrons, and prison chaplain, with whom she sometimes takes walks. Her tendency to tell on the other prisoners is why she earned the reputation as a snitch.

There is no real death row for women in Kentucky, and persons under death sentence must be held in a maximum security prison. Since Kentucky does not even have such a prison for women, the state

created maximum security segregation as the death row environment of LaVerne O'Bryan. Her cell at the medium security Kentucky State Reformatory for Women is ten feet by six feet and has a metal bed attached to the wall, a sink, and a toilet. O'Bryan is required to have a twenty-four-hour guard, no contact with other inmates, and can only exercise alone in an unused prison courtyard five days a week. The only other release from her small cell is for showers. At her trial psychologists found her to be extremely neurotic, with a tendency to distort reality. Also they determined that her judgment is not very good under stress. Considering her forced isolation in prison, one fears for LaVerne O'Bryan's mental survival in light of her background of poor emotional health. As in the Florida Jacobs case, O'Bryan and each of the other women currently on the death rows in this country may be experiencing "cruel and unusual punishment." Like their male counterparts on death rows, they too know what "living death" means.

epilogue

removing the blindfold
from justice

Until very recently criminological literature revealed an abundance of research and theory on the male juvenile delinquent, while empirical research and theoretical deliberation relative to his female counterpart received little attention. Early delinquency literature usually made some mention of female offenders as part of their theses but did not delimit, define, or approach the question to any depth. Thrasher, for example, in his classic work on gangs in 1927, viewed the involvement of boys in gangs as a response to the larger society during the adolescent stage of development.[1] Citing the Italian method of chaperonage of girls as an example, Thrasher felt that girls are usually more protected and supervised than boys, thus, by implication, do not have the same adjustment problems that would lead to gang behavior. Thrasher admitted there were a few girls' gangs, and even that some girls became members of boys' gangs, but for the most part he felt that girls did not form or join gangs and omitted them from his study.

Another member of this theoretical school which emphasized *social disorganization* as an etiological factor in delinquency, E. Franklin Frazier, explored illegitimacy in black families and reported that there was considerable disorganization in the family background of delinquent girls.[2] Although it was not stressed in his work, an examination of the cases in the juvenile court during the years of Frazier's study reveals that in all but 1930, the percentage of cases of delinquent black girls was higher than their male peers. This provocative finding was reported but not further explored.

Edwin Sutherland also lacked development of a female perspective of delinquency when he outlined his theory of *differential association*.[3] He felt that theories of boys' delinquency differed from those of girls' delinquency. Sutherland attributed the differences to situational factors such as different kinds of supervision and expected behavior for

boys and girls. But his seminal work on the concept of differential association did not include females or any allusion to females. Another moment was lost.

The *anomie* or *strain* theorists also had little to say about youthful female deviance. Albert Cohen, for example, devoted less than four pages to the topic in his book and generally dismissed girls' delinquency by limiting their deviance to sex delinquency[4]—a view we have noted as typical since the inception of criminology. According to Cohen, this "specialized" form of delinquency centered around relationships with the opposite sex, but further explanation of the dynamics involved went unexamined. This body of thinking, which derived from Emile Durkheim's anomie theory, views the cause of delinquency as a result of pressure or strain due to youngsters' legitimate desires and aspirations not being in accord with what they hope to accomplish; the opportunity is missing. Cloward and Ohlin go one step further: some boys are blocked from illegitimate opportunities as well as the legitimate avenues to success.[5]

Another theory of the 1960s, *control* or *bonding* theory, appeared to offer high promise as a "unisex" theory of delinquency. Here deviance is taken for granted since conformity is the concept to be explained. In other words, what differentiates a good child from a bad child? Why does the first conform to the rules, regulations, and mores of society, while the latter does not? In the development of delinquency theory it had (as today) been repeatedly emphasized that girls, because of different socialization, were more conforming than boys. In his study of 17,500 students control theorist Travis Hirschi stratified his samples by race, sex, school, and grade. He included 1,076 black girls and 846 nonblack girls; but in the analysis of his data Hirschi admits "the girls disappear," and he adds, "Since girls have been neglected for too long by students of delinquency, the exclusion of them is difficult to justify. I hope I return to them soon."[6] He didn't.

David Matza's delinquent *drift* perspective also had promise but fell short of its potential by its neglect of females.

> The image of the delinquent I wish to convey is one of drift; an actor neither compelled nor committed to deeds nor freely choosing them; neither different in any simple or fundamental sense from the law abiding, nor the same; conforming to certain traditions in American life while partially unreceptive to other more conventional traditions; and finally, an actor whose motivational system may be explored along lines explicitly commended by classical criminology—his peculiar relation to legal institutions.[7]

Closely associated with the concept of drift between conventional and delinquent behavior, between freedom and control, is a subterranean value system, which Matza and Gresham Sykes describe as three patterns of youthful rebelliousness that develop out of the tensions of youth in modern society—delinquency, radicalism, and Bohemianism.[8] These subterranean traditions parallel conventional traditions and, in fact, reflect a continuing dialectic:

> Among youth, conventional versions of subterranean traditions—reasonable facsimilies stripped of the more intolerable aspects—are experienced by broad segments of the population. Teenage culture consists of the frivolous and mindless pursuit of fun and thrill. The experiences in this pursuit ordinarily include many of the juvenile status offenses. Its spirit is a modification of that implicit in the subculture of delinquency. Thus, teenage culture may be conceived as a conventional version, a reasonable facsimile, of subcultural delinquency.[9]

In essence, then, most youth are conventional. Girls have always been presumed to be more conventional than boys, but this connection was not developed by Matza and Sykes and the potential formulation of a unisex theory of delinquency was again lost.

Several researchers of middle-class delinquency demonstrated the emergence of a teen-age culture and its relationship to delinquency. In all cultures the adolescent period is seen as a striving for adult status,[10] but in Western culture youth are not recognized as adults and are relegated to an inferior status position, despite their levels of sophistication and physical development. Most youngsters in our society face the problem of being physically mature, yet not permitted to indulge in adult pursuits, especially the fulfillment of their sexual drives. Girls in particular are victims of this double bind.

After World War II, the media and communications systems rapidly increased the awareness among teen-agers of a teen culture that provided them with a status denied them by the dominant culture of adults.[11] The media actually catered to youths and assisted in accelerating the emergence of the youth subculture. Adolescents, including girls, now had an "in group" feeling and, in a sense, their own society. The genesis of this situation lay in structural changes in the larger society.[12] Changing social and economic conditions, changes in the nuclear family, more permissive and democratic child-rearing practices, extensive peer group activities, and the vague definition of the adolescent status laid the foundation for the emergence of a mass youth culture with too much leisure time. Dating, parties, the ready accessibility of cars, and the fact that youth already were a cohesive

antigroup contributed to the incidence of middle-class delinquency. Girls are an integral part of that youth culture, but with the exception of a few studies devoted to the delinquency of middle-class girls, which was studied as a separate phenomenon from males, the opportunity for a single theory encompassing both sexes was ignored.

Thus went the delinquency theories of the 1960s; the next decade offered more promise, but not much more. According to *labeling* theory, persons who are deviant are so defined or labeled by the conforming members of society. The labelers represent conventional morality either as the powerful in society or those who enforce the interests of the powerful—for example, police, prosecutors, and judges. Those who are labeled criminals, prostitutes, drug addicts, and so on, are the persons who suffer negative consequences of labeling.[13] Positive consequences accrue to those who apply the label, since they and the community will benefit from knowing the difference between right and wrong, good and evil, thus preserving the social order and social cohesion.

Our earlier discussions of the madonna/whore phenomenon and the historical emphasis on the sexuality and sexual misbehavior of females clearly suggest that labeling theory, as perceived, could readily be applied to females. The labels of madonna, whore, prostitute, and the like not only have assigned a dichotomous good/evil status to women, but also these negative stigmata have contributed to the unequal treatment of females by the criminal and juvenile justice systems. Unfortunately, labeling theorists also bypassed females in developing their position on deviance causation.

An outgrowth of the labeling perspective is seen in *conflict* theory, which generally finds that conflicts exist in the value system of the society—a condition that produces rebellion and alienation on the part of individuals and groups. The previously described youth culture is an example of a subordinate value system subject to the vagaries of the dominant value system of society, in this case one established by adults. Basic to the conflict perspective is the notion of group conflict between the majority or powerful, who define deviance, enact laws to further circumscribe that deviance, and provide the means of enforcing the laws, and the minority, or those who are controlled, oppressed, and criminalized. The powerful, then, apply the label or status of criminal to the powerless. The powerful, as the ruling class, also have control over the legal apparatus; they set the norms, they make the laws, and they oppress the nonpowerful whom they have already predefined. Included within this oppressed, controlled minority are members of sex and ethnic groups. With conflict theory women became recognized in a theory of crime and deviance.

Critical criminology is probably most associated with Richard Quinney, who adopts a Marxian view: "The primary interest of the ruling class is to preserve the existing order and, in so doing, to protect its existential and material base. This is accomplished ultimately by means of the legal system. Any threats to the established order can be dealt with by invoking the final weapon of the ruling class, the legal system."[14]

According to critical criminology, the ruling class evolves out of capitalist society, an economic system upon which contemporary Marxist feminists also base their criminological theory. These new feminists, whether addressing crime and deviance or other forms of sexist oppression in capitalist society, variously identify themselves as radical feminists, socialist feminists, or Marxist feminists. Whatever the self-assigned label, their arguments are basically the same and their purpose, coincide; they are committed to understanding the power that emerges from capitalism and the effects of this power. Socialist feminists, for example, "emphasize the mutually reinforcing dialectical relationship between capitalist class structure and hierarchical sexual structuring."[15] Male supremacy (patriarchy) is known to have existed before capitalism but has since taken the form of "capitalist patriarchy." The exploitation implicit in capitalism is more vividly seen in women's class position under such a system, a position of powerlessness.[16] While radical feminists view patriarchy as "a sexual system of power in which the male possesses superior power and economic privilege,"[17] to the socialist feminist, "women's oppression is rooted in more than her class position (her exploitation); one must address her position within patriarchy—both structurally and ideologically—as well."[18]

Marxist feminists within criminology are concerned with the economic and social positions women occupy in today's capitalist society, or "how the economic system *itself* promotes the conditions for typical criminal behavior."[19] Two proponents of this perspective, Nicole Rafter and Elena Natalizia, point out the relationship between capitalism and sexism, a relationship that coincides with the powerlessness experienced by women in the American criminal justice system.[20] This system is controlled and dominated by men in every step of the process, from the evolution of laws to the management of the women's prison system. Women, who occupy inferior economic positions in capitalist society—through lower pay and double work as unpaid housewives and workers—are contained in an economically exploited status through the law, which also acts as an instrument of social control for women. This is accomplished in two primary ways:

The first is paternalism, the restriction of women through enactment of "chivalrous" statutes ostensibly aimed at their protection. For example, differential sentencing statutes, which allow women to be incarcerated for longer periods than men for similar offenses, have traditionally been justified on the grounds of their rehabilitative potential. . . . The second way in which the legal system oppresses women is through its almost total failure to respond to issues of concern to women.[21]

Carol Smart even goes as far as to suggest that maybe a *feminist criminology* should be formulated as an alternative perspective, since none of the criminology theories contain a feminist perspective or even "serious consideration of female offenders."[22] She finds the new perspectives not much better than those of the traditional criminologies preceding them.

Clearly, the contemporary feminist efforts to explain how women have arrived at their untenable position in the criminal justice system appear to compound the errors of their male antecedents—they too are adopting a one-sided perspective. They are suggesting that we look at women offenders from a specific political or philosophical stance, which is really not too different from the sexist approach by which female offenders have been scrutinized in the past. As seen in Chapters 3 and 4, the emphasis on biological or psychological differences presupposed that women offenders were in some way "different" from men offenders. The economic and sociological explanations offered in Chapter 5, while focusing on women, have relevance as well for the examination of men, but few comparisons between the sexes are drawn.

Most theorists presumably have notions of "solving" the problems they address, of discovering the common thread underlying the topic of their concern; perhaps they even harbor fantasies of deriving a "grand" theory that will explain all. If social scientists interested in uncovering the root causes of crime are sincere, it is fundamental to examine all possible variables and individuals involved in the phenomenon. Any effort to understand the causes of crime must include both sexes, all ages, all classes, and all ethnic groups in the model. How can one profess to seek to uncover crime causation without studying representation from one half of the human population— women? Yet this has essentially been the practice since the genesis of the field of criminology. But today criminology has reached a point where it must derive a *unisex* theory of crime and delinquency if a theory is sought that will have explanatory power.

Donald Cressey's study of embezzlers identified a central problem and a methodological procedure to study the phenomenon which included "determining whether a definable sequence or conjuncture of events is always present when criminal trust violation is present and never when trust violation is absent."[23] Dozens of cases were examined, phenomena were redefined and reformulated until there were no more cases left, and a relationship was established that not a single case could challenge. And at that point a statement could be made with some degree of assurance. What Cressey demonstrated was that theories must be grounded in and consistent with data; if there are no data, there can be no theory. By the same token, if only one sex is studied, how can a theory of crime be derived? To be meaningful, such a theory must generate from a unisex perspective.

The study of female offenders and their offenses may offer the only realistic way to approach an analysis of crime and deviance. The same factors that have prohibited or discouraged empirical research on female offenders are possibly the identical factors that might lead to the etiology of crime: their small numbers, the types of offenses females commit, their differential treatment in the juvenile and criminal justice systems, their lower rates of recidivism, and their institutional experiences.

Under a unisex approach to crime and delinquency, the basic, underlying assumption must be that criminologically there is no difference between males and females. The previous emphases on differences, especially the differences assumed to be peculiar to women, are precisely why none of the theoretical perspectives outlined in this book have been fruitful in explaining the origins of crime. Even when aggregated the current theories of crime and delinquency cannot accomplish the tasks set forth by Taylor, Walton, and Young as requisite for the formulation of theory:

> (1) The theory must be able, in other words, to place the act in terms of its wider structural origins; (2) . . . must be able to explain the different events, experiences or structural development that precipitate the deviant act; (3) . . . would need to be able to explain the relationship between beliefs and action, between the optimum "rationality" that men have chosen and the behaviours they actually carry through; (4) . . . the requirement . . . is for an explanation of the immediate reaction of the social audience in terms of the range of choices available to that audience; (5) . . . is explicable only in terms of the position and the attributes of those who instigate the reaction against the deviant; (6) . . . would require us to see the reaction he evolves to rejection or stigmatization . . . as being bound up with the conscious choices that precipitated the initial infraction; and (7) . . . these formal requirements must all

appear in the theory, as they do in the real world, in a complex, dialecti-
cal relationship to one another.[24]

The most cogent conclusion one can draw from the status of the
study of female crime and delinquency is that while there is awaken-
ing interest in female deviance in this country, we are still unable to
define accurately the extent of the problem. Until the FBI Uniform
Crime Reports and every other level of crime reporting include break-
downs by sex and ethnicity, we cannot do more than speculate about
the true incidence of female criminality.

A second task to be undertaken before we are able to approach
theory formulation entails a comprehensive survey of all female
offenders in all fifty states and territories who are imprisoned, proba-
tioned, and paroled. This suggested research should include a needs
assessment and analysis of basic information on this study population
as reported on local, state, regional, and national levels. Finally, data
on female offenders should be gathered from the court systems, at
every level of encounter in those systems, to ascertain the handling
and processing of female offenders.

Collecting such data for the purposes of generating theory is of
serious import, but more importantly, specific policy and program
changes should be instituted within the criminal justice system to
make the treatment of girls and women more equitable while also
addressing the special kinds of problems faced by women offenders.

Law enforcement personnel should be sensitized to the special sit-
uations confronting the mothers they arrest. Police training programs
should include the problems and procedures necessary in arrest
scenes where children are present as well as when they are not at home at
the time of their mother's arrest.

Another problem faced by women offenders at the pretrial stage of
the criminal justice system processing is bonding procedures. More
effort should be made to release women offenders on their own recog-
nizance, since most are poor and cannot make bail. If bail is felt to be
required, it should be nominal, or within the realm of possibility for
the specific offender. Standardized pretrial release procedures
should be developed which establish release on recognizance for cer-
tain nonviolent crimes. More diversion alternatives to avoid incarcera-
tion before trial, such as community-based facilities and restitution
programs, should be initiated, particularly for those offenders who
are mothers.

Several changes are needed in the area of law and the courts. First,
indeterminate sentencing in those jurisdictions where such statutes
exist exclusively for women should be eliminated. The passage of the

Twenty-seventh Amendment to the Constitution (ERA) should be vigorously supported in order to provide equal justice to women. In lieu of ERA passage, other constitutional avenues of attack should be investigated, such as the Fourteenth Amendment (equal protection) and the Eighth Amendment (cruel and unusual punishment). Prostitution should be legalized, since these laws impact discriminatorily against women, especially minority women, while simultaneously ignoring the illegal acts of male customers. Victimless crimes such as drug and alcohol abuse should be decriminalized and not be imprisonable offenses. These crimes usually harm no one but the abuser and her family and should not be treated as criminal offenses.

The corrections systems for both adolescent and adult female offenders are sorely in need of reform. All states should adopt legislation permitting pregnant mothers to keep their babies while in prison until "bonding" to the mother has successfully been accomplished. Conjugal visits, home furloughs, and weekend visits should be instituted at all women's facilities in an effort to sustain family ties. Increased opportunities to communicate with families, friends, and attorneys should be made available to all incarcerated women through an expansion of visitation hours, telephone access, and mail privileges, with less censorship of these communication forms. Public transportation should be made accessible or provided to the children and families of women inmates housed in remote, isolated prisons. Legal services, law libraries, law materials, and access to courts should be afforded women in prisons and jails to assist them in the preparation of defenses and appeals. All language restrictions, especially those applied to Hispanic and Native American women offenders, should be eliminated and translators made available at every step of the criminal justice process for those women who are not proficient in English.

Standards should be developed for the medical and health care of incarcerated women, including special, individualized attention and facilities for the pregnant woman; gynecologists and other medical staff specialists informed about women's physical and psychological needs should be available to female offenders; specialized treatment programs for drug, alcohol, and other substance abusers should be available in women's facilities, and tranquilizers and other drugs used as means of social control of female inmates should be abolished.

Women in prison industries should be paid wages equal to men in such industries; more coed prisons and co-correctional arrangements should be instituted to provide women inmates with the same employment, educational, and vocational training opportunities as male inmates; vocational training should be in nontraditional jobs offering

new career avenues for women and should include on-the-job training and other apprenticeships for women; incarcerated females should be offered educational and work-release programs to prepare them for reintegration into society; work-release programs should ensure payment of the prevailing wage in the free world; and substantially more halfway houses and other transitional programs for women offenders should be developed to ensure a meaningful job future.

Criminal justice personnel at every level—police, prosecutors, public defenders, probation officers, judges, parole officers, corrections officers, and administrators—should be sensitized and trained in race relations and other human relations efforts toward making such personnel better understand and assist girl and women offenders, especially those members of minority ethnic groups. Finally, serious attention should be devoted to the "living death" experience of those women on death rows who are in maximum secure segregation that borders on cruel and unusual punishment.

Often when we study a phenomenon, we simultaneously begin to bring attention to or alleviate the problems encompassed in that phenomenon. Attention to the plight of the female offender might contribute to the erasure of the discriminatory treatment and neglect she has received. And then, we can remove the blindfold from Justice. Undoubtedly to many men it has seemed fitting and appropriate that Justice is depicted as a blindfolded woman. Men, as the dominant group, those in power, possibly conceived this representation of Justice precisely because they viewed women as different, as unable to reason, to think, to see. Many men continue to hold these beliefs. The removal of the blindfold from Justice must lead to a nonsexist, nonclassist, nonracist, and just society; for, as Martin Luther King, Jr., so well said, "Injustice anywhere is a threat to justice everywhere."

notes

Chapter 1: The Extent of Female Crime and Delinquency

1. Michael J. Hindelang, "Sex Differences in Criminal Activity," *Social Problems* 27 (1979): 143–56.

2. Sue Titus Reid, *Crime and Criminology*, 2nd ed. (New York: Holt, Rinehart, and Winston, 1979), p. 60.

3. Walter C. Reckless, *The Crime Problem*, 5th ed. (Pacific Palisades, Calif.: Goodyear Publishing Co., 1973), p. 11.

4. Edwin W. Sutherland and Donald R. Cressey, *Criminology*, 10th ed. (Philadelphia: J. B. Lippincott, 1978), p. 29.

5. Ibid., pp. 31–35.

6. It is estimated, for example, that 8 to 10 percent of Afro-American males ages 20–24, the "population at risk," are missed in census enumerations. If the base is undercounted, the crime rates are inflated.

7. Otto Pollak, *The Criminality of Women* (Philadelphia: University of Pennsylvania Press, 1950).

8. Rita James Simon, *The Contemporary Woman and Crime* (Washington, D.C.: U.S. Government Printing Office, 1975), p. 36.

9. Laurel Rans, "Women's Crime: Much Ado About . . . ?" *Federal Probation* (March, 1978).

10. Also, many are female officers who are not as reluctant as male officers to search a female suspect or to arrest another female.

11. Laura Crites, ed., *The Female Offender* (Lexington, Mass.: D. C. Heath, 1976).

12. Arson was established as an Index offense in 1979.

13. FBI Uniform Crime Reports, 1980.

14. Simon, *Contemporary Woman and Crime*, p. 37.

15. Ibid., p. 39.

16. Simon's examination of adult female arrests between 1953 and 1972 shows increased female criminal involvement in embezzlement, fraud, and forgery, as well as in larceny. See Simon, "Women and Crime Revisited," *Social Science Quarterly* 56 (1976): 658–63.

17. Rans, "Women's Crime," p. 2.

18. George W. Noblit and Janie M. Burcart, "Women and Crime: 1960–1970," *Social Science Quarterly* 56 (1976): 651.

19. Ibid., p. 655.

20. Simon, *Contemporary Woman and Crime.*

21. Freda Adler, *Sisters in Crime: The Rise of the New Female Criminal* (New York: McGraw-Hill, 1975), p. 15.

22. Darrell J. Steffensmeier, "Sex Differences in Patterns of Adult Crime, 1965–77: A Review and Assessment," *Social Forces* 58 (1980): 1080–1108.

23. *Masculine* crimes include murder, aggravated assault, other assaults, weapons, robbery, burglary, auto theft, vandalism, and arson; *violent* crimes are murder, aggravated assault, other assaults, weapons, and robbery; *male-dominated* crimes include the masculine crimes and stolen property, gambling, driving under influence, liquor law violations, drunkenness, narcotic drug laws, sex offenses (except forcible rape and prostitution), and offenses against family; *serious* crimes are murder, robbery, aggravated assault, burglary, larceny-theft, and auto theft; and *petty property crimes* are larceny-theft, fraud, forgery, and embezzlement (Steffensmeier, "Sex Differences," p. 1092).

24. Ibid., p. 1096.

25. Darrell J. Steffensmeier and Renee Hoffman Steffensmeier, "Trends in Female Delinquency," *Criminology* 18 (1980): 80.

26. *Violent* crimes are murder, aggravated assault, other assaults, weapons, and robbery; *masculine* crimes include the violent offenses plus burglary, auto theft, stolen property, vandalism, arson, and gambling; *serious* crimes are homicide, aggravated assault, robbery, burglary, larceny-theft, and auto theft; *petty property crimes* includes larceny-theft, fraud, forgery, and embezzlement; *status and sex-related* offenses refer to behaviors that would not be crimes if committed by adults (Steffensmeier and Steffensmeier, "Trends," pp. 69–74).

27. Ibid., p. 76.

28. See, for example, John P. Clark and Edward Haurek, "Age and Sex Roles of Adolescents and Their Involvement in Misconduct: A Reappraisal," *Sociology and Social Research* 50 (1966): 495–508; Nancy Wise, "Juvenile Delinquency Among Middle-Class Girls," in Edmund Vas, ed., *Middle-Class Delinquency* (New York: Harper & Row, 1967); Martin Gold and David Reimer, "Changing Patterns of the Delinquent Behavior Among Americans 13 Through 16 Years Old: 1967–72," *Crime and Delinquency Literature* 7 (1975): 483–517; and Peter C. Kratcoski and John E. Kratcoski, "Changing Patterns in Delinquent Activities of Boys and Girls," *Adolescence* 10 (1975): 83–90.

29. Gold and Reimer, "Changing Patterns."

30. Kratcoski and Kratcoski, "Delinquent Activities," p. 87.

Chapter 2: The Nature of Female Crime and Delinquency

1. For detailed definitions of these concepts see Carol Smart, *Women, Crime, and Criminology: A Feminist Critique* (Boston: Routledge and Kegan Paul, 1976), pp. 6–8.

2. David A. Ward, Maurice Jackson, and Renee Ward, "Crimes of Violence by Women," in *The Criminology of Deviant Women*, Freda Adler and Rita James Simon, eds. (Boston: Houghton Mifflin, 1979), pp. 117–18.

3. Ellen Rosenblatt and Cyril Greenland, "Female Crimes of Violence," *Canadian Journal of Crime and Corrections* 16 (1974): 173–80.

4. Smart, *Women, Crime*, p. 6.

5. Otto Pollak, *The Criminality of Women* (Philadelphia: University of Pennsylvania Press, 1950), pp. 20–23.

6. Maria W. Piers, *Infanticide* (New York: W. W. Norton, 1978), p. 14.

7. Pollak, *Criminality of Women*, pp. 23–24.

8. Richard J. Gelles, *Violence Toward Children in the United States* (Durham, N.H.: University of New Hampshire Press, 1977).

9. Beulah Amsterdam, Mary Brill, Noa Weiselberg, and Dan Edwards, "Coping With Abuse: Adolescents' Views," *Victimology* 4 (1979): 281.

10. Ibid.

11. Brandt F. Steele, "Psychology of Infanticide Resulting from Maltreatment," in *Infanticide and the Value of Life*, Marvin Kohl, ed. (Buffalo: Prometheus, 1978), p. 79.

12. Roger Langley and Richard C. Levy, *Wife Beating: The Silent Crisis* (New York: E. P. Dutton, 1977).

13. Ibid., p. 190.

14. Suzanne K. Steinmetz, "The Battered Husband Syndrome," *Victimology* 2 (1978): 507.

15. Richard J. Gelles, "The Myth of Battered Husbands," *MS* (October, 1979): 65–66, 71–72.

16. Ibid., p. 66.

17. Ibid.

18. Lewis Koch and Joanne Koch, "Parent Abuse . . . A New Plague," *Tallahassee Democrat*, January 27, 1980, pp. 14, 16.

19. Robert Ryan, "Abuse of Elderly Extensive, Report Says," *Tallahassee Democrat*, April 3, 1981, p. 3A.

20. Ibid.

21. Nan Hervig Giordano, Dissertation, University of Georgia, 1982, pp. 65–66.

22. Ryan, "Abuse of Elderly Extensive."

23. FBI Uniform Crime Reports, 1978, p. 189.

24. Ward et al., "Crimes of Violence by Women," p. 116.

25. Darrell J. Steffensmeier and John Kokenda, "The Views of Male Thieves Regarding Patterns of Female Criminality." Paper presented at the annual meeting of the American Society of Criminology, 1979.

26. Eddyth P. Fortune, Manuel Vega, and Ira J. Silverman, "A Study of Female Robbers in a Southern Correctional Institution," *Journal of Criminal Justice* 8 (1980): 324.

27. H. H. A. Cooper, "Woman as Terrorist," in *Criminology of Deviant Women*, p. 151.

28. Charles A. Russell and Bowman H. Miller, "Profile of a Terrorist," in *Contemporary Terrorism*, John D. Elliot and Leslie K. Gibson, eds. (Gaithersburg, Md.: International Association of Chiefs of Police, 1978), p. 85.

29. See, for example, Richard W. Kobetz and H. H. A. Cooper, "Target Terrorism: Providing Protective Services," *Risks International* (1979), or Russell and Miller, "Profile of a Terrorist."

30. *Executive Risks Assessment* 1 (January, 1979), prepared by Risks International.

31. Cooper, "Woman as Terrorist," p. 151.

32. FBI Uniform Crime Reports, 1963, p. 109.

33. FBI Uniform Crime Reports, 1978, p. 199.

34. Ibid., p. 191.

35. See, for example, Stephen Norland and Neal Shover, "Gender Roles and Female Criminality," *Criminology* 15 (1978): 82–104; Darrell J. Steffensmeier, "Sex Differences in Patterns of Adult Crime, 1965–77: A Review and Assessment," *Social Forces* 58 (1980): 1080–1108.

36. Smart, *Women, Crime,* p. 8

37. Steffensmeier and Kokenda, "Views of Male Thieves," p. 15.

38. Ward et al., "Crimes of Violence by Women," pp. 122–25.

39. Ibid., p. 125.

40. Ibid.

41. Ibid.

42. Carl E. Pope, *Crime-Specific Analysis: An Empirical Examination of Burglary Offender Characteristics* (Washington, D.C.: U.S. Department of Justice, 1977).

43. Steffensmeier and Kokenda, "Views of Male Thieves," p. 10.

44. Pollak, *Criminality of Women,* p. 34.

45. Freda Adler, *Sisters in Crime: The Rise of the New Female Criminal* (New York: McGraw-Hill, 1975), p. 164.

46. Marshall B. Clinard and Richard Quinney, *Criminal Behavior Systems: A Typology,* 2nd ed. (New York: Holt, Rinehart, and Winston, 1973), p. 60.

47. Pollak, *Criminality of Women,* p. 35.

48. Adler, *Sisters in Crime,* p. 164.

49. Mary Owen Cameron, *The Booster and the Snitch* (New York: The Free Press, 1964), pp. 146–47.

50. Pollak, *Criminality of Women,* p. 35, suggests this possibility.

51. FBI Uniform Crime Reports, 1978, p. 197.

52. Jennifer James, "Motivations for Entrance into Prostitution," in *The Female Offender,* Laura Crites, ed. (Lexington, Mass.: D. C. Heath, 1976); Jennifer James and J. Meyerding, "Early Sexual Experience and Prostitu-

tion," *American Journal of Psychiatry* 134 (1977): 1381–85; Jennifer James and Peter P. Vitaliano, "The Transition from Primary to Secondary Deviance in Females" (1979) and "Factors in the Drift Towards Female Sex Role Deviance," (1979), unpublished papers received from the authors.

53. Robert E. L. Faris, *Social Disorganization* (New York: Ronald Press, 1955), p. 269.

54. Nathan C. Heard, *Howard Street* (New York: Dial Press, 1970), p. 86.

55. Marshall B. Clinard, *Sociology of Deviant Behavior* (New York: Holt, Rinehart, and Winston, 1957), p. 249.

56. Edwin M. Lemert, *Social Pathology* (New York: McGraw-Hill, 1951).

57. Charles Winick and Paul M. Kinsie, *The Lively Commerce* (Chicago: Quadrangle Books, 1971), p. 3.

58. Kate Millett, "Prostitution: A Quartet for Female Voices," in *Woman in a Sexist Society,* Vivian Gornick and Barbara K. Moran, eds. (New York: New American Library, 1971), p. 79.

59. Smart, *Women, Crime.*

60. Marilyn G. Haft, "Hustling for Rights," in *The Female Offender.*

61. Ibid., pp. 212–13.

62. Xaviera Hollander, *The Happy Hooker* (New York: Dell, 1972).

63. Coramae Richey Mann, "White Collar Prostitution" (1974), unpublished paper.

64. The reader should consult the referenced authors for a more comprehensive, in-depth examination of the etiology of prostitution.

65. Wayland Young, "Prostitution," in *Sexual Deviance,* John H. Gagnon and William Simon, eds. (New York: Harper & Row, 1967), p. 106.

66. Winick and Kinsie, *Lively Commerce.*

67. Lemert, *Social Pathology.*

68. James, "Motivations," p. 194.

69. Ibid.

70. Winick and Kinsie, *Lively Commerce.*

71. Kingsley Davis, "The Sociology of Prostitution," *American Sociological Review* 2 (1937): 744–55.

72. Lemert, *Social Pathology,* p. 237.

73. Faris, *Social Disorganization,* p. 271.

74. James, "Motivations," p. 186.

75. Norman Jackman, Richard O'Toole, and Gilbert Geis, "The Self-Image of the Prostitute," in *Sexual Deviance,* p. 146.

76. Ibid., p. 143.

77. James, "Motivations," p. 190.

78. Adler, *Sisters in Crime,* p. 73.

79. Mann, "White Collar Prostitution."

80. James and Vitaliano, "Factors in the Drift."

81. Ronald L. Akers, *Deviant Behavior: A Social Learning Approach,* 2nd ed. (Belmont, Calif.: Wadsworth Publishing Co., 1977), p. 86. Also see Adler, *Sisters in Crime,* p. 114.

82. Walter R. Cuskey, T. Premkumar, and Lois Siegel, "Survey of Opiate Addiction Among Females in the U.S. Between 1850 and 1970," in *Criminology of Deviant Women.*

83. See, for example, Martin Gold and David J. Reimer, "Changing Patterns of Deviant Behavior Among Americans 13 to 16 Years Old: 1967–1972," *Crime and Delinquency Literature* 7 (1975): 483–517; and Darrell J. Steffensmeier and Renee Hoffman Steffensmeier, "Trends in Female Delinquency," *Criminology* 18 (1980): 62–85.

84. FBI Uniform Crime Reports, 1978, p. 189.

85. Ibid., p. 197.

86. FBI Uniform Crime Reports, 1958, p. 96.

87. Whereas white women tend to obtain their drugs from medical sources, their nonwhite cohorts are more apt to be at the mercy of street dope dealers.

88. Leonard S. Brahen, "Housewife Drug Abuse," *Journal of Drug Education* 3 (1973): 14.

89. Marvin R. Burt, Thomas J. Glynn, and Barbara J. Sowder, *Psychosocial Characteristics of Drug-Abusing Women* (Rockville, Md.: U.S. Department of Health, Education, and Welfare, 1979), p. 6.

90. Ibid., p. 10.

91. Ibid.

92. Ibid., p. 14.

93. Denise F. Polit, Ronald L. Nuttall, and Joan B. Hunter, "Women and Drugs: A Look at Some of the Issues," *Urban and Social Change Review* 9 (1976): 9–16.

94. Alex Thio, *Deviant Behavior* (Boston: Houghton Mifflin, 1978).

95. P. T. D'Orban, "Female Narcotic Addicts: A Follow-Up Study of Criminal and Addiction Careers," *British Medical Journal* 4 (1973): 345–47.

96. James A. Inciardi, "Women, Heroin and Property Crime," in *Women, Crime, and Justice,* Susan K. Datesman and Frank R. Scarpitti, eds. (New York: Oxford University Press, 1980).

97. Jane E. Prather and Linda S. Fidell, "Drug Use and Abuse Among Women: An Overview," *The International Journal of Addictions* 13 (1978): 863–81.

98. Polit et al., "Women and Drugs."

99. Ibid.

100. Mary Ellen Colten, "A Descriptive and Comparative Analysis of Self-Perceptions and Attitudes of Heroin-Addicted Women," in *Addicted Women: Family Dynamics, Self-Perceptions, and Support Systems,* Margruetta B. Hall, ed. (Rockville, Md.: U.S. Department of Health, Education, and Welfare, 1979), p. 15.

101. Ibid.

102. Ibid.

103. FBI Uniform Crime Reports, 1978, p. 197.

104. Lis Harris, "Persons in Need of Supervision," *The New Yorker* (August, 1978), p. 56.

105. Celeste MacLeod, "Street Girls of the 70's," *The Nation* 218 (1974): 486.

106. Ames Robey, Richard Rosenwald, John E. Snell, and Rita E. Lee, "The Runaway Girl: A Reaction to Family Stress," *American Journal of Orthopsychiatry* 34 (1964): 762–67.

107. Ames Robey, "The Runaway Girl," in *Family Dynamics and Female Sexual Delinquency,* Otto Pollak, ed. (Palo Alto, Calif.: Science Behavior Books, 1969), pp. 127–37.

108. Clyde B. Vedder and Dora B. Somerville, *The Delinquent Girl* (Springfield, Ill.: Charles C. Thomas, 1970), p. 66.

109. Marshall P. Duke and Eulalie Fenhagen, "Self-Parental Alienation and Locus of Control in Delinquent Girls," *The Journal of Genetic Psychology* 127 (1975): 103–7.

110. Franklyn W. Dunford and Tim Brennan, "A Taxonomy of Runaway Youth," *Social Service Review* 50 (1976): 457–70.

111. Ibid., p. 463.

112. Dorothy Bracey, *Baby Pros* (New York: The John Jay Press, 1979), p. 41.

113. Diana Gray, "Turning-Out: A Study of Teenage Prostitution," *Urban Life and Culture* 1 (1973): 401–25.

114. Travis Hirschi, *Causes of Delinquency* (Berkeley, Calif.: University of California Press, 1969).

115. Bracey, *Baby Pros,* p. 18.

116. Ibid., p. 58.

117. Frederic M. Thrasher, *The Gang* (Chicago: University of Chicago Press, 1927).

118. Lee H. Bowker, Helen Shimota Gross, and Malcolm W. Klein, "Female Participation in Delinquent Gang Activities." Paper presented at the annual meeting of the American Society of Criminology, 1979.

119. Walter B. Miller, "The Molls," *Society* 11 (1973): 32–35. There may be racial/ethnic differences in gang activities. Research on female involvement in the black gang subculture in Philadelphia found that girl gangs fought members of opposing male gangs as well as other rival girl gang members. Other gang-related functions included acting as spies and luring rival male gang members into ambush. While sex was occasionally provided to male gang members, especially boyfriends, these black female gang members did not have "the automatic connotation of being a sexual object subject to the whims of male gang members." At least one black all-female gang found to exist in Philadelphia, the Holly Whores, functioned similar to male gangs, and its activities were primarily aggressive and violent. This gang was described as "an awesome, fear inspiring group of females," resembling warring Amazons. For details, see Waln K. Brown, "Black Female Gangs in Philadelphia," *International Journal of Offender Therapy and Comparative Criminology* 3 (1977): 221–28.

120. Adler, *Sisters in Crime,* p. 22.

121. Ibid., p. 99.

122. Peggy C. Giordano, "Girls, Guys, and Gangs: The Changing Social Context of Female Delinquency," *Journal of Criminal Law and Criminology* 69 (1978): 130.

123. Walter B. Miller, *Violence by Youth Gangs and Youth Groups as a Crime Problem in Major American Cities* (Washington, D.C.: U.S. Government Printing Office, 1975).

124. Edwin H. Sutherland and Donald R. Cressey, *Criminology,* 10th ed. (Philadelphia: J. B. Lippincott, 1978), p. 30.

125. Ruth M. Glick and Virginia V. Neto, *National Study of Women's Correctional Programs* (Washington, D.C.: U.S. Government Printing Office, 1977).

126. Obviously such comparisons are spurious, considering the fact the data are from different years and we are comparing part of a national sample with that larger sample, but there are few other female arrest figures available to examine crime by race/ethnicity.

127. Adler, *Sisters in Crime*, p. 137.

128. Vernetta Young, "Women, Race, and Crime," *Criminology* 18 (1980): 31.

129. Adler, *Sisters in Crime*, p. 29.

130. Douglas A. Smith and Christy A. Visher, "Sex and Involvement in Deviance/Crime: A Quantitative Review of the Empirical Literature," *American Sociological Review* 45 (1980): 697.

Chapter 3: Biological/Constitutional Theories of Female Deviance

1. Carol Smart, *Women, Crime, and Criminology: A Feminist Critique* (Boston: Routledge and Kegan Paul, 1976), p. 28.

2. C. Ray Jeffery, "The Historical Development of Criminology," in *Pioneers in Criminology*, Hermann Mannheim, ed. (Montclair, N.J.: Patterson Smith, 1972), pp. 458-98.

3. Marvin E. Wolfgang, "Cesare Lombroso," in *Pioneers in Criminology*, pp. 232-91.

4. Cesare Lombroso and William Ferrero, *The Female Offender* (New York: Appleton, 1916), p. 21.

5. Apparently Lombroso and Ferrero did not consider the possibility that such physiological characteristics of prostitutes might have been occupationally linked through streetwalking and oral sex.

6. Smart, *Women, Crime*. p. 32.

7. Morris Janowitz, *W. I. Thomas* (Chicago: University of Chicago Press, 1966).

8. William I. Thomas, *Sex and Society*, (Boston: Little, Brown, 1907), pp. 93-94.

9. Janowitz, *W. I. Thomas*, p. xxvii.

10. William I. Thomas, *The Unadjusted Girl* (New York: Harper & Row, 1923), Chapter 1.

11. Ibid., p. 12.

12. Janowitz, *W. I. Thomas*, p. 120.

13. Ibid., pp. 133-134.

14. Thomas, *Unadjusted Girl*, p. 109.

15. See, for example, Otto Pollak, *The Criminality of Women* (Philadelphia: University of Pennsylvania Press, 1950); and John Cowie, Valerie Cowie, and Eliot Slater, *Delinquency in Girls* (London: Heinemann, 1968).

16. Irene H. Frieze, Jacquelynne E. Parsons, Paula B. Johnson, Diane N. Ruble, and Gail L. Zellman, *Women and Sex Roles: A Social Psychological Perspective* (New York: W. W. Norton, 1978), p. 74.

17. Julia A. Sherman, *On the Psychology of Women* (Springfield, Ill.: Charles C. Thomas, 1971), p. 8.

18. Pollak, *Criminality of Women,* p. 123.

19. Cowie et al., *Delinquency in Girls.*

20. Freda Adler, *Sisters in Crime: The Rise of the New Female Criminal* (New York: McGraw-Hill, 1975), p. 36.

21. Ursula Mittwoch, "Sex Differences in Cells" (San Francisco: W. H. Freeman and Co., 1963): 1-10.

22. Both sexes produce androgens just as they both produce estrogen, which is often mislabeled a "female" hormone. There are no "male" and "female" hormones despite the frequent use of these concepts in sex-linked fashion.

23. Laura Crites, ed., *The Female Offender* (Lexington, Mass.: D. C. Heath, 1976), p. 27. Sherman, *Psychology of Women,* states that there is no medical support for such a position and, furthermore, that little is known about the contents or composition of the Y chromosome.

24. Sherman, *Psychology of Women.*

25. Seymour Levine, "Sex Differences in the Brain," *Scientific American* 214 (1966): 89.

26. Frieze et al., *Women and Sex Roles,* p. 88.

27. Ibid., p. 89.

28. Pollak, *Criminality of Women.*

29. Sherman, *Psychology of Women,* p. 125.

30. Julie Horney, "Menstrual Cycles and Criminal Responsibility," *Law and Human Behavior* 2 (1978).

31. Katharina Dalton, "Menstruation and Crime," *British Medical Journal* 2 (1961): 1752-53.

32. Pollak, *Criminality of Women,* p. 126.

33. J. H. Morton, H. Additon, R. G. Addison, L. Hunt, and J. J. Sullivan, "A Clinical Study of Premenstrual Tension," *American Journal of Obstetrics and Gynecology* 65 (1953): 1182-91.

34. Hamish Sutherland and Iain Stewart, "A Critical Analysis of the Premenstrual Syndrome," *The Lancet* (June 5, 1965), pp. 1180-83.

35. These figures appear to be inaccurate since the percentages are based on forty-two, not fifty-eight, inmates. According to their Table VI (p. 1189), fifty-eight inmates committed crimes of violence, but apparently the menstruation phases of sixteen of the female prisoners could not be determined and were indicated as: no period (N = 3), cannot remember (N = 8), no indication on records (N = 2), pregnant (N = 2), and flowing from abortion (N = 1).

36. Katharina Dalton, "Effect of Menstruation on School Girls' Weekly Work," *British Medical Journal* 1 (1960): 326-28.

37. Sherman, *Psychology of Women,* p. 141.

38. Katharina Dalton, "School Girls' Behavior and Menstruation," *British Medical Journal* 2 (1960): 1647-49.

39. Dalton later refers to this conception of "naughty" as being concerned with petty offenses, but neglected to make that observation in the original research.

40. An examination of the bar graphs in Dalton's article reveals that the punishments administered by the prefects occurred above the incidence expected during the first sixteen days of the menstrual cycle. There was a higher percentage of offenses than expected committed by the girls about Day 12. It is recalled that this is one of the days when estrogen levels are quite high (see Table 3-1), whereas they are lowest during Days 1 to 4. In other words, Dalton's figures reveal high levels of offenses committed during the premenstrual, menstrual, and possibly the ovulatory periods.

41. Dalton, "Menstruation and Crime."

42. Geraldine Youcha, "How Drinking Affects Women," *Woman's Day* (November, 1976), p. 76.

43. Dalton, "Menstruation and Crime," p. 1753.

44. Pollak, *Criminality of Women,* pp. 128–29.

45. Lee H. Bowker, "Menstruation and Female Criminality: A New Look at the Data." Paper presented at the annual meeting of the American Society of Criminology, 1978.

46. Frieze et al., *Women and Sex Roles,* p. 194.

47. Bowker, "Menstruation and Female Criminality," p. 7.

48. Ayres L. Ribeiro, "Menstruation and Crime," *British Medical Journal* 1 (1962): 640.

49. Desmond P. Ellis and Penelope Austin, "Menstruation and Aggressive Behavior in a Correctional Center for Women," *Journal of Criminal Law, Criminology, and Police Science* 62 (1971): 389.

50. The sample, which included 65.1 percent of the total inmate population, was defined as having menstrual cycle stability according to certain criteria: (1) if they fell within the selected twenty to forty-five age group; (2) data from at least three cycles were obtained; (3) their menstrual cycle was "non-pathological." Those women who were pregnant had a recent drug abuse history, dysmenorrhea, or amenorrhea were considered "pathological."

51. Compounding of the number of offenses is seen in the fact that the authors counted every recorded aggressive act, yet frequently one might have been reported by two different officers and thus recorded as two aggressive acts. Also, some officers reported behaviors they had learned of through hearsay from other inmates and had not observed the behavior themselves.

52. Ellis and Austin, "Menstruation and Aggressive Behavior," p. 392.

53. According to their Figure 1, this frequency exceeded all the days included in the menstrual portion of the cycle. It is remembered that Dalton's study of "naughtiness" of schoolgirls revealed a higher percentage of offenses than expected by chance on Day 12 of the menstrual cycle.

54. Mary Brown Parlee, "The Premenstrual Syndrome," *Psychological Bulletin* 80 (1973): p. 456.

55. Ibid.

56. Horney, "Menstrual Cycles," pp. 14–15. Horney offers valuable insight into methodological flaws in menstrual distress studies and provides rather provocative examples of possible distortions of those data.

57. Karen E. Paige, "Women Learn to Sing the Menstrual Blues," *Psychology Today* 7 (1973): 46.

58. Frieze et al., *Women and Sex Roles,* p. 197.

59. Paige, "Women Learn . . . the Menstrual Blues," p. 44.

60. Diane N. Ruble, "Premenstrual Symptoms: A Reinterpretation," *Science* 197 (1977): 291–92.

61. Ibid., p. 292.

62. Bowker, "Menstruation and Female Criminality," p. 10.

63. Paige, "Women Learn . . . the Menstrual Blues," p. 43.

64. Pollak, *Criminality of Women,* p. 132.

65. Ibid., pp. 131–32.

66. Sherman, *Psychology of Women,* 179.

67. Ibid.

68. Pollak, *Criminality of Women,* pp. 132–33.

69. Ibid., pp. 206–7.

70. Smart, *Women, Crime,* p. 52.

Chapter 4: Psychogenic Approaches to Female Crime and Delinquency

1. Carol Smart, *Women, Crime, and Criminology: A Feminist Critique* (Boston: Routledge and Kegan Paul, 1976), p. 33.

2. Ibid.

3. Otto Pollak, *The Criminality of Women* (Philadelphia: University of Pennsylvania Press, 1950), p. 9.

4. Ibid., p. 11.

5. Ibid., p. 10.

6. Calvin Hall and Gardner Lindzey, *Theories of Personality* (New York: John Wiley and Sons, 1957), pp. 32–36. In addition to this resource the reader could consult any general psychology text for details on Freudian concepts.

7. Ibid., p. 34.

8. Ibid., pp. 51–55.

9. Ibid., p. 52.

10. Irene H. Frieze, Jacquelynne E. Parsons, Paula B. Johnson, Diane N. Ruble, and Gail L. Zellman, *Women and Sex Roles: A Social Psychological Perspective* (New York: W. W. Norton, 1978), p. 31.

11. Ibid., p. 32.

12. Julia A. Sherman, *On the Psychology of Women* (Springfield, Ill.: Charles C. Thomas, 1971), p. 48.

13. Peter Blos, "Preoedipal Factors in the Etiology of Female Delinquency," *Psychoanalytic Study of the Child* 12 (1957): 232.

14. Peter Blos, "Three Typical Constellations in Female Delinquency," in *Family Dynamics and Female Sexual Delinquency,* Otto Pollak, ed. (Palo Alto, Calif.: Science and Behavior Books, 1969), pp. 99–110.

15. Ibid., p. 109.

16. Herbert H. Herskovitz, "A Psychodynamic View of Sexual Promiscuity," in *Family Dynamics and Female Sexual Delinquency,* p. 89.

17. Gisela Konopka, *The Adolescent Girl in Conflict* (Englewood Cliffs, N.J.: Prentice-Hall, 1966).

18. Ibid., p. 4.

19. Ibid., p. 123.

20. Marion Earnest, "Criminal Self-Conceptions of Female Offenders in a Penal Community," *Wisconsin Sociologist* (Fall–Winter, 1971), pp. 98–105.

21. Ibid., p. 104.

22. Susan K. Datesman, Frank R. Scarpitti, and Richard M. Stephenson, "Female Delinquency: An Application of Self and Opportunity Theories," *Journal of Research in Crime and Delinquency* 12 (1975), 107–23.

23. Nathan W. Ackerman, "Sexual Delinquency Among Middle-Class Girls," in *Family Dynamics and Female Sexual Delinquency,* pp. 45–50.

24. Gertrude Pollak, "Developing Standards of Sexual Conduct Among Deprived Girls," in *Family Dynamics and Female Sexual Delinquency,* pp. 51–63.

25. John Cowie, Valerie Cowie, and Elliot Slater, *Delinquency in Girls* (London: Heinemann, 1968).

26. Raymond J. Adamek and Edward Z. Dager, "Familial Experience, Identification, and Female Delinquency," *Sociological Focus* 2 (1969): 37–62.

27. Mary Riege, "Parental Affection and Juvenile Delinquency in Girls," *British Journal of Criminology* 12 (1972): 55–73. Girls who had psychiatric or mental defects, were neurotic, or were from broken homes were excluded.

28. Alfred S. Freidman, "The Family and the Female Delinquent: An Overview," in *Family Dynamics and Female Sexual Delinquency,* p. 113.

29. Dora Capwell, "Personality Patterns of Adolescent Girls: Delinquent and Non-Delinquent," *Journal of Applied Psychology* 29 (1945): 289–97. There are various psychological typologies of delinquents. One of the most noteworthy is Marguerite Q. Warren's patterns based on a developmental concept of interpersonal maturity (see "Classification of Offenders as an Aid to Efficient Management and Effective Treatment," *Journal of Criminal Law, Criminology, and Police Science* 62 [1971]: 239–58). However, the discussion here is limited to those psychological typologies exclusively concerned with girl delinquents.

30. Interestingly, the Terman-Miles test of masculinity/femininity did not differentiate between the delinquents and nondelinquents in this study.

31. Edgar W. Butler, "Personality Dimensions of Delinquent Girls," *Criminologica* 3 (1965): 7–10.

32. Marianne Felice and David R. Offord, "Girl Delinquency . . . A Review," *Corrective Psychiatry and Journal of Social Therapy* 17 (1971): 18–33.

33. Marianne Felice and David R. Offord, "Three Developmental Pathways to Delinquency in Girls," *British Journal of Criminology* 12 (1972): 375–89.

34. Ibid., p. 386.

35. Dorcas Susan Butt, "Psychological Styles of Delinquency in Girls," *Canadian Journal of Behavioral Science* 4 (1972): 298–306.

36. Leslie Stevenson, *Seven Theories of Human Nature* (New York: Oxford University Press, 1974), pp. 74–76.

37. Sherman, *Psychology of Women,* p. 48.

38. Leland E. Hinsie and Robert Jean Campbell, *Psychiatric Dictionary* (New York: Oxford University Press, 1960), p. 581.

39. Sherman, *Psychology of Women,* p. 50.

40. Frieze et al., *Women and Sex,* p. 38.

41. Sherman, *Psychology of Women.*

42. Ibid., p. 87.

43. Ibid., p. 88.

44. See, for example, Laura Crites, ed., *The Female Offender* (Lexington, Mass.: D. C. Heath, 1976); and Frieze et al., *Women and Sex.*

45. Frieze et al., *Women and Sex,* p. 34.

46. Ibid.

Chapter 5: Contemporary Efforts to Explain Female Deviance

1. Edwin H. Sutherland and Donald R. Cressey, *Criminology,* 10th ed. (Philadelphia: J. B. Lippincott, 1978), p. 36. The 1975 murder rate is used for comparative purposes; the 1980 rate is 10.2 per 100,000.

2. Dorie Klein, "The Etiology of Female Crime: A Review of the Literature," *Issues in Criminology* 8 (1973): 6.

3. Clarice Feinman, *Women in the Criminal Justice System* (New York: Praeger, 1980), p. 1.

4. Laura Crites, ed., *The Female Offender* (Lexington, Mass.: D. C. Heath, 1976).

5. Carol Smart, *Women, Crime, and Criminology: A Feminist Critique* (Boston: Routledge and Kegan Paul, 1976), pp. 90–91.

6. Jennifer James, "Motivations for Entrance into Prostitution," in *The Female Offender.*

7. Ibid., p. 177.

8. Ibid., p. 179.

9. Ibid., p. 202.

10. Ibid., p. 204.

11. Ibid., p. 205.

12. Diana Gray, "Turning-Out: A Study of Teenage Prostitution," *Urban Life and Culture* 1 (1973): 401–25.

13. A later discussion of the alleged rise of female crime will explore the "opportunity" perspective more fully.

14. Laurel Rans, "Women's Crime: Much Ado About . . . ?" *Federal Probation* (March, 1978), p. 5.

15. Rita Simon, "Women and Crime Revisited," *Social Science Quarterly* 56 (1976): 663.

16. George W. Noblit and Janie M. Burcart, "Women and Crime: 1960–1970," *Social Science Quarterly* 56 (1976): 656–57.

17. Carol Smart, "The New Female Criminal: Reality or Myth," *British Journal of Criminology* 19 (1979): 57.

18. Clarice Feinman, *Women in the Criminal Justice System,* p. 20.

19. Darrell J. Steffensmeier, "Crime and the Contemporary Woman: An Analysis of Changing Levels of Female Property Crime, 1960–1975," in *Women and Crime In America,* Lee H. Bowker, ed. (New York: Macmillan, 1981), p. 53.

20. Dale Hoffman-Bustamante, "The Nature of Female Criminality," *Issues in Criminology* 8 (1973): 117–36.

21. Ibid., p. 132.

22. Ibid., p. 131.

23. Ibid., p. 132.

24. John C. Ball and Nell Logan, "Early Sexual Behavior of Lower-Class Delinquent Girls," *Journal of Criminal Law, Criminology and Police Science* 51 (1960): 209–14.

25. Arthur L. Stinchcombe, *Rebellion in a High School* (Chicago: Triangle Books, 1964).

26. William I. Thomas, *The Unadjusted Girl* (New York: Harper & Row, 1923).

27. Edwin M. Schur, *Our Criminal Society* (Englewood Cliffs, N.J.: Prentice-Hall, 1969); Otto Pollak, *The Criminality of Women* (Philadelphia: University of Pennsylvania Press, 1950).

28. Richard A. Cloward and Lloyd Ohlin, *Delinquency and Opportunity* (New York: The Free Press, 1960).

29. Ruth Morris, "Female Delinquency and Relational Problems," *Social Forces* 43 (1964): 82–89.

30. Susan K. Datesman, Frank R. Scarpitti, and Richard M. Stephenson, "Female Delinquency: An Application of Self and Opportunity Theories," *Journal of Research in Crime and Delinquency* 12 (1975): 107–23.

31. Ibid., p. 116.

32. Stephen A. Cernkovich and Peggy C. Giordano, "Delinquency, Opportunity and Gender," *Journal of Criminal Law and Criminology* 70 (1979): 145–51.

33. Ibid., p. 150.

34. Freda Adler, *Sisters in Crime: The Rise of the New Female Criminal* (New York: McGraw-Hill, 1975).

35. Ibid., p. 95.

36. Ibid., p. 104.

37. Travis Hirschi, *Causes of Delinquency* (Berkeley: University of California Press, 1969). Hirschi's bonding or control theory states that delinquent acts result when one's bond to society is weak or broken.

38. William E. Thornton and Jennifer James, "Masculinity and Delinquency Revisited," *British Journal of Criminology* 19 (1979): 225–41.

39. Ibid., p. 227.

40. Ibid., p. 234.

41. Gloria Leventhal, "Female Criminality: Is 'Women's Lib' to Blame?" *Psychological Reports* 41 (1977): 1179–82.

42. Ibid., p. 1181.

43. Cathy S. Widom, "Female Offenders: Three Assumptions About Self-Esteem, Sex-Role Identity, and Feminism," *Criminal Justice and Behavior* 6 (1979): 365–82.

44. Francis T. Cullen, Kathryn M. Golden, and John B. Cullen, "Sex and Delinquency: A Partial Test of the Masculinity Hypothesis," *Criminology* 17 (1979): 301–10.

45. Ibid., pp. 306–7.

46. Smart, *Women, Crime.*

47. Ibid., p. 69.

48. Stephen Norland and Neal Shover, "Gender Roles and Female Criminality," *Criminology* 15 (1978): 87–104.

49. Thornton and James, "Delinquency Revisited."

50. Ibid., p. 226.

51. Norland and Shover, "Gender Roles," p. 96.

52. Ibid., pp. 99–100.

53. Rita James Simon, *The Contemporary Woman and Crime* (Washington, D.C.: U.S. Government Printing Office, 1975).

54. Ibid., p. 19.

55. Ibid., p. 48.

56. Noblit and Burcart, "Women and Crime: 1960–1970."

57. Ibid., p. 656.

58. Simon, "Women and Crime Revisited."

59. Crites, ed., *The Female Offender,* pp. 36–37.

60. Darrell J. Steffensmeier, "Sex Differences in Patterns of Adult Crime, 1965–77: A Review and Assessment," *Social Forces* 58 (1980): 1080–1108.

61. Ibid., pp. 1098–99.

62. Darrell J. Steffensmeier and Renee Hoffman Steffensmeier, "Trends in Female Delinquency," *Criminology* 18 (1980): 62–85.

63. Smart, "The New Female Criminal," pp. 50–59.

64. Rans, "Women's Crime: Much Ado About . . . ?"

65. Simon, *Contemporary Woman and Crime.*

66. Simon, "Women and Crime Revisited."

67. Freda Adler, "The Rise of the Female Crook," *Psychology Today* (November, 1975), p. 114.

68. Adler, *Sisters in Crime,* p. 14.

69. Steffensmeier, "Sex Differences," p. 1093.

70. Norland and Shover, "Gender Roles," p. 99.

71. Ibid., p. 100.

72. Simon, *Contemporary Woman and Crime,* pp. 17–18.

73. Ibid., p. 48.

74. Noblit and Burcart, "Women and Crime: 1960–1970," p. 657.

75. Rans, "Women's Crime."

76. Steffensmeier, "Sex Differences," p. 1080.

Chapter 6: The Origin and Development of Different Laws for Females

1. Frederick J. Ludwig, *Youth and the Law* (Brooklyn: Foundation Press, 1955), p. 14.

2. Julia A. Sherman, *On the Psychology of Women* (Springfield, Ill.: Charles C. Thomas, 1971), p. 116.

3. Douglas R. Rendleman, "Parens Patriae: From Chancery to the Juvenile Court," in *Juvenile Justice Philosophy,* Frederic Faust and Paul Brantingham, eds. (St. Paul: West Publishing Co., 1974), p. 86.

4. Edwin M. Lemert, "Legislating Change in the Juvenile Court," *Wisconsin Law Review* (1967), pp. 421–48.

5. The major portion of this section is taken from an earlier article by the author, "Making Jail the Hard Way: Law and the Female Offender," *Corrections Today* 41 (1979): 35–41. Reprinted with permission of the American Correctional Association.

6. Samuel Davis and Susan C. Chaires, "Equal Protection for Juveniles: The Present Status of Sex-Based Discrimination in Juvenile Court Laws," *Georgia Law Review* 7 (1973): 494–532.

7. Freda Adler, *Sisters in Crime: The Rise of the New Female Criminal* (New York: McGraw Hill, 1975), p. 207.

8. Karen DeCrow, *Sexist Justice* (New York: Vintage Books, 1974).

9. Davis and Chaires, "Equal Protection."

10. Rosemary C. Sarri, *Under Lock and Key: Juveniles in Jails and Detention* (Ann Arbor: National Assessment of Juvenile Corrections, 1974).

11. Alex Thio, *Deviant Behavior* (Boston: Houghton Mifflin, 1978), p. 72.

12. Linda Riback, "Juvenile Delinquency Laws: Juvenile Women and the Double Standard of Morality," *UCLA Law Review* 19 (1971): 313–42.

13. Nancy B. Greene and T. C. Esselstyn, "The Beyond Control Girl," *Juvenile Justice* 23 (1972): 13–19.

14. See, for example, Sarri, *Under Lock and Key,* or Catherine Milton and Mona Lyons, *Little Sisters and the Law* (Washington, D.C.: American Bar Association, 1977).

15. National Council on Crime and Delinquency, Fact Sheet #2, April 10, 1975.

16. Stuart Stiller and Carol Elder, "Pins—A Concept in Need of Supervision," *American Criminal Law Review* 12 (1974): 33–60.

17. William L. Hickey, "Status Offenses and the Juvenile Court," *Criminal Justice Abstracts* 9 (1977): 91–122.

18. Stiller and Elder, "Pins—A Concept," p. 41.

19. Juvenile Justice and Delinquency Prevention Act, Public Law No. 93-415, 93rd Congress, 1974: 12, 21.

20. Ibid., p. 21.

21. Hickey, "Status Offenses," p. 102.

22. See *In re Gault,* 387 U.S. 28, 1967.

23. Florida Center for Children and Youth, Inc., "Policy Analyses of Status Offenders: Final Report," 1979.

24. Carole R. Horwitz, "Get the Hookers off the Hook," *Inside/Outside* 3 (1976): 1, 3–4.

25. Marilyn Haft, *"Hustling for Rights,"* in *The Female Offender,* Laura Crites, ed. (Lexington, Mass.: D. C. Heath, 1976).

26. DeCrow, *Sexist Justice*; also see Charles Rosenbleet and Barbara Pariente, "The Prostitution of the Criminal Law," *The American Criminal Law Review* 11 (1973): 373–425.

27. Joe Freeman, "The Legal Basis of the Sexual Caste System," *Valparaiso University Law Review* 5 (1971): 203–36.

28. Kenneth Davidson, Ruth Ginsburg, and Herma Kay, *Sex-Based Discrimination* (St. Paul: West Publishing Co., 1974); also see Sarri, *Under Lock and Key.*

29. Interview with James White, former Florida Assistant State's Attorney, 1978.

30. Barbara Allen Babcock, Ann E. Freeman, Eleanor Holmes Norton, and Susan C. Ross, *Sex Discrimination and the Law* (Boston: Little Brown, 1975).

31. Mark Clements, "Sex and Sentencing," *Southwestern Law Journal* 26 (1972): 890–904.

32. Susan C. Ross, *The Rights of Women* (New York: E. P. Dutton, 1973), p. 166.

33. *Robinson* v. *York* 1968 281 F. Supp. 8 (D. Conn.).

34. Gail Armstrong, "Females Under the Law—'Protected' but Unequal," *Crime and Delinquency* 23 (1977): 114.

35. Leo Kanowitz, "Constitutional Aspects of Sex-Based Discrimination in American Law," *Nebraska Law Review* 48 (1968): 154.

36. Davidson et al., *Sex-Based Discrimination,* p. 895.

37. See Carolyn E. Temin, "Discriminatory Sentencing of Women Offenders: The Argument for ERA in a Nutshell," *American Criminal Law Review* 11 (1973): 355–72. Temin lists the five ways Pennsylvania sentencing laws discriminated against women.

38. *Commonwealth* v. *Daniel* 1968 430 Pa. 642, 243 A. 2d 400.

39. *Commonwealth* v. *Douglas* 1968 430 Pa. 642, 243 A. 2d 400.

40. Armstrong, "Females Under the Law," and Davidson et al., *Sex-Based Discrimination.*

41. Temin, "Discriminatory Sentencing."

42. Armstrong, "Females Under the Law."

43. *State* v. *Chambers* 1973 13 Cr. L. 2330 (E.D. N.J.).

44. Sharon Horne, "State v. Chambers: Sex Discrimination in Sentencing," *New England Journal on Prison Law* 1 (1974): 140.

45. Ibid., p. 139.

46. Ibid. Also see Armstrong, "Females Under the Law."

47. John D. Johnston, "Sex Discrimination and the Supreme Court—1975," *UCLA Law Review* 23 (1975): 235–65; and Victor Marcello, "Sex Discrimination: Ad Hoc Review in the Highest Court," *Louisiana Law Review* 35 (1975): 703–10.

48. See, for example, DeCrow, *Sexist Justice*; Johnston, "Sex Discrimination"; Marcello, "Discrimination: Ad Hoc Review"; and Sarri, *Under Lock and Key.*

49. Davis and Chaires, "Equal Protection," p. 525.

50. Joel Grossman and Richard Wells, *Constitutional Law and Judicial Policy Making* (New York: John Wiley and Sons, 1972), p. 810.

51. DeCrow, *Sexist Justice,* p. 36.

52. Grossman and Wells, *Constitutional Law,* p. 812.

53. Ibid., p. 813.

54. DeCrow, *Sexist Justice,* p. 37.

55. Clements, "Sex and Sentencing," p. 890.

56. See, for example, Meda Chesney-Lind, "Judicial Paternalism and the Female Status Offender: Training Women to Know Their Place," *Crime and Delinquency* 23 (1977): 121–30; Mimi Goldman, "Women's Crime in a Male Society," *Juvenile Court Journal* 22 (1971): 33–35.

Chapter 7: The Differential Application of the Law

1. Catherine Milton and Mona Lyons, *Little Sisters and the Law* (Washington, D.C.: American Bar Association, 1977), p. 6.

2. William W. Wattenberg and Frank Saunders, "Sex Differences Among Juvenile Offenders," *Sociology and Social Research* 39 (1954): 24–31.

3. Milton and Lyons, *Little Sisters,* p. 7.

4. Meda Chesney-Lind, "Judicial Paternalism and the Female Status Offender: Training Women to Know Their Place," *Crime and Delinquency* 23 (1977): 123.

5. Mimi Goldman, "Women's Crime in a Male Society," *Juvenile Court Journal* 22 (1971): 34.

6. Ibid.

7. Don C. Gibbons and Manzer J. Griswold, "Sex Differences Among Juvenile Court Referrals," *Sociology and Social Research* 42 (1957): 106–10.

8. Chesney-Lind, "Judicial Paternalism," p. 124.

9. Ibid.

10. Milton and Lyons, *Little Sisters,* p. 7.

11. Freda Adler, *Sisters in Crime: The Rise of the New Female Criminal* (New York: McGraw-Hill, 1975).

12. Rita James Simon, *The Contemporary Woman and Crime* (Washington, D.C.: U.S. Government Printing Office, 1975), p. 18.

13. Laura Crites, ed., *The Female Offender* (Lexington, Mass.: D. C. Heath, 1976), p. 39.

14. Adler, *Sisters in Crime,* p. 18.

15. Barbara Allen Babcock, Ann E. Freeman, Eleanor Holmes Norton, and Susan C. Ross, *Sex Discrimination and the Law* (Boston: Little Brown, 1975), pp. 880–81.

16. Ibid. For similar police harassment of New York City prostitutes see Karen DeCrow, *Sexist Justice* (New York: Vintage Books, 1974), p. 233.

17. Babcock et al., *Sex Discrimination,* p. 915.

18. Imogene L. Moyer and Garland F. White, "Police Processing of Female Offenders," in *Women and Crime in America,* Lee H. Bowker, ed. (New York: Macmillan, 1981), pp. 366–77.

19. Ibid., p. 371.

20. Ibid., pp. 369–70.

21. Ibid., p. 373.

22. Ibid., p. 374.

23. Ibid., p. 375.

24. Carol Kleiman, "Not an Isolated Strip—Chicago Police Methods Exposed," *Ms.* (June, 1979), p. 23.

25. James S. Granelli, "ACLU Sues Chicago Police to Stop Searches of Women Told to Disrobe," *The Washington Post* (March 3, 1979).

26. Larry Green, "U.S. Won't Act in Strip-Search Cases," *The Los Angeles Times* (March 21, 1979).

27. Granelli, "ACLU Sues."

28. Green, "U.S. Won't Act."

29. Pamela Ellis Simons, "Strip Search: The Abuse of Women in Police Stations," *Barrister* 6 (1979): 8–10, 56–57.

30. Ibid. In 1982 a Chicago federal judge declared the Chicago strip-search policy unconstitutional as a result of the ACLU class-action suit, permitting such searches only if a woman is believed to conceal contraband (*Jet,* February 4, 1982, p. 23).

31. Peter Horne, *Women in Law Enforcement* (Springfield, Ill.: Charles C. Thomas, 1975), p. 17.

32. Clarice Feinman, *Women in the Criminal Justice System* (New York: Praeger, 1980), p. 66.

33. Ibid., p. 67.

34. Ibid.

35. Lewis J. Sherman, "Policewomen Around the World," *International Review of Criminal Policy* 33 (1977): 25–33.

36. Horne, *Women in Law Enforcement,* p. 18.

37. Catherine Milton, *Women in Policing,* (Washington, D.C.: Police Foundation, 1972).

38. Carl Glassman, "How Lady Cops are Doing," *Tallahassee Democrat* (July 27, 1980).

39. Milton, *Women in Policing,* p. 27. A recent study by the Police Foundation reports that women on police patrol increased eightfold during the 1970s (*The Atlanta Constitution,* April 6, 1982).

40. Kenneth W. Kerber, Steven M. Andes, and Michele B. Mittler, "Citizen Attitudes Regarding the Competence of Female Police Officers," *Journal of Police Science and Administration* 5 (1977): 337–47.

41. Lewis J. Sherman, "An Evaluation of Policewomen on Patrol in a Suburban Police Department," *Journal of Police Science and Administration* 3 (1975): 434–38.

42. Susan Edmiston, "Policewomen, How Well Are They Doing a Man's Job?" *Ladies Home Journal* (April, 1975), pp. 82–83, 122–28.

43. Virginia Armat, "Policewomen in Action," *Saturday Evening Post* (July–August, 1975): pp. 48–49, 84–87.

44. Milton, *Women in Policing,* pp. 17–26.

45. Ibid., p. 27.

46. Feinman, *Women in Criminal Justice*, p. 77.

47. Manuel Vega and Ira J. Silverman, "Police Perceptions of Female Roles and Women in Policing," *Southern Journal of Criminal Justice* 3 (1978): 34–41.

48. Kerber et al., "Citizen Attitudes," p. 341.

49. Vega and Silverman, "Police Perceptions," p. 35. Ironically, according to the Police Foundation national study (see note 39), the South leads the nation in employment and promotion of women police officers. About 8 percent of city police officers in the South are women compared, for example, to 3 percent in the Northeast. Also in the South 2.49 percent of higher positions are held by policewomen compared to only .79 percent in the Northeast. Perhaps the officers queried perceive job security threats from women officers and prefer they remain in the home!

50. Feinman, *Women in Criminal Justice*, p. 80.

51. Glassman, "How Lady Cops Are Doing."

52. Milton, *Women in Policing,* p. 25.

53. Ibid., pp. 37–38.

54. William O. Weldy, "Women in Policing: A Positive Step Toward Increased Police Enthusiasm," *The Police Chief* 43 (1976): 46–47.

55. Lewis J. Sherman, "A Psychological View of Women in Policing," *Journal of Police Science and Administration* 1 (1973): 383–94.

56. See Chapter 5 for discussion on this belief.

57. Sherman, "Psychological View," p. 388.

58. Susan E. Martin, "*Police*women and Police*women*: Occupational Role Dilemmas and Choices of Female Officers," *Journal of Police Science and Administration* 7 (1979): 314–23.

59. Ibid., p. 316.

60. Ibid., p. 318.

61. Ibid., p. 320.

62. Ibid., p. 322.

Chapter 8: The Juvenile Female in the Judicial Process

1. Anthony Platt, *The Child Savers* (Chicago: University of Chicago Press, 1969).

2. Mark R. Lipschutz, "Runaways in History," *Crime and Delinquency* 23 (1977): 321–32.

3. Robert Mennel, "Origins of the Juvenile Court: Changing Perspectives on the Legal Rights of Juvenile Delinquents," *Crime and Delinquency* (1972), pp. 68–79.

4. Robert G. Caldwell, "The Juvenile Court: Its Development and Some Major Problems," in *Juvenile Delinquency,* Rose Giallombardo, ed. (New York: John Wiley and Sons, 1961), p. 401.

5. Sheldon Glueck and Eleanor Glueck, *One Thousand Juvenile Delinquents* (Cambridge: Harvard University Press, 1934).

6. Joel Handler, "The Juvenile Court and the Adversary System: Problems of Function and Form," *Wisconsin Law Review* 54 (1965): 7–51.

7. Paul W. Tappan, *Delinquent Girls in Court* (New York: Columbia University Press, 1947), p. 175.

8. Ibid.

9. Lois G. Forer, "A Children and Youth Court: A Modest Proposal," *Columbia Human Rights Law Review* (1973), pp. 49–100.

10. Platt, *Child Savers*, p. 139.

11. Caldwell, "Juvenile Court," p. 402.

12. Robert Winslow, *Juvenile Delinquency in a Free Society* (Belmont, Calif.: Dickenson Publishing Co., 1968).

13. Sanford J. Fox, "Justice Reform: A Historical Perspective," *Stanford Law Review* 22 (1970): 1221.

14. Jeffrey E. Glen, "Juvenile Court Reform: Procedural Process—Substantive Stasis," *Wisconsin Law Review* 2 (1970): 441–42.

15. Edward Pabon, "Servicing the Status Offender," *Juvenile and Family Court Journal* 29 (1978): 42.

16. Coramae Richey Mann, "Making Jail the Hard Way: Law and the Female Offender," *Corrections Today* 41 (1979): 37–38.

17. Meda Chesney-Lind, "Judicial Paternalism and the Female Status Offender: Training Women to Know Their Place," *Crime and Delinquency* 23 (1977): 123.

18. Milton G. Rector, "Jurisdiction over Status Offenses Should Be Removed from the Juvenile Court" (Hackensack, N.J.: National Council on Crime and Delinquency, 1974), p. 2.

19. Milton G. Rector, *PINS Cases: An American Scandal* (Hackensack, N.J.: National Council on Crime and Delinquency, 1975), p. 2.

20. William L. Hickey, "Status Offenses and the Juvenile Court," *Criminal Justice Abstracts* 9 (1977): 122.

21. Monrad Paulsen, "Juvenile Courts, Family Courts and the Poor Man," *California Law Review* 54 (1966): 694.

22. Alan Susman, "Practitioner's Guide to Changes in Juvenile Law and Procedure," *Criminal Law Bulletin* 14 (1978): 311–42.

23. Stephen Wizner and Mary F. Keller, "The Penal Model of Juvenile Justice: Is Juvenile Court Delinquency Jurisdiction Obsolete?" *New York University Law Review* 52 (1977): 1132.

24. Francis Barry McCarthy, "Should Juvenile Delinquency Be Abolished?" *Crime and Delinquency* 23 (1977): 196–203.

25. Sanford J. Fox, "Abolishing the Juvenile Court," *Harvard Law School Bulletin* 28 (1977): 22–27.

26. McCarthy, "Should Delinquency Be Abolished?" pp. 198–99.

27. Susan K. Datesman and Frank R. Scarpitti, "Female Delinquency and Broken Homes: A Reassessment," *Criminology* 13 (1975): 35. This tendency has also been found to occur with our Canadian neighbors; see, for example, Barbara Landau, "The Adolescent Female Offender: Our Dilemma," *Canadian Journal of Criminology and Corrections* 17 (1975): 146–53.

28. Catherine Milton and Mona Lyons, *Little Sisters and the Law* (Washington, D.C.: American Bar Association, 1977), p. 8; also see Freda Adler, *Sisters in*

Crime: The Rise of the New Female Criminal (New York: McGraw-Hill, 1975), p. 89.

29. Adler, *Sisters in Crime,* p. 89.

30. Sanford J. Fox, *The Law of Juvenile Courts in a Nutshell* (St. Paul: West Publishing Co., 1971), pp. 26–28.

31. Daniel Katkin, Drew Hyman, and John Kramer, *Juvenile Delinquency and the Juvenile Justice System* (North Scituate, Mass.: Duxbury Press, 1976).

32. Paul F. Cromwell, George G. Killinger, Rosemary C. Sarri, and H. M. Soloman, *Introduction to Juvenile Delinquency* (St. Paul: West Publishing Co., 1977), p. 272.

33. Ted Rubin, *Juvenile Justice* (Santa Monica, Calif.: Goodyear Publishing Co., 1979), p. 110.

34. Ibid., p. 86.

35. Mark Levin and Rosemary C. Sarri, *Juvenile Delinquency: A Comparative Analysis of Legal Codes* (Ann Arbor: National Assessment of Juvenile Corrections, 1974), p. 30.

36. Ibid., p. 31.

37. Rubin, *Juvenile Justice,* p. 89.

38. Allan Conway and Carol Bogdan, "Sexual Delinquency: The Persistence of a Double Standard," *Crime and Delinquency* 23 (1977): 132.

39. Milton and Lyons, *Little Sisters,* p. 9.

40. Ibid., p. 10.

41. Rosemary C. Sarri, "Juvenile Law: How It Penalizes Females," in *The Female Offender,* Laura Crites, ed. (Lexington, Mass.: D. C. Heath, 1976), p. 67.

42. Rosemary C. Sarri, *Under Lock and Key: Juveniles in Jails and Detention* (Ann Arbor: National Assessment of Juvenile Corrections, 1974).

43. Meda Chesney-Lind, "Judicial Enforcement of the Female Sex Role: The Family Court and the Female Delinquent," *Issues in Criminology* 8 (1973): 51–59.

44. Peter C. Kratcoski, "Differential Treatment of Delinquent Boys and Girls in Juvenile Court," *Child Welfare* 53 (1974): 16–22.

45. Mann, "Making Jail the Hard Way."

46. Kenneth Wooden, "The Sexuality of Punishment," *Inside/Outside* 3 (1976): 1.

47. Terence Dungworth, "Discretion in the Juvenile Justice System: The Impact of Case Characteristics on Prehearing Detention," in *Juvenile Delinquency: Little Brother Grows Up,* Theodore N. Ferdinand, ed. (Beverley Hills, Calif.: Sage Publications, 1977).

48. Ibid., p. 30.

49. Ibid., p. 33.

50. Ibid., p. 30.

51. Edward Pawlak, "Differential Selection of Juveniles for Detention," *Journal of Research in Crime and Delinquency* 14 (1977): 158.

52. Ibid., p. 162.

53. Ibid., p. 164.

54. Ibid., p. 165.

55. Chesney-Lind, "Judicial Enforcement."

56. Elaine Selo, "The Cottage Dwellers: Boys and Girls in Training Schools," in *The Female Offender,* Laura Crites, ed. (Lexington, Mass.: D. C. Heath and Co., 1976), p. 154.

57. Rubin, *Juvenile Justice,* p. 90.

58. Chesney-Lind, "Judicial Paternalism," p. 125.

59. U.S. Department of Justice, *Children in Custody* (Washington, D.C.: U.S. Government Printing Office, 1974), p. 18.

60. U.S. Department of Justice, *Children in Custody, Advance Report* (Washington, D.C.: U.S. Government Printing Office, 1977).

61. Rubin, *Juvenile Justice,* p. 134.

62. Fox, *The Law of Juvenile Courts,* p. 195.

63. Rubin, *Juvenile Justice,* p. 136.

64. Fox, *The Law of Juvenile Courts,* p. 202.

65. For more detailed descriptions of these options see Douglas J. Besharov, *Juvenile Justice Advocacy* (New York: Practising Law Institute, 1974), pp. 378–79; Katkin et al., *Juvenile Delinquency,* pp. 301–2; Fox, *The Law of Juvenile Courts,* pp. 202–25.

66. Susman, "Practitioner's Guide."

67. Ibid.

68. Rubin, *Juvenile Justice,* p. 139.

69. Ibid., p. 151.

70. Chesney-Lind, "Judicial Enforcement."

71. Coramae Richey Mann, "The Differential Treatment Between Runaway Boys and Girls in Juvenile Court," *Juvenile and Family Court Journal* 30 (1979): 37–48.

72. Mimi Goldman, "Women's Crime in a Male Society," *Juvenile Court Journal* 22 (1971): 35.

73. Susan K. Datesman and Frank R. Scarpitti, "Unequal Protection for Males and Females in the Juvenile Courts," in *Juvenile Delinquency: Little Brother Grows Up,* p. 73.

74. Don C. Gibbons and Manzer J. Griswold, "Sex Differences Among Juvenile Court Referrals," *Sociology and Social Research* 42 (1957): 109.

75. Milton and Lyons, *Little Sisters,* p. 12.

76. Datesman and Scarpitti, "Unequal Protection."

77. Ibid., p. 64.

78. Milton and Lyons, *Little Sisters,* p. 12.

79. Mann, "Differential Treatment."

80. Selo, "Cottage Dwellers," pp. 152–54.

81. Rector, *Jurisdiction Over Status Offenses.*

82. See, for example, Conway and Bogdan, "Sexual Delinquency"; Gail Armstrong, "Females Under the Law—'Protected' But Unequal," *Crime and Delinquency* 23 (1977): 109–20; Sarah Gold, "Equal Protection for Juvenile Girls in Need of Supervision in New York State," *New York Law Forum* 17 (1971): 570–98.

83. Patrick T. Murphy, *Our Kindly Parent—The State* (New York: Viking Press, 1974), pp. 104–5.

84. Ibid., p. 135.

85. Stuart Nagel and Lenore Weitzman, "The Double Standard of American Justice," *Society* (March, 1972), pp. 18–25, 62–63.

86. Gold, "Equal Protection," p. 594.

Chapter 9: Women in the Criminal Justice System

1. Elizabeth T. Moulds, "Chivalry and Paternalism—Disparities of Treatment in the Criminal Justice System," *Western Political Quarterly* 31 (1978): 415–30.

2. Elizabeth Gould Davis, *The First Sex* (New York: Penguin Books, 1971), p. 229.

3. Ibid., pp. 229–30.

4. Carolyn E. Temin, "Discriminatory Sentencing of Women Offenders: The Argument for ERA in a Nutshell," *American Criminal Law Review* 11 (1973): 358.

5. Anne Strick, *Injustice for All: How Our Adversary System of Law Victimizes Us and Subverts Justice* (New York: Penguin Books, 1977), p. 150.

6. Martin R. Haskell and Lewis Yablonsky, *Crime and Delinquency,* 2nd ed. (Chicago: Rand McNally, 1974), p. 208.

7. Edwin H. Sutherland and Donald R. Cressey, *Criminology,* 10th ed. (Philadelphia: J. B. Lippincott, 1978), p. 427.

8. James T. Carey, *An Introduction to Criminology* (Englewood Cliffs, N.J.: Prentice-Hall, 1978), p. 199.

9. Haskell and Yablonsky, *Crime and Delinquency,* p. 46.

10. Stuart Nagel and Lenore Weitzman, "Women as Litigants," *The Hastings Law Journal* 23 (1971): 172.

11. Ibid., p. 176.

12. Ibid., Table 1, p. 175.

13. Karen DeCrow, *Sexist Justice* (New York: Vintage Books, 1974), pp. 233–34.

14. C. Barrus and A. Slavin, *Movements and Characteristics of Women's Detention Center Admissions, 1969* (Washington, D.C.: District of Columbia Department of Corrections, 1971).

15. Nagel and Weitzman, "Women as Litigants," p. 178.

16. Ibid., p. 180.

17. See, for example, Darrell J. Steffensmeier, "Assessing the Impact of the Women's Movement on Sex-Based Differences in the Handling of Adult Criminal Defendants," *Crime and Delinquency* 26 (1980): 344–57. A national study currently in progress which uses PROMIS (Prosecutor's Management Information System) data should offer a quantitative assessment of the effect of defendant gender on judicial processing. This project by Rosemary Sarri and Josefina Figueria-McDonough of the Institute for Social Research, the University of Michigan, will analyze PROMIS data for six metropolitan criminal justice systems across the country.

18. "Alabama Law Review Summer Project 1975: A Study of Differential Treatment Accorded Female Defendants in Alabama Criminal Courts," *Alabama Law Review* 27 (1975): 676–746.

19. Ibid., pp. 691–92.

20. Ibid., p. 694.

21. Ibid., pp. 694–95.

22. Temin, "Discriminatory Sentencing."

23. Susan C. Ross, *The Rights of Women* (New York: E. P. Dutton, 1973).

24. Temin, "Discriminatory Sentencing"; see also Barbara Allen Babcock, "Introduction to an Issue on Women and the Criminal Law," *American Criminal Law Review* 11 (1973): 291–95.

25. Babcock, "Introduction to an Issue," p. 293.

26. Nagel and Weitzman, "Women as Litigants," p. 176.

27. Stuart Nagel and Lenore Weitzman, "The Double Standard of American Justice," *Society* (March, 1972), pp. 18–25, 62–63, Table 1, p. 20.

28. Ilene Bernstein, Edward Kick, Jan T. Leung, and Barbara Schultz, "Charge Reduction: An Intermediary Stage in the Process of Labelling Criminal Defendants," *Social Forces* 56 (1977): 362–84.

29. Ibid., p. 374.

30. Rita James Simon, *The Contemporary Woman and Crime* (Washington, D.C.: U.S. Government Printing Office, 1975).

31. Ibid., p. 56.

32. Ibid.

33. Ibid., p. 59.

34. Carol Fenster, "Females as Partners in Crime: The Adjudication of Criminal Co-Defendants." Paper presented at annual meeting of the Society of Criminology, November, 1979.

35. Carl E. Pope, "The Influence of Social and Legal Factors on Sentence Dispositions: A Preliminary Analysis of Offender-Based Transaction Statistics," *Journal of Criminal Justice* 4 (1976): 203–21.

36. Ibid., p. 205.

37. Nagel and Weitzman, "Women as Litigants," p. 173.

38. Pope, "The Influence of Social and Legal Factors," p. 206.

39. Moulds, "Chivalry and Paternalism."

40. Ibid., p. 429.

41. Susan Katzenelson, "The Female Defendant in Washington, D.C.," in *Offenders and Corrections,* Dennis Szabs and Susan Katzenelson, eds. (New York: Praeger, 1978), p. 16.

42. Bernstein et al., "Charge Reduction," p. 379.

43. Steffensmeier, "Assessing the Impact of the Women's Movement." In an earlier work Rita Simon also referred to the concepts "naïveté" and "practicality" in discussing this issue; see Simon, *Contemporary Woman and Crime,* p. 49.

44. Moulds, "Chivalry and Paternalism," p. 417.

45. Otto Pollak, *The Criminality of Women* (Philadelphia: University of Pennsylvania Press, 1950), p. 151.

46. Etta A. Anderson, "Chivalrous Treatment of the Female Offender in the Arms of the Criminal Justice System—A Review of the Literature," *Social Problems* 23 (1976): 351.

47. Ibid., p. 355.

48. Moulds, "Chivalry and Paternalism," p. 419.

49. Steffensmeier, "Assessing the Impact of the Women's Movement," p. 350.

50. Simon, *Contemporary Woman and Crime*, p. 49.

51. Ibid.

52. Steffensmeier, "Assessing the Impact of the Women's Movement," p. 350.

53. Gail Armstrong, "Females Under the Law—'Protected' But Unequal," *Crime and Delinquency* 23 (1977): 109.

54. Steffensmeier, "Assessing the Impact of the Women's Movement," p. 352.

55. Ibid.

56. Ibid., p. 353.

57. Anderson, "Chivalrous Treatment," p. 355.

58. Mark C. Clements, "Sex and Sentencing," *Southwestern Law Journal* 26 (1972): 890–904.

59. A notable exception is the 1975 study of Pennsylvania sentencing of women in nine counties reported by Margery Velimesis in *Courts and the Woman Offender* (Philadelphia: Program for Women and Girl Offenders, Inc., 1977).

Chapter 10: Correctional Institutions for Girls

1. Rose Giallombardo, *The Social World of Imprisoned Girls* (New York: John Wiley and Sons, 1974), p. 5.

2. For example, see ibid. and Kenneth Wooden, *Weeping in the Playtime of Others: America's Incarcerated Children* (New York: McGraw-Hill, 1976). Most criminology texts include a chapter on female offenders.

3. Norma Holloway Johnson, "Special Problems of the Female Offender," *Juvenile Justice* 28 (1977): 7.

4. Catherine Pierce, "State Profile: Young Women Offenders in Massachusetts," *The Women Offender Report* (July–August, 1975), pp. 4–5.

5. Wooden, *Weeping*, pp. 24–25.

6. An entire book would be required to discuss children held in jails and the harm that results from their incarceration experiences. For descriptions of the conditions of jail, confinement of children in such facilities, and the physical and psychological effects on these children, see Thomas J. Cottle, "Children in Jail," *Crime in Delinquency* 25 (1979): 318–34; see also, the Florida Center for Children and Youth, *Juvenile Injustice: The Jailing of Children in Florida* (Tallahassee: FCCY, 1979).

7. Wooden, *Weeping*, pp. 28–29.

8. Law Enforcement Assistance Administration, *Children in Custody: Advance Report on the 1977 Census of Public Juvenile Facilities* (Washington, D.C.: U.S. Department of Justice, 1977).

9. Kristine O. Rogers, "For Her Own Protection . . . Conditions of Incarceration for Female Juvenile Offenders in the State of Connecticut," *Law and Society Review* 7 (1972): 223–46.

10. Elaine Selo, "The Cottage Dwellers: Boys and Girls in Training Schools," in *The Female Offender,* Laura Crites, ed. (Lexington, Mass.: D. C. Heath, 1976), pp. 149–51.

11. Wooden, *Weeping,* pp. 118–19.

12. Kenneth Wooden, "The Sexuality of Punishment," *Inside/Outside* 3 (1976): 1.

13. Catherine Milton, *Female Offenders: Problems and Programs* (Washington, D.C.: American Bar Association, 1976), pp. 14, 32.

14. David B. Chein, "Sex as a Factor in the Processing of Juvenile Delinquents: An Analysis of Institutional Decision-Making." Paper presented at the annual meeting of the American Society of Criminology, 1977.

15. Giallombardo, *Social World,* pp. 256–57.

16. Milton, *Female Offenders,* p. 16.

17. Johnson, "Special Problems," pp. 7–8.

18. See Henry P. Lampman, *The Wire Womb: Life in a Girl's Penal Institution* (Chicago: Nelson-Hall, 1973), for a description of such socializing.

19. Giallombardo, *Social World,* pp. 256–57.

20. Law Enforcement Assistance Administration, *Children in Custody* (Washington, D.C.: U.S. Department of Justice, 1974), p. 10.

21. Ibid.

22. Ibid.

23. Milton, *Female Offenders,* p. 16.

24. Wooden, *Weeping,* p. 119.

25. Milton, *Female Offenders,* p. 16.

26. Giallombardo, *Social World,* p. 123.

27. Milton, *Female Offenders,* p. 18.

28. Giallombardo, *Social World,* p. 141.

29. Ibid., p. 139.

30. Ibid., p. 141.

31. Lampman, *Wire Womb,* pp. 21–22.

32. Giallombardo, *Social World,* p. 122.

33. Lampman, *Wire Womb,* p. 41.

34. Giallombardo, *Social World,* pp. 131–32.

35. Ibid., pp. 56, 60.

36. Lampman, *Wire Womb,* p. 6.

37. Selo, "The Cottage Dwellers," p. 159.

38. Howard W. Polsky, *Cottage Six: The Social System of Delinquent Boys in Residential Treatment* (New York: Russell Sage Foundation, 1962).

39. Coramae Richey Mann, "The Family Instructor: A Study and an Intra-Organizational Comparative Analysis." Unpublished paper, University of Illinois, Chicago Circle (1976).

40. Wooden, *Weeping,* p. 121.

41. Milton, *Female Offenders,* p. 18.

42. Selo, "The Cottage Dwellers," p. 159.

43. Wooden, *Weeping,* p. 121.

44. Ibid.

45. Selo, "The Cottage Dwellers," pp. 160–61.

46. Milton, *Female Offenders*, p. 18.

47. Wooden, *Weeping*, p. 123.

48. Giallombardo, *Social World*, p. 68.

49. Wooden, *Weeping*, p. 120.

50. Milton, *Female Offenders*, p. 17.

51. Giallombardo, *Social World*, p. 68.

52. Johnson, "Special Problems," p. 8.

53. Ibid.

54. Milton, *Female Offenders*, p. 16.

55. Giallombardo, *Social World*, p. 87.

56. Milton, *Female Offenders*, p. 17.

57. Giallombardo, *Social World*, p. 3.

58. See, for example, Giallombardo, *Social World*; Lampman, *Wire Womb*; Wooden, *Weeping*. Also, in the next chapter the comparable social system of women's prisons is discussed.

59. Giallombardo, *Social World*, p. 3.

60. Wooden, *Weeping*, p. 125.

61. Giallombardo, *Social World*, p. 245.

Chapter 11: Prisons for Women

1. See, for example, Freda Adler, *Sisters in Crime: The Rise of the New Female Criminal* (New York: McGraw-Hill, 1975); Rita James Simon, *The Contemporary Woman and Crime* (Washington, D.C.: U.S. Government Printing Office, 1975).

2. U.S. Department of Justice (USDJ), *Prisoners in State and Federal Institutions on December 31, 1978, Advance Report* (Washington, D.C.: U.S. Government Printing Office, 1979).

3. U.S. Department of Justice (USDJ), *Census of Jails and Survey of Jail Inmates, 1978* (Washington, D.C.: U.S. Government Printing Office, 1979).

4. Adler, *Sisters in Crime*, p. 174.

5. Rose Giallombardo, *Society of Women—A Study of a Women's Prison* (New York: John Wiley and Sons, 1966), p. 7.

6. Edna Walker Chandler, *Women in Prison*, (Indianapolis: Bobbs Merrill, 1973), p. 3.

7. Ibid., p. 7.

8. Kathryn Burkhart, *Women in Prison* (Garden City, N.Y.: Doubleday, 1973), pp. 252–53.

9. Louis P. Carney, *Introduction to Correctional Science* (New York: McGraw-Hill, 1974), p. 210.

10. Adler, *Sisters in Crime*, p. 175.

11. Burkhart, *Women in Prison*, p. 367.

12. Ruth M. Glick and Virginia V. Neto, *National Study of Women's Correctional Programs* (Washington, D.C.: U.S. Government Printing Office, 1977), p. 20.

13. James G. Ross and Esther Heffernan, "Women in a Coed Joint," *Quarterly Journal of Corrections* 1 (1977): 24.

14. Ibid.

15. Phyllis Jo Baunach and Thomas O. Murton, "Women in Prison: An Awakening Minority," *Crime and Corrections* 1 (1973): 9.

16. Ross and Heffernan, "Women in a Coed Joint," pp. 24–25.

17. Claudine SchWeber, "The Implications and Complications of Coed Prisons." Paper presented at the annual meeting of the American Society of Criminology, 1979.

18. Ibid.

19. Ibid.

20. Clarice Feinman, *Women in the Criminal Justice System* (New York: Praeger, 1980), p. 27.

21. Joan Potter, "In Prison, Women Are Different," *Corrections Magazine* 4 (1978): 15.

22. Ibid., p. 14.

23. U.S. Department of Justice (USDJ), *Prisoners in State and Federal Institutions On December 31, 1978* (Washington, D.C.: U.S. Government Printing Office, 1980), Table 3, p. 14. Preliminary prison statistics reported in a USDJ Bulletin, *Prisoners at Midyear 1981*, show an increase of 10.6 percent of women in state and federal institutions over the 1980 figure. Thus, on June 30, 1981, there was a total of 14,656 incarcerated females. This followed increases of 1.5 percent from 1978 to 1979 and a 2.0 increase from 1979 to 1980.

24. USDJ, *Prisoners . . . 1978*, p. 5.

25. Ibid., p. 14. In 1979, however, the number of women given sentences of more than a year rose 4.2 percent (USDJ Advance Report, May, 1980, *Prisoners in State and Federal Institutions on December 31, 1979*).

26. USDJ, *Prisoners . . . 1978*.

27. Glick and Neto, *National Study*, p. 219.

28. The fourteen states are California, Colorado, Florida, Georgia, Illinois, Indiana, Massachusetts, Michigan, Minnesota, Nebraska, New York, North Carolina, Texas, and Washington.

29. FBI Uniform Crime Report, 1979, p. 199.

30. Information from the Bureau of Criminal Statistics and Special Services, the State of California (1981).

31. Information from the Statistical Analysis Center, Division of Criminal Justice Services, State of New York (1981).

32. Glick and Neto, *National Study*, pp. 152–53.

33. Burkhart, *Women in Prison*, p. 55.

34. Ralph R. Arditi, F. Goldberg, M. M. Hartle, J. H. Peters, and W. R. Phelps, "The Sexual Segregation of American Prisons," *Yale Law Journal* 82 (1973): 1229–73.

35. Glick and Neto, *National Study*, p. 19.

36. Alfreda Iglehart, "Personal and Social Characteristics of Female Offenders," in *Females in Prison in Michigan, 1968–1978: A Study of Commitment Patterns,* Josefina Figueria-McDonough, Alfreda Iglehart, Rosemary Sarri, and Terry Williams, eds. (Ann Arbor: School of Social Work and the Institute for Social Research, University of Michigan, 1981), p. 38.

37. Statistical Analysis Center, State of New York.

38. Glick and Neto, *National Study,* p. 153.

39. Chandler, *Women in Prison,* p. 8.

40. U.S. General Accounting Office (GAO), *Female Offenders: Who Are They and What Are the Problems Confronting Them?* (Washington, D.C.: U.S. Government Printing Office, 1979), p. 7.

41. Glick and Neto, *National Study,* pp. 104–5.

42. GAO, *Female Offenders,* p. 8.

43. USDJ, *Prisoners . . . 1978,* p. 19.

44. Ibid., Table 9, p. 21. Data from the New York State Department of Correctional Services reveal a steady rise in Puerto Rican female commitments. Within this group there was almost a 5 percent statewide increase and a 9.1 percent increment from New York City in new commitments between 1976 and 1977. In 1968 Puerto Rican women were only 7.6 percent of the female commitments; by 1977 they made up 18.6 percent, as compared to 56.1 percent black and 24.3 percent white.

45. Burkhart, *Women in Prison,* p. 260.

46. Esther Heffernan, *Making It in Prison: The Square, the Cool and the Life* (New York: John Wiley and Sons, 1972), p. 59.

47. Chandler, *Women in Prison,* p. 41; emphasis added.

48. Glick and Neto, *National Study,* p. 12.

49. Heffernan, *Making It,* pp. 58–59.

50. Giallombardo, *Society of Women,* p. 29.

51. Burkhart, *Women in Prison,* p. 151.

52. Giallombardo, *Society of Women,* p. 82.

53. Potter, "In Prison," p. 17.

54. Heffernan, *Making It,* p. 51.

55. Potter, "In Prison," p. 17.

56. Heffernan, *Making It,* p. 174.

57. Glick and Neto, *National Study,* p. 36.

58. Giallombardo, *Society of Women,* pp. 41–42.

59. Linda Singer, "Women and the Correctional Process," *The American Criminal Law Review* 11 (1973): 301.

60. Helen E. Gibson, "Women's Prisons: Laboratories for Penal Reform," in *The Female Offender,* Laura Crites, ed. (Lexington, Mass.: D. C. Heath, 1976), p. 99.

61. Glick and Neto, *National Study,* p. 39.

62. Ibid., pp. 41–42.

63. Burkhart, *Women in Prison,* p. 148.

64. Imogene L. Moyer, "Leadership in a Women's Prison," *Journal of Criminal Justice* 8 (1980): 233–41.

65. Glick and Neto, *National Study,* p. 61.

66. Glick and Neto describe complete medical services thus: "Complete routine intake physical examination includes pregnancy test, pap smear and VD tests. Annual physical examinations include pap smear and breast examination. Twenty-four hour emergency coverage. Dental care includes fillings, extractions and possibly restorations. In addition—minor surgery, cosmetic surgery, X-rays, laboratory services, physical therapy, eye glasses and educational programs" (ibid., p. 62).

67. Ibid., p. 69.

68. Burkhart, *Women in Prison,* p. 344.

69. Ibid., p. 333.

70. American Bar Association (ABA), *Female Offenders: Problems and Programs* (Washington, D.C.: Female Offender Resource Center, American Bar Association, 1976), p. 3.

71. Giallombardo, *Society of Women,* p. 73.

72. Chandler, *Women in Prison,* pp. 51–52. At the time of her book (1973) Chandler identified ten states that make college available to female inmates: Colorado, Delaware, Georgia, Illinois, Indiana, Iowa, Kansas, Minnesota, New Jersey, and New York.

73. Albert R. Roberts, *Sourcebook on Prison Education* (Springfield, Ill.: Charles C. Thomas, 1971), p. 131.

74. GAO, *Female Offenders.*

75. Marilyn G. Haft, "Women in Prison—Discriminatory Practices and Some Legal Solutions," *Clearinghouse Review* 8 (1974): 1–2.

76. Ibid.

77. Eileen Ogintz, "Women in Prison," *Chicago Tribune,* August 5, 1980.

78. Glick and Neto, *National Study,* p. 79.

79. Potter, "In Prison," p. 20.

80. Burkhart, *Women in Prison,* p. 303.

81. Giallombardo, *Society of Women,* p. 58.

82. Arditi et al., "Sexual Segregation," p. 1243.

83. Rita James Simon, *Contemporary Woman and Crime,* p. 76.

84. Judy Sammon, "'Campus Look' Is Sharp Contrast to Reality of Penitentiary Walls," *Quarterly Journal of Corrections* 1 (1977): 46.

85. Burkhart, *Women in Prison,* p. 306.

86. Ibid., p. 308.

87. Potter, "In Prison," p. 20.

88. Giallombardo, however, feels that a homosexual alliance is the basic dyad of the kinship families.

89. Giallombardo, *Society of Women,* pp. 107–23.

90. Ibid., p. 123.

91. Heffernan, *Making It,* p. 97.

92. Moyer, "Leadership in a Women's Prison," pp. 239–40.

93. Ibid., p. 204.

94. Simon, *Contemporary Woman and Crime,* pp. 79–80.

95. Haft, "Women in Prison," p. 4.

96. GAO, *Female Offenders*, p. 56.

97. Carney, *Introduction to Correctional Science*, p. 353.

98. Adler, *Sisters in Crime*, pp. 193–94.

Chapter 12: The Most Forgotten Female Offenders

1. Gerald Austin McHugh, "Protection of the Rights of Pregnant Women in Prisons and Detention Facilities," *New England Journal on Prison Law* 6 (1980): 235–37.

2. Ibid., p. 233.

3. Brenda G. McGowan and Karen L. Blumenthal, "Why Punish the Children?" *Children's Rights Report* 3 (November, 1978), p. 5.

4. McHugh, "Protection of the Rights of Pregnant Women," p. 241.

5. Ibid., p. 242.

6. Clarice Feinman, *Women in the Criminal Justice System* (New York: Praeger, 1980), p. 32.

7. McHugh, "Protection of the Rights of Pregnant Women," p. 245.

8. Ibid., pp. 246–47.

9. Ibid., pp. 258–59.

10. Kathleen Haley, "Mothers Behind Bars: A Look at the Parental Rights of Incarcerated Women," *New England Journal on Prison Law* 4 (1977): 153.

11. Sharlette Holdman, "Babies Born in Prison and Other Women Prisoners' Issues." Memorandum from the Florida Clearing House on Criminal Justice, Tallahassee, Florida, July 9, 1980.

12. Clare Raulerson, "Current Status and History of Mothers and Babies in Florida's Prisons as of 2/4/81." Memorandum from the Florida Clearing House on Criminal Justice, Tallahassee, Florida, February 4, 1981.

13. Florida Statute 944.24 (2): 1977.

14. Editorial, "Baby Precious Goes Free," *St. Petersburg Times*, August 22, 1979.

15. Raulerson, "Current Status," p. 4.

16. Johnathon Peterson, "Prison-Baby Ban Stirs Heat," *Tallahassee Democrat*, April 10, 1981.

17. Robert Barnes, "Fight Over 'Prison Babies' May Yet Continue," *Tallahassee Democrat*, July 23, 1981.

18. Peterson, "Prison-Baby Ban."

19. Florida Clearing House on Criminal Justice (FCCJ), "Legislative Alert." Memorandum, Tallahassee, Florida, February 10, 1981.

20. Diony Young, *Bonding* (Rochester, N.Y.: International Childbirth Education Association, 1978), p. 1.

21. FCCJ, "Legislative Alert."

22. Peterson, "Prison-Baby Ban."

23. FCCJ, "Legislative Alert."

24. Peterson, "Prison-Baby Ban."

25. FCCJ, "Legislative Alert."

26. Ruth M. Glick and Virginia V. Neto, *National Study of Women's Correctional Programs* (Washington, D.C.: U.S. Government Printing Office, 1977), p. 116.

27. Brenda G. McGowen and Karen L. Blumenthal, "Children of Women Prisoners: A Forgotten Minority," in *The Female Offender*, Laura Crites, ed. (Lexington, Mass.: D. C. Heath, 1976), p. 125.

28. Phyllis Jo Baunach, "The Separation of Inmate Mothers from Their Children," in *Incarcerated Parents and Their Children*, Velma LaPoint and Coramae Richey Mann, eds. (Washington, D.C.: U.S. Government Printing Office, forthcoming).

29. American Bar Association (ABA), *Female Offenders: Problems and Programs* (Washington, D.C.: Female Offender Resource Center, American Bar Association, 1976).

30. Holdman, "Babies Born in Prison."

31. Glick and Neto, *National Study*, p. 117.

32. Ibid., pp. 118–20.

33. McGowan and Blumenthal, "Children of Women Prisoners," p. 121.

34. Ibid., p. 123.

35. McGowan and Blumenthal, "Why Punish the Children?" p. 3.

36. Ibid.

37. Feinman, *Women in the Criminal Justice System*, p. 33.

38. Phyllis Jo Baunach, "The Separation of Inmate Mothers from Their Children."

39. Velma LaPoint, "Mothers Inside, Children Outside: Some Issues Surrounding Imprisoned Mothers and Their Children," *Proceedings of the 107th Annual Congress of Corrections of the American Correctional Association*, (College Park, Md.: American Correctional Association, 1977), pp. 7–8.

40. Velma LaPoint, "The Impact of Incarceration on Families: Research and Policy Issues." Paper presented to the Research Forum on Family Issues, National Advisory Committee of the White House Conference on Families, 1980, p. 8.

41. Ibid., p. 6.

42. Baunach, "Separation of Inmate Mothers."

43. Ibid.

44. The Yale Law Journal, "On Prisoners and Parenting: Preserving the Tie That Binds," *The Yale Law Journal* 87 (1978): 1409.

45. William H. Sack, "Reactions of Children, Ages 5 to 15, to the Incarceration of a Parent," in *Incarcerated Parents and Their Children*.

46. Velma LaPoint, "Enforced Family Separation: Black Imprisoned Mothers and Their Children." Paper presented at the National Council for Black Child Development, 1979, p. 11.

47. Janel Pueschel and Ronald Moglia, "The Effects of the Penal Environment on Relationships," *The Family Coordinator* (October, 1977), p. 374.

48. Ellen M. Barry, "Legal Services Available to Incarcerated Parents and Their Children: An Assessment of Needs and Services," in *Incarcerated Parents and Their Children*.

49. Haley, "Mothers Behind Bars," p. 154.

50. "On Prisoners and Parenting," p. 1424.

51. "Mothers Raise Babies Behind Prison Walls," *Miami Herald,* April 26, 1979.

52. Ibid.

53. "On Prisoners and Parenting," p. 1423, note 74.

54. McGowan and Blumenthal, "Children of Women Prisoners," p. 129.

55. Richard D. Palmer, "The Prisoner-Mother and Her Child," *Capital University Law Review* 1 (1972): 128.

56. Sandra Boteler, "A General Description of Legal Problems Facing an Incarcerated Parent with Respect to His/Her Child," in *Incarcerated Parents and Their Children.*

57. Haley, "Mothers Behind Bars," p. 146.

58. According to the *Miami Herald,* April 26, 1979, these states are Florida, Illinois, Montana, New York, and Wyoming.

59. "On Prisoners and Parenting," pp. 1409–10.

60. Ibid., p. 1428.

61. Palmer, "The Prisoner-Mother," pp. 135–36.

62. Baunach, "Separation of Inmate Mothers," p. 71.

63. Barry, "Legal Services."

64. Palmer, "The Prisoner-Mother," pp. 135–36.

65. Kathryn Burkhart, *Women in Prison* (Garden City, N.Y.: Doubleday, 1973), p. 94.

66. Assata Shakur, "Women in Prison: How We Are," *The Black Scholar* 9 (1978): 8.

67. U.S. Department of Justice (USDJ), *Census of Jails and Survey of Jail Inmates, 1978, Preliminary Report* (Washington, D.C.: U.S. Department of Justice National Prison Statistics Bulletin, 1979).

68. U.S. Department of Justice (USDJ), *Profile of Jail Inmates* (Washington, D.C.: U.S. Government Printing Office, 1980), p. 2.

69. Patsy Sims, "Women in Southern Jails," in *The Female Offender,* Laura Crites, ed. (Lexington, Mass.: D. C. Heath, 1976), p. 137.

70. U.S. General Accounting Office (GAO), *Female Offenders: Who Are They and What Are the Problems Confronting Them?* (Washington, D.C.: U.S. Government Printing Office, 1979), p. 32.

71. Sims, "Women in Southern Jails," p. 138.

72. Ibid., p. 143.

73. Burkhart, *Women in Prison,* p. 97. This processing is said to take place at the Los Angeles County Jail for Women.

74. USDJ, *Profile,* p. 8.

75. GAO, *Female Offenders,* p. 45.

76. Glick and Neto, *National Study,* p. 70.

77. USDJ, *Profile,* p. 5.

78. Ibid., p. 4.

79. Glick and Neto, *National Study,* p. 9.

80. GAO, *Female Offenders,* pp. 17–18.

81. U.S. Department of Justice (USDJ), *Capital Punishment 1979* (Washington, D.C.: U.S. Government Printing Office, 1980), p. 4.

82. U.S. Department of Justice (USDJ), *Capital Punishment, Advance Report, June, 1980* (Washington, D.C.: U.S. Government Printing Office, 1980). As of May, 1982, these figures had increased as follows: Florida (175), Texas (145), and Georgia (113). The nation's death row population grew to 1,009, according to Brenda Mooney, "Death Row Population Hits 1,009 in Nation," *The Atlanta Constitution,* May 3, 1982.

83. Information from the NAACP Legal Defense Fund, New York City, July 21, 1981.

84. See Robert Johnson, "Warehousing For Death," *Crime and Delinquency* 26 (1980): 545–62. The entire issue of this journal is devoted to the subject of capital punishment in the United States.

85. *Furman v. Georgia* 408 U.S. 238 (1972).

86. USDJ, *Capital Punishment, Advance Report,* Table 4, p. 19.

87. Linda Cicero, "These Are Death Row's Five Women," The *Miami Herald,* May 29, 1979. These and other accounts of the women on death rows have been taken from the only currently available sources, media accounts, which at times may be biased, incomplete, and sensational.

88. Lao Rupert, "Woman in North Carolina Fights to Stay Alive," *Southern Coalition Report on Jails and Prisons* 7 (1980): 1–8.

89. Information from the Oklahoma City Public Defender who represented Carla Rapp, August 3, 1981.

90. Daisey Harris, "Women on Death Row," *Ebony Magazine* (September, 1980), p. 52.

91. Fran Hesser, "2 Death Sentences Affirmed," *The Atlanta Constitution,* February 13, 1981.

92. In January, 1982, Mrs. Tyler was moved to the State Diagnostic and Classification Center near the electric chair at Jackson, Georgia, but a routine stay of execution led to her subsequent transfer to the Women's Correctional Institute, according to *The Atlanta Constitution,* January 11, 1982.

93. Hesser, "2 Death Sentences."

94. Glenn Smith, "Only Woman in Texas Condemned to Die Calls Prison a 'Zoo,'" The Houston, Texas *Chronicle,* June 17, 1980.

95. Nene Foxhall, "Suit by Convicted Murderer Burnett Accuses Her Attorney of Malpractice," Houston *Chronicle,* December 1, 1979.

96. Jo Ellen Meyers Sharp, "A Different Case: Woman Is First in State Sentenced to Die," The Louisville *Courier Journal,* September 13, 1980.

97. Jo Ellen Meyers Sharp, "Woman Condemned to Die in Electric Chair for Arsenic Poisoning," *The Louisville Times,* September 13, 1980.

98. Sharp, "A Different Case."

99. Juan Ramon Palomo, "Sentencing Adds Another Woman to Death Row List," The Houston, Texas *Post,* August 23, 1980.

100. Nene Foxhall, "Woman's Death Penalty First in County Since '63," Houston *Chronicle,* August 22, 1980.

101. Mary Flood, "Woman Sentenced to Death in Strangulation," *Houston Post,* August 22, 1980.

102. "Annette Stebbing Is Sentenced to the Gas Chamber," The Bel Air, Maryland *Aegis,* April 30, 1981.

103. Ibid.

104. The Atlanta *Journal,* August 29 and September 1, 1981.

105. *The Atlanta Constitution,* May 8, 1982.

106. Rupert, "Women in North Carolina," p. 8.

107. Nanci Koser Wilson, "The Masculinity of Violent Crime—Some Second Thoughts," *Journal of Criminal Justice* 9 (1981): 111–23.

108. Robert Johnson, "Under Sentence of Death: The Psychology of Death Row Confinement," *Law and Psychology Review* 5 (1979): 141–92.

109. Ibid., p. 154.

110. Ken Klein, "Court Takes Woman Off Death Row," *Tallahassee Democrat,* March 27, 1981.

111. Cicero, "Death Row's Five Women."

112. Ibid.

113. Jingle Davis, "Death Row Loneliness for Women," *The Atlanta Constitution,* September 13, 1981.

Epilogue: Removing the Blindfold from Justice

1. Frederic M. Thrasher, *The Gang* (Chicago: University of Chicago Press, 1927).

2. E. Franklin Frazier, *The Negro Family in Chicago* (Chicago: University of Chicago Press, 1932).

3. Edwin H. Sutherland, "Theory of Differential Association," in *Juvenile Delinquency,* 3rd ed., Rose Giallombardo, ed. (New York: John Wiley and Sons, 1976).

4. Albert K. Cohen, *Delinquent Boys: The Culture of the Gang* (New York: The Free Press, 1964).

5. Richard A. Cloward and Lloyd Ohlin, *Delinquency and Opportunity: A Theory of Delinquent Gangs* (New York: The Free Press, 1960).

6. Travis Hirschi, *Causes of Delinquency* (Berkeley: University of California Press, 1969), p. 36.

7. David Matza, *Delinquency and Drift* (New York: John Wiley and Sons, 1964), p. 28.

8. David Matza and Gresham Sykes, "Juvenile Delinquency and Subterranean Values," *American Sociological Review* 26 (1961): 712–19.

9. Matza, *Delinquency and Drift,* p. 64.

10. Herbert Block and Arthur Niederhoffer, *The Gang: A Study in Adolescent Behavior* (New York: Philosophical Library, 1958).

11. Ralph W. England, "A Theory of Middle-Class Juvenile Delinquency," *Journal of Criminal Law, Criminology and Police Science* 50 (1960): 535–40.

12. Joseph W. Scott and Edward W. Vaz, "A Perspective on Middle-Class Delinquency," *Canadian Journal of Economics and Political Science* 3 (1963): 324–35.

13. Alex Thio, *Deviant Behavior* (Boston: Houghton Mifflin, 1978).

14. Richard Quinney, *Critique of Legal Order* (Boston: Little Brown, 1973), pp. 54–55.

15. Zillah R. Eisenstein, "Developing a Theory of Capitalist Patriarchy and Socialist Feminism," in *Capitalist Patriarchy and the Case for Socialist Feminism,* Zillah R. Eisenstein, ed. (New York: Monthly Review Press, 1979), p. 5.

16. Ibid., p. 8.

17. Ibid., p. 17.

18. Ibid., pp. 23–24.

19. Dorie Klein and June Kress, "Any Woman's Blues," in *The Criminology of Deviant Women,* Freda Adler and Rita James Simon, eds. (Boston: Houghton Mifflin, 1979), pp. 82–83.

20. Nicole Hahn Rafter and Elena M. Natalizia, "Marxist Feminism: Implications for Criminal Justice," *Crime and Delinquency* 27 (1981): 81–98.

21. Ibid., p. 84.

22. Carol Smart, *Women, Crime and Criminology: A Feminist Critique* (Boston: Routledge and Kegan Paul, 1976), p. 82.

23. Donald R. Cressey, *Other People's Money* (New York: The Free Press, 1953).

24. Ian Taylor, Paul Walton, and Jock Young, *The New Criminology: For a Social Theory of Deviance* (New York: Harper & Row, 1973), pp. 270–77.

SELECTED BIBLIOGRAPHY

Ackerman, Nathan W. "Sexual Delinquency Among Middle-Class Girls." In *Family Dynamics and Female Sexual Delinquency,* Otto Pollak, ed. Palo Alto, Calif.: Science and Behavior Books, 1969.

Adamek, Raymond J., and Dager, Edward Z. "Familial Experience, Identification, and Female Delinquency." *Sociological Focus* 2 (1969): 37–62.

Alder, Freda. *Sisters in Crime: The Rise of the New Female Criminal.* New York: McGraw-Hill, 1975.

———. "The Rise of the Female Crook." *Psychology Today* 9 (1975): 42–48, 112–14.

Adler, Freda, and Simon, Rita James. *The Criminology of Deviant Women.* Boston: Houghton Mifflin, 1979.

Akers, Ronald L. *Deviant Behavior: A Social Learning Approach.* 2nd ed. Belmont, Calif.: Wadsworth Publishing Co., 1977.

"Alabama Law Review Summer Project 1975: A Study of Differential Treatment Accorded Female Defendants in Alabama Criminal Courts." *Alabama Law Review* 27 (1975): 676–746.

American Bar Association. *Female Offenders: Problems and Programs.* Washington, D.C.: Female Offender Resource Center, American Bar Association, 1976.

Amsterdam, Beulah; Brill, Mary; Bell, Noa Weiselberg; and Edwards, Dan. "Coping With Abuse: Adolescents' Views." *Victimology* 4 (1979): 278–84.

Anderson, Etta A. "Chivalrous Treatment of the Female Offender in the Arms of the Criminal Justice System—A Review of the Literature." *Social Problems* 23 (1976): 350–57.

Arditi, Ralph R.; Goldberg, F.; Hartle, M. M.; Peters, J. H.; and Phelps, W. R. "The Sexual Segregation of American Prisons." *Yale Law Journal* 82 (1973): 1229–73.

Armat, Virginia. "Policewomen in Action." *Saturday Evening Post* (July–August, 1975); pp. 48–49, 84–87.

Armstrong, Gail. "Females Under the Law—'Protected' but Unequal." *Crime and Delinquency* 23 (1977): 109–20.

Babcock, Barbara Allen. "Introduction to an Issue on Women and the Criminal Law." *American Criminal Law Review* 11 (1973): 291–95.

———; Freeman, Ann E.; Norton, Eleanor Holmes; and Ross, Susan C. *Sex Discrimination and the Law.* Boston: Little Brown, 1975.

Ball, John C., and Logan, Nell. "Early Sexual Behavior of Lower-Class Delinquent Girls." *Journal of Criminal Law, Criminology and Police Science* 51 (1960): 209–14.

Barrus, C., and Slavin, A. *Movements and Characteristics of Women's Detention Center Admissions, 1969.* Washington, D.C.: District of Columbia Department of Corrections, 1971.

Barry, Ellen M. "Legal Services Available to Incarcerated Parents and Their Children: An Assessment of Needs and Services." In *Incarcerated Parents and Their Children,* Velma LaPoint and Coramae Richey Mann, eds. Washington, D.C.: U.S. Government Printing Office, forthcoming.

Baunach, Phyllis Jo, and Murton, Thomas O. "Women in Prison: An Awakening Minority." *Crime and Corrections* 1 (1973): 4–12.

———. "The Separation of Inmate Mothers from Their Children." In *Incarcerated Parents and Their Children,* Velma LaPoint and Coramae Richey Mann, eds. Washington, D.C.: U.S. Government Printing Office, forthcoming.

Bernstein, Ilene; Kick, Edward; Leung, Jan T.; and Schultz, Barbara. "Charge Reduction: An Intermediary Stage in the Process of Labelling Criminal Defendants." *Social Forces* 56 (1977): 362–84.

Besharov, Douglas J. *Juvenile Justice Advocacy.* New York: Practising Law Institute, 1974.

Block, Herbert, and Niederhoffer, Arthur. *The Gang: A Study in Adolescent Behavior.* New York: Philosophical Library, 1958.

Blos, Peter. "Preoedipal Factors in the Etiology of Female Delinquency." *Psychoanalytic Study of the Child* 12 (1957): 229–49.

———. "Three Typical Constellations in Female Delinquency." In *Family Dynamics and Female Sexual Delinquency,* Otto Pollak, ed. Palo Alto, Calif.: Science and Behavior Books, 1969.

Boteler, Sandra. "A General Description of Legal Problems Facing an Incarcerated Parent with Respect to His/Her Child." In *Incarcerated Parents and Their Children,* Velma LaPoint and Coramae Richey Mann, eds. Washington, D.C.: U.S. Government Printing Office, forthcoming.

Bowker, Lee H. "Menstruation and Female Criminality: A New Look at the Data." Paper presented at the annual meeting of the American Society of Criminology, Dallas, November, 1978.

———; Gross, Helen Shimota; and Klein, Malcom W. "Female Participation in Delinquent Gang Activities." Paper presented at the annual meeting of the American Society of Criminology, Philadelphia, November, 1979.

Bowker, Lee H., ed. *Women and Crime in America.* New York: Macmillan, 1981.

Bracey, Dorothy. *Baby Pros.* New York: The John Jay Press, 1979.

Brahen, Leonard S. "Housewife Drug Abuse." *Journal of Drug Education* 3 (1973): 13–25.

Brown, Waln K. "Black Female Gangs in Philadelphia." *International Journal of Offender Therapy and Comparative Criminology* 3 (1977): 221–28.

Burkhart, Kathryn. *Women in Prison.* Garden City, N.Y.: Doubleday, 1973.

Burt, Marvin R.; Glynn, Thomas J.; and Sowder, Barbara J. *Psychosocial Characteristics of Drug-Abusing Women.* Rockville, Md.: U.S. Department of Health, Education, and Welfare, 1979.

Butler, Edgar W. "Personality Dimensions of Delinquent Girls." *Criminologica* 3 (1965): 7–10.

Butt, Dorcas Susan. "Psychological Styles of Delinquency in Girls." *Canadian Journal of Behavioral Science* 4 (1972): 298–306.

Caldwell, Robert G. "The Juvenile Court: Its Development and Some Major Problems." In *Juvenile Delinquency,* Rose Giallombardo, ed. New York: John Wiley and Sons, 1961.

Capwell, Dora. "Personality Patterns of Adolescent Girls: Delinquent and Non-Delinquent." *Journal of Applied Psychology* 29 (1945): 289–97.

Carey, James T. *An Introduction to Criminology.* Englewood Cliffs, N.J.: Prentice-Hall, 1978.

Carney, Louis P. *Introduction to Correctional Science.* New York: McGraw-Hill, 1974.

Cernkovich, Stephen A., and Giordano, Peggy C. "Delinquency, Opportunity and Gender." *Journal of Criminal Law and Criminology* 70 (1979): 145–51.

Chandler, Edna Walker. *Women in Prison.* Indianapolis: Bobbs Merrill, 1973.

Chein, David B. "Sex as a Factor in the Processing of Juvenile Delinquents: An Analysis of Institutional Decision-Making." Paper presented at the annual meeting of the American Society of Criminology, Atlanta, November, 1977.

Chesney-Lind, Meda. "Judicial Enforcement of the Female Sex Role: The Family Court and the Female Delinquent." *Issues in Criminology* 8 (1973): 51–59.

———. "Judicial Paternalism and the Female Status Offender: Training Women to Know Their Place." *Crime and Delinquency* 23 (1977): 121–30.

Clements, Mark C. "Sex and Sentencing." *Southwestern Law Journal* 26 (1972): 890–904.

Clinard, Marshall B. *Sociology of Deviant Behavior.* New York: Holt, Rinehart, and Winston, 1957.

Cloward, Richard A., and Ohlin, Lloyd. *Delinquency and Opportunity: A Theory of Delinquent Gangs.* New York: The Free Press, 1960.

Cohen, Albert K. *Delinquent Boys: The Culture of the Gang.* New York: The Free Press, 1964.

Colten, Mary Ellen. "A Descriptive and Comparative Analysis of Self-Perceptions and Attitudes of Heroin-Addicted Women." In *Addicted Women: Family Dynamics, Self-Perceptions, and Support Systems,* Margruetta B. Hall, ed. Rockville, Md.: U.S. Department of Health, Education, and Welfare, 1979.

Conway, Allan, and Bogdan, Carol. "Sexual Delinquency: The Persistence of a Double Standard." *Crime and Delinquency* 23 (1977): 131–35.

Cooper, H. H. A. "Woman as Terrorist." In *The Criminology of Deviant Women,* Freda Adler and Rita James Simon, eds. Boston: Houghton Mifflin, 1979.

Cottle, Thomas J. "Children in Jail." *Crime and Delinquency* 25 (1979): 318–34.

Cowie, John; Cowie, Valerie; and Slater, Elliot. *Delinquency in Girls.* London: Heinemann, 1968.

Cressey, Donald R. *Other People's Money.* New York: The Free Press, 1953.

Crites, Laura, ed. *The Female Offender.* Lexington, Mass.: D. C. Heath, 1976.

Cromwell, Paul F.; Killinger, George G.; Sarri, Rosemary C.; and Soloman, H. M. *Introduction to Juvenile Delinquency.* St. Paul: West Publishing Co., 1977.

Cullen, Francis T.; Golden, Kathryn M.; and Cullen, John B. "Sex and Delinquency: A Partial Test of the Masculinity Hypothesis." *Criminology* 17 (1979): 301–10.

Cuskey, Walter R.; Premkumar, T.; and Siegel, Lois. "Survey of Opiate Addiction Among Females in the U.S. Between 1850 and 1970." In *The Criminology of Deviant Women,* Freda Adler and Rita James Simon, eds. Boston: Houghton Mifflin, 1979.

Dalton, Katharina. "Effect of Menstruation on School Girls' Weekly Work." *British Medical Journal* 1 (1960): 326–28.

———. "School Girls' Behavior and Menstruation." *British Medical Journal* 2 (1960): 1647–49.

———. "Menstruation and Crime." *British Medical Journal* 2 (1961): 1752–53.

Datesman, Susan K., and Scarpitti, Frank R. "Female Delinquency and Broken Homes: A Reassessment." *Criminology* 13 (1975): 33–35.

———. "Unequal Protection for Males and Females in the Juvenile Courts." In *Juvenile Delinquency: Little Brother Grows Up,* Theodore N. Ferdinand, ed. Beverley Hills, Calif.: Sage Publications, 1977.

Datesman, Susan K.; Scarpitti, Frank R.; and Stephenson, Richard M. "Female Delinquency: An Application of Self and Opportunity Theories." *Journal of Research in Crime and Delinquency* 12 (1975): 107–23.

Davidson, Kenneth; Ginsburg, Ruth; and Kay, Herma. *Sex-Based Discrimination.* St. Paul: West Publishing Co., 1974.

Davis, Elizabeth Gould. *The First Sex.* New York: Penguin Books, 1971.

Davis, Kingsley. "The Sociology of Prostitution." *American Sociological Review* 2 (1937): 744–55.

Davis, Samuel, and Chaires, Susan C. "Equal Protection for Juveniles: The Present Status of Sex-Based Discrimination in Juvenile Court Laws." *Georgia Law Review* 7 (1973): 494–532.

DeCrow, Karen. *Sexist Justice.* New York: Vintage Books, 1974.

D'Orban, P. T. "Female Narcotic Addicts: A Follow-up Study of Criminal and Addiction Careers." *British Medical Journal* 4 (1973): 345–47.

Duke, Marshall P., and Fenhagen, Eulalie. "Self-Parental Alienation and Locus of Control in Delinquent Girls." *The Journal of Genetic Psychology* 127 (1975): 103–7.

Dunford, Franklyn W., and Brennan, Tim. "A Taxonomy of Runaway Youth." *Social Service Review* 50 (1976): 457–70.

Dungworth, Terence. "Discretion in the Juvenile Justice System: The Impact of Case Characteristics on Prehearing Detention." In *Juvenile Delinquency: Little Brother Grows Up*, Theodore N. Ferdinand, ed. Beverly Hills, Calif.: Sage Publications, 1977.

Earnest, Marion. "Criminal Self-Conceptions of Female Offenders in a Penal Community." *Wisconsin Sociologist* (Fall–Winter 1971), pp. 98–105.

Edmiston, Susan. "Policewomen, How Well Are They Doing a Man's Job?" *Ladies Home Journal* (April, 1975), pp. 82–83, 122–28.

Eisenstein, Zillah R. "Developing a Theory of Capitalist Patriarchy and Socialist Feminism." In *Capitalist Patriarchy and the Case for Socialist Feminism*, Zillah R. Eisenstein, ed. New York: Monthly Review Press, 1979.

Ellis, Desmond P., and Austin, Penelope. "Menstruation and Aggressive Behavior in a Correctional Center for Women." *Journal of Criminal Law, Criminology, and Police Science* 62 (1971): 388–95.

England, Ralph W. "A Theory of Middle-Class Juvenile Delinquency." *Journal of Criminal Law, Criminology, and Police Science* 50 (1960): 535–40.

Faris, Robert E. L. *Social Disorganization*. New York: Ronald Press, 1955.

Feinman, Clarice. *Women in the Criminal Justice System*. New York: Praeger, 1980.

Felice, Marianne, and Offord, David R. "Girl Delinquency . . . A Review." *Corrective Psychiatry and Journal of Social Therapy* 17 (1971): 18–33.

———. "Three Developmental Pathways to Delinquency in Girls." *British Journal of Criminology* 12 (1972): 375–89.

Fenster, Carol. "Females as Partners in Crime: The Adjudication of Criminal Co-Defendants." Paper presented at the annual meeting of the American Society of Criminology, Philadelphia, November, 1979.

Florida Center for Children and Youth. "Policy Analyses of Status Offenders: Final Report," 1979.

———. *Juvenile Injustice: The Jailing of Children in Florida*. Tallahassee: FCCY, 1979.

Forer, Lois G. "A Children and Youth Court: A Modest Proposal." *Columbia Human Rights Law Review* 5 (1973): 49–100.

Fortune, Eddyth P.; Vega, Manuel; and Silverman, Ira J. "A Study of Female Robbers in a Southern Correctional Institution." *Journal of Criminal Justice* 8 (1980): 317–25.

Fox, Sanford J. "Justice Reform: A Historical Perspective." *Stanford Law Review* 22 (1970): 1187–1239.

———. *The Law of Juvenile Courts in a Nutshell*. St. Paul: West Publishing Co., 1971.

———. "Abolishing the Juvenile Court." *Harvard Law School Bulletin* 28 (1977): 22–27.

Frazier, E. Franklin. *The Negro Family in Chicago*. Chicago: University of Chicago Press, 1932.

Freeman, Joe. "The Legal Basis of the Sexual Caste System." *Valparaiso University Law Review* 5 (1971): 203–36.

Friedman, Alfred S. "The Family and the Female Delinquent: An Overview." In *Family Dynamics and Female Sexual Delinquency,* Otto Pollak, ed. Palo Alto, Calif.: Science and Behavior Books, 1969.

Frieze, Irene H.; Parsons, Jacquelynne E.; Johnson, Paula B.; Ruble, Diane N.; and Zellman, Gail L. *Women and Sex Roles: A Social Psychological Perspective.* New York: W. W. Norton, 1978.

Gelles, Richard J. *Violence Toward Children in the United States.* Durham, N.H.: University of New Hampshire Press, 1977.

———. "The Myth of Battered Husbands." *Ms.* (October, 1979), pp. 65–66, 71–72.

Giallombardo, Rose. *Society of Women—A Study of a Women's Prison.* New York: John Wiley and Sons, 1966.

———. *The Social World of Imprisoned Girls.* New York: John Wiley and Sons, 1974.

Gibbons, Don C., and Griswold, Manzer J. "Sex Differences Among Juvenile Court Referrals." *Sociology and Social Research* 42 (1957): 106–10.

Gibson, Helen E. "Women's Prisons: Laboratories for Penal Reform." In *The Female Offender,* Laura Crites, ed. Lexington, Mass.: D. C. Heath, 1976.

Giordano, Peggy C. "Girls, Guys, and Gangs: The Changing Social Context of Female Delinquency." *Journal of Criminal Law and Criminology* 69 (1978): 126–32.

Glen, Jeffrey E. "Juvenile Court Reform: Procedural Process—Substantive Stasis." *Wisconsin Law Review* 2 (1970): 431–49.

Glick, Ruth M., and Neto, Virginia V. *National Study of Women's Correctional Programs.* Washington, D.C.: U.S. Government Printing Office, 1977.

Glueck, Sheldon, and Glueck, Eleanor. *One Thousand Juvenile Delinquents.* Cambridge: Harvard University Press, 1934.

Gold, Martin, and Reimer, David J. "Changing Patterns of Deviant Behavior Among Americans 13 to 16 Years Old: 1967–1972." *Crime and Delinquency Literature* 7 (1975): 483–517.

Gold, Sarah. "Equal Protection for Juvenile Girls in Need of Supervision in New York State." *New York Law Forum* 17 (1971): 570–98.

Goldman, Mimi. "Women's Crime in a Male Society." *Juvenile Court Journal* 22 (1971): 33–35.

Gray, Diana. "Turning-Out: A Study of Teenage Prostitution." *Urban Life and Culture* 1 (1973): 401–25.

Greene, Nancy B., and Esselstyn, T. C. "The Beyond Control Girl." *Juvenile Justice* 23 (1972): 13–19.

Grossman, Joel, and Wells, Richard. *Constitutional Law and Judicial Policy Making.* New York: John Wiley and Sons, 1972.

Haft, Marilyn G. "Women in Prison—Discriminatory Practices and Some Legal Solutions." *Clearinghouse Review* 8 (1974): 1–6.

———. "Hustling for Rights." In *The Female Offender,* Laura Crites, ed. Lexington, Mass.: D. C. Heath, 1976.

Haley, Kathleen. "Mothers Behind Bars: A Look at the Parental Rights of Incarcerated Women." *New England Journal on Prison Law* 4 (1977): 141–55.

Hall, Calvin, and Lindzey, Gardner. *Theories of Personality.* New York: John Wiley and Sons, 1957.

Handler, Joel. "The Juvenile Court and the Adversary System: Problems of Function and Form." *Wisconsin Law Review* 54 (1965): 7–51.

Harris, Daisey. "Women on Death Row." *Ebony Magazine* (September, 1980), pp. 44–46, 48–53.

Haskell, Martin R., and Yablonsky, Lewis. *Crime and Delinquency.* 2nd ed. Chicago: Rand McNally, 1974.

Heard, Nathan C. *Howard Street.* New York: Dial Press, 1970.

Heffernan, Esther. *Making It in Prison: The Square, the Cool and the Life.* New York: John Wiley and Sons, 1972.

Herskovitz, Herbert H. "A Psychodynamic View of Sexual Promiscuity." In *Family Dynamics and Female Sexual Delinquency,* Otto Pollak, ed. Palo Alto, Calif.: Science and Behavior Books, 1969.

Hickey, William L. "Status Offenses and the Juvenile Court." *Criminal Justice Abstracts* 9 (1977): 91–122.

Hindelang, Michael J. "Sex Differences in Criminal Activity." *Social Problems* 27 (1979): 143–56.

Hinsie, Leland E., and Campbell, Robert Jean. *Psychiatric Dictionary.* New York: Oxford University Press, 1960.

Hirschi, Travis. *Causes of Delinquency.* Berkeley: University of California Press, 1969.

Horne, Sharon. "State v. Chambers: Sex Discrimination in Sentencing." *New England Journal on Prison Law* 1 (1974): 138–47.

Horney, Julie. "Menstrual Cycles and Criminal Responsibility." *Law and Human Behavior* 2 (1978): 25–36.

Horwitz, Carole R. "Get the Hookers off the Hook." *Inside/Outside* 3 (1971): 1, 3–4.

Iglehart, Alfreda. "Personal and Social Characteristics of Female Offenders." In *Females in Prison in Michigan, 1968–1978: A Study of Commitment Patterns,* Josefina Figueria-McDonough, Alfreda Iglehart, Rosemary Sarri, and Terry Williams, eds. Ann Arbor: School of Social Work and the Institute for Social Research, University of Michigan, 1981.

Inciardi, James A. "Women, Heroin and Property Crime." In *Women, Crime, and Justice,* Susan K. Datesman and Frank R. Scarpitti, eds. New York: Oxford University Press, 1980.

Jackman, Norman; O'Toole, Richard; and Geis, Gilbert. "The Self-Image of the Prostitute." In *Sexual Deviance,* John H. Gagnon and William Simon, eds. New York: Harper & Row, 1967.

James, Jennifer. "Motivations for Entrance into Prostitution." In *The Female Offender,* Laura Crites, ed. Lexington, Mass.: D. C. Heath, 1976.

Janowitz, Morris. *W. I. Thomas.* Chicago: University of Chicago Press, 1966.

Jeffery, C. Ray. "The Historical Development of Criminology." In *Pioneers in Criminology,* Hermann Mannheim, ed. Montclair, N.J.: Patterson Smith, 1972.

Johnson, Norma Holloway. "Special Problems of the Female Offender." *Juvenile Justice* 28 (1977): 3–10.

Johnson, Robert. "Under Sentence of Death: The Psychology of Death Row Confinement." *Law and Psychology Review* 5 (1979): 141–92.

———. "Warehousing for Death." *Crime and Delinquency* 26 (1980): 545–62.

Johnston, John D. "Sex Discrimination and the Supreme Court—1975." *UCLA Law Review* 23 (1975): 235–65.

Kanowitz, Leo. "Constitutional Aspects of Sex-Based Discrimination in American Law." *Nebraska Law Review* 48 (1968): 131–82.

Katkin, Daniel; Hyman, Drew; and Kramer, John. *Juvenile Delinquency and the Juvenile Justice System.* North Scituate, Mass.: Duxbury Press, 1976.

Katzenelson, Susan. "The Female Defendant in Washington, D.C." In *Offenders and Corrections,* Dennis Szabs and Susan Katzenelson, eds. New York: Praeger, 1978.

Kerber, Kenneth W.; Andes, Steven M.; and Mittler, Michele B. "Citizen Attitudes Regarding the Competence of Female Police Officers." *Journal of Police Science and Administration* 5 (1977): 337–47.

Kleiman, Carol. "Not an Isolated Strip—Chicago Police Methods Exposed." *Ms. Magazine* (June, 1979), p. 23.

Klein, Dorie. "The Etiology of Female Crime: A Review of the Literature." *Issues in Criminology* 8 (1973): 3–31.

———, and Kress, June. "Any Woman's Blues." In *The Criminology of Deviant Women,* Freda Adler and Rita James Simon, eds. Boston: Houghton Mifflin, 1979.

Kobetz, Richard W., and Cooper, H. H. A. "Target Terrorism: Providing Protective Services." *Risks International* (1979).

Konopka, Gisela. *The Adolescent Girl in Conflict.* Englewood Cliffs, N.J.: Prentice-Hall, 1966.

Kratcoski, Peter C. "Differential Treatment of Delinquent Boys and Girls in Juvenile Court." *Child Welfare* 53 (1974): 16–22.

Kratcoski, Peter C., and Kratcoski, John E. "Changing Patterns in Delinquent Activities of Boys and Girls." *Adolescence* 10 (1975): 83–90.

Lampman, Henry P. *The Wire Womb: Life in a Girls' Penal Institution.* Chicago: Nelson-Hall, 1973.

Landau, Barbara. "The Adolescent Female Offender: Our Dilemma." *Canadian Journal of Criminology and Corrections* 17 (1975): 146–53.

Langley, Roger, and Levy, Richard C. *Wife Beating: The Silent Crisis.* New York: E. P. Dutton, 1977.

LaPoint, Velma. "Mothers Inside, Children Outside: Some Issues Surrounding Imprisoned Mothers and Their Children." *Proceedings of the 107th Annual Congress of Corrections of the American Correctional Association.* College Park, Md.: American Correctional Association, 1977.

———. "Enforced Family Separation: Black Imprisoned Mothers and Their Children." Paper presented at the National Council for Black Child Development, Washington, D.C., February, 1979.

———. "The Impact of Incarceration on Families: Research and Policy Issues." Paper presented to the Research Forum on Family Issues, National Advisory Committee of the White House Conference on Families, Washington, D.C., April, 1980.

LaPoint, Velma, and Mann, Coramae Richey, eds. *Incarcerated Parents and Their Children.* Washington, D.C.: U.S. Government Printing Office, forthcoming.

Lemert, Edwin M. *Social Pathology.* New York: McGraw-Hill, 1951.

―――. "Legislating Change in the Juvenile Court." *Wisconsin Law Review* (1967), pp. 421–48.

Leventhal, Gloria. "Female Criminality: Is 'Women's Lib' to Blame?" *Psychological Reports* 41 (1977): 1179–82.

Levin, Mark, and Sarri, Rosemary. *Juvenile Delinquency: A Comparative Analysis of Legal Codes.* Ann Arbor: National Assessment of Juvenile Corrections, 1974.

Levine, Seymour. "Sex Difference in the Brain." *Scientific American* 214 (1966): 84–90.

Lipschutz, Mark R. "Runaways in History." *Crime and Delinquency* 23 (1977): 321–32.

Lombroso, Cesare, and Ferrero, William. *The Female Offender.* New York: Appleton, 1916.

Ludwig, Frederick J. *Youth and the Law.* Brooklyn: Foundation Press, 1955.

McCarthy, Francis Barry. "Should Juvenile Delinquency Be Abolished?" *Crime and Delinquency* 23 (1977): 196–203.

McGowan, Brenda G., and Blumenthal, Karen L. "Children of Women Prisoners: A Forgotten Minority." In *The Female Offender,* Laura Crites, ed. Lexington, Mass.: D. C. Heath, 1976.

―――. "Why Punish the Children?" *Children's Rights Report* 3 (November, 1978).

McHugh, Gerald Austin. "Protection of the Rights of Pregnant Women in Prisons and Detention Facilities." *New England Journal on Prison Law* 6 (1980): 231–63.

MacLeod, Celeste. "Street Girls of the 70's." *The Nation* 218 (1974): 486–88.

Mann, Coramae Richey. "White Collar Prostitution." Unpublished paper, University of Illinois, Chicago Circle, 1974.

―――. "The Family Instructor: A Study and an Intra-Organizational Comparative Analysis." Unpublished paper, University of Illinois, Chicago Circle, 1976.

―――. "Making Jail the Hard Way: Law and the Female Offender." *Corrections Today* 41 (1979): 35–41.

―――. "The Differential Treatment Between Runaway Boys and Girls in Juvenile Court." *Juvenile and Family Court Journal* 30 (1979): 37–48.

Marcello, Victor L. "Sex Discrimination: Ad Hoc Review in the Highest Court." *Louisiana Law Review* 35 (1975): 703–10.

Martin, Susan E. "*Police*women and Police*women*: Occupational Role Dilemmas and Choices of Female Officers." *Journal of Police Science and Administration* 7 (1979): 314–23.

Matza, David. *Delinquency and Drift.* New York: John Wiley and Sons, 1964.

―――, and Sykes, Gresham. "Juvenile Delinquency and Subterranean Values." *American Sociological Review* 26 (1961): 712–19.

Mennel, Robert. "Origins of the Juvenile Court: Changing Perspectives on the Legal Rights of Juvenile Delinquents." *Crime and Delinquency* (January, 1972), pp. 68–79.

Miller, Walter B. "The Molls." *Society* 11 (1973): 32–35.

———. *Violence by Youth Gangs and Youth Groups as a Crime Problem in Major American Cities.* Washington, D.C.: U.S. Government Printing Office, 1975.

Millett, Kate. "Prostitution: A Quartet for Female Voices." In *Woman in a Sexist Society,* Vivian Gornick and Barbara K. Moran, eds. New York: New American Library, 1971.

Milton, Catherine. *Women in Policing.* Washington, D.C.: Police Foundation, 1972.

———. *Female Offenders: Problems and Programs.* Washington, D.C.: American Bar Association, 1976.

———, and Lyons, Mona. *Little Sisters and the Law.* Washington, D.C.: American Bar Association, 1977.

Mittwoch, Ursula. *Sex Differences in Cells.* San Francisco: W. H. Freeman and Co., 1963.

Morris, Ruth. "Female Delinquency and Relational Problems." *Social Forces* 43 (1964): 82–89.

Morton, J. H.; Additon, H.; Addison, R. G.; Hunt, L.; and Sullivan, J. J. "A Clinical Study of Premenstrual Tension." *American Journal of Obstetrics and Gynecology* 65 (1953): 1182–91.

Moulds, Elizabeth T. "Chivalry and Paternalism—Disparities of Treatment in the Criminal Justice System." *Western Political Quarterly* 31 (1978): 415–30.

Moyer, Imogene L. "Leadership in a Women's Prison." *Journal of Criminal Justice* 8 (1980): 233–41.

———, and White, Garland F. "Police Processing of Female Offenders." In *Women and Crime in America,* Lee H. Bowker, ed. New York: Macmillan, 1981.

Murphy, Patrick T. *Our Kindly Parent—The State.* New York: Viking Press, 1974.

Nagel, Stuart, and Weitzman, Lenore. "Women as Litigants." *The Hastings Law Journal* 23 (1971): 171–98.

———. "The Double Standard of American Justice." *Society* (March, 1972), pp. 18–25, 62–63.

Noblit, George W., and Burcart, Janie M. "Women and Crime: 1960–1970." *Social Science Quarterly* 56 (1976): 650–57.

Norland, Stephen, and Shover, Neal. "Gender Roles and Female Criminality." *Criminology* 15 (1978): 87–104.

Pabon, Edward. "Servicing the Status Offender." *Juvenile and Family Court Journal* 29 (1978): 41–48.

Paige, Karen E. "Women Learn to Sing the Menstrual Blues." *Psychology Today* 7 (1973): 41–46.

Palmer, Richard D. "The Prisoner-Mother and Her Child." *Capital University Law Review* 1 (1972): 127–44.

Parlee, Mary Brown. "The Premenstrual Syndrome." *Psychological Bulletin* 80 (1973): 454–65.

Paulsen, Monrad. "Juvenile Courts, Family Courts and the Poor Man." *California Law Review* 54 (1966): 694–704.

Pawlak, Edward. "Differential Selection of Juveniles for Detention." *Journal of Research in Crime and Delinquency* 14 (1977): 152–65.

Pierce, Catherine. "State Profile: Young Women Offenders in Massachusetts." *The Women Offender Report* (1975), pp. 4–5.

Piers, Maria W. *Infanticide*. New York: W. W. Norton, 1978.

Platt, Anthony. *The Child Savers*. Chicago: University of Chicago Press, 1969.

Polit, Denise F.; Nuttall, Ronald L.; and Hunter, Joan B. "Women and Drugs: A Look at Some of the Issues." *Urban and Social Change Review* 9 (1976): 9–16.

Pollak, Gertrude. "Developing Standards of Sexual Conduct Among Deprived Girls." In *Family Dynamics and Female Sexual Delinquency*, Otto Pollak, ed. Palo Alto, Calif.: Science and Behavior Books, 1969.

Pollak, Otto. *The Criminality of Women*. Philadelphia: University of Pennsylvania Press, 1950.

———, ed. *Family Dynamics and Female Sexual Delinquency*. Palo Alto, Calif.: Science and Behavior Books, 1969.

Polsky, Howard W. *Cottage Six: The Social System of Delinquent Boys in Residential Treatment*. New York: Russell Sage Foundation, 1962.

Pope, Carl E. "The Influence of Social and Legal Factors on Sentence Dispositions: A Preliminary Analysis of Offender-Based Transaction Statistics." *Journal of Criminal Justice* 4 (1976): 203–21.

———. *Crime-Specific Analysis: An Empirical Examination of Burglary Offender Characteristics*. Washington, D.C.: U.S. Department of Justice, 1977.

Potter, Joan. "In Prison, Women Are Different." *Corrections Magazine* 4 (1978): 14–24.

Prather, Jane E., and Fidell, Linda S. "Drug Use and Abuse Among Women: An Overview." *The International Journal of Addictions* (1978), pp. 863–81.

Pueschel, Janet, and Moglia, Ronald. "The Effects of the Penal Environment on Relationships." *The Family Coordinator* (October, 1977), pp. 373–75.

Quinney, Richard. *Critique of Legal Order*. Boston: Little Brown, 1973.

Rafter, Nicole Hahn, and Natalizia, Elena M. "Marxist Feminism: Implications for Criminal Justice." *Crime and Delinquency* 27 (1981): 81–98.

Rans, Laurel. "Women's Crime: Much Ado About . . . ?" *Federal Probation* (March, 1978).

Reckless, Walter C. *The Crime Problem*. 5th ed. Pacific Palisades, Calif.: Goodyear Publishing Co., 1973.

Rector, Milton G. *Jurisdiction over Status Offenses Should Be Removed from the Juvenile Court*. Hackensack, N.J.: National Council on Crime and Delinquency, 1974.

———. *PINS Cases: An American Scandal*. Hackensack, N.J.: National Council on Crime and Delinquency, 1975.

Reid, Sue Titus. *Crime and Criminology*. 2nd ed. New York: Holt, Rinehart, and Winston, 1979.

Rendleman, Douglas R. "Parens Patriae: From Chancery to the Juvenile Court." In *Juvenile Justice Philosophy*, Frederic Faust and Paul Brantingham, eds. St. Paul: West Publishing Co., 1974.

Riback, Linda. "Juvenile Delinquency Laws: Juvenile Women and the Double Standard of Morality." *UCLA Law Review* 19 (1971): 313–42.

Riege, Mary. "Parental Affection and Juvenile Delinquency in Girls." *British Journal of Criminology* 12 (1972): 55–73.

Roberts, Albert R. *Sourcebook on Prison Education*. Springfield, Ill.: Charles C. Thomas, 1971.

Robey, Ames. "The Runaway Girl." In *Family Dynamics and Female Sexual Delinquency*, Otto Pollak, ed. Palo Alto, Calif.: Science Behavior Books, 1969.

Robey, Ames; Rosenwald, Richard; Snell, John E.; and Lee, Rita E. "The Runaway Girl: A Reaction to Family Stress." *American Journal of Orthopsychiatry* 34 (1964): 762–67.

Rogers, Kristine O. "For Her Own Protection . . . Conditions of Incarceration for Female Juvenile Offenders in the State of Connecticut." *Law and Society Review* 7 (1972): 223–46.

Rosenblatt, Ellen, and Greenland, Cyril. "Female Crimes of Violence." *Canadian Journal of Crime and Corrections* 16 (1974): 173–80.

Rosenbleet, Charles, and Pariente, Barbara. "The Prostitution of the Criminal Law." *The American Criminal Law Review* 11 (1973): 373–425.

Ross, James G., and Heffernan, Esther. "Women in a Coed Joint." *Quarterly Journal of Corrections* 1 (1977): 24–28.

Ross, Susan C. *The Rights of Women*. New York: E. P. Dutton, 1973.

Rubin, Ted. *Juvenile Justice*. Santa Monica, Calif.: Goodyear Publishing Co., 1979.

Ruble, Diane N. "Premenstrual Symptoms: A Reinterpretation." *Science* 197 (1977): 291–92.

Rupert, Lao. "Woman in North Carolina Fights to Stay Alive." *Southern Coalition Report on Jails and Prisons* 7 (Fall, 1980): 1–8.

Russell, Charles A., and Miller, Bowman H. "Profile of a Terrorist." In *Contemporary Terrorism*, John D. Elliot and Leslie K. Gibson, eds. Gaithersburg, Md.: International Association of Chiefs of Police, 1978.

Sack, William H. "Reactions of Children, Ages 5 to 15, to the Incarceration of a Parent." In *Incarcerated Parents and Their Children*, Velma LaPoint and Coramae Richey Mann, eds. Washington, D.C.: U.S. Government Printing Office, forthcoming.

Sammon, Judy. "'Campus Look' Is Sharp Contrast to Reality of Penitentiary Walls." *Quarterly Journal of Corrections* 1 (1977): 45–47.

Sarri, Rosemary C. *Under Lock and Key: Juveniles in Jails and Detention*. Ann Arbor: National Assessment of Juvenile Corrections, 1974.

———. "Juvenile Law: How It Penalizes Females." In *The Female Offender*, Laura Crites, ed. Lexington, Mass.: D. C. Heath, 1976.

Schur, Edwin M. *Our Criminal Society*. Englewood Cliffs, N.J.: Prentice-Hall, 1969.

SchWeber, Claudine. "The Implications and Complications of Coed Prisons." Paper presented at the annual meeting of the American Society of Criminology, Philadelphia, November, 1979.

Scott, Joseph W., and Vaz, Edward W. "A Perspective on Middle-Class Delinquency." *Canadian Journal of Economics and Political Science* 3 (1963): 324–35.

Selo, Elaine. "The Cottage Dwellers: Boys and Girls in Training Schools." In *The Female Offender*, Laura Crites, ed. Lexington, Mass.: D. C. Heath, 1976.

Shakur, Assata. "Women in Prison: How We Are." *The Black Scholar* 9 (1978): 8–16.

Sherman, Julia A. *On the Psychology of Women.* Springfield, Ill.: Charles C. Thomas, 1971.

Sherman, Lewis J. "A Psychological View of Women in Policing." *Journal of Police Science and Administration* 1 (1973): 383–94.

———. "An Evaluation of Policewomen on Patrol in a Suburban Police Department." *Journal of Police Science and Administration* 3 (1975): 434–38.

———. "Policewomen Around the World." *International Review of Criminal Policy* 33 (1977): 25–33.

Simon, Rita James. *The Contemporary Woman and Crime.* Washington, D.C.: U.S. Government Printing Office, 1975.

———. "Women and Crime Revisited." *Social Science Quarterly* 56 (1976): 658–63.

Simons, Pamela Ellis. "Strip Search: The Abuse of Women in Police Stations." *Barrister* 6 (1979): 8–10, 56–57.

Sims, Patsy. "Women in Southern Jails." In *The Female Offender*, Laura Crites, ed. Lexington, Mass.: D. C. Heath, 1976.

Singer, Linda. "Women and the Correctional Process." *The American Criminal Law Review* 11 (1973): 295–308.

Smart, Carol. *Women, Crime, and Criminology: A Feminist Critique.* Boston: Routledge and Kegan Paul, 1976.

———. "The New Female Criminal: Reality or Myth." *British Journal of Criminology* 19 (1979): 50–59.

Smith, Douglas A., and Visher, Christy A. "Sex and Involvement in Deviance/ Crime: A Quantitative Review of the Empirical Literature." *American Sociological Review* 45 (1980): 691–701.

Steele, Brandt F. "Psychology of Infanticide Resulting from Maltreatment." In *Infanticide and the Value of Life*, Marvin Kohl, ed. Buffalo: Prometheus, 1978.

Steffensmeier, Darrell J. "Assessing the Impact of the Women's Movement on Sex-Based Differences in the Handling of Adult Criminal Defendants." *Crime and Delinquency* 26 (1980): 344–57.

———. "Sex Differences in Patterns of Adult Crime, 1965–77: A Review and Assessment." *Social Forces* 58 (1980): 1080–1108.

———. "Crime and the Contemporary Woman: An Analysis of Changing Levels of Female Property Crime, 1960–1975." In *Women and Crime in America*, Lee H. Bowker, ed. New York: Macmillan, 1981.

———, and Steffensmeier, Renee Hoffman. "Trends in Female Delinquency." *Criminology* 18 (1980): 62–85.

———, and Kokenda, John. "The Views of Male Thieves Regarding Patterns of Female Criminality." Paper presented at the annual meeting of the American Society of Criminology, Philadelphia, November, 1979.

Steinmetz, Suzanne K. "The Battered Husband Syndrome." *Victimology* 2 (1978): 499–509.

Stevenson, Leslie. *Seven Theories of Human Nature.* New York: Oxford University Press, 1974.

Stiller, Stuart, and Elder, Carol. "Pins—A Concept in Need of Supervision." *American Criminal Law Review* 12 (1974): 33–60.

Stinchcombe, Arthur L. *Rebellion in a High School.* Chicago: Triangle Books, 1964.

Strick, Anne. *Injustice for All: How Our Adversary System of Law Victimizes Us and Subverts Justice.* New York: Penguin Books, 1977.

Susman, Alan. "Practitioner's Guide to Changes in Juvenile Law and Procedure." *Criminal Law Bulletin* 14 (1978): 311–42.

Sutherland, Edwin H. "Theory of Differential Association." In *Juvenile Delinquency.* 3rd ed. Rose Giallombardo, ed. New York: John Wiley and Sons, 1976.

———, and Cressey, Donald R. *Criminology.* 10th ed. Philadelphia: J. B. Lippincott, 1978.

Sutherland, Hamish, and Stewart, Iain. "A Critical Analysis of the Premenstrual Syndrome." *The Lancet* (June 5, 1965), pp. 1180–83.

Tappan, Paul W. *Delinquent Girls in Court.* New York: Columbia University Press, 1947.

Taylor, Ian; Walton, Paul; and Young, Jock. *The New Criminology: For a Social Theory of Deviance.* New York: Harper & Row, 1973.

Temin, Carolyn E. "Discriminatory Sentencing of Women Offenders: The Argument for ERA in a Nutshell." *American Criminal Law Review* 11 (1973): 355–72.

Thio, Alex. *Deviant Behavior.* Boston: Houghton Mifflin, 1978.

Thomas, William I. *Sex and Society.* Boston: Little Brown, 1907.

———. *The Unadjusted Girl.* New York: Harper & Row, 1923.

Thornton, William E., and James, Jennifer. "Masculinity and Delinquency Revisited." *British Journal of Criminology* 19 (1979): 225–41.

Thrasher, Frederic M. *The Gang.* Chicago: University of Chicago Press, 1929.

Vedder, Clyde B., and Somerville, Dora B. *The Delinquent Girl.* Springfield, Ill.: Charles C. Thomas, 1970.

Vega, Manuel, and Silverman, Ira J. "Police Perceptions of Female Roles and Women in Policing." *Southern Journal of Criminal Justice* 3 (1978): 34–41.

Velimesis, Margery. *Courts and the Woman Offender.* Philadelphia: Program for Women and Girl Offenders, Inc., 1977.

Ward, David A.; Jackson, Maurice; and Ward, Renee. "Crimes of Violence by Women." In *The Criminology of Deviant Women,* Freda Adler and Rita James Simon, eds. Boston: Houghton Mifflin, 1979.

Wattenberg, William W., and Saunders, Frank. "Sex Differences Among Juvenile Offenders." *Sociology and Social Research* 39 (1954): 24–31.

Weldy, William O. "Women in Policing: A Positive Step Toward Increased Police Enthusiasm." *The Police Chief* 43 (1976): 46–47.

Widom, Cathy S. "Female Offenders: Three Assumptions About Self-Esteem, Sex-Role Identity, and Feminism." *Criminal Justice and Behavior* 6 (1979): 365–82.

Wilson, Nanci Koser. "The Masculinity of Violent Crime—Some Second Thoughts." *Journal of Criminal Justice* 9 (1981): 111–23.

Winick, Charles, and Kinsie, Paul M. *The Lively Commerce.* Chicago: Quadrangle Books, 1971.

Winslow, Robert. *Juvenile Delinquency in a Free Society.* Belmont, Calif.: Dickeson Publishing Co., 1968.

Wizner, Stephen, and Keller, Mary F. "The Penal Model of Juvenile Justice: Is Juvenile Court Delinquency Jurisdiction Obsolete?" *New York University Law Review* 52 (1977): 1120–35.

Wolfgang, Marvin E. "Cesare Lombroso." In *Pioneers in Criminology,* Hermann Mannheim, ed. Montclair, N.J.: Patterson Smith, 1972.

Wooden, Kenneth. "The Sexuality of Punishment." *Inside/Outside* 3 (September, 1976).

———. *Weeping in the Playtime of Others: America's Incarcerated Children.* New York: McGraw-Hill, 1976.

The Yale Law Journal. "On Prisoners and Parenting: Preserving the Tie That Binds." *Yale Law Journal* 87 (1978): 1408–29.

Youcha, Geraldine. "How Drinking Affects Women." *Women's Day* (November, 1976), pp. 76, 80, 230.

Young, Diony. *Bonding.* Rochester, N.Y.: International Childbirth Education Association, 1978.

Young, Vernetta. "Women, Race, and Crime." *Criminology* 18 (1980): 26–34.

Young, Wayland. "Prostitution." In *Sexual Deviance,* John H. Gagnon and William Simon, eds. New York: Harper & Row, 1967.

Index